D0062627

Pocket Louvre

Front cover: I. M. Pei's pyramid, entrance to the Louvre.
Photograph by Julien Levy.
Spine: *The Winged Victory of Samothrace.* See plate 138.

Photography: Photo Josse
Designer: Thomas Gravemaker, Studio X-Act
Maps: Jean-Philippe Guillerme

Translated from the French by John Goodman

English-Language Edition
Editor: Nancy Grubb
Designer: Kevin Callahan
Production Manager: Louise Kurtz

First edition
10 9 8 7 6 5 4 3 2 1

Library of Congress Cataloging-in-Publication Data

Mignot, Claude.
The pocket Louvre: a visitor's guide to 500 works/Claude Mignot.
p. cm.
Includes bibliographical references and index.
ISBN 0-7892-0578-5
1. Musée du Louvre—Guidebooks. 2. Art—France—Paris—
Guidebooks. I. Title.
N2030.M53 1999
708.4'361—dc 21
99-18384

Pocket Louvre

Claude MIGNOT

ABBEVILLE PRESS PUBLISHERS
New York ▲ London ▲ Paris

Contents

USER'S GUIDE 6

General Information 6 • Hours 7 • Tickets 7
Passes 8 • Transportation 9 • Wheelchair Access 9
The Louvre, Museum and Monument 10 • Getting Your
Bearings 11 • Getting to the Pyramid 15 • Getting into
the Museum 16 • Avoiding Lines 18 • Services in the
Hall of the Pyramid 18 • Places to Eat and Relax 18

AN ARRAY OF TOURS 20

Introductory Tour A (three hours) 21
Introductory Tour B (three hours) 23
Classic Tour C (one day) 26
Classic Tour D (one day) 26
Comprehensive Tour E (four half-days) 27

THE LOUVRE: HISTORY AND ARCHITECTURAL TOURS 31

From Castle to Palace (1190–1682) 31
 A Medieval Fortress 31
 Remains of the Medieval Louvre: A Tour 32
 The Palace of the Valois 33
 The Lescot Louvre: A Tour 35
 The Grand (and Unfinished) Louvre of the Bourbons 38
 The Bourbon Additions: A Tour 43
The Birth and Triumph of the Museum (1682–2000) 47
 Rough Draft for a Palace of the Arts 47
 From the Muséum Central des Arts to the Musée
 du Louvre 48
 Fontaine's Louvre 50
 The New Louvre of Napoleon III 52
 The Napoleonic Louvres: A Tour 56
 The Grand Louvre 65
History of the Collections 68

THE COLLECTIONS
73

Egyptian Antiquities 73
 Access and Tour 75 • History of the Collection 76 •
 Plates 78

Oriental Antiquities and Islamic Art 117
 Access and Tour 119 • History of the Collection 119 •
 Plates 121

Greek, Etruscan, and Roman Antiquities 153
 Access and Tour 155 • History of the Collection 157 •
 Plates 158

French Painting 197
 Access and Tour 199 • History of the Collection 199 •
 Plates 201

Northern European Painting 269
 Access and Tour 271 • History of the Collection 272 •
 Plates 274

Italian and Spanish Painting 331
 Access and Tour 333 • History of the Collection 333 •
 Plates 336

Sculpture 397
 Access and Tour 399 • History of the Collection 400 •
 Plates 402

Objets d'Art 449
 Access and Tour 451 • History of the Collection 451 •
 Plates 454

Prints and Drawings 493
 Access and Tour 495 • History of the Collection 496 •
 Plates 497

Chronology 527
Suggestions for Further Reading 530
Index 531

User's Guide

Pocket Louvre offers a concise introduction to the history of the Louvre—both the building and the collections—which can be read before or after a visit to the museum. For use during a visit, it provides a series of architectural tours plus tours of each department, illustrated with reproductions of five hundred works. These illustrations serve both as a record of works seen and as a capsule history of Western art. The following pages contain:

▲ Practical information and tips for getting the most out of a visit of any length
▲ A variety of museum-wide tours
▲ A history of the Louvre plus an architectural tour
▲ A survey of the museum's seven curatorial departments (the painting department is subdivided into three segments)

General Information

Musée du Louvre
75058 Paris Cedex 01
Located in the first arrondissement, on the Right Bank of the Seine, bordered to the east by the Place Saint-Germain-l'Auxerrois, to the south by the Seine River, to the west by the Tuileries gardens, and to the north by the rue de Rivoli.
Information Desk: (33) 01 40 20 53 17
Recorded Information: (33) 01 40 20 51 51
Group Reservations (required for groups of seven or more):
 (33) 01 40 20 57 60
To reserve a tour by one of the museum's guides:
 (33) 01 40 20 51 77
Disabled Visitors: (33) 01 40 20 59 90
Administrative Offices: (33) 01 40 20 50 50
Fax: (33) 01 40 20 54 42
Minitel: 3615 Louvre
Internet: http://www.louvre.fr
E-mail: info@louvre.fr

Hours

Closed Tuesdays and New Year's Day, Easter, May 1, November 11, and Christmas, as well as occasional other holidays

Mondays and Wednesdays: 9:00 A.M.–10:00 P.M.

Thursdays, Fridays, Saturdays, and Sundays: 9:00 A.M.–6:00 P.M.

The ticket windows close forty-five minutes before the museum closes. Guards start to clear the galleries thirty minutes before the announced closing time.

The Hall of the Pyramid, the Medieval Louvre display and nearby rooms on the history of the Louvre, the Restaurant Le Grand Louvre, and the Cafés de la Pyramide are all open every day except Tuesdays and holidays, from 9:00 A.M. to 10:00 P.M. The bookstore is open every day except Tuesdays and holidays, from 9:30 A.M. to 10:00 P.M.

The study room of the Prints and Drawings Department is open to selected researchers by appointment only; tel.: (33) 01 40 20 50 22.

The Center for Documentation of Museum Holdings is open to selected researchers by appointment only; tel.: (33) 01 40 20 50 50.

Tickets

Prices (2000)

45 French francs

26 French francs after 3:00 P.M. and on Sundays

An additional fee of 30 French francs, requiring separate tickets, is charged for temporary exhibitions.

Entry is free for everyone the first Sunday of every month.

Entry is always free for children under eighteen, for art students in public schools, for teachers, and for the unemployed.

Tickets can be purchased in advance via the Internet (consult http://www.louvre.fr for links to the ticketing sites) and at FNAC ticket counters; tel.: (33) 01 49 87 54 54.

Passes

Carte Louvre Jeunes (120 French francs): For persons twenty-five years and under (remember that those under eighteen automatically enter free) and for professionals engaged in educating the young (teachers and so on). Pass holders receive free entry, via the priority entrances in the Passage Richelieu and the Porte des Lions, to the museum and its temporary exhibitions, *plus free entry for a second person on Monday evenings (6:00 P.M.–10:00 P.M.).*

Cartes Louvre Jeunes can be purchased by mail or in the Hall of the Pyramid.

Tel.: (33) 01 40 20 51 04
Address: Carte Louvre Jeunes
Service Culturel
Musée du Louvre
75058 Paris Cedex 01

Carte Musées–Monuments: A pass good for one (80 French francs; 12.20 euros), three (160 French francs; 24.40 euros), or five (240 French francs; 36.60 euros) days; admits the holder to seventy museums and monuments in Paris and its environs. It can be purchased in the Hall of the Pyramid, major metro stations, or FNAC ticket counters.

Tel.: (33) 01 44 61 96 60
Fax: (33) 01 44 61 96 69
Address: Association interMusées
4, rue Brantôme
75003 Paris
Internet: http://www.intermusees.com

Pass holders can use the priority entrance in the Passage Richelieu and enter the galleries from the Hall of the Pyramid without having to line up to buy tickets.

Carte des Amis du Louvre (300 French francs a year; 45.73 euros): Pass holders receive free entry, via the priority entrance in the Passage Richelieu, to the museum and its temporary exhibitions. If you anticipate making frequent visits to the Louvre, this might be a good investment.

Tel.: (33) 01 40 20 53 34

Address: Société des Amis du Louvre
34, quai du Louvre
75058 Paris Cedex 01

Transportation

By Metro

▲ Lines 1 and 7 to station "Palais-Royal/Musée du Louvre": Exit directly into the Carrousel du Louvre promenade or on the Place Palais-Royal.

▲ Line 1 to station "Louvre," and line 5 to station "Pont Neuf": Exit on the side of the facade of the Colonnade.

By Bus

Lines 21 (Palais-Royal), 24 (Pont du Carrousel or Pont des Arts), 27, 39, 48 (Musée du Louvre or Palais-Royal), 67 (Palais-Royal), 68, 69 (Musée du Louvre or Palais-Royal), 72, 81, 95 (Palais-Royal).

By Car

There is direct access to the Carrousel parking garage from avenue du général Lemonnier, between the Pont Royal and the rue de Rivoli (7:00 A.M.–11:00 P.M.). Once parked, you can walk through the underground promenade to the Hall of the Pyramid.

By Taxi

Have the driver drop you off: (1) at the designated taxi stop on the traffic circle in front of the pyramid; (2) in front of the *mairie* (borough hall) of the first arrondissement (on the east side of the museum), which will give you a view of Claude Perrault's monumental Colonnade; or (3) on the quai des Tuileries (west end of the museum) in front of the new Porte des Lions entrance, if your first priority is to avoid the crowds.

Wheelchair Access

The Louvre publishes a map annotated with access information for disabled visitors, available by calling or faxing the museum. A small platform elevator is available at the pyramid entrance, and other elevators and ramps provide access to the galleries throughout the museum. Wheelchairs are available free of charge from the information desk in the Hall of the Pyramid.

The Louvre, Museum and Monument

The Louvre is both a museum and a monument. Its architecture and interiors make it one of the major historical monuments of Paris, while its vast and varied collections, which encompass almost every aspect of Western art, make it the greatest museum in the world.

The building, which evolved over eight hundred years, offers a concise history of French architecture. It began as a medieval fortress in the twelfth century, the age of the Crusades, then was transformed during the fourteenth century into a luxurious Gothic residence. Next it became a royal palace, with Renaissance courtyard facades and a grand Colonnade that are high points of the French classical tradition. After the Revolution it was transformed, in part, into a Neoclassical museum for the people, then expanded into a stylistically eclectic palace-museum under Napoleon III. Most recently, over a span of some twenty years, it has been ambitiously remodeled to meet contemporary museum standards, becoming the Grand Louvre—a state-of-the-art museum and cultural center.

Originally built outside the city walls, along the Right Bank of the Seine, the Louvre is located slightly west of the heart of nineteenth-century Paris: the Place du Châtelet, where the city's east-west (rue de Rivoli) and north-south (boulevards Saint-Michel and Sébastopol) axes intersect. Today, however, with its monumental glass pyramid marking the main entrance to the Grand Louvre, it proclaims itself the center of twenty-first-century Paris.

An encyclopedic museum, the Louvre has seven curatorial departments: Egyptian antiquities; Oriental antiquities and Islamic art; Greek, Etruscan, and Roman antiquities; paintings; sculpture; objets d'art; and prints and drawings. Its collections extend from the sixth millennium before Christ to the middle of the nineteenth century. With some 30,000 works distributed over 1.6 million square feet, 645,600 of which are devoted to exhibition spaces on four levels, the Louvre offers an almost complete panorama of European and Mediterranean art.

The art of indigenous peoples (African, Oceanic, Eskimo, and American Indian, among others) will be represented at the Louvre by a small installation scheduled to open in spring 2000 (near the new Porte des Lions entrance), pending the eventual opening of a museum entirely devoted to the subject on the quai Branly. The art of the Far East is exhibited in Paris in the Musée Guimet. The Musée d'Orsay (on the other side of the Seine) and the Centre Georges Pompidou (popularly known as the Beaubourg) contain, respectively, art of the second half of the nineteenth century and twentieth-century art.

Getting Your Bearings

The Louvre is a quadrangular structure enclosing the Cour Carrée (square court) plus two large wings embracing the Cour Napoléon, which is now dominated by I. M. Pei's glass pyramid.

The Cour Carrée can be entered through passages in the center of each of its four sides, but its main facade is the Colonnade, to the east. The courtyard is dominated by the Pavillon de l'Horloge (Clock Pavilion) at the center of the west wing. Three more courtyards (some roofed, others open to the sky) are enclosed within each of the two long and slightly oblique wings that extend past the Cour Carrée to the west: the north, or Richelieu, wing, which runs along the rue de Rivoli as far as the Pavillon de Marsan; and the south, or Denon, wing, which runs along the Seine as far as the Pavillon de Flore. The two pavilions were once linked by the Tuileries palace, but that structure was destroyed by fire in 1871 (the still-existing Arc du Carrousel once marked the entrance to its courtyard).

The west side of the Cour Carrée and the two long wings define a large esplanade, the Cour Napoléon, that opens onto a view of the Tuileries gardens, to the west, beyond the Arc du Carrousel. In the center of this courtyard is the famous glass pyramid (inaugurated in 1989), which is now the main entrance to the museum.

The heart of the Grand Louvre, directly below the pyramid, is the subterranean Hall Napoléon, better known as the Hall of the Pyramid (fig. 1), which houses the museum's visitor facilities.

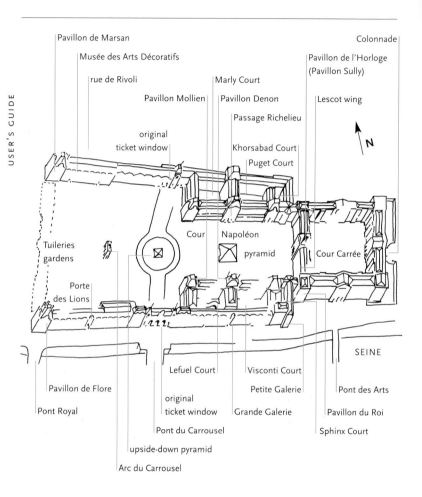

Pavillon de Marsan

Musée des Arts Décoratifs

rue de Rivoli

Pavillon Mollien

Colonnade

Pavillon de l'Horloge
(Pavillon Sully)

Marly Court

Pavillon Denon

Lescot wing

Passage Richelieu

original
ticket window

Khorsabad Court

Puget Court

N

Cour

Napoléon

pyramid

Cour Carrée

Tuileries
gardens

Porte
des Lions

Lefuel Court

Visconti Court

SEINE

Pavillon de Flore

Petite Galerie

Pont des Arts

Pont Royal

original
ticket window

Grande Galerie

Pavillon du Roi

Pont du Carrousel

Sphinx Court

upside-down pyramid

Arc du Carrousel

DIAGRAM 1.
Overview of the
Louvre

From the Hall of the Pyramid visitors can proceed to the exhibition areas in any one of three directions, signaled by the three small pyramids placed around the large one (the fourth direction, westward to the Carrousel shopping promenade, is indicated by a suspended upside-down pyramid that is invisible at ground level).

▲ *Direction Sully*—to the east, toward the Cour Carrée—leads to the archaeological crypt with its excavations of the medieval Louvre (entresol level); the classical, Egyptian, and Oriental antiquities galleries (ground floor); Egyptian and classical antiquities as well as seventeenth- to nineteenth-century objets d'art (first floor); and French paintings (second floor).

▲ *Direction Richelieu*—to the north, toward the rue de Rivoli—leads, if you turn right, to elevators as well as large escalators up to the galleries of Oriental antiquities (ground floor), objets d'art (first floor), and French and northern European paintings (second floor). If you turn left, it leads to the two roofed Puget and Marly courtyards and the adjacent ground-floor galleries, all of which contain French sculpture.

Fig. 1.
The Hall of the Pyramid.

▲ *Direction Denon*—to the south, toward the Seine, has three courtyards (Sphinx, Visconti, and Lefuel, all on the same level as the Denon vestibule, which was once the main entrance to the Louvre). It leads, if you turn left, to the galleries of Greek, Etruscan, and Roman antiquities, exhibited on three levels. If you turn right, it

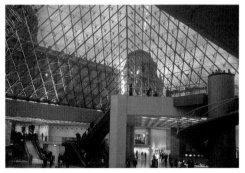

leads to Italian and other non-French sculpture, exhibited on the entresol and ground-floor levels, as well as to the painting galleries on the first floor. These galleries are accessible via the Victory of Samothrace stair (to Italian

13

paintings, which start in room 1) or via the Mollien stair (which leads to room 77, where large nineteenth-century French paintings are on display).

There is also another entrance, the Porte des Lions, which opens onto both the quai des Tuileries and the Carrousel garden. This delivers you into the galleries of Spanish and Italian paintings on the first floor (and, after they open, into the ground-floor galleries that will contain the arts of the indigenous peoples).

The far ends of the Richelieu and Denon wings house ancillary institutions: in Richelieu, the Musée des Arts Décoratifs (107, rue de Rivoli); in Denon, conservation workshops in the Pavillon de Flore and the Ecole du Louvre at the Porte Jaujard.

In the museum, as in this guide, the seven curatorial departments are identified by color:

- ▲ *Green* for Egyptian antiquities (see page 73)
- ▲ *Yellow* for Oriental antiquities and Islamic art (see page 117)
- ▲ *Blue* for Greek, Etruscan, and Roman antiquities (see page 153)
- ▲ *Red* for paintings (see page 197)
- ▲ *Brown* for sculpture (see page 397)
- ▲ *Violet* for objets d'art (see page 449)
- ▲ *Pink* for prints and drawings (see page 493)

For convenience, we have subdivided the painting department into three parts: French, northern European (Flemish, Dutch, German, and English), and Italian and Spanish.

Due to their fragility, most of the museum's prints and drawings are kept in the Cabinet des Dessins and can be viewed only by art professionals and by appointment. A few, however, are on display in the galleries alongside works from other departments.

The exhibition spaces are situated on four levels (see maps on the jacket flaps as well as the detailed maps at the beginning of each departmental tour):

- ▲ *Entresol:* underground, between the Hall of the Pyramid level and ground level

- *Ground floor (rez-de-chaussée in French)*: level with the Cour Carrée and the pyramid courtyard
- *First floor*
- *Second floor*

The location of individual works of art is identified in the Collections section of this guide by wing—Sully, Richelieu, or Denon—and by floor as well as by departmental color and by the number of the room within the department. The rooms are numbered continuously within each department, independent of floor level, but in the case of paintings the sequence is broken by our subdivision of that department into French, northern European, and Italian and Spanish schools.

The Louvre is currently closing entire sections of the museum on a rotating basis, and departments may be completely open only one day a week (Greek and Roman antiquities), two days (most departments), or three days (paintings). To avoid running into closed doors, ask at the information desk for a daily list of what's closed or call in advance (see page 6 for sources of museum information). Also, individual objects at the Louvre tend to move around, whether they've been lent to an exhibition, removed for conservation, or shifted to storage to make way for a new acquisition. As a result, some of the works you see illustrated here may not be on view at the time of your visit.

Getting to the Pyramid

There are several ways to reach the pyramid, where the main entrance to the museum is situated. All of them are wheelchair accessible.

- *From the Cour Carrée,* which can be entered from the rue de Rivoli to the north, from the Place Saint-Germain-l'Auxerrois to the east, or by crossing the pedestrian bridge over the Seine known as the Pont (or Passerelle) des Arts (metro stops: Louvre; Pont Neuf). Once in the Cour Carrée, pass through the Pavillon de l'Horloge and you will see the pyramid. The approach from the Left Bank and across the Pont des Arts is

especially recommended in good weather, for it offers a fine view of the palace as a whole.

▲ *Via the Passage Richelieu,* from the Place du Palais-Royal (Palais-Royal metro or bus stop), which offers attractive views of the two roofed courtyards containing French sculpture. This is the approach most often used.

▲ *From the Tuileries gardens,* which requires either crossing the traffic circle aboveground or taking the less scenic sub-terranean route through the Carrousel du Louvre.

Getting into the Museum

Entering the Louvre without a long wait is not easy.

▲ *Entry via the pyramid, the main entrance—the slowest but the most spectacular*

If the weather is fine, if you enjoy standing in the rain under an umbrella (which will entail two more lines—first to check it in the Hall of the Pyramid and then to reclaim it when leaving), if the line is not too long, or if you feel that a wait intensifies the momentous-ness of the occasion, you can enter the Hall of the Pyramid, the museum's great reception space, directly via the pyramid.

Otherwise, you have three options.

▲ *Entry via the underground Carrousel du Louvre promenade, the most convenient*

To the west of the pyramid, below the ground-level Carrousel garden and esplanade, is a vast underground complex of parking garages, conference rooms, and shops. The center, at the crossroads of two commercial promenades, is indicated by a suspended upside-down glass pyramid that serves as a light well. This Carrousel entrance, which leads directly to the Hall of the Pyramid, is the most direct route for those who arrive by car and park in one of the adjacent garages.

There is another pedestrian entrance to the Carrousel (99, rue de Rivoli), but the most pleasant entrance is from the Tuileries gardens, using two stairways flanking the Arc du Carrousel that

descend to the crypt adjacent to the moats of Charles V. From there you can easily enter the Hall of the Pyramid via the central Carrousel promenade. When it is raining, this underground route becomes especially appealing. However, during peak hours (and especially when the security personnel have been instructed to search all bags) the lines here can be as long as those for the pyramid—and the experience can be quite unpleasant for those who dislike noisy enclosed spaces.

▲ *Entry via the Passage Richelieu, restricted to those with priority passes*

In the Passage Richelieu—a corridor through the north wing of the museum, leading from the Place du Palais-Royal to the pyramid courtyard—there is an entrance restricted to priority visitors (groups, students, teachers, those with passes). You may want to consider obtaining a pass by purchasing a Carte Musées–Monuments, a Carte Louvre Jeunes, or a Carte des Amis du Louvre (see pages 8–9).

▲ *Entry via the Porte des Lions on the quai des Tuileries, the least-known entrance*

The Porte des Lions (opened spring 1999), the only entrance independent of the Hall of the Pyramid, affords direct access to the rooms containing Spanish and Italian painting. This entrance results in a backwards-in-time itinerary, proceeding from the eighteenth to the fourteenth century, but when the line in front of the pyramid is long, this can be a welcome alternative for those without priority passes.

Avoiding Lines

Once inside the pyramid, you must line up again to purchase a ticket from one of the cashiers. This irritating delay can be avoided by purchasing one of the priority passes in advance: Carte Musées–Monuments, Carte Louvre Jeunes, Carte des Amis du Louvre (see pages 8–9). If you have a pass, you can go directly into the museum after showing your pass to the guard at the entrance to whichever wing you want to visit.

Another useful tip: if you arrive about an hour and a half before closing time, you will likely be able to walk right up to the ticket window. This will mean a short visit (especially since guards start clearing the galleries thirty minutes before closing time), but you won't have wasted any of it standing in line.

Services in the Hall of the Pyramid

In addition to the ticket windows, the reception hall boasts an array of facilities: an information desk (in the middle), coat and package checkrooms (be aware that you cannot bring any food into the Louvre, even if you intend to stash it in the checkroom), diaper-changing rooms, an infirmary, free baby strollers and wheelchairs (inquire at the information desk), restrooms, and public telephones (behind the Richelieu and Denon escalators). The hall also encompasses a large art bookstore, an auditorium for films and lectures (see the detailed program schedule posted in front of the auditorium), and reception spaces for groups and visitors gathering for guided tours.

There are many more restrooms inside the museum, but neither these nor the cafés have public telephones; if you are not equipped with a portable phone, you will have to return to the Hall of the Pyramid to make calls. None of the public phones accept change, so you will have to purchase a phone card (minimum amount 49 French francs/7.47 euros); cards are on sale in the Louvre's post office (in the Carrousel promenade), as well as throughout the city.

Places to Eat and Relax

Inside the museum, there are three restaurants.

- ▴ *Café Denon,* on the entresol level, accessible from the galleries devoted to Roman Egypt (room A). Situated below the horseshoe-shaped stair of the Lefuel Court, this is the most agreeable spot for a cup of coffee or a light lunch.
- ▴ *Café Mollien,* on the first floor at the far end of the Denon wing, nestled under the arches at the top of the Mollien stairwell, near

room 77. It boasts a beautiful view of the pyramid courtyard, but it can be noisy, with strong cooking smells.

▲ *Café Richelieu*, on the first floor of the Richelieu wing, near the entrance to the Napoleon III Apartments. There is a lovely view of the pyramid courtyard, especially when the terrace is open. The decor is handsome and the food excellent (though not elaborate), but a bit expensive.

Outside the galleries, there are several places to eat within the Louvre-Carrousel complex.

▲ *Les Cafés de la Pyramide: Cafeteria du Musée and Restaurant Self-Service,* both on the mezzanine overlooking the Hall of the Pyramid. Typical cafeteria fare; very convenient but often crowded, as is the Café du Louvre directly below them.

▲ *Restaurant Le Grand Louvre,* a quiet refuge tucked under the mezzanine, near the information desk, offering waiter service and multicourse meals.

▲ *Self-Services du Monde Entier,* an assortment of fast-food places on the entresol level of the Carrousel promenade. Various regional cuisines: Lebanese, Italian, Asian, Breton, and so on. Noisy and crowded, with food of varying quality, but inexpensive.

▲ *Café Marly,* on the ground floor of the Richelieu wing, entered from the Passage Richelieu. Terrace and interior service; stylish decor; food carefully prepared but quite expensive.

Outside the complex, there are numerous cafés and restaurants in the immediate vicinity of the museum.

An Array of Tours

The Louvre is its own world, and there are many different ways to experience it. The most serious approach is that adopted by methodical visitors, who systematically absorb the full range of the Louvre's holdings. The most original approach is the one preferred by independent-minded enthusiasts, who drop by for an hour or two just to visit a handful of favorite works, much as one might reread a favorite book. The most relaxed approach is that preferred by dilettantes, who wander haphazardly through the Louvre, taking their pleasures as they find them. The most expeditious (and exhausting) approach is the one preferred by tourists in a hurry, who can devote only half a day to the Louvre but want to see as many famous artworks as possible.

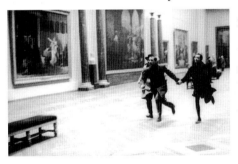

FIG. 2.
The sprint through the Grande Galerie in Jean-Luc Godard's film *Band of Outsiders*, 1964.

In 1964 the rebellious young heroes of Jean-Luc Godard's film *Band of Outsiders* visited the Louvre in just three and a half minutes, galloping through the Grande Galerie in record time (fig. 2). It would be hard to top their speed. Even if you spent only a few seconds looking at each of the museum's roughly 30,000 works on view, over forty hours would be required—an entire work week.

Those settling in for an extended stay in Paris, and those who come to the city regularly, might want to visit the Louvre one department at a time, perhaps allotting one-half day for each—or more, depending on personal interests and inclinations. Detailed itineraries for such visits, lasting about two hours each, can be found at the head of each of the departmental chapters, which begin on page 73. For those with less time, we propose the following tours.

Introductory Tour A (three hours)

From the Hall of the Pyramid, enter the Sully wing and pro-
ceed to the Medieval Louvre exhibit, where you can see the
excavated stone walls of its moat and round keep. After
visiting the medieval artifacts in the Salle Saint-Louis, walk up
the Henri II stair to the ground floor. This will take you to what
was the ballroom in King Henri II's "new Louvre"; it is also
known as the Salle des Cariatides (Hall of the Caryatids; room
17), named after the beautiful female figures by the French
sculptor Jean Goujon that support the platform where musi-
cians once played (fig. 7).

You may want to spend some time with the Roman statues
now on view in this room (*Diana the Huntress,* plate 103;
Hanging Marsyas, plate 105) before passing through the area
formerly occupied by the royal "tribunal," or podium, at the
end of the ballroom. From there you will see, on the left, the
rooms containing Greco-Roman sculpture (rooms 7–16),
handsomely decorated in red marble that sets off the white
marble sculpture (room 12: *Venus de Milo,* plate 100).

If you want to save some extra time for French and north-
ern European painting later in the tour, turn right from the
Salle des Cariatides, toward the Denon wing, and go straight
down the corridor to the Victory of Samothrace stair; if you
go up and then turn right at the landing where *The Winged
Victory* (plate 138) is displayed, the stair will take you directly
up to the Italian painting galleries on the first floor.

Otherwise, behind the *Venus de Milo* and adjacent to room 13
you will find a stairway leading down to the Crypt of the
Sphinx (room 1), which introduces the rooms containing
Egyptian antiquities (reached by walking up one flight). You
can shorten this part of the tour by walking through to room 11
and then up the south stair of the Colonnade wing (which is
sometimes closed off), in which case you will skip most of the
ground-floor thematic installation of Egyptian antiquities and
concentrate instead on the chronological one on the floor above.
(If you want a full tour of the Egyptian collection, consult

pages 73–115.) If you prefer, you can stay on the ground floor and take in all of the thematic display—including the Temple Room (room 12)—which concludes at the north stair of the Colonnade wing.

In addition to offering a fine view of the Cour Carrée from room 23, the first-floor Egyptian galleries contain the royal bedchambers of Henri II and Louis XIV (rooms 25 and 26), which boast superb wood paneling. From the south stair of the Colonnade wing (which offers a good view of the Pont Neuf), enter the Musée Charles X (starting with room 27), which occupies the first floor of the south side of the Cour Carrée. Below its beautiful painted ceilings celebrating the discovery of Egyptian art, Herculaneum and Pompeii, and Italian Renaissance art, you will find the final galleries of the Egyptian department (rooms 27–30) as well as a collection of Roman ceramics (rooms 38–35). If you chose to shorten the Egyptian antiquities part of your tour by skipping the thematic installation, you may want to use some of the time you saved to examine the splendid collection of Greek vases in the series of galleries overlooking the Seine, known collectively as the Galerie Campana (rooms 44–47).

Proceeding straight ahead to the Salle des Sept-Cheminées (Hall of Seven Chimneys; room 74) and the Apollo Rotunda (and passing by the entrance to the Apollo Gallery, room 66, which holds royal jewelry, silverware, and crowns), you will arrive at the Victory of Samothrace stair.

Turn left, toward the *Victory*, and pass through the Percier and Fontaine rooms (rooms 1 and 2) to the Salon Carré (room 3) and the adjacent Grande Galerie (rooms 5, 8, and 12; fig. 3). You are now in the heart of the original Musée du Louvre, where Italian paintings are on view. A third of the way down the Grande Galerie is a door to the right that leads to the Salle des Etats (Hall of State; room 6), which contains masterpieces by Raphael, Titian, and Veronese as well as the *Mona Lisa* (plate 314) by Leonardo da Vinci. (A departmental tour of the Italian paintings is offered on pages 331–87.)

You can return to the Grande Galerie and walk all the way to the Spanish paintings at the very end, where you will find an exit (Porte des Lions) that puts you near the Tuileries gardens. Or, you can continue only as far as the paintings by Caravaggio, near which you will find a door leading to rooms 9–11, which contain Italian "cartoons" (full-scale working drawings) and, beyond, to the Mollien stair and the large galleries of nineteenth-century French paintings (rooms 77 and 75). You can take a look at these now (or come back later), before taking the Mollien stair down to the ground floor. There you will arrive in the Italian sculpture hall, which contains works by Michelangelo (*Slaves*, plate 412) and Antonio Canova (*Cupid and Psyche*, plate 415). After reaching the Denon vestibule, you can either go straight ahead and pay a quick visit to the large Galerie Daru (room B) beyond, which contains beautiful Roman sculpture from the Borghese collection, or you can turn right and proceed directly to the Hall of the Pyramid via the escalators in the Salle du Manège (former site of the imperial riding school).

This brief introductory tour does not give you time to see the French sculpture collection, the Oriental antiquities, the objets d'art galleries, or most of the French paintings (unless, of course, you opted to skip the Egyptian galleries, in which case you may have time for them now). If you regret having missed them, take the Classic Tour C or the departmental tours.

Introductory Tour B (three hours)

From the Hall of the Pyramid, enter the Richelieu wing and proceed straight ahead to the roofed Puget and Marly courtyards, which you may have glimpsed en route from the vaulted Passage Richelieu. Depending on your preferences, you can admire this sculpture installation as a whole or you can take a closer look at a few major pieces—for example, the *Marly Horses* by the Coustou brothers (plate 379) or the *Milo of Crotona* by Pierre Puget (plate 382).

On the upper level of the Puget Court, go to the back of the

court, turn left into room 33, and then turn right to the entrance to the Oriental antiquities galleries. Be sure to take a look at Hammurabi's stele (room 3; plate 65); go through the winged bulls of the Khorsabad Court (room 4; plate 69); and, farther on, visit the *Frieze of Archers* in glazed-brick relief (room 12; plate 76). (For more information, see the departmental tour, pages 117–51.)

Go all the way to the far end of the Oriental antiquities galleries (getting there requires going down and up two spiral staircases), then take the north stair of the Colonnade wing up to the first-floor landing. After admiring the beautiful view down the Colonnade balcony, enter room 20 and begin your walk through the chronological section of the Egyptian antiquities galleries. Here you will find the *Seated Scribe* (room 22; plate 20), the colossal head of Akhenaton (room 25; plate 30), and the statue of Tutankhamen (room 26; plate 37).

After admiring the views of the Seine and the Pont Neuf from the south stairwell of the Colonnade wing, turn right and enter the Musée Charles X. Via the Hall of Columns in the center of this wing, enter room 40 of the Galerie Campana, a series of several rooms that contain ancient Greek pottery. Even if such artifacts hold little interest for you, it is worth glancing at the elegant display cases and painted ceilings and taking in the view of the Seine. If they hold great interest for

FIG. 3.
The Grande
Galerie.

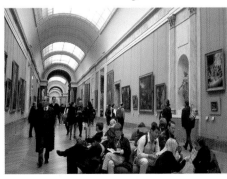

you, consult the classical department tour (pages 153–95) for an expanded visit.

After going back to the Musée Charles X and completing your circuit of its galleries, with their displays of ancient Roman pottery, and after passing through the spectacular Salle des Sept-Cheminées (room 74), you will arrive in the Apollo Rotunda, which opens into the Apollo

Gallery (room 66). In the latter you might want to spend time admiring the crown jewels, and the central ceiling panel painted by Eugène Delacroix. On exiting the Apollo Rotunda, you will have a view of *The Winged Victory of Samothrace* (plate 138). It has been displayed here since 1883, when this stairway was inaugurated as the principal route to the first floor.

If you pass through the two small Percier and Fontaine rooms beyond the *Victory,* which contain frescoes by Botticelli (room 1; plate 289), you will enter the Salon Carré (room 3), the first of the galleries devoted to Italian painting. Beyond this is the Grande Galerie (rooms 5, 8, and 12), where you can linger over individual works according to your taste and time. A third of the way down the gallery is a door on the right leading to the Salle des Etats (Hall of State; room 6), which contains some of the most famous masterpieces in the museum, notably the *Mona Lisa* by Leonardo da Vinci (plate 314) and *The Marriage at Cana* by Veronese (plate 321).

You can leave the Salle des Etats at the far end and go into the Salon Denon (room 76), which is flanked by two immense galleries containing large nineteenth-century French paintings. To the right is room 75, with *The Oath of the Horatii* (plate 211) by Jacques-Louis David, as well as portraits by Jean-Auguste-Dominique Ingres. To the left is room 77, with *The Raft of the Medusa* (plate 217), by Théodore Géricault and *Liberty Leading the People* (plate 219), by Eugène Delacroix.

You can then descend the Mollien stair (you may want to take a break at the Café Mollien) to the Italian sculpture gallery on the ground floor (be sure to see Michelangelo's *Slaves,* plate 412). Continue on to the Denon vestibule and perhaps take a quick look at the adjacent Salle du Manège (earlier site of the imperial riding school), with its curious capitals. From the vestibule you can easily return to the Hall of the Pyramid.

You might want to conclude this introductory tour with a short visit to the Medieval Louvre display (through the Sully entrance), after which we recommend taking a look at the

building's exteriors (see the architectural tours, pages 31–68), if you haven't already done so.

Classic Tour C (one day)

For the first half of our complete one-day tour (which can also be divided into two half-day visits—a more relaxed alternative), follow the same route as Introductory Tour A but linger with the individual works that most interest you.

You might pause for lunch in the Café Denon, in which case you can have a look at the Egyptian funerary portraits from Faiyum exhibited nearby (room A; plate 47). Or, if you eat in the Café Richelieu (from the Hall of the Pyramid, proceed through the Richelieu entrance to the first floor), after lunch you can visit the nearby Napoleon III Apartments.

Next, you can explore the rich collection of objets d'art (rooms 1–88); or you can ascend to the second floor of the Richelieu wing, whose galleries contain northern European paintings (with both a Rubens room and a Rembrandt room) and French paintings (by Georges de La Tour, Nicolas Poussin, and so on). In going back down, you can visit the Puget and Marly Courts of French sculpture. On the upper level of the Puget Court, you will find the galleries of Oriental antiquities, where you might want to see at least the Khorsabad Court, with its spectacular winged bulls (room 4; plate 69).

Classic Tour D (one day)

For the first part of this itinerary, see Introductory Tour B, which you can follow more slowly, devoting a good half-day to it. After a break for lunch, pass through the Sully entrance and proceed to the Medieval Louvre display. After examining the archaeological excavations there, take the Henri II stair up to the ground floor. This will lead you to the Salle des Cariatides (room 17); after passing through it, turn left and visit the Greek antiquities galleries (rooms 8–16; the *Venus de Milo*, plate 100, is in room 12). The departmental tour of the classical collection (pages 153–95) will give you useful guidance.

Return to the Henri II stair and ascend to the first floor. Turn left and go through the room in the Pavillon de l'Horloge that was once the palace chapel, turn right, and you will arrive in rooms formerly occupied by the Conseil d'Etat (Council of State), now used to display objets d'art. The north side of the Cour Carrée and all of this floor of the Richelieu wing are now given over to this superb collection (see the departmental tour, pages 449–91). Some of its rooms are occasionally closed, but it is well worth your time to visit whatever is open.

To bring your tour to a close, take the large escalator to the second floor, where both the Richelieu and Sully wings are devoted entirely to painting. To the right is a sequence of galleries tracing French painting from François Clouet to Jean-Baptiste-Siméon Chardin; for a departmental tour, see pages 196–267. To the left are galleries containing northern European paintings: paintings by Albrecht Dürer and Hans Holbein, a room of Rembrandts, and so on; for a tour of this department, see pages 269–329.

Comprehensive Tour E (four half-days)

First Half-Day

From the Hall of the Pyramid, take the Sully entrance to the Medieval Louvre. After examining the remains of the original castle's moats and keep, retrace your steps to the Crypt of the Sphinx (room 1), which marks the entrance to the Egyptian antiquities galleries (see the departmental tour, pages 73–115). These are organized in two distinct sequences, one thematic (ground floor; rooms 3–19), the other chronological (first floor; rooms 20–30). Visit the ground-floor galleries first, then ascend the north stair of the Colonnade section and walk through the first-floor galleries. Beyond the central Hall of Columns (after room 30) are the remaining four rooms of the Musée Charles X (rooms 38–35). Pass through these, paying more attention for now to the decor than to the artifacts, to which we will return on the second half-day.

Proceeding straight ahead, pass through the spectacular Salle des Sept-Cheminées (room 74) and the Apollo Rotunda, to the left of which opens the grandiose Apollo Gallery. Beyond the rotunda is *The Winged Victory of Samothrace* (plate 138), past which are the Italian painting galleries (see the departmental tour, pages 331–87). You may want to linger in the Salon Carré (room 3), in the Grande Galerie (rooms 5, 8, and 12), and in the Salle des Etats (room 6), where many of the museum's Italian masterpieces are exhibited alongside Leonardo's *Mona Lisa* (plate 314).

Exiting the far end of the Salle des Etats, you will arrive in the Salon Denon (room 76), with its spectacular vaulted ceiling and its superb view of the pyramid. This room is flanked by two galleries (rooms 75 and 77) devoted to large French paintings of the nineteenth century. From the Salon Denon, take the elevator down to the entresol level, where you may want a break at the Café Denon. This would make it possible to have a look at the beautiful Roman Egyptian portraits from Faiyum (room A; plate 47). Or you may prefer to go up and relax in the café at the top of the Mollien stair, on the first floor.

Second Half-Day

This part of the tour begins on the entresol level just inside the Denon entrance. To the right are galleries on two levels: the former imperial stables and, on the ground floor, the Galerie Mollien; both contain non-French sculpture (for a tour of the museum's sculpture collection, see pages 397–447). To the left is another pair of galleries on two levels: artifacts from archaic Greece are exhibited on the entresol level (rooms 1–3), and statues from the Borghese collection are in the ground-floor Galerie Daru (room B); see pages 153–95 for a full departmental tour. More of the Borghese statues are displayed in the adjacent Sphinx Court, Pan Corridor, and Salle des Cariatides (room 17).

The tour of the Greco-Roman collection continues on the first floor, which can be reached via the Henri II stair. Head

through the Salle du Roi (room 32) to the Salle Henri II (the former royal dressing room; room 33); to its left, in the south wing of the Cour Carrée, are the four western rooms of the Musée Charles X (rooms 35–38), with their displays of Roman pottery, and the Galerie Campana (rooms 47–44), with its superb collection of Greek vases.

Now retrace your steps to the Henri II stair, beyond which are the objets d'art galleries (for the departmental tour, see pages 449–91), but be sure not to miss the Napoleon III Apartments.

Third Half-Day

Go in the Richelieu entrance and take the large escalator all the way up to the galleries of French and northern European painting on the second floor.

The first three rooms (1–3) are shared by the two schools. It makes most sense to see the northern European paintings (rooms 4–39; departmental tour, pages 269–329), then retrace your steps to room 4 and start over with the French painting galleries (rooms 4–73, A–C; departmental tour, pages 197–267). They continue along the entire perimeter of the Cour Carrée; after visiting them, you can go back down via the elevator or take the Henri II or IV stairs.

Fourth Half-Day

Go in the Richelieu entrance, then continue straight ahead for the collection of French sculpture exhibited in and around the Puget and Marly Courts. Next, visit the adjacent galleries of Oriental antiquities and Islamic art; for a departmental tour, see pages 117–95.

This tour concludes with an examination of the building's exteriors, which will already be somewhat familiar to you from your initial view of the building as you came in and from the views from inside the galleries. See the architectural tours, pages 31–68.

The Louvre: History and Architectural Tours

From Castle to Palace (1190–1682)

A Medieval Fortress

In 1190 King Philippe-Auguste ordered the people of Paris to surround their city "with a complete wall outfitted with good towers and gates." Within a dozen years (the precise date is uncertain), a fortress called "the Louvre" was erected against the outside of this wall to the west, overlooking the Seine, in order to secure control of the river downstream from the city. After serving also as an arsenal, a prison, and a royal treasury (at that point the king lived in a palace on the Ile de la Cité, in the middle of the Seine), the Louvre became a royal residence in the fourteenth century, under King Charles V.

At the beginning of the seventeenth century, under King Henri IV, the inner and outer walls of the wide moat were lined with masonry; in 1624–34, under King Louis XIII, they were demolished during construction of a wall still farther west. Unearthed during construction of the Grand Louvre in the 1980s, the remains of the moat walls can now be seen at the end of the Carrousel du Louvre (Salle Charles V). Within the walls, the Louvre became a residence: the architect to King Charles V, Raymond du Temple, added floors to the old buildings and built two new sections to the east and north, the latter reached by a large spiral staircase.

The landscape backgrounds of two paintings, the *Pietà of Saint-Germain-des-Prés* (fig. 4) and the *Retable of the Parlement of Paris* (plate 145), feature precise images of the medieval Louvre: a fortress 256 by 236 feet (78 by 72 meters), with ten towers and a quadrangle enclosing a

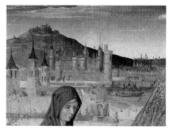

FIG. 4.
The Master of Saint-Germain-des-Prés.
Pietà of Saint-Germain-des-Prés (detail), c. 1500.
Second floor, northern European painting galleries, room 10.

DIAGRAM 2.
The Medieval Louvre.

1. Keep
2. Large spiral stair of
 Charles V
3. Beginning of the tour

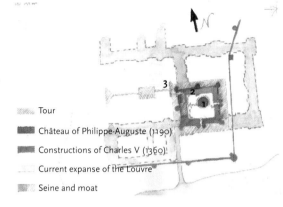

▨ Tour
▰ Château of Philippe-Auguste (1190)
▰ Constructions of Charles V (1360)
┈ Current expanse of the Louvre
▨ Seine and moat

courtyard that was almost square. Within it rose a bulky circular keep, surrounded by a moat, that was roughly 50 feet in diameter and 100 feet tall (15 by 30 meters).

The aboveground elements of the medieval Louvre gradually disappeared. In 1528 the keep was razed; the wings to the west and south were replaced by new ones in the sixteenth century. The two other wings were demolished beginning in 1639, when the area of the courtyard was quadrupled (it eventually evolved into the present Cour Carrée).

Remains of the Medieval Louvre: A Tour
The fact that the Louvre's medieval foundations still existed had been known since 1866, but they remained hidden until construction of the Grand Louvre resulted in a meticulous and extensive excavation campaign in 1984–86. At that time, the decision was made to create an archaeological display that would reveal to visitors the substructure of the first Louvre (diagram 2).

To reach the Medieval Louvre display from the Hall of the Pyramid, take the Sully escalator to the entresol level. The display follows the course of the old moat around the castle,

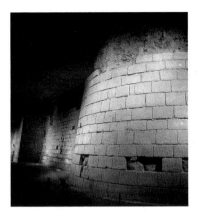

which, roughly 40 feet wide and 23 feet deep (12 by 7 meters), was initially filled with water (fig. 5). Note the quality of the masonry construction of the moat's exterior wall (on your left) and of the sloping wall of the castle itself (at right). Also visible is a stone piling that once supported a pedestrian bridge leading to the king's garden, north of the moat.

After following the north and east sides of the outer moat, you can enter the inner moat around the keep; this moat was dry and faced with dressed stone slabs. Returning to the outer moat you will find, to the left, the remains of the large lower hall from the medieval complex, known as the Salle Saint-Louis, with its vaulted ceiling from about 1230 (fig. 6). Here artifacts recovered during the 1984–86 excavations are on display—notably fragments of the gilt-iron crowns in the form of fleurs-de-lys that decorated the roofs, turrets, and dormers of the medieval structure.

FIG. 5 (above, left). The moats, late 12th century, in the archaeological crypt below the Cour Carrée.

FIG. 6 (above, right). Remains of the Salle Saint-Louis with its piers and vault springs, c. 1230. Entresol, below the Salle des Cariatides.

The Palace of the Valois

In 1527 François I (one of the kings in the Valois line) proclaimed his intention to reside henceforth in "Paris and environs more than elsewhere in the realm" (as opposed to

DIAGRAM 3.
The Louvre
of the Valois.

1. Lescot's new wing
2. Petite Galerie,
 ground floor
3. Tuileries palace

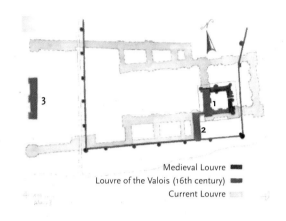

Medieval Louvre ■■■
Louvre of the Valois (16th century) ■■■
Current Louvre ▢

the Loire Valley, which he, like his predecessors, had previously favored). A year later he began the process of making the Louvre a more comfortable place to live by having the large keep demolished. In 1546 he commissioned Pierre Lescot to build a new block to the rear of the Louvre's courtyard—a decision that effectively began the transformation of the complex into a modern palace (diagram 3). Lescot's design assumed definitive form during the reign of François's son Henri II, when the staircase formerly situated at the center of Lescot's new block was shifted to the north end of the block to make room for a large ballroom on the ground floor. This shift required a new facade; at the same time, the center of interest within the complex shifted to the south. The tower at the southwest corner was replaced by a rectangular structure known as the Pavillon du Roi (King's Pavilion), destined to house the king's bedchamber (1551–56).

Henri II also rebuilt the south block (which had been erected under Philippe-Auguste) along the same lines as the west block—a project continued by his son, Charles IX. Catherine de Médicis, the widow of Henri II, built a garden alongside the

Seine; a seven-arched gallery with a roof terrace (c. 1566–67) opened onto it and was linked to the Pavillon du Roi by a narrow passage. Farther west, outside the walls, she also built a vast palace, the Tuileries, which was left unfinished for the moment (1564–72). The idea soon arose of linking the two palaces with a long gallery—just as, in Florence, the Medici had linked the Signoria to the Palazzo Pitti. Charles IX favored the idea, but it was his brother Henri III who first created such a corridor in the form of a passage adjacent to the wall along the Seine.

The Lescot Louvre: A Tour

The configuration of the Louvre under the Valois has been altered somewhat, but its essential features remain legible. You can reach the Lescot wing via a ramp that leads from the Medieval Louvre to the Henri II stair. On the ground floor, the large ballroom now known as the Salle des Cariatides (room 17; fig. 8) opens to the right of the staircase.

A few feet in front of the entry wall are the four large caryatids that give the room its name. Carved by Jean Goujon following Lescot's designs (1550), they support a musicians' tribune (fig. 7). Located at the other end of the room was a tribunal—an area a few steps higher than the rest of the room, reserved for the sovereign and his intimates. The steps have disappeared, but the space once occupied by the tribunal is still legible, complete with its screen of columns. The original ceiling was a beamed wooden one, but in 1629, under Louis XIII, this was replaced by a stone vault designed by Jacques Lemercier.

Go back to the Henri II stair and walk up it. By the time it was built, dogleg stairways were no longer

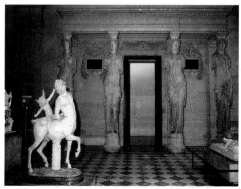

FIG. 7.
Caryatid Tribune, designed by Pierre Lescot and carved by Jean Goujon, 1550–54. Salle des Cariatides (see fig. 8).

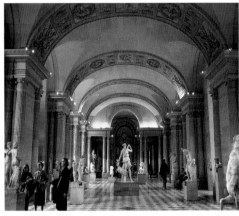

Fig. 8 (above).
Salle des Cariatides.
Ground floor, room 17.

Fig. 9 (below).
Barrel vault over the
Henri II stair, 1553.

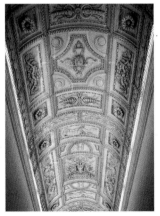

novel, but the width of this one made it exceptional. Especially noteworthy are the reliefs on the barrel vaults (carved 1553; fig. 9), which represent rustic, royal, and hunting themes: Diana the huntress, dogs, deer, satyrs playing with the king's initial *H* and the crescent of Diana (another emblem of Henri II).

After reaching the first floor, you enter, on the right, the Salle du Roi (Royal Hall; room 32), directly above the ballroom. This room, which retains its original dimensions but has lost all of its sixteenth-century decor, overlooks the Cour Carrée to the east and, to the west, what was originally the kitchen courtyard (now the site of the pyramid). Originally, a door at the far end of the Salle du Roi led to an antechamber and dressing room, but the wall defining those spaces has since been demolished. Its former location can be detected by examining the compartments of the gilt-wood ceiling, which is now decorated with paintings by Georges Braque, commissioned in 1953 (fig. 50). Beyond was the king's bedchamber, or Pavillon du Roi, which was remodeled during the Restoration to become the Salle des Sept-Cheminées (Hall of Seven Chimneys; room 74); its original ceiling, removed in 1817, was reinstalled in a room in the Colonnade wing in 1831 (room 25; fig. 10).

Our tour of the Valois Louvre now moves outside. From the reign of Henri II to that of Henri IV, the new wing built by Pierre Lescot was the westernmost part of the Louvre. It survives today to the south of the Pavillon de l'Horloge on

the inside of the Cour Carrée, but the magnitude of the court's current four wings can distort the perception of Lescot's delicate architecture. Its qualities are best appreciated if you stand in the middle of the southwest quadrant of the Cour Carrée and conjure up in your mind's eye what would have been there at the time: the large residence of Charles V with its grand spiral staircase, which was located to the right of what is now the Pavillon de l'Horloge.

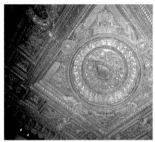

Lescot's new wing (fig. 11) is the most impressive manifesto of the new *à l'antique* style of architecture and the founding work of French classical architecture. The facade is composed as rigorously as a sonnet: the frontispieces (in a scheme inspired by ancient triumphal arches) incorporate columns arrayed in rhythmic bays; the large central bays, which contain doors, are flanked by subsidiary bays framed by slender columns. These frontispieces contrast with the expanses of walls beyond, which are punctuated only by simple pilasters. The ornamental sculpture by Jean Goujon, which is more elaborate on the three frontispieces than on the walls connecting them, reinforces this articulation. The whole is covered by a broken, or mansard, roof, the first appearance of an element often mistakenly said to have been invented by the French architect François Mansart.

FIG. 10.
Ceiling of the Henri II bedchamber, 1556. First floor, Colonnade wing, Egyptian antiquities galleries, room 25.

FIG. 11.
The block designed and built for Henri II by Pierre Lescot, 1546–56. View from the Cour Carrée.

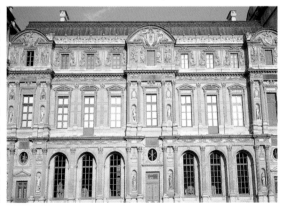

The entire facade is a paean to Henri II, decorated with his initial *(H)*, his heraldic motto (*Donec totum impleat orbem*, "Until It Fill the Whole

DIAGRAM 4.
Iconography of Pierre
Lescot's triumphal
facade for Henri II.

1. Abundance
2. Genies and shield
 with initials of
 Henri II
3. Mercury
4. Captives
5. Trophies
6. Neptune
7. Ceres
8. Mars
9. Bellona
10. Archimedes
11. Euclid
12. Royal emblems
13. History
14. Victory
15. Hope
16. Fortune
17. The King's glory
18. Fame

Universe"), and his emblem (a lunar crescent, which has two meanings—being both the implied subject of his motto and the emblem of Diane de Poitiers, his mistress). The low reliefs flanking the oculi, the prisoners and trophies of arms depicted in the attic bays, and the Victories flanking the royal coats of arms in the central pediment reinforce the triumphal motif of the frontispieces and express the king's imperial pretensions (diagram 4). (On the adjacent south wing, the initials *K* [Charles IX], *H* [Henri III], and *BHB* [Henri de Bourbon—in other words, Henri IV] record the later history of the building.)

The Grand (and Unfinished) Louvre of the Bourbons

In 1594 Henri IV (the first Bourbon king) entered a Paris newly pacified after the prolonged crisis of the wars of religion. There he announced his intention to make the city his principal place of residence, and construction of the Louvre and the Tuileries soon resumed.

Previously, for Henri II, Lescot had drafted designs for a project about which almost nothing is known, except that it called for quadrupling the size of the Louvre's courtyard. In

1594–95 Henri IV revived this ambitious project (which was modified in 1603; fig. 12), and he also began planning a long gallery connecting the Louvre and Tuileries palaces.

Between 1595 and about 1610 (the year Henri IV was assassinated), the king's architects, Jacques Androuet du Cerceau and Louis Métézeau, built the Grande Galerie along the riverbank (fig. 22). Roughly 1,475 feet (450 meters) in length, it linked the Petite Galerie of Catherine de Médicis to the new pavilion at the south end of the Tuileries, called the Pavillon de Flore (1607).

After a false start in 1624, construction on a significant scale did not resume until 1639, during the tenure of Cardinal Richelieu as prime minister and François Sublet de Noyers as superintendent of buildings. The work was entrusted to Jacques Lemercier, architect to both Louis XIII and the cardinal. Lemercier designed the large central pavilion on the west side of the Cour Carrée, which has been known as the Pavillon de l'Horloge since 1857, when a clock was installed in it. To the north of this structure, he contented himself with duplicating Lescot's wing to assure symmetry.

During Cardinal Mazarin's tenure as prime minister (1642–61), after the civil war known as the Fronde (1649–53) and the death of Lemercier in 1654, construction resumed under the direction of the new architect to the king, Louis Le Vau. He concentrated on the north and south wings. A frontispiece was added to the riverfront facade facing the Collège des Quatre-

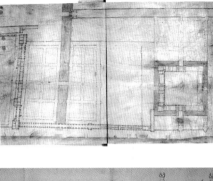

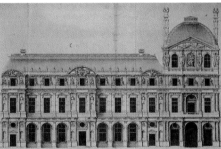

FIG. 12 (top). Anonymous, *Plan of the Louvre and the Tuileries*, 16th century. Bibliothèque Nationale de France, Destailleur Collection.

FIG. 13 (bottom). Jacques Lemercier, *The Louvre*, c. 1639. Musée du Louvre, Département des Arts Graphiques.

FIG. 14 (below).
Louis Le Vau, *Design for Completion of the Louvre*, 1661.
Musée du Louvre, Département des Arts Graphiques.

FIG. 15 (opposite, top).
Giovanni Francesco Romanelli and Michel Anguier, Salle des Saisons (Hall of the Seasons), salon of Queen Anne of Austria's summer apartment, 1654–58.
Ground floor, below the Apollo Gallery.

FIG. 16 (opposite, bottom). Ceiling of the alcove bedchamber in the apartment of Louis XIV, 1654. First floor, Colonnade wing.

Nations, which was established across the Seine in accordance with Mazarin's will and also designed by Le Vau. There were even plans (fig. 14) to build a bridge between the Louvre and the college; this project was realized only much later, with construction of the Pont des Arts.

In 1655–58 Louis Le Vau devised two residential suites for the queen mother, Anne of Austria—a winter apartment on the ground floor of the south wing (destroyed; now the Pan Corridor) and a summer apartment on the ground floor of the Petite Galerie (next to the Mars Rotunda; fig. 15).

On the first floor, Le Vau designed and constructed a new apartment for Louis XIV in the Pavillon du Roi (1654–69). He created a bedchamber with an alcove (fig. 16) and completed the decorative woodwork in the bedchamber of Henri II; dismantled in 1817 during construction of the Salle des Sept-Cheminées, these two decors were reinstalled in the Colonnade wing in 1831. Le Vau also oversaw decoration of the Grand Cabinet du Roi; the Apollo Rotunda, linking the Grand Cabinet to the Petite Galerie; and a chapel on the second floor of the Pavillon de l'Horloge.

The original decor of the gallery on the first floor of the Petite Galerie, dating from the reign of Henri IV, was destroyed by fire in 1661 and rebuilt by Le Vau. Le Vau then paralleled the Petite Galerie with a new block whose facade is now the east side of the Sphinx Court (roofed since 1934). He flanked this facade with a theater to the north and an enlarged Pavillon des Antiques to the south, dubbed the

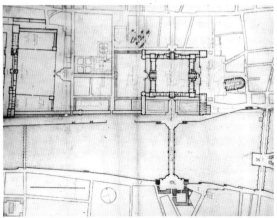

DIAGRAM 5.
Ceiling of the Apollo Gallery.

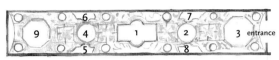

1. *Apollo Vanquishing the Serpent Python*
2. *Evening*
3. *Night*
4. *The Morning Star*
5. *Autumn*
6. *Summer*
7. *Winter*
8. *Spring*
9. *Dawn*

"Salon Carré" (square salon) to distinguish it from the round Salon d'Apollon (Apollo Rotunda).

In January 1664, after having been named superintendent of buildings by Louis XIV, Jean-Baptiste Colbert suspended work on the Louvre and began to solicit ideas from prominent architects—most notably four Parisians (François Mansart, Pierre Cottard, François Le Vau, and Louis Le Vau) and three Romans (Gianlorenzo Bernini, Pietro da Cortona, and Carlo Rainaldi).

After sending two drawings, Bernini was invited to Paris, where he arrived in early June 1665. He elaborated a third design that was approved by the king, engraved, and struck on a medal commemorating the laying of the foundation stone

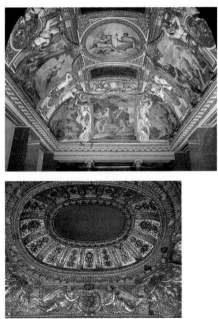

of the east facade. The old buildings of Lescot, Lemercier, and Le Vau were to be encased within grandiose new exterior and courtyard facades. But after Bernini's departure, the French architects, who had never stopped presenting designs of their own, succeeded in winning Colbert over to their side, and in 1667 he organized a small committee consisting of Claude Perrault, Charles Le Brun, Le Vau, and Le Vau's assistant François d'Orbay. They produced a new design for the east facade—often referred to as "Perrault's Colonnade" but doubtless a collaborative effort to which all the committee members contributed. Construction of a modified version of this design began in 1668 (fig. 17), but the upper portion was not completed until the end of the eighteenth century, when houses and other structures that had encroached upon it were demolished (fig. 26).

In addition, the old facade facing the Seine was replaced by a new one consistent with the Colonnade, work that required destruction of the south frontispiece designed by Le Vau (fig. 18). Louis XIV's increasing preoccupation with Versailles, culminating in his announcement in 1682 that it would be the official seat of government from that point on, again interrupted construction at the Louvre prior to completion. The north, east, and south wings were left unroofed, with their court and exterior facades left incomplete.

FIG. 17.
Anonymous (German engraver?), *Construction of the Louvre Colonnade,* 17th century.

All that survives of the interiors created under Louis XIII and Louis XIV are the Mars Rotunda and the apartment of Anne of Austria on the ground floor of the Petite Galerie, the Apollo Gallery and its adjacent rotunda (completed in the nineteenth cen-

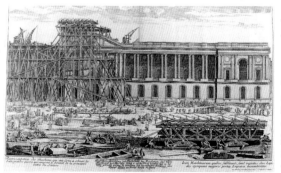

tury) on the first floor, the ceiling of the king's bedchamber (remounted on the first floor of the Colonnade wing; fig. 16), and a few paintings.

On the ground floor of the Petite Galerie, the apartment decorated in 1655–58 for Anne of Austria by Le Vau (architect), Giovanni Francesco Romanelli (ceiling frescoes), and Michel Anguier (stuccos) consists of six rooms: a hall, a salon (Salle des Saisons; fig. 15), a vestibule (Salon de la Paix), a large cabinet, a ceremonial bedchamber, and a small cabinet. This rich decor is characteristic of the Italianizing tendency of Parisian taste in interior design after the Fronde.

After Le Vau's reconstruction of the burned first floor of the Petite Galerie, the vault was decorated by Charles Le Brun around the theme of Apollo—hence its current name, the Apollo Gallery. The vault was left incomplete until the eighteenth century, when the blank compartments were filled with new paintings. The whole was restored under Félix Duban's direction and completed with a central *Apollo Vanquishing the Serpent Python* by Eugène Delacroix, in 1849–51 (diagram 5).

The Bourbon Additions: A Tour

To get a sense of the Grand Louvre of the Bourbons (diagram 6), walk to the center of the Cour Carrée (fig. 19; now decorated with a ridiculous modern water basin). From there, face west (with the Seine on your left), and the symmetry of the two sections flanking the Pavillon de l'Horloge will be readily apparent (the section on the left is by Lescot; on the right, by Lemercier).

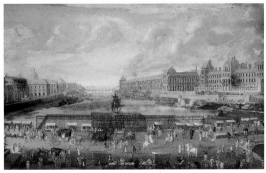

FIG. 18.
French School, *View of the Pont Neuf, the Louvre, and the Collège des Quatre-Nations*, c. 1680. Musée Carnavalet, Paris.

DIAGRAM 6.
The Louvre of the
Bourbons.

1. Grande Galerie
2. Pavillon de Flore
3. Tuileries palace
4. Pavillon de l'Horloge
5. Expanded Cour Carrée
6. Colonnade
7. Saint-Thomas-du-
 Louvre quarter
8. Courtyard of the
 Tuileries palace

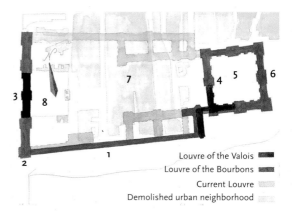

Louvre of the Valois ▬▬
Louvre of the Bourbons ▬▬
Current Louvre ▬▬
Demolished urban neighborhood ▬▬

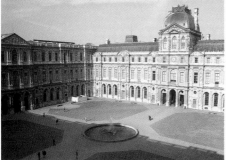

FIG. 19.
The Cour Carrée.

The Pavillon de l'Horloge, designed by Lemercier in 1639 (not 1624, as is often claimed), is similar in volume to the Pavillon du Roi at the southwest corner of the courtyard, but its facade was inspired by the adjacent wing. Note the quality of the design of the Ionic capitals, inspired by the ones Michelangelo designed for the Palazzo Capitolino in Rome. At the top of the Pavillon de l'Horloge there are large paired caryatids, carved by Jacques Sarazin (fig. 20), that hold up a composition of three nested pediments decorated with allegorical figures of Fame.

Though the section on the right side of the Pavillon de l'Horloge was also designed by Lemercier, its sculpted decor was not completed until 1806 (like that of the adjacent north wing). The topmost floors of the north, east, and south wings differ from that of the west wing as a result of work undertaken in two phases: Jacques-Ange Gabriel altered the

east wing in 1759, and in 1810 Pierre-François Fontaine repeated Gabriel's design on the upper level of the north and south wings. The original attic reliefs on the south wing were removed at that time and can now be seen in the corridor leading to the Medieval Louvre.

Now walk through the passage at the center of the south wing. After reemerging on the side of the Seine, you will see an area on the right, between the riverfront facade of the palace and the Petite Galerie, that once was occupied by the small Garden of the Infanta, named after the Infanta Marie-Anne-Victoire—the young fiancée of Louis XV, who lived for a time in the adjacent ground-floor apartment.

The Pavillon du Roi is no longer discernible from the south, having been absorbed by surrounding structures, but the facade of the Petite Galerie calls for comment. The original design of 1566–67 has been modified three times: by the addition of an upper floor in 1594–95; by reconstruction under Le Vau's direction after the fire of 1661; and by restoration work overseen by Félix Duban in 1849–50.

To the west is the Grande Galerie, which stretches all the way down the quay to the end of the museum. Although the riverfront facade to the west of the arched passage leading to the Place du Carrousel was completely recast under the Second Empire (1861–70), the eastern half retains many original elements. But its decorative sculpture dates, again, to the intensive restoration campaign overseen by Duban, who replaced damaged carvings and completed portions of the structure that had been left unfinished (1848–53). The present facades, with their rich network of ornament (figs. 22 and 23),

FIG. 20.
Jacques Sarazin, *Maquette for the Caryatid Tribune,* c. 1640. Entresol, History of the Louvre galleries.

FIG. 21.
Balcony overlooking the Seine at the south end of the Apollo Gallery, restored by Félix Duban in 1849–50.

FIGS. 22 and **23**.
East end of the
riverfront facade (built
1603), as restored by
Félix Duban, 1848–53.

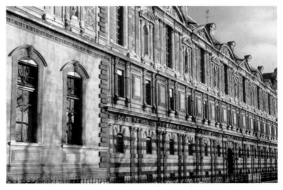

combine Mannerist decorative elements dating from Henri IV with other motifs consistent with Duban's archaeological eclecticism.

Now cross the road that runs along the quay and proceed to the pedestrian bridge known as the Pont (or Passerelle) des Arts, which offers splendid views of the south facade of the Louvre and its environs. Upriver is the Pont Neuf, with its little balconies overlooking the river, and the brick and masonry buildings of the Place Dauphine; on the bank opposite the Louvre is the Collège des Quatre-Nations (now the Institut de France, home of the Académie Française). Then, to get a view of the Louvre's east facade, recross the road, turn right, and walk to the large square at the end of the long block. This is fronted on its east side by a unified architectural ensemble comprising Saint-Germain-l'Auxerrois, which became the king's parish church in the fourteenth century, and the *mairie,* or borough hall, of the first arrondissement.

With its austere basement level and its paired columns set in front of a bare wall, the Louvre's east facade, or Colonnade, ingeniously combines an effect of transparency with total closure against the city (fig. 24). This sense of a barricade reflected the young Louis XIV's distrust of Paris as a result of his experiences

during the tumultuous civil war known as the Fronde (1648–52)—traumatic memories that probably influenced his decision to move the seat of government from Paris to Versailles and effectively strip the Louvre of its functions as royal palace.

The Birth and Triumph of the Museum (1682–2000)

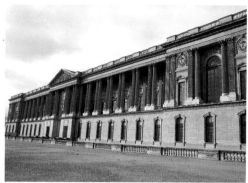

FIG. 24.
The Colonnade (east facade), designed by Claude Perrault, 1667.

Rough Draft for a Palace of the Arts

While serving as a royal residence the Louvre had provided a place to display the royal collections. At the east end of the Grande Galerie, Henri IV built and decorated a room, the Salle des Antiques, for exhibiting the most beautiful antique statues in his collection. Later, after being enlarged following the 1661 fire, this pavilion housed antiquities on the ground floor (now the Salle des Empereurs; room 27) and, on the floor above, paintings from the collection of Louis XIV (now the Salon Carré; room 3). In 1608 Henri IV set aside much of the ground floor of the Grande Galerie to serve as lodgings for artists and craftsmen holding royal warrants.

When Louis XIV officially left Paris for Versailles in 1682, the art-related functions of the Louvre increased, and it became home to the royal academies. In a parallel development even more related to the Louvre's current function, works from the king's collection were displayed in the rooms of the Académie Royale de Peinture et de Sculpture, which had begun to mount its exhibitions in the palace. In 1692 the antiquities from the Palais-Royal were installed in the Salle des Cariatides; in 1699 (fig. 25) and 1704 the painters of the Académie presented their works in the Grande Galerie. After being revived in 1737, the

Académie's exhibitions were held in the Salon Carré, which is why they came to be known as "Salons."

Despite all this activity, the Louvre—still incomplete and increasingly invaded by artists' ateliers and shops—was becoming dilapidated. In 1749, in a pamphlet entitled *L'Ombre du grand Colbert* (The shadow of the great Colbert), Lafont de Saint-Yenne complained about the state of the Louvre, now generally deemed a scandal. Construction resumed in 1755 under the direction of two architects, Jacques-Ange Gabriel (designer of the Place de la Concorde) and Jacques-Germain Soufflot (designer of the Panthéon). The Cour Carrée was completed by finishing the western face of the top floor of the Colonnade, and the aristocratic town houses that had obscured that facade from view were demolished (fig. 26).

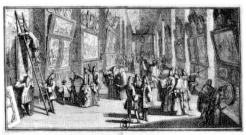

Exposition des Peintures et Sculptures de MM. de l'Académie, dans le galerie du Louvre, 1699.

FIG. 25.
Exhibition of Paintings and Sculptures by the Members of the Academy, 1699, engraving. Bibliothèque Nationale de France, Département des Estampes.

Enlightened minds throughout Europe argued that the French royal and princely collections should be made accessible to the public. Two directors of the king's buildings under Louis XV and Louis XVI envisioned opening both a royal library and a museum in the Louvre. In 1765, in Denis Diderot's *Encyclopédie,* the chevalier de Jaucourt advocated placing on view there "all the paintings of the king that are now piled up helter-skelter in storage facilities, where no one can enjoy them," and "the most beautiful statues of the king" then scattered though gardens, "where exposure to air and the elements is ruining them." This cherished dream, long postponed, would finally be realized in the convulsions of the Revolution.

From the Muséum Central des Arts to the Musée du Louvre
In 1789 the Revolution erupted in Paris. That October, in a

symbolic gesture as significant as the taking of the Bastille on July 14, Louis XVI was forcibly moved by the revolutionaries from Versailles to the Tuileries palace, which once again became a royal residence. On May 26, 1791, the National Assembly decreed that "the Louvre and the Tuileries together will be a national palace to house the king and for gathering together all the monuments of the sciences and the arts and all the principal establishments of public instruction." On August 10, 1793, one year to the day after the fall of the monarchy and some months after the executions of Louis XVI and Marie-Antoinette, the Muséum Central des Arts, installed in the Salon Carré and the eastern half of the Grande Galerie, opened its doors (fig. 27).

The former royal collections were augmented by works seized from churches and convents as well as from émigrés (the members of the nobility and others opposed to the Revolution who had fled the country after 1789). Soon thereafter, these were joined by artistic booty seized in Belgium and, especially, Italy by the armies of the French Republic.

New rooms were opened to hold these treasures. Between 1798 and 1800 the

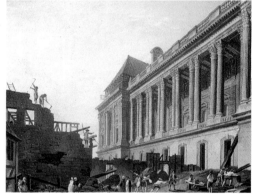

Fig. 26.
Pierre-Antoine de Machy, *The Clearing of the Louvre Colonnade*. Musée Carnavalet, Paris.

architect Jean-Arnaud Raymond remodeled the former apartment of Anne of Austria on the ground floor of the Petite Galerie, replacing the dividing walls with screens of columns and merging the bedchamber and small cabinet into one large room intended for the exhibition of antiquities looted from Italy. On November 9, 1800, the first anniversary of the "coup d'état of 18 brumaire," First Consul Napoleon Bonaparte inaugurated the Salles des Antiques; the following July 14, the western half of the

Grande Galerie was opened, with more than nine hundred paintings on view.

The Muséum Central des Arts was renamed the Musée Napoléon in 1803. It was administered by Dominique-Vivant Denon, who had become its director in 1802 (fig. 28). A draftsman and printmaker as well as a novelist, Denon became the soul of the new museum. In the vast post-revolutionary reorganization scheme overseen by Napoleon, the Louvre became a major element in the emperor's arts policy, functioning as the central museum of the new Napoleonic Europe.

Fontaine's Louvre

Napoleon took up residence in the Tuileries palace, as if to

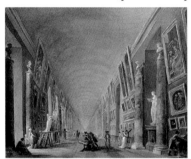

FIG. 27.
Hubert Robert, *The Grande Galerie of the Louvre between 1801 and 1805*, 1796. Painting galleries, second floor, room 5.

suggest a certain continuity between the old and new regimes (after the emperor's defeat in 1814–15, King Louis XVIII likewise resided there, as did King Louis-Philippe after the July Revolution of 1830). The dual function—seat of power and art museum—of the Louvre-Tuileries palace complex determined the changes made under the joint supervision of the architects Charles Percier and Pierre-François Fontaine and then of Fontaine alone. He remained in charge under the Restoration (1815–30) and the July Monarchy (1830–48), a continuity that fostered the ongoing development of projects initiated at the Louvre under Napoleon.

To the west, between the Louvre and the Tuileries, the Arc du Carrousel (fig. 36), built to designs by Percier and Fontaine (1806–8), marked the entrance to the courtyard of the Tuileries palace. The decision to extend the rue de Rivoli as far as the Louvre (1806) prompted a revival of the old project to link the two palaces by building a second wing to the north. A design drafted by Percier and Fontaine that

called for this transverse wing was adopted. Demolition of the Saint-Thomas-du-Louvre quarter (town houses that had been built in what is now the Cour Napoléon) was begun, as was construction of a north gallery modeled after that of the west end of the Grande Galerie.

The museum-related remodeling begun under the Directory and the Consulate continued on an even vaster scale during the Empire. For the display of antiquities Percier and Fontaine recast rooms on the ground floor of the Cour Carrée's south wing: the Salle de Diane, decorated with paintings and stuccos (1801–3), the Pan Corridor (1810–15), and the Galerie des Antiques (1815), whose walls were dressed with red marble. The Salle des Cariatides, vacated by the Institut when it moved to the Collège des Quatre-Nations, was outfitted with carved ceiling beams and a reconstructed mantelpiece.

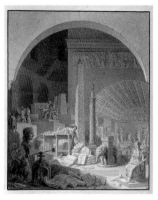

FIG. 28.
Benjamin Zix, *Vivant Denon at the Louvre*. Musée du Louvre, Département des Arts Graphiques.

In 1808–9, in the Colonnade wing's north and south corners, Percier and Fontaine built two grand staircases leading to a projected imperial apartment on the first floor. They also punctuated the first floor of the Grande Galerie with groups of double columns (1805–10) and penetrated the top of the barrel vault with skylights resembling those envisioned by Hubert Robert in 1796 (fig. 27).

Now that the museum was established in the southwest corner of the palace, the traditional entrances into the Pavillon de l'Horloge—the Henri II and Henri IV staircases—were deemed inadequate. The Mars Rotunda, its decor newly completed, became the main entrance to the museum in 1809; the emperor ordered construction of an adjacent main stairway that would lead visitors from it to the Salon Carré and the Grande Galerie, where the Salons were still held (figs. 29 and 30). Completed in time for the Salon of 1812, this stair was demolished in 1855 to make way, eventually, for the grand Daru stairway (inaugurated 1883; more familiarly known now

as the Victory of Samothrace stair); two Percier and Fontaine rooms survive on the first floor (rooms 1 and 2).

After Napoleon's defeat in 1815, France was compelled to return much of its artistic booty, which prompted Denon to resign. Despite this contraction of the collection, the new king, Louis XVIII, retained the plan to build a north wing—paralleling the Grande Galerie to the south and uniting the two palaces along the rue de Rivoli. New museum spaces were prepared to accommodate the collections, which never stopped growing. To exhibit works of French sculpture transferred from the Musée des Monuments Français, as well as works seized from churches and émigrés, Fontaine decorated the ground floor of the Lemercier wing in the style of the Salle des Cariatides. This section—named the Galerie d'Angoulême after the duc d'Angoulême, son of Charles X—was inaugurated in 1824. Fontaine also emptied the former Pavillon du Roi to create a large skylit salon known as the Salle des Sept-Cheminées, or Hall of Seven Chimneys.

Fontaine oversaw renovations to accommodate the Musée Charles X (inaugurated 1827): a sequence of nine rooms with painted ceilings on the first floor of the south wing of the Cour Carrée, overlooking the courtyard, intended primarily to house the rapidly growing Egyptian collection. In 1819 Fontaine had also overseen the remodeling of the nine parallel rooms on the Seine side of this wing (now the Galerie Campana).

The New Louvre of Napoleon III

A month after the revolution of February 1848, the provisional government of the Second Republic decreed: "1. The Palace of the Louvre will be completed. 2. It will be known as the Palace of the People. 3. This palace will be used for the exhibition of paintings, for the exhibition of the industrial productions, for the national library." The renovations for this "New Louvre" were entrusted to Louis Visconti, architect of Napoleon's tomb, while restoration of the "Old Louvre" was overseen by Félix Duban, whose skill had been demonstrated in restoration work

FIG. 29 (opposite, top). Louis-Charles-Auguste Couder, *Percier and Fontaine Presenting the Plan for the Staircase of the Museum to Napoleon.* Musée du Louvre.

FIG. 30 (opposite, bottom). Grand Stair of the Musée Royal, now destroyed. Bibliothèque Nationale de France, Département des Estampes, Album Clarac.

at the Château de Blois and the Sainte-Chapelle.

The decorative elements of the river facade of the Grande Galerie had never been completed. Duban resolved to respect both the insistent ornamentation dating back to Henri IV and the additions made during the reign of Louis XIV: "It seems that the completion of so many parts now crumbling or never finished should, if not precede, then at least proceed in tandem with new work intended to complete [the facade]," he wrote. In addition to also reestablishing the design of the upper levels of the Petite Galerie in accordance with old engravings, Duban created the loggia bearing the initials of Anne of Austria (which cannot be, as sometimes is claimed, the balcony from which Charles IX had shot at Protestants during the Saint Bartholomew's Day Massacre of 1572; fig. 21). Inside, he restored the museum's three most beautiful rooms: the Apollo Gallery, the Salon Carré, and the Salle des Sept-Cheminées, collectively "destined to become the sanctuary of our collections." They were inaugurated in June 1851 by Prince-President Louis-Napoleon Bonaparte.

After the coup d'état of December 2, 1851, the prince-president took up residence in the Tuileries palace, and even before the plebiscite that proclaimed him Emperor Napoleon III on December 2, 1852, he began to develop the New Louvre (fig. 31), following the plan established by

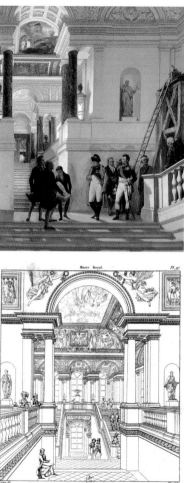

Musée Royal. Pl. 97.

GRAND ESCALIER DU MUSÉE ROYAL
par MM. Percier et Fontaine.

Visconti between 1848 and 1852 (diagram 7). After the latter's sudden death in December 1853, work was overseen by Hector Lefuel, who for twenty-seven years was the soul of construction of the New Louvre. Napoleon III's inauguration of the Cour Napoléon in 1857 marked completion of the "grand project" of the Valois and the Bourbons—an accomplishment noted by two inscriptions on the Pavillon de l'Horloge, below the newly installed clock that gave it its current name.

Lefuel adhered to the plan established by Visconti. To correct the slightly trapezoidal divergence of the two long north and south wings and to mask the misalignment of the Louvre and Tuileries palaces, three small courtyards were enclosed on either side of a larger planted one, which was left open toward the Tuileries.

Visconti had wanted the New Louvre to be consistent with the spirit of the Old Louvre. Lefuel honored this principle, but he inflected the facades and their ornament with the same grandiloquent eclecticism characteristic of the new Opéra then being built by Charles Garnier. The west facade of the Cour Carrée's west wing was recast to make it consistent with the style of this new Louvre. The river facade of the western half of the Grande Galerie and the entire Pavillon de Flore at its end were rebuilt in the spirit of the portion restored by Duban, to assure the symmetry of the two halves flanking the new passage known as the Guichets (ticket windows) du Louvre. Not everyone approved of the result. "Our new Louvre is sumptuous and frivolous; colossal, but not grand," fumed Louis Veuillot in *Les Odeurs de Paris* (1867). "The colossal is as far from grandeur as prettiness is from beauty. The ornamentation is excessive. . . . It has

Fig. 31.
Victor-Joseph Chavet, *The Louvre of Napoleon III*, 1857. Entresol, History of the Louvre galleries.

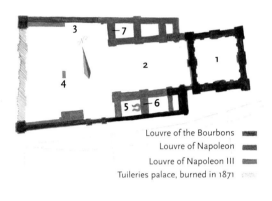

DIAGRAM 7.
The New Louvre of
Napoléon III.

1. Cour Carrée
2. Cour Napoléon
3. Percier and Fontaine
 wing
4. Arc du Carrousel
5. Lefuel Court and
 stair to the Imperial
 riding school
6. Visconti Court and
 Salle des Etats
7. Napoléon III
 Apartments

Louvre of the Bourbons
Louvre of Napoleon
Louvre of Napoleon III
Tuileries palace, burned in 1871

the air of a vulgar nouveau riche, overloaded with gewgaws
and excrescences."

Except for visitors with special authorization, the museum
had previously been open only on Sundays, but beginning in
1855 it was accessible to the general public six days a week
(closed Mondays). The new vestibule in the Pavillon Denon
(the entrance to the museum, on the south side of the current
Cour Napoléon) and the two large galleries flanking it offered
spacious rooms for the bourgeois worship of art. But many
of the new spaces were still occupied by the palace and
government agencies: imperial stables (fig. 33) and riding
school (fig. 37) in the south wing; Ministry of State in the
north wing.

The proclamation of the Third Republic after the fall of the
Second Empire in 1870 and the burning of the Tuileries palace
by the Communards in May 1871 would reshuffle the cards.
After a long delay, in 1882 the ruins of the Tuileries (fig. 34)
were razed, opening up a grand perspective from the Cour
Napoléon to the Place de la Concorde and, beyond, to the Arc
de Triomphe. The Finance Ministry was installed in the
Richelieu wing to the north, and various administrative

FIG. 32.
The Lefuel Court.

FIG. 33.
The imperial stables.
Now the gallery of
archaic Greek art,
entresol.

agencies occupied the Pavillon de Flore, but the Louvre was, at last, more museum than palace.

The Napoleonic Louvres: A Tour

Our visit to the "New Louvre" of the two Napoleons begins in the Louvre of the Bourbons. After looking at the facades of the Colonnade wing, Cour Carrée, and the Petite and Grande Galeries, whose decors include many elements from the first decades of the nineteenth century, head to the Seine and then walk west as far as the triple-arched passage known as the Guichets du Louvre (fig. 35). From the Pont du Carrousel across from it you'll be able to appreciate the sumptuous grandiloquence of the New Louvre, which was envisioned by Napoleon I, realized in large part by Napoleon III, and brought to completion during the Third Republic.

After walking through the Guichets du Louvre, you will see ahead of you (across the esplanade and the traffic circle) the facade of the slender north wing built by Percier and Fontaine. Its colossal paired pilasters supporting alternating triangular and rounded pediments echo elements in Jacques II Androuet du Cerceau's Grande Galerie to the south.

The Arc du Carrousel (fig. 36), built to serve as an entrance to the Tuileries palace courtyard, now stands all alone, framing the long view through the Tuileries gardens to the Champs-Elysées and the Arc de Triomphe. Like the Arc de Triomphe (completed under King Louis-Philippe), the Arc du Carrousel commemorates the triumphs of

Napoleon. Originally the chariot at the top, which was pulled by the famous horses from San Marco (looted from Venice), was driven by a figure of Napoleon, but the horses were returned to Italy in 1815 and a new, non-Napoleonic group was installed in 1827.

If you turn and face east, all the architecture visible from the arch belongs to Lefuel's New Louvre—except the pyramid, of course. The silhouette of Lemercier's Pavillon de l'Horloge at the far end of the court, with its large square dome, was copied in the Richelieu and Denon pavilions. These three pavilions, which now orient the museum's principal axes and itineraries, are flanked by smaller pavilions culminating in steep pitched roofs with elaborate dormer windows. Vermiculated bosses inspired by the Old Louvre, pervasive ornament, and emphatic projections combine to create a pompous effect that was criticized by some of Lefuel's contemporaries and that long remained abhorrent to modern taste. Only in the last twenty years or so has Lefuel's design taken on a certain dated charm.

FIG. 34.
Ruins of the Tuileries palace after the fire set by the Communards in May 1871. Entresol, History of the Louvre galleries.

To begin our tour of the interior portions of the building dating from the two Napoleons and the Third Republic, return to the Hall of the Pyramid and take the Denon escalator up to

the ground-floor vestibule. From there it is easy to grasp the locations of the museum's three successive entrances—originally the Mars Rotunda, then the Denon vestibule, and now the pyramid. The Mars Rotunda (room 5), which served as the entrance from 1809 to 1855, originally led

FIG. 35.
The arched passage below the Grande Galerie.

to the Napoleon stair (destroyed in 1855), which culminated in two rooms by Percier and Fontaine (rooms 1 and 2, at the top of the present Victory of Samothrace stair). The Denon vestibule, which was the main entrance until the inauguration of the glass pyramid in 1989, is flanked by the Mollien and Daru

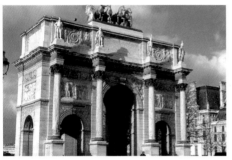

FIG. 36.
The Arc du Carrousel.

galleries, originally intended to house sculpture during the Salon. Their architecture was inspired by the Salle des Cariatides. In 1928 the south wall of the vestibule was removed to link it with the Salle du Manège (fig. 37), the room now first encountered on entering the Denon wing from the Hall of the Pyramid.

Each of the galleries flanking the Denon vestibule leads to a monumental stair. To the west is the Mollien stair (fig. 38), whose ceiling is decorated at the center with a painting by Charles-Louis Müller *(Glory Distributing Crowns to the Arts)* and, in the lunettes, four allegories of the arts in low relief *(Architecture, Painting, Sculpture, Printmaking)*. To the east is the Victory of Samothrace stair, long the main route to the painting galleries.

A tour of the Neoclassical elements designed by Percier and Fontaine can begin at the top of the Victory of Samothrace stair. If you turn right at the landing and continue upward to the first floor, you will find yourself in the Percier and Fontaine rooms (rooms 1 and 2). The Sphinx Court to their right (fig. 39) has since been roofed, depriving the rooms of natural light, but their decor survives largely intact, making it possible to imagine the rich impression originally created by the whole ensemble. The rooms are decorated with a series of works glorifying French art. In room 1 is Charles Meynier's *France in the Guise of Minerva Protecting the Arts* (she holds their attributes: plans, brushes, chisels), surrounded by portraits of artists. Room 2 features *The Genii of the Arts Paying*

Homage to Busts of Apollo and Minerva, carved by Auguste Taunay and Louis-Messidor Petitot; in the next room, *The Triumph of French Painting: The Apotheosis of Poussin, Le Sueur, and Le Brun* is surrounded by medallion portraits of French painters.

Now retrace your steps back to *The Winged Victory of Samothrace* and go up the other flight of this stair; turn right and enter the Apollo Rotunda. The stuccos in this room date from Louis XIV, but the painted decors were executed under Louis XVIII. *The Fall of Icarus,* by Merry-Joseph Blondel, is surrounded by narrative evocations of the four elements: *Air* by Blondel; *Water, Earth,* and *Fire* by Couder. Ignore, for the moment, the long Apollo Gallery off to one side and keep going in the same direction until you enter the Grand Cabinet du Roi (room 34), elegantly designed by Fontaine for the display of precious objects. In the ceiling painting, *Time Indicating the Ruins He Creates and the Masterpieces He Subsequently Allows to Be Discovered* (by Jean-Baptiste Mauzaisse), note the inclusion of a depiction of the *Venus de Milo,* which had just been unearthed. The paintings in the coving represent the four seasons.

The next room, the Salle des Sept-Cheminées (room 74), leads to the two parallel sequences of rooms that occupy the first floor of the south wing of the Cour Carrée: overlooking the courtyard is the Musée Charles X, inaugurated in 1827; overlooking the Seine is the Galerie Campana, completed in 1833.

FIG. 37 (top). The Salle du Manège (the imperial riding school) was the museum's reception hall before the pyramid was built.

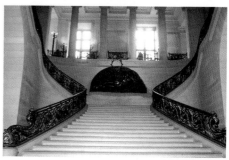

FIG. 38 (bottom). The Mollien stair.

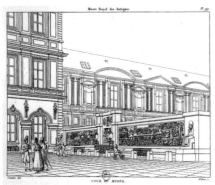

Musée Royal des Antiques.

COUR DU MUSÉE.

FIG. 39 (above). Courtyard of the Musée Royal des Antiques. Bibliothèque Nationale de France, Département des Estampes, Album Clarac.

The first four rooms of the Musée Charles X (rooms 35–38) celebrate ancient civilization. Room 35 is decorated with a ceiling painting by Jean-Auguste-Dominique Ingres, *The Apotheosis of Homer* (now replaced by a copy; the original is in room 77); room 36 has *Vesuvius Receiving from Jupiter the Fire That Would Consume Pompeii, Hercula-neum, and Stabiae,* by François-Joseph Heim; room 37 has *The Nymphs of Partenope [Naples] Trans-porting Their Household Gods to the Banks of the Seine* by Charles Meynier, an allusion to the excavations at Pompeii; room 38 has *Cybele Protecting the Cities of Herculaneum, Pompeii, Stabiae, and Retina from Vesuvius,* by François-Edouard Picot, which replaced a painting by Alexandre-Evariste Fragonard, *François I . . . Receiving Paintings and Sculptures Brought Back from Italy by Primaticcio* (fig. 41; now in the Galerie Campana). The central pavilion of the Musée Charles X is the Hall of Columns, where the three central ceiling paintings are by Baron Gros: *Mars Listening to Moderation, Time Elevating Truth Toward the Throne of Wisdom,* and, in the center, *True Glory Supported by Virtue.*

The ceilings in the next two rooms are decorated with *Study and Genius Revealing Ancient Egypt to Greece,* by François-Edouard Picot (room 30) and *Egypt Saved by Joseph* by Abel de Pujol (room 29). In the last two rooms are *Julius II Ordering Work in the Vatican and Saint Peter's, Surrounded by Bramante, Raphael,*

and Michelangelo, by Horace Vernet (room 28) and *The Genius of France Animating the Arts,* by Baron Gros (room 27).

Straight ahead is the south stair of the Colonnade wing, whose decor by Percier and Fontaine incorporates low reliefs of gods and allegories. Now retrace your steps back through rooms 27–30 to the Hall of Columns, from which you can enter room 40 of the Galerie Campana. All of the decor in the Campana rooms glorifies French history and the patronage of French kings.

Return to the Salle des Sept-Cheminées (room 74) and pass through rooms 32 and 33 as well as the Pavillon de l'Horloge, after which you will enter the sequence of four rooms remodeled for the Conseil d'Etat (rooms 65–62). Room 65 is decorated with *France Victorious at Bouvines,* by Blondel, a work exemplifying the new interest in national history. Room 64 features another work by Blondel, *France Surrounded by Her Legislator-Kings and Legal Advisors* (Saint Louis, Charlemagne, Henri IV and Sully, Louis XIV and Colbert, and so on), as well as trompe l'oeil ceiling reliefs chronicling the promulgation of various charters. In room 63 is a painting by Michel Drölling, *Law Descending to Earth to Distribute Her Benefits,* in which an allegorical figure of the Law in Minerva's chariot is followed by Mercury, god of commerce; Flora and Ceres, goddesses of agriculture; and so on, all overthrowing ignorance. Room 62 is decorated with a painting by Jean-Baptiste Mauzaisse, *Divine Wisdom, Flanked by Equity and Prudence, Handing Down Laws to Kings and Legislators* (Moses, Confucius, Muhammad, Charlemagne, and so on).

The corner room (room

FIG. 40 (opposite, bottom). François Biard, *Four O'Clock at the Salon.* Entresol, History of the Louvre galleries.

FIG. 41 (below). Alexandre-Evariste Fragonard, *François I, Accompanied by the Queen of Navarre, His Sister, and Surrounded by His Court, Receiving Paintings and Sculptures Brought Back from Italy by Primaticcio,* ceiling painting, 1833. First floor, Galerie Campana, room 39.

34) boasts a ceiling painting by Carolus-Duran, *The Triumph of Marie de Médicis,* originally intended for the Luxembourg palace. If you turn right from room 34 and traverse all the decorative arts galleries on the north side of the Cour Carrée, you will find yourself in the north stair of the Colonnade wing; like the corresponding one to the south, it was designed by Percier and Fontaine. If you turn left from room 34 into room 33, you will enter another sequence of decorative arts galleries. Their decor constitutes the spectacular remains of Lefuel's palatial designs for the north wing of the New Louvre (1852–57), and here we can begin our tour of the Louvre of Napoleon III.

Three monumental stairways survive from this period. First is the Colbert stair (near room 24), whose helmets above the door serve as a reminder that it originally led to a barracks. Next comes the spectacular, multiflight Lefuel stair

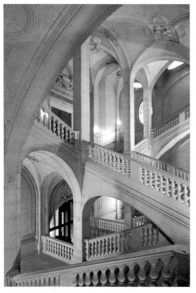

FIG. 42.
The Lefuel stair.

(near room 5; fig. 42), which formerly led to a library (burned during the Commune in 1871); it is decorated with reliefs carved by Claude Vignon. (On the ground floor of the Lefuel stair is Vignon's *Geniuses of Letters*; on the ceiling surrounding the skylight is his *Geniuses of the Arts and the Sciences*). And third is the Ministry stair (near room 85), decorated with two landscape paintings by Charles-François Daubigny, *The Tuileries Gardens* and *The Pavillon de Flore*. This third stair was designed as access to the rooms occupied by the Ministry of State—now known as the Napoleon III Apartments (fig. 43).

Inaugurated in 1861 and occupied by the Finance Ministry from 1871 to 1989, this section consists of small rooms on one side (now occupied by the museum's doc-

umentation department) and a sequence of ceremonial rooms on the other. Room 77, at the southwest corner of the Richelieu wing, offers magnificent views of the Arc du Carrousel and the pyramid. Its decor celebrates the history of the Louvre, which is illustrated on its four walls by depictions of François I, Catherine de Médicis, Henri IV, and Louis XIV presenting designs, and on the ceiling by Napoleon III linking the Louvre and the Tuileries.

Now walk back to the west wing of the Cour Carrée and continue through it to reach the Salle des Sept-Cheminées (room 74). Its ceiling, which features a large skylight surrounded by Victories crowning the names of great artists of the First Empire, was designed by Félix Duban in 1849–51, when plans were being made to use the room, like the Salon Carré, to display masterpieces of painting.

Proceed via room 34 and the Apollo Rotunda to the grandiose Apollo Gallery. Most of the gallery's sumptuous decor dates from the reign of Louis XIV (paintings by Charles Le Brun and superb stuccowork, including a *Neptune* by François Girardon), but its present appearance reflects a completion and restoration campaign overseen by Duban (fig. 44). The walls are hung with Gobelins tapestries representing artists and rulers with ties to the Louvre. On the ceiling (see diagram 5), the most notable feature is the central composition by Eugène Delacroix, *Apollo Vanquishing the Serpent Python.*

FIG. 43.
The Napoleon III Apartments.

Now go back to the entrance of the Apollo Gallery and head past *The Winged Victory of Samothrace* to the Salon Carré (room 3). Also remodeled by Duban in 1849–51, its

decor celebrates artists of four European schools of painting (French, Italian, Northern, and Spanish), identified in panels on the frieze (fig. 45). Despite this nod to internationalism, the stucco medallions by Pierre-Charles Simart use only Frenchmen to embody the four arts: the architect Pierre Lescot and the sculptor Jean Goujon, who both were active at the Louvre; the painter Nicolas Poussin,

FIG. 44 (below). Victor Duval, *The Apollo Gallery after Renovation by Félix Duban*. Entresol, History of the Louvre galleries.

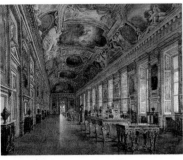

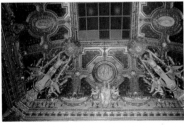

FIG. 45 (above). Ceiling of the Salon Carré, renovated by Duban.

also linked to the history of the Louvre and, more important, considered the French painter par excellence (despite having resided in Rome for most of his career); and the engraver Jean Pesne, doubtless included primarily because of his engravings after works by Poussin. The decor was inaugurated by Prince-President Louis-Napoleon Bonaparte in June 1851, before the coup d'état that made him emperor, which explains the incorporation of the initials *RF* (République Française).

The Salon Carré opens onto the Grande Galerie (rooms 5, 8, and 12; figs. 3 and 46), whose current appearance reflects a remodeling campaign overseen by Lefuel. The spaced groups of columns were introduced by Percier and Fontaine, but the skylights were pierced only in 1938–46. In the second long bay of the Grande Galerie, a doorway to the right leads to the Salle des Etats (room 6), built to accommodate legislative assemblies under the Second Empire. The lavish original interior by Lefuel and Charles-Louis Müller (1858–59), disappeared in 1886, when the room was converted into a skylit exhibition space. Among other treasures, it now houses the *Mona Lisa* by Leonardo da Vinci (plate 314) (whose theft in August 1911—see fig. 47—shocked the world) and *The Marriage at Cana* by Paolo Veronese (plate 321).

Beyond the north end of the Salle des Etats is the Salon Denon (room 76), which once served as the hall's vestibule. Rising to the full height of the square dome crowning the Denon pavilion, the salon has a grandeur recalling that of the Salle des Sept-Cheminées. The ceiling, realized by Müller in 1864–66, celebrates four French rulers who were notable patrons of the arts: Louis IX (Saint Louis), François I, Louis XIV, and Napoleon, whose respective initials ornament the corner escutcheons. Also celebrated are the arts themselves, in the guise of busts of Philibert Delorme (architecture), Poussin (painting), Goujon (sculpture), and Audran (printmaking), repeating only two of the four figures similarly honored in the Salon Carré. To the left and right of the Salon Denon are the Salle Mollien (room 77) and the Salle Daru (room 75)—large rooms whose red-and-gold decorative scheme dates from 1863, when these spaces were set aside for the display of paintings in the imperial collection.

FIG. 47.
The theft of the *Mona Lisa*.

The Grand Louvre

Between the Revolution of 1789 and the Commune of 1871, the amount of space

allocated to the museum continued to expand, but the Finance Ministry, having moved into the rooms formerly occupied by the Ministry of State, remained staunchly opposed to any further enlargement.

In 1967 President Charles de Gaulle envisioned transferring the Finance Ministry to the Halles neighborhood, whose redevelopment was then being planned. Even though that project miscarried, André Malraux, de Gaulle's minister of culture, did manage to reclaim the Pavillon de Flore for the museum. In 1981 President François Mitterand proclaimed his intention "to restore the Louvre to its [museological] purpose" by transferring the Finance Ministry elsewhere, thereby clearing the entire palace for the museum's use, and by creating as well the new spaces and services needed for a monumental modern museum.

Early in 1983 the new project was awarded directly, without a formal competition, to the American architect I. M. Pei, largely on the basis of his design for the recently built East Wing of the National Gallery of Art in Washington, D.C. Pei delivered his scheme in November 1983: "A strong symbolic element was called for. . . . I settled without hesitation on a pyramid, delicate and stable, correctly

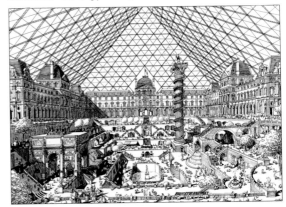

FIG. 48.
Cartoon by Jean Pattou,
Le Quotidien de Paris,
April 8, 1985.

proportioned so as not to overwhelm the architecture of the Louvre but rearing its point there, manifest and pure, without style, impeccably geometric." Despite heated opposition (fig. 48), by 1985 all the necessary authorizations had been obtained. On October 15, 1988, the pyramid (fig. 49) was inaugurated before opening to the public in 1989, for the bicentennial of the Revolution.

The pyramid covers the underground reception hall and serves as the museum's main entrance. Rising to a height of some 70 feet (21.64 meters) from a base 116 feet square (35.4 meters; its proportions are modeled after those of the pyramid of Giza), it weighs roughly 200 tons, divided about equally between its steel grid and its 666 glass lozenges, which become triangular at the base. It is surrounded by seven pools made of gray granite as well as by three smaller pyramids situated directly above the escalators leading to the Denon, Sully, and Richelieu wings.

Inside the pyramid, at plaza level, is a triangular platform supported by a slender column; a spiral ramp and escalators descend from it to the floor of the grand reception hall. From there, visitors can proceed to the galleries in one of three directions (the fourth, opening to the west, leads directly to the commercial public spaces of the Carrousel du Louvre, at whose center is suspended an inverse glass pyramid that serves as a light well).

Throughout the museum the emphasis is on variety, in a design scheme that incorporates the archaeological excavations of the Medieval Louvre, rooms restored in Renaissance, Neoclassical, and eclectic styles; large escalators accessing the north wing; and contemporary fittings

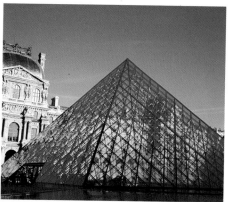

FIG. 49.
I. M. Pei's pyramid.

and furniture by Wilmotte. Despite the visual diversity of these elements, the overall effect is harmonious—as any visitor will attest.

History of the Collections

When the Muséum Central des Arts opened its doors in 1793, the core of its holdings was the former royal collection, which the leaders of the Revolution had declared national property the preceding year. It was rich in sculpture and in painting (Italian as well as French), much of it acquired directly from the artists during their lifetimes, from the *Mona Lisa* by Leonardo da Vinci (plate 314) to *The Oath of the Horatii* by Jacques-Louis David (plate 209). In some cases works had been commissioned for royal residences—for example, the Marie de Médicis cycle by Peter Paul Rubens for the gallery of the Luxembourg palace (plate 245) and *Allegory of Wealth* (plate 158) by Simon Vouet for the new château at Saint-Germain. Louis XIV had acquired masterpieces of Italian painting—notably *Baldassare Castiglione* by Raphael (plate 325), *The Entombment* by Titian, and *The Death of the Virgin* by Caravaggio (plate 334)—but the first important acquisitions of historical French painting were made under Louis XV, with the Life of Saint Bruno cycle and Eustache Le Sueur's decorative panels of the Cabinet de l'Amour from the Hôtel Lambert (plate 168). The collection of Dutch seventeenth-century painting grew considerably under Louis XVI, with acquisitions including *The Supper at Emmaus* by Rembrandt (plate 261), and *The Ray of Sunlight* by Jacob van Ruisdael (plate 279).

In 1796 the bronzes and *pietra dura* vases that had previously been part of the royal collection were also transferred to the Louvre. After suppression of the royal academies during the Revolution, the collection of the Académie Royale de Peintres et Sculptures reverted to the Louvre—notably the works that each applicant had to submit in order to qualify for academy membership.

These riches were soon augmented by further acquisitions, the most prestigious being that of the Borghese collection of antique sculpture in 1808. The bulk of the additions were acquired by seizing the property of émigrés and appropriating church property. This netted the Louvre the regalia from the abbey church of Saint-Denis (plate 425); the series of large canvases presented by the goldsmiths' guild to the church of Notre-Dame every May from 1630 to 1707 (plate 157); and many fifteenth-century Flemish works, including *The Madonna of Chancellor Rolin* (plate 222) by Jan van Eyck, taken from the church of Notre-Dame in Autun, France.

The government's policy of having its armies take artistic booty extended throughout Europe. The spectacular gains that resulted were ephemeral, however, for after the defeat of Napoleon in 1815 these works had to be returned, although a few treasures did remain in Paris: an *Annunciation* attributed to Rogier van der Weyden (plate 223); *Calvary* by Andrea Mantegna (plate 299); *The Marriage at Cana* by Paolo Veronese (plate 321).

Acquisitions under the Restoration reflect the Neoclassical taste then in fashion: *The Son Punished*, by Jean-Baptiste Greuze, arrived in 1820 and Jean-Antoine Houdon's *Diana the Huntress* in 1829. Newer tendencies were also acknowledged, notably with the purchase of *The Raft of the Medusa* (plate 217) by Théodore Géricault in 1824 and Eugène Delacroix's *Liberty Leading the People* (plate 219) in 1831.

Initially, only ancient sculpture was allowed in the museum, with the exception of Michelangelo's *Slaves* (plate 412). The modern sculpture that eventually found its way into the Louvre had accumulated elsewhere. Monumental pieces as well as fragments of tomb and altar ensembles seized during the Revolution were assembled by Alexandre Lenoir in the former convent of the Petits-Augustins (now part of the Ecole des Beaux-Arts) to constitute the Musée des Monuments Français. When it was closed in 1817, some fifty works were transferred to the Louvre, where they joined the

academic reception pieces by sculptors that had been moved there from Versailles in 1798. In 1824 a hundred modern sculptures were placed on display in the Galerie d'Angoulême, which was still under the authority of the curator of antiquities.

Shortly before 1830 the first symptoms appeared of a marked change in taste—namely, a revival of interest in the Middle Ages and the early Renaissance, which led to the acquisition of two collections of objets d'art, Durand's in 1825 and Revoil's in 1828. A shift in interest to the east was reflected in the addition of antiquities from Egypt and Assyria; the creation of a new department of Egyptian antiquities in 1826 and the acquisition for it of three collections (Durand, 1824; Salt, 1826; Drovetti, 1827), which all found their place in the Musée Charles X, inaugurated in 1827; and the opening of an "Assyrian Museum" in 1847 to display artifacts unearthed during excavations at the palace of Sargon II in Khorsabad (Iraq)—the core of the department of Oriental antiquities established in 1881.

Under the Second Empire (1852–70), which saw the development of the museum and the introduction of modern museological practices, painting acquisitions focused on periods that had long been neglected: fifteenth-century Flemish painting as well as work by the first French masters (*Parement de Narbonne; Saint Denis Altarpiece*, plate 143). Romanesque and Gothic sculpture also began to receive attention, including *King Childebert* (plate 359), acquired 1851, and the *Tomb of Philippe Pot* (plate 364), acquired 1889. The archaeological collections were enriched as a result of excavations carried out in Egypt and in the Near East.

The museum's holdings were deepened by significant donations: collections of objets d'art by Sauvageot (1856) and Campana (1861); of eighteenth-century paintings by Dr. Louis La Caze (1869); and of modern paintings—including works by Delacroix, Jean-Baptiste-Camille Corot, and the Impressionists—by Etienne Moreau-Nélaton (1906). There were also

FIG. 50.
Georges Braque,
The Birds, 1953.
First floor, Greek,
Etruscan, and Roman
antiquities galleries,
room 33.

important gains as a result of the transfer of furniture, tapestries, and bronzes from royal residences in 1870 and 1901.

Acquisitions were also influenced by art historical rediscoveries and shifts in taste. In 1870, shortly after Thoré-Bürger's rediscovery of Jan Vermeer, the artist's *Lacemaker* (plate 276) was purchased. In 1908 it was the turn of El Greco's *Christ on the Cross Adored by Two Donors* (plate 348), whose expressionist idiom accorded with developments in contemporary art; and in 1915 of the *Peasant Family* by Le Nain (plate 179), whose artistic stock was rising.

Egyptian Antiquities

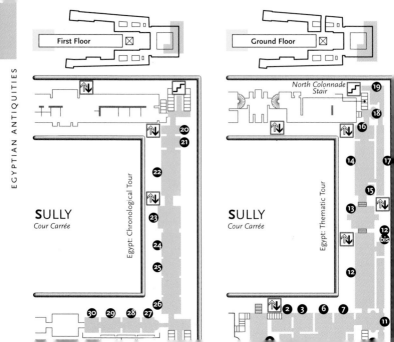

EGYPTIAN ANTIQUITIES

First Floor

Ground Floor

North Colonnade Stair

SULLY
Cour Carrée

Egypt: Chronological Tour

SULLY
Cour Carrée

Egypt: Thematic Tour

Access and Tour

From the Hall of the Pyramid, enter the Sully wing on the entresol level and continue through the Medieval Louvre section until you reach *The Large Sphinx* (room 1; plate 1), which stands guard in the Crypt of the Sphinx at the entrance to the Egyptian collection.

The present installation, inaugurated in December 1997, offers two approaches—a thematic one followed by a chronological one. The rooms on the ground floor (rooms 3–19) provide an introduction to various aspects of Egyptian civilization:

- the Nile (room 3)
- daily life (rooms 4–10): work in the fields, hunting and fishing, the home, writing, artisans and their materials, adornment, and leisure activities
- religious life (rooms 11–19): temples and temple squares; burial crypts, tombs, and sarcophagi; gods and cults

The chronological part of the installation is located on the first floor (rooms 20–30). After you've visited rooms 3–19, these galleries can be reached by ascending the north stair of the Colonnade. These Egyptian galleries contain major works displayed in chronological order, from the origins of Egyptian civilization in the fourth millennium B.C. to the Roman conquest in 30 B.C., as well as groups of smaller objects displayed in wall cases:

- Predynastic (Nagada) Period (room 20) and the Early Dynastic Period (room 21)
- Old Kingdom (room 22) and Middle Kingdom (room 23)
- New Kingdom (rooms 24–28)
- Third Intermediate Period, Late Period, and Ptolemaic Period (rooms 29–30)

Egyptian antiquities from the Roman and Christian (Coptic) eras are exhibited on the entresol of the Denon wing—the former in room A, opposite the escalator at the Denon entrance; the latter in rooms B and C, next to the preclassical Greek rooms. A stop in the Café Denon, located beneath the horse-

Frontispiece:
The Large Sphinx
(detail; see plate 1)

shoe stair in the Lefuel Court (entered from room A), makes a pleasant conclusion to this circuit.

History of the Collection

The department of Egyptian antiquities consists of more than 50,000 cataloged artifacts, which makes it one of the largest such collections in the world. This vast size was not just a matter of chance. Curiosity about Egypt, which had been evident throughout Europe as early as the sixteenth century, intensified greatly in the eighteenth century. Napoleon's military campaign in Egypt (1798–99) was also an ambitious scientific expedition. One of the participants was Dominique-Vivant Denon (later the first director of the Musée Napoléon), who declared: "All my life I had wanted to make the trip to Egypt."

Modern Egyptology was born with the remarkable achievement of Jean-François Champollion, who used the newly discovered Rosetta Stone and the Philae obelisk to decipher the meaning of hieroglyphics in 1822. This breakthrough prompted King Charles X to establish the Louvre's department of Egyptian antiquities in 1826, naming Champollion its first curator. The architect Pierre-François Fontaine remodeled the first floor of the south wing of the Cour Carrée to house the collection, incorporating cabinets with bronze Neoclassical fittings, "Egyptian" grisaille panels, and painted ceilings celebrating recent discoveries in the field (*Study and the Genius of the Arts Revealing Egypt to Greece*, room 30).

In 1824 the museum's collection was augmented by twenty-five hundred objects from the Durand collection, which contained representative examples of "everything that Egypt managed to produce in the way of small and medium-sized monuments." On Champollion's recommendation, these pieces were joined two years later by some four thousand objects from the collection of Consul Salt, the English consul to Alexandria (including *The Large Sphinx*, plate 1; *Nebqued Papyrus*, plate 13; *The Lady Naÿ*, plate 29), and in 1827 by five hundred works from the second collection of the French con-

sul, Bernardino Drovetti (*Patera of General Djehuty*, plate 27). By 1832 (the year of Champollion's death) the Louvre already boasted some nine thousand Egyptian artifacts. The collection grew still larger during the reign of Napoleon III, when in 1853 it acquired twenty-five hundred objects assembled by Clot Bey (physician to the viceroy, Muhammad Ali Pasha), as well as many pieces unearthed during Auguste-Ferdinand-François Mariette's excavations at Memphis in 1852–53 (*Seated Scribe*, plate 20). The establishment of the Institut Français du Caire in 1880 reflected the continuing vitality of French Egyptology, and the many sites excavated under its auspices yielded still more objects.

The discovery of Tutankhamen's tomb in 1922 marked the end of this period of continual enrichment, for Egypt refused to surrender the boy king's treasures. Nonetheless, this did not signal the end of the collection's growth. In 1922 the Louvre acquired the Egyptian objects from the Bibliothèque Nationale's collection, followed in 1946 by those from the Musée Guimet. It has also shared in the yield from certain contemporary excavations as well as benefitting from additional donations—the most important being the fifteen hundred pieces in the Curtis collection.

EGYPTIAN ANTIQUITIES

PLATE 1.
The Large Sphinx
Old Kingdom,
c. 2600 B.C.
Tanis
Pink granite,
6 ft. x 15 ft. 9 in. x
5 ft. ⅝ in. (1.83 x
4.80 x 1.54 m)

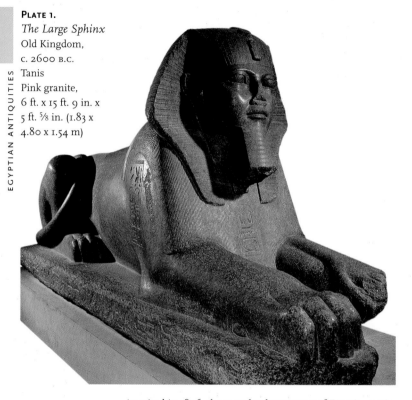

☞ *To reach the
thematic installation
on the ground floor,
take the stairway on
the left (the stairway
on the right leads to
the Greco-Roman
antiquities).*

Acquired in 1826, the year the department of Egyptian antiquities was founded, this large sphinx comes from Tanis on the Nile Delta. Sphinxes—which have the body of a lion and the head of a pharaoh, with the traditional headdress of striped fabric and an artificial beard—served as guardians of sanctuaries and tombs; this one, appropriately, stands at the entry to the Egyptian galleries.

This example bears the names of pharaohs from the Middle and New Kingdoms, but these were added later; it is now believed to date from the Old Kingdom.

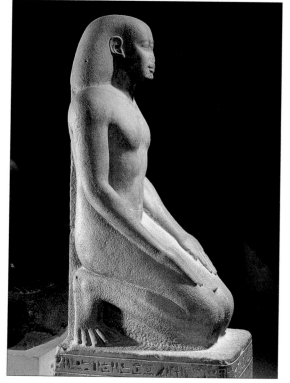

PLATE 2.
*Nakhthhoreb
in Prayer*
Late Period, 595–589
B.C. (26th Dynasty,
reign of Psamtik II)
Crystallized sand-
stone, 58⅜ x 18⅜ x
27½ in. (148 x 46.5
x 70 cm)

EGYPTIAN ANTIQUITIES

Egyptian art is characterized by the imposing stability of its
forms and figures. This dignitary serving a king of the Late
Period, shown praying, wears clothing from the Old Kingdom,
but its realistic modeling indicates that it is a product of the
Late Period, contemporary with Greek archaic art.

PLATE 3.
Model of a Boat
Middle Kingdom,
C. 2000 B.C.
Painted wood
and stucco,
11⅜ x 26⅜ in.
(29 x 67 cm)

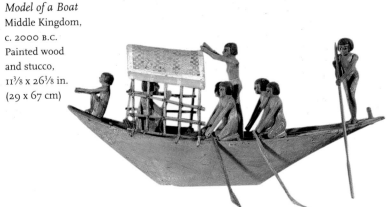

PLATE 4.
Frog and Frog Seal
New Kingdom,
1295–1069 B.C.
(19th–20th Dynasties)
Egyptian faience,
⅞ x 1⅜ in. (2.2 x 3.2
cm); 1⅜ x 1⅞ in.
(3.3 x 4.8 cm)

Situated on a narrow strip of cultivable land between river and
desert, Egypt is the "gift of the Nile." A map in this gallery
illustrates the country's principal sites.

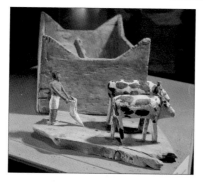

EGYPTIAN ANTIQUITIES

PLATE 5.
Models of a Scene of Labor and a Granary
Middle Kingdom, c. 2000–1900 B.C.
Painted wood,
Scene of Labor:
6½ x 14⅝ x 9 in.
(16.5 x 37 x 23 cm)

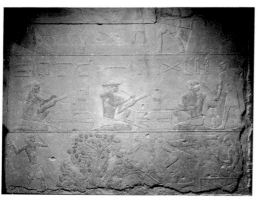

PLATE 6.
Wall Fragment from the Akhthetep Mastaba (detail)
Upper register:
Scribes Recording
Harvested Crops
Lower register:
Hunting with Snares
Old Kingdom,
c. 2400 B.C. (5th
Dynasty)
Saqqara
Painted-limestone
bas-relief, set into
modern masonry
Interior dimensions
of the mastaba: 13 ft.
11⅜ in. x 5 ft. 4¼ in.
(4.25 x 1.63 m)

By illustrating all aspects of their daily lives and beliefs on their tombs walls and by placing models of objects from everyday life as well as functional objects next to the dead, the Egyptians left us vivid evidence about their civilization, which has inspired our ongoing fascination with their culture.

6. The reliefs illustrated here are on the back side of the tomb's entry wall, to the left.

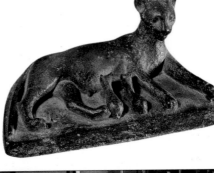

PLATE 7.
*Two Kittens
Nursing*
Late Period,
664–332 B.C.
Bronze, 1⅞ x 4 in.
(5 x 10.2 cm)

EGYPTIAN ANTIQUITIES

PLATE 8.
Household Objects
New Kingdom,
c. 1450 B.C.
(18th Dynasty)
Mostly from a
cemetery near
Deir al-Medineh

7. Cats figure prominently in Egyptian culture from about 2000 B.C.; see the small bronze figurines in room 5 and the cat goddess (room 29; plate 43). The ancient Egyptians mummified cats beginning in the Late Period (room 18).

8. This display, in the center of room 8, contains examples of the furnishings and objects of varying quality, some of which show signs of use, that were placed in tombs to accompany the dead to the afterlife.

PLATE 9.
Lute
Late Period,
c. 700 B.C.
Wood and leather,
length: 40 in.
(101.5 cm)

Triangular Harp
Third Intermediate
Period or Late Period,
1069–332 B.C.
Sea pine, cedar,
colored leather,
and modern strings,
height: 43⅜ in.
(110 cm)

EGYPTIAN ANTIQUITIES

The front of these instruments, which show signs of having been played, are decorated with scenes of musicians.

*General view of the
Temple Room*

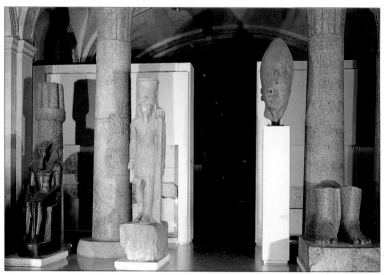

After the galleries devoted to Egyptian domestic life (rooms
3–10), a second sphinx marks the beginning of a series of gal-
leries devoted to ancient Egyptian temples, sepulchers, and
religious beliefs (rooms 11–19). In room 11 six late sphinxes
from Memphis evoke the entryway that once led to these tem-
ples. Room 12, which has been part of the Egyptian antiquities
galleries since 1849, now houses artifacts of various periods
relating to the Egyptian temple.

👁 *From the corner of
room 12, there is a fine
view of the Cour Carrée,
the Pavillon de
l'Horloge, and the
Lescot wing.*

PLATE 10.
King Ramses II
New Kingdom,
c. 1275 B.C. (19th
Dynasty)
From the Temple
of Abydos
Painted limestone,
height: 23⅝ in.
(60 cm)

👁 *Renovated by the
architects Percier and
Fontaine in 1807–12,
room 12 was used to
display Egyptian
Antiquities starting
in 1849, but the
presentation has been
much changed over
the years.*

EGYPTIAN ANTIQUITIES

PLATE 11.
*Sarcophagus of
King Ramses III*
New Kingdom,
1184–1153 B.C.
(20th Dynasty)
From his tomb
in the Valley of
the Kings
Pink granite,
70⅞ x 120 x 59 in.
(180 x 305 x 150 cm)

☛ *A short flight of
steps leads down to
a cryptlike room con-
taining the monu-
mental sarcophagus of
Ramses III; its cover
is now in the Fitz-
william Museum,
Cambridge, England.*

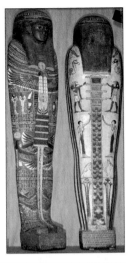

PLATE 12.
Coffin of Imeneminet
Third Intermediate Period,
1069–664 B.C.
Various materials, painted and plastered, height:
74 in. (188 cm)

PLATE 13.
Nebqued Papyrus
New Kingdom,
c. 1300 B.C.
(19th Dynasty)
Painted papyrus, height: 11¾ in. (30 cm)

13. Next to the mummified corpse, the Egyptians would place scrolls bearing information that they believed would assure the survival of the dead in the afterlife, notably the Book of the Dead. One of these, the spectacular *Nebqued Papyrus*, is exhibited in a long display on the wall of room 17. Only a detail is shown above.

🖝 *Coming up from the Crypt of Osirus, you arrive in the second section of the ground-floor Colonnade galleries, which contains displays relating to ancient Egyptian funerary rites and religious beliefs.*

PLATE 14.
Statuette of a Man
Late Predynastic–
Early Dynastic
Period,
C. 4000–3500 B.C.
Ivory (hippopotamus
incisor), height:
9⅜ in. (24 cm)

☞ *To begin this part
of the tour, leave room
19 and go up the north
Colonnade stair to
room 20, on the first
floor, where you will
find a timeline of
Egyptian history and a
helpful map.*

During the Nagada Period (4000–3000 B.C.) Egyptian crafts-
men mastered the techniques of faience, copper metallurgy,
ivory carving, and *pietra dura* mosaic.

PLATE 15.
Palette Celebrating a Victory
Late Predynastic–
Early Dynastic
Period, c. 3300–
3100 B.C.
Schist, height:
10⅛ in. (26 cm)

PLATE 16.
Guebel el-Arak Dagger
Late Predynastic
Period, c. 3300–
3200 B.C.
Guebel el-Arak
(south of Abydos)
Slate blade and ivory
(hippopotamus
canine) handle,
overall length: 10 in.
(25.5 cm)

15. Palettes like this one were used to crush the makeup that Egyptians used to color their eyelids. The bull knocking over a man celebrates the power of the king who owned this piece.

PLATE 17.
*Stele of Djet, the
Serpent King*
Archaic Period,
c. 3100 B.C.
(1st Dynasty)
From the tomb of
the Serpent King
at Abydos
Limestone, height:
25¾ in. (65.5 cm)

EGYPTIAN ANTIQUITIES

Dating from the time of the first pharaohs, this monumental
stele represents the Serpent King, Djet, in his palace under the
protection of a falcon, the god Horus.

PLATE 18.
Princess Nefertiabet with a Meal
Old Kingdom,
2590–2565 B.C.
(4th Dynasty,
reign of Cheops)
Stele from the
necropolis at Giza
Painted limestone,
14¾ x 20⅝ in.
(37.5 x 52.5 cm)

PLATE 19.
Head of King Djedefre as a Sphinx
Old Kingdom,
c. 2570 B.C. (4th
Dynasty, reign
of Cheops)
Abu Roach
Red crystallized
sandstone (originally
painted), height:
10¼ in. (26 cm)

18. Nefertiabet was the sister or daughter of King Cheops.

19. Djedefre was Cheops's son and successor.

EGYPTIAN ANTIQUITIES

PLATE 20.

Seated Scribe
Old Kingdom,
c. 2600–2350 B.C.
(4th–6th Dynasty)
Saqqara
Painted limestone,
alabaster, and rock
crystal eyes inlaid in
copper, height:
21⅛ in. (53.7 cm)

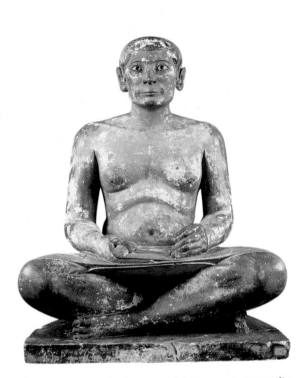

This anonymous scribe from a tomb in Saqqara (a necropolis near Memphis) is remarkable for its mastery of form and its lifelike expression, with eyes made of rock crystal.

PLATE 21.
Couple
Old Kingdom,
c. 2350–2200 B.C.
(6th Dynasty)
Acacia wood,
height: 27½ in.
(69.9 cm)

EGYPTIAN ANTIQUITIES

PLATE 22.

Raherka, Inspector of Scribes, and His Wife Merseankh
Old Kingdom,
c. 2500–2350 B.C.
(end 5th–6th Dynasty)
Painted limestone,
height: 20¾ in.
(52.8 cm)

EGYPTIAN ANTIQUITIES

PLATE 23.
Hippopotamus
Middle Kingdom,
C. 2000–1900 B.C.
(early 12th Dynasty)
Egyptian faience,
5 x 8⅛ x 3¼ in.
(12.7 x 20.5 x 8.1 cm)

In ancient Egypt hippopotamuses were numerous on the banks of the Nile. Like those painted or carved in relief on the walls of mastabas, this statuette (like the one exhibited in room 3) was intended to accompany the dead.

👁 Room 23, situated in the central pavilion of the Colonnade wing, offers the most beautiful view of the Cour Carrée. Directly opposite, in the center, is the Pavillon de l'Horloge, which masks the glass pyramid from view; it is flanked to the left by the Lescot wing and to the right by the Lemercier wing.

PLATE 24.
Chancellor Nakhti
Middle Kingdom,
c. 1900 B.C. (early
12th Dynasty)
Asyut
Acacia wood, 70⅜
x 43⅜ x 19½ in.
(178.5 x 110 x 49.5 cm)

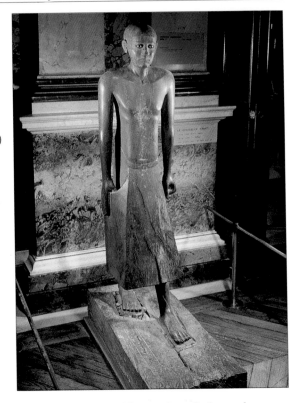

Originally painted, this life-size statue of a deceased man was placed in a tomb in Asyut, in Middle Egypt.

PLATE 25.

Sesostris III as a Young Man
Middle Kingdom, 1862–1843 B.C.
(12th Dynasty)
From the temple at Medamud
Diorite, height: 46¾ in. (119 cm)

EGYPTIAN ANTIQUITIES

The rulers of the Middle Kingdom chose Thebes as their capital; Medamud is situated to its north.

PLATE 26.

Lintel from a Door: King Sesostris III Making an Offering of Bread to the God Montu
Middle Kingdom, 1862–1843 B.C.
(12th Dynasty)
From the temple at Medamud
Limestone, height: 87 in. (221 cm)

PLATE 27.

*Patera of
General Djehuty*

New Kingdom,
c. 1490–1439 B.C.
(18th Dynasty)
Gold, diameter: 7 in.
(17.9 cm); height:
⅞ in. (2.2 cm)

EGYPTIAN ANTIQUITIES

PLATE 28.
Senynefer, Head of the King's Office, and His Wife Hatchepsut
New Kingdom,
C. 1410 B.C.
(18th Dynasty)
Painted sandstone,
24⅜ x 32⅜ in.
(62 x 82 cm)

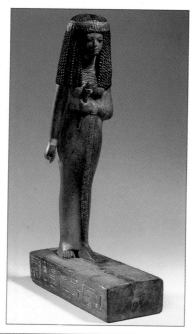

PLATE 29.
The Lady Naÿ
New Kingdom,
C. 1400 B.C.
(18th Dynasty)
Painted and gilded conifer wood,
height: 12¼ in.
(31 cm)

PLATE 30.
*King Akhenaton/
Amenhotep IV*
New Kingdom,
c. 1350 B.C. (18th
Dynasty, years 3–5
in the reign of
Akhenaton/
Amenhotep IV)
Fragment of a col-
umn from a build-
ing east of Karnak
Sandstone (origi-
nally painted),
54 x 34⅝ in.
(137 x 88 cm)

EGYPTIAN ANTIQUITIES

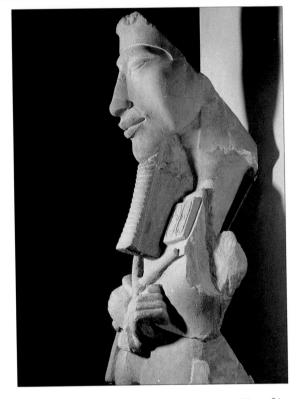

This colossus was presented to France in recognition of its contribution to saving the Nubian temples threatened by construction of the Aswan High Dam.

👁 *The elaborate
ceiling and wainscoting
come from the ceremo-
nial bedchamber of
King Henri II, which
was originally located in
what is now the Salle
des Sept-Cheminées
(room 74).*

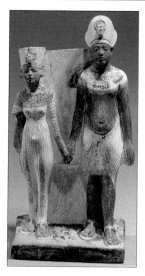

PLATE 31.
*Akhenaton
and Nefertiti*
New Kingdom,
after 1345 B.C.
(18th Dynasty, after
year 9 in the reign
of Akhenaton/
Amenhotep IV)
Painted limestone,
height: 8⅝ in.
(22.2 cm)

PLATE 32.
*Body of a Woman,
Probably Nefertiti*
New Kingdom,
c. 1353–1337 B.C.
(18th Dynasty, reign
of Akhenaton/
Amenhotep IV)
Crystallized red
sandstone, height:
11⅜ in. (29 cm)

31. A monotheistic believer in the sun god, Aton, Pharaoh
Amenhotep IV took the name Akhenaton ("he who is benefi-
cent for Aton"). Here he is represented with his wife, Nefertiti.

PLATE 33.

A Princess from the Family of Akhenaton/ Amenhotep IV
New Kingdom, c. 1353–1337 B.C.
(18th Dynasty, reign of Akhenaton/ Amenhotep IV)
Painted limestone, height: 6 x 3⅞ in. (15.4 x 10 cm)

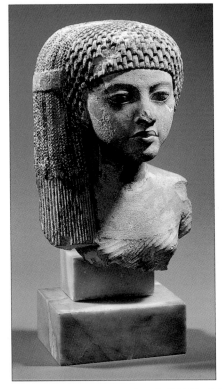

PLATE 34.

Cosmetics Spoon: Young Woman Swimming
New Kingdom, c. 1353–1337 B.C.
(18th Dynasty, reign of Akhenaton/ Amenhotep IV)
Wood and ivory, length: 12¾ in. (32.5 cm)

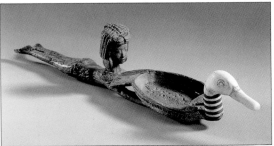

PLATE 35.
*Imenmes and
Depet, Parents
of General*

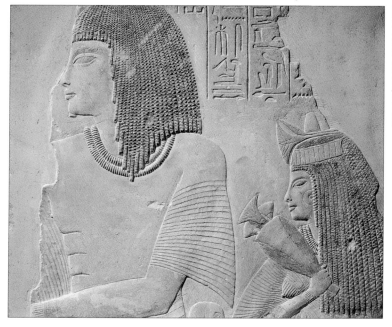

Imeneminet
New Kingdom,
c. 1330–1300 B.C.
(18th Dynasty)
Painted limestone,
height: 22 in.
(56 cm)

EGYPTIAN ANTIQUITIES

PLATE 36.
Lamentation during a Burial
New Kingdom,
c. 1330 B.C.
(18th Dynasty)
From a tomb
in Saqqara
Limestone,
29⅛ x 14⅛ in.
(75 x 36 cm)

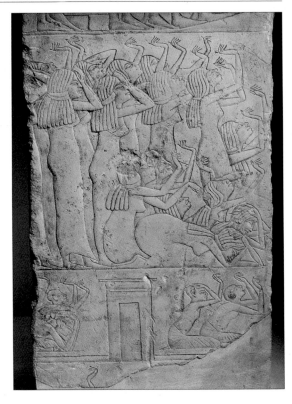

👁 *The carved wood-work in this room comes from the alcove bed-chamber of King Louis XIV, which was orig-inally located in what is now the Salle des Sept-Cheminées (room 74).*

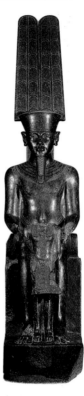

PLATE 37.
The God Amun Protecting Tutankhamen
New Kingdom,
1336–1327 B.C.
(18th Dynasty, reign
of Tutankhamen)
Diorite, height:
84¼ x 17⅜ in.
(214 x 44 cm)

👁 *Adjacent to room 26 is the south stairwell of the Colonnade wing. Its landing offers fine views of the Seine, the Pont Neuf, the towers of Notre-Dame, the spire of the Sainte-Chapelle, and the dome of the Panthéon. Around the corner, to the west, the galleries continue into the former Musée Charles X (inaugurated 1827), whose painted ceilings are worth a look. The subjects of the ceilings in rooms 29 and 30 indicate that some of these rooms were intended for the display of the museum's first Egyptian holdings.*

Tutankhamen restored the old religious cults, following the brief period of monotheism under Akhenaton.

EGYPTIAN ANTIQUITIES

PLATE 38.

The Goddess Hathor Welcoming Seti I
New Kingdom,
c. 1303–1290 B.C.
(19th Dynasty)
From the tomb
of Seti I (Valley
of the Kings)
Painted limestone,
89¼ x 41⅜ in.
(226.5 x 105 cm)

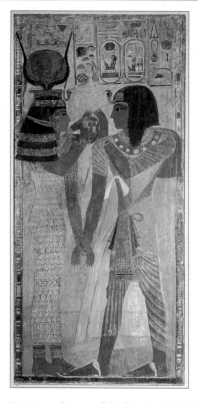

Seti I was the son of the founder of the Nineteenth Dynasty, which reached its apogee during the reign of his son Ramses II. Seti waged war against the Hittites (battle of Qadech), with whom Ramses II negotiated a lasting peace.

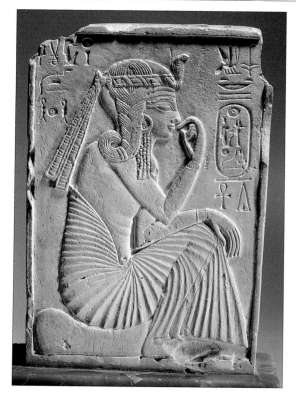

PLATE 39.
*Ramses II Depicted
as a Child*
New Kingdom,
c. 1290–1224 B.C.
(19th Dynasty)
Limestone, height:
7⅛ in. (18 cm)

PLATE 40.
*Amulet in the Form
of a Falcon with
a Ram's Head*
New Kingdom,
c. 1290–1224 B.C.
(19th Dynasty, reign
of Ramses II)
Saqqara
Gold inlaid with
lapis lazuli,
turquoise, and car-
nelian, 2¾ x 5⅜ in.
(7.1 x 13.5 cm)

PLATE 41.
*The God Osiris
with His Family*
Third Intermediate
Period, c. 874–850
B.C. (22d Dynasty,
reign of Osorkon II)
Gold, lapis lazuli,
and glass, 3½ x 2¾
in. (9 x 6.6 cm)

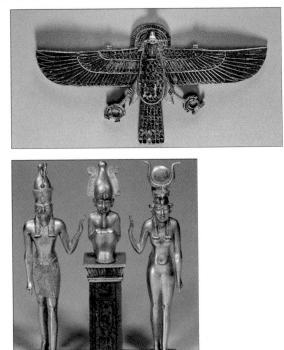

40. From a mummy found in Saqqara.

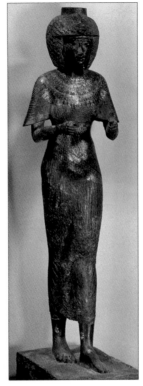

PLATE 42.
The "Divine Consort," Karomama
Third Intermediate Period, c. 850 B.C. (22d Dynasty)
Bronze inlaid with gold, electrum, and silver, 23⅜ x 4⅞ in. (59.5 x 12.5 cm)

Acquired by Champollion in Egypt in 1829, this statue depicts one of the daughters of the pharaoh, considered to be the wife, or "divine consort," of the god Amun.

PLATE 43.

*The Cat
Goddess Bastet*
Late Period,
664–610 B.C.
(26th Dynasty)
Bronze and blue
glass, height:
10⅞ in. (27.6 cm)

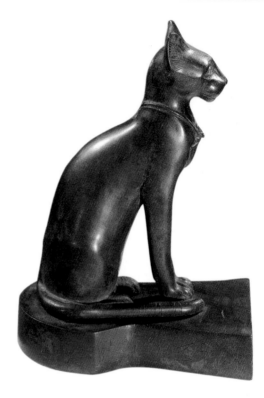

This cat wears the escutcheon of King Psamtik I, founder of
the Twenty-sixth Dynasty.

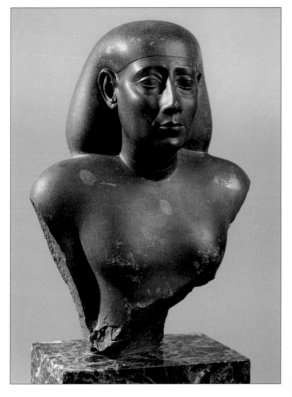

PLATE 44.
*Fragment of
a Statue of an
Old Man*
Ptolemaic Period,
C. 252 B.C.
Graywacke, height:
9⅞ in. (25.2 cm)

👁 *In room 29
the Neoclassical
mantelpiece, the
paintings in grisaille
illustrating the lives of
ancient Egyptians, and
the ceiling painting
representing Egypt
saved by Joseph all
evoke an Egypt that is
more biblical than
archaeological.*

EGYPTIAN ANTIQUITIES

PLATE 45.
*Man with
Shaved Head*
Late Period,
378–341 B.C.
(30th Dynasty)
Graywacke, height:
5¼ in. (12.9 cm)

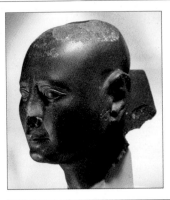

PLATE 46. *The
Preparation of
Lily Perfume*
Late Period,
4th century B.C.
Fragment of a
tomb decoration
Limestone, height:
14⅝ in. (37 cm)

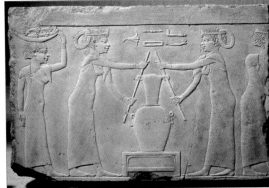

👁 *The Neoclassical
decor of room 30
celebrates the birth of
the arts and the dis-
covery of Egyptian art.*

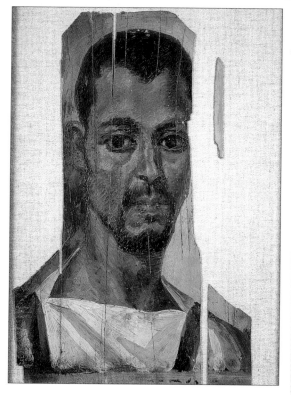

PLATE 47.
*Funerary Portrait
from Faiyum*
A.D. 2d century
Encaustic on wood,
15 x 9⅜ in.
(38 x 24 cm)

Funerary portraits appeared in Egypt at the time of the Roman occupation (30 B.C.). Most of those known today come from the oasis of Faiyum, but the practice was widespread.

☞ *The galleries containing artifacts from Roman and Coptic Egypt are located on the entresol level. To reach them, leave room 30 and pass through the galleries containing Greek terra-cottas, the Salle des Sept-Cheminées (room 74), and the Apollo Rotunda; descend the Victory of Samothrace stair to the entresol level, where rooms A, B, and C are adjacent to the galleries of preclassical Greek art.*

PLATE 48.
*Tapestry with Putti
Harvesting Grapes*
(detail), A.D. 3d–4th
century
Wool and flax,
38¼ x 63¼ in.
(97 x 162 cm)

The theme of grape-harvesting putti, initially associated with
Bacchic festivals, was appropriated by Christian iconography
to illustrate a remark made by Christ in the gospels (John 15:1):
"I am the vine and my father is the vintner."

PLATE 49.
Christ and Abbot Mena, A.D. 6th– 7th century
From Bawit Monastery
Tempera on fig wood, 22⅜ x 22⅜ in. (57 x 57 cm)

PLATE 50.
Capital, A.D. 6th–7th century
From the church south of Bawit Monastery
Limestone, height: 21¼ in. (54 cm)

The monastery of Bawit in Upper Egypt was excavated in 1901–2; most of the artifacts recovered there are now in the Coptic Museum in Cairo.

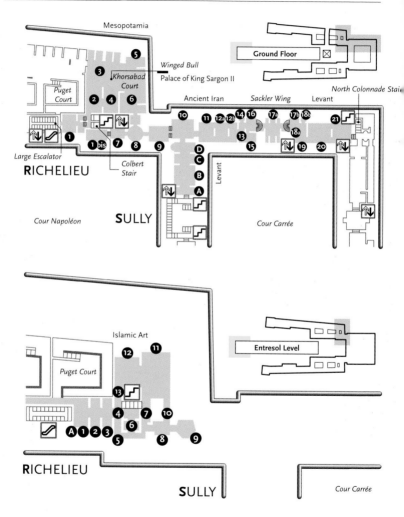

Mesopotamia

Ground Floor

⑤

Winged Bull
Palace of King Sargon II

③
Khorsabad Court

Puget Court

② ④ ⑥

Ancient Iran *Sackler Wing* Levant

North Colonnade Stair

⑩ ⑪ ⑫a ⑫b ⑭ ⑯ ⑰a ⑰b ⑱b ㉑

⑬

⑱a

① ①bis ⑦ ⑧ ⑨ ⑮

⑲ ⑳

Large Escalator

RICHELIEU

Colbert Stair

Ⓓ
Ⓒ
Ⓑ
Ⓐ

Levant

Cour Napoléon

SULLY

Cour Carrée

Entresol Level

Islamic Art

⑫ ⑪

Puget Court

⑬

④ ⑦ ⑩

⑥

Ⓐ ① ② ③ ⑧ ⑨

⑤

RICHELIEU

SULLY

Cour Carrée

Access and Tour

From the Hall of the Pyramid, take the Richelieu escalator to the ground floor and turn right. The Oriental antiquities are exhibited in twenty-five galleries, the most recent of which opened in 1993 (others will open later in the Denon wing). These rooms are devoted, respectively, to Mesopotamia (rooms 1–6, around the roofed Khorsabad courtyard), Iran (rooms 7–18, in the wing on the north side of the Cour Carrée), and the Levant (rooms 19–21 in the same wing, as well as rooms A–D in the Lemercier [west] wing).

The collection of Islamic art is exhibited on the entresol level of the Richelieu wing (rooms A plus 1–13).

History of the Collection

These galleries display artifacts from the civilizations of the ancient Near East (except Egypt), ranging from North Africa to the Indus River: Mesopotamia (Sumer, Babylon, Assur), Iran (Susa), and the Levant (Syria, Cyprus, Palmyra, Phoenicia, Carthage). Hostile relations with the Ottoman Empire long kept the remains of these civilizations, which figure prominently in the Bible, inaccessible to Westerners. The first discoveries were made by archaeologists attached to diplomatic missions. Just as Champollion's deciphering of hieroglyphics had led to the establishment of the Louvre's department of Egyptian antiquities, so Paul-Emile Botta's discovery of the remains of the palace of Sargon II, king of Assyria, near Mosul (Iraq), and the ensuing shipments of material back to France prompted the establishment of an "Assyrian Museum" within the Louvre in 1847. Archaeology in the Levant progressed under the Second Empire, and Ernest Renan explored Phoenicia in 1860. In 1877 Ernest de Sarzec discovered the statues of Gudea (plates 59 and 60) on the Mesopotamian site of Tello (then in the Ottoman Empire; present-day Al-Hiba, Iraq), where excavations continued until 1933—a campaign that led to the rediscovery of Sumerian civilization. Similarly, in Persia (Iran) in 1884–86, Marcel

Frontispiece:
*King Sargon II
and a Dignitary*
(detail; see plate 68)

Dieulafoy excavated the site of Susa, one of the capitals of the empire of Darius I. In 1881 the Louvre's department of Oriental antiquities was founded, a sign of the vitality of this branch of archaeology.

After the dismemberment of the Ottoman Empire in the wake of World War I, the newly created Arab nations established their own agencies overseeing national antiquities. The Louvre participated in many excavation campaigns in Iraq (Larsa) and, especially, in Libya and in Syria (Mari, Ugarit), which had been placed under French mandate. The resulting discoveries were shared between the Louvre and the young national museums of the respective countries. In addition, the Louvre's collection has continued to be enriched by acquisitions and donations from other sources, such as the David-Weill gift in 1972.

PLATE 51.
Idol of the Eyes,
c. 3500 B.C.
Northern
Mesopotamia (now
northern Syria)
Terra-cotta, height:
10⅝ in. (27 cm)

ORIENTAL ANTIQUITIES AND ISLAMIC ART

The rich plains of Mesopotamia, irrigated by the Tigris and Euphrates Rivers, were the site of the "neolithic revolution." Archaic Mesopotamian civilization (8000–3500 B.C.) invented animal husbandry and agriculture—which replaced hunting and gathering—as well as ceramics, in addition to constructing villages and irrigation networks.

PLATE 52.
*Praying Figure,
Dedicated by
Prince Ginak*
Early Dynastic II,
c. 2700 B.C.
Mesopotamia
Limestone,
10¼ x 4⅜ in.
(26 x 10.8 cm)

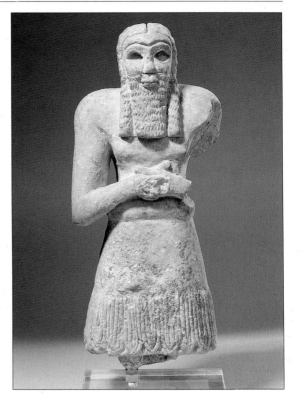

The first towns and the first dynasties of Lower Mesopotamia
appeared between 3500 and 2600 B.C., including that of the
legendary Gilgamesh, king of Uruk, the city where writing
appeared around 3000 B.C.

PLATE 53.
*Votive Relief of
Urnanshe, King
of Lagash*
Early Dynastic III,
C. 2550–2500 B.C.
Girsu (now Tello,
Syria)
Limestone,
15⅝ x 18½ in.
(40 x 47 cm)

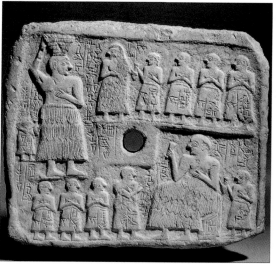

The first ruler of the dynasty of Lagash, Urnanshe is celebrated
in this small relief as the founder of a temple honoring the gods
Ningirsu and Nanshe. At upper left he is shown carrying a bas-
ket of bricks; at lower right, he drinks with his court.

👁 *This room offers a
view of two courts:
Puget at left and
Napoléon at right.*

PLATE 54.
Stele of the Vultures
Early Dynastic,
c. 2450 B.C.
Girsu (now Tello,
Syria)
Limestone,
70⅞ x 51⅝ in.
(180 x 130 cm)

ORIENTAL ANTIQUITIES AND ISLAMIC ART

This broken stele records the victory of Urnanshe's grandson over his neighbors: on the front, the king holds his enemies captive and grasps an eagle, symbol of the god Ningirsu; on the back, he leads the battle from his chariot (a detail of soldiers is seen here), and vultures rip apart corpses.

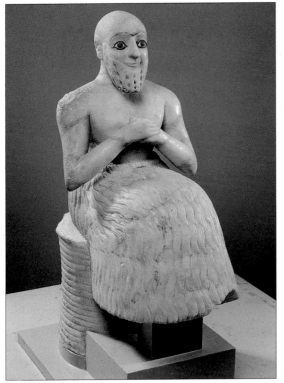

PLATE 55.
Ebih-Il, the
Superintendent
of Mari
Early Dynastic,
c. 2400 B.C.
From the Temple of
Ishtar, Mari, Middle
Euphrates (now Tell
Hariri, Syria)
Alabaster inlaid with
lapis lazuli and shell,
height: 20½ in.
(52 cm)

Votive statue found in 1934 in the Temple of Ishtar in Mari
(now Tell Hariri, Syria), on the Euphrates River.

PLATE 56.
*Frieze from a Mosaic
Panel,* called *The
Standard of Mari,*
2500–2400 B.C.
From the Temple of
Ishtar, Mari, Middle
Euphrates
Shell and schist,
length: 28⅜ in.
(72 cm)

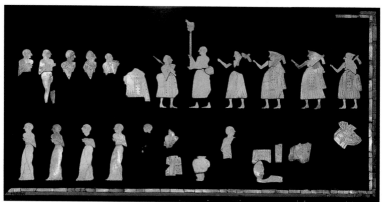

Reconstructed from pieces found in the Temple of Ishtar, this
votive image celebrates a victory.

PLATE 57.
*Vase Dedicated by
Entema, King of
Lagash, to the
God Ningirsu,*
C. 2400 B.C.
Girsu (now Tello,
Syria)
Silver and copper,
13¾ x 7⅛ in.
(35 x 18 cm)

ORIENTAL ANTIQUITIES AND ISLAMIC ART

The decoration of this ritual vase incorporates four images of
the god Ningirsu—an eagle with a lion's head.

☛ Go past the Colbert
stair, which leads up to
the objets d'art
galleries, and turn left
into room 2.

ORIENTAL ANTIQUITIES AND ISLAMIC ART

PLATE 58.
*Victory Stele
of Naram-Sin,
King of Akkad*
Akkad Period,
C. 2250 B.C.
Mesopotamia
(found in Susa)
Pink sandstone,
78⅝ x 41⅜ in.
(200 x 105 cm)

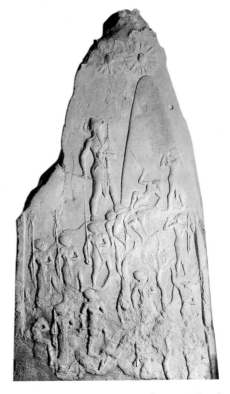

This votive stele celebrates the victory of Naram-Sin, the
Semitic king of Akkad, who unified northern and southern
Mesopotamia and the Sumerian lands (from Akkad and Elam
to Iran). He gives thanks here to the sun god. The stele was
found in Susa, where it had been taken as booty in the twelfth
century B.C.

👁 *There is an exhibit
devoted to Akkadian
seals to the left of the
Victory Stele of
Naram-Sin, King of
Akkad (plate 58).*

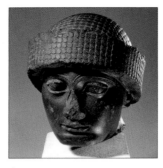

PLATE 59.
*Head of Gudea,
Prince of Lagash,*
c. 2120 B.C.
Girsu (now Tello,
Syria)
Diorite, 9 x 4⅜ in.
(23 x 11 cm)

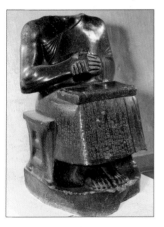

PLATE 60.
*Gudea, Prince
of Lagash,* called
*Architect with
a Plan,* c. 2120 B.C.
Girsu (now Tello,
Syria)
Diorite,
36⅝ x 16⅛ in.
(93 x 41 cm)

ORIENTAL ANTIQUITIES AND ISLAMIC ART

59. After the anarchy that followed the collapse of the
Akkadian dynasty, Lagash was ruled by the dynasty to which
Gudea belonged.

60. This votive statue represents the king as a builder of tem-
ples; it is dedicated to the goddess Gatumdu.

👁 *From room 2 you
have a lovely view of
the Puget Court.*

PLATE 61.
*Fragment of a
Female Statuette,*
called *Woman
with a Stole,*
c. 2120 B.C.
Girsu (now Tello,
Syria)
Chlorite,
6⅝ x 3½ in.
(17 x 9 cm)

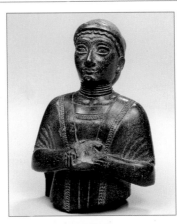

PLATE 62.
*Cylinder Seal of
Sharkalisharri,
King of Akkad,*
c. 2200 B.C.
Mesopotamia
(found in Susa)
Chlorite,
height: 1⅝ in.
(4.1 cm)

61. The subject is a princess from the family of Gudea, prince
of Lagash.

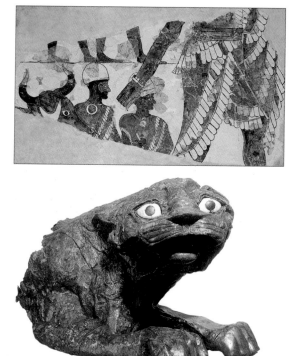

PLATE 63.
The Overseer of Royal Sacrifices, 2d quarter of 18th century B.C.
From the palace of Zimrilin, Mari, Middle Euphrates (now Tell Hariri, Syria)
Fresco on white plaster, 29⅞ x 52 in. (76 x 132 cm)

PLATE 64.
Temple Guardian Lion, 19th century B.C.
From Temple of Dagan, Mari, Middle Euphrates (now Tell Hariri, Syria)
Copper with inlay, height: 27⅝ in. (70 cm)

64. This lion once served as the guardian of a temple in Mari.

PLATE 65.

Law Codex of Hammurabi, King of Babylon,
1792–1750 B.C.
Mesopotamia
(found in Susa)
Basalt, height:
88⅝ in. (225 cm)

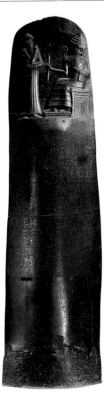

Hammurabi, king of Babylon, succeeded in unifying the whole of Mesopotamia around his city. Reviving a practice that predated him, he had a stele bearing his legal code erected in each of the principal cities of his empire. At the top of this one, the king is shown seated in front of a sun god. The Louvre stele was found in Susa, where it had been taken as booty around 1200 B.C.

👁 *At left is a view of the rue de Rivoli.*

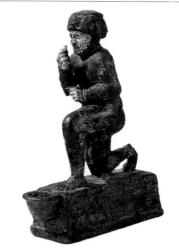

PLATE 66.
Statuette of a Praying Figure, beginning of 2d millennium B.C. Larsa, South Babylonia (now Iraq) Bronze, silver, and gold, 7½ x 5⅞ in. (19 x 15 cm)

ORIENTAL ANTIQUITIES AND ISLAMIC ART

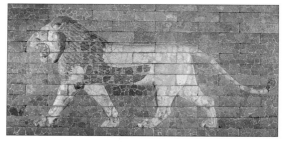

PLATE 67.
Walking Lion, 6th century B.C. From the Temple of Ishtar, Babylon Glazed brick, 41⅜ x 85⅜ in. (105 x 217 cm)

66. This small votive figure was offered by one of Hammurabi's subjects, to wish his sovereign well, and it may depict Hammurabi himself.

☞ To the right of the Walking Lion is the entrance to the Khorsabad Court.

ORIENTAL ANTIQUITIES AND ISLAMIC ART

PLATE 68.

*King Sargon II
and a Dignitary,*
713–705 B.C.
From the palace of
King Sargon II, Dur
Sharrukin (now
Khorsabad, Iraq)
Alabaster,
117⅜ x 48 in.
(298 x 122 cm)

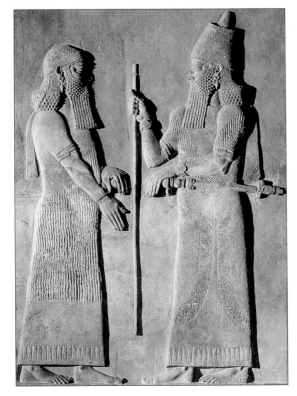

The Assyrian Empire, which flourished along the Tigris River
from the ninth to the seventh century B.C., had three succes-
sive capitals: Nimrud, south of Nineveh; Dur Sharrukin (now
Khorsabad), northeast of Nineveh; and Nineveh itself, situated
on the banks of the Tigris across from present-day Mosul. Dur
Sharrukin (Fort Sargon) was founded in 717 by King Sargon II,
whose palace there was inaugurated in 706.

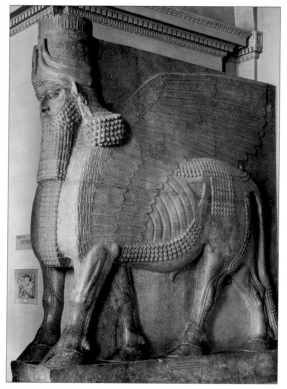

ORIENTAL ANTIQUITIES AND ISLAMIC ART

PLATE 69.
Winged Bull,
713–705 B.C.
From the palace of
King Sargon II,
Dur Sharrukin (now
Khorsabad, Iraq)
Alabaster, 13 ft.
9⅜ in. x 14 ft. 3⅝ in.
(4.2 x 4.36 m)

Winged bulls with human heads served as ritual guardians of the foundations of the world and warded off evil spirits from the palace gates. The inscription between their hooves indicates "palace of Sargon, the great king" and recounts the establishment of the city.

👁 *There is a map of Sargon's palace at the back of the gallery.*

ORIENTAL ANTIQUITIES AND ISLAMIC ART

PLATE 70.
*War Scene:
Cavalrymen of
Ashurbanipal,*
668–630 B.C.
Palace of
Ashurbanipal,
Nineveh (now Iraq)
Alabaster,
50¾ x 44⅞ in.
(129 x 114 cm)

This relief from the palace of the most famous Assyrian king,
Ashurbanipal, in Nineveh, chronicles his military campaigns.
Nineveh was captured and destroyed in 612 B.C.

👁 *In room 6, look at
the north façade of the
Louvre, then move on
to room 8, which offers
a lovely view of the
pyramid courtyard.*

PLATE 71.
Goblet with Animal Decoration: Ibex, Greyhounds, Wader Birds,
C. 4000 B.C.
Susa (now Iran)
Painted terra-cotta, height: 11 in. (28 cm); diameter: 6⅜ in. (16 cm)

ORIENTAL ANTIQUITIES AND ISLAMIC ART

The city of Susa was founded on the Susiana plain, at the foot of the high Iranian plateau, around 4200 B.C. Its painted ceramics combine geometric motifs with stylized animals.

Room 7 leads to the Colbert stair, which heads down to the Islamic art galleries.

PLATE 72.

Queen Napirasu, Wife of Untash-Napirisha,

c. 1340–1300 B.C.

Mound of the Acropolis, Susa (now Iran)

Bronze and copper, 50¾ x 28⅝ in. (129 x 73 cm)

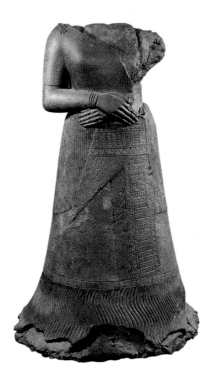

☞ *To the right of room 10, you will find the entrance to rooms A–D. You can come back to visit them once you've finished seeing rooms 11–21, which continue along the north side of the Cour Carrée.*

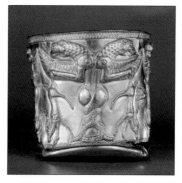

PLATE 73.
Vase with Two-Headed Winged Monsters Carrying Gazelles,
14th–11th century B.C.
From the necropolis in Malik (now northern Iran)
Electrum, height: 4⅜ in. (11 cm); diameter: 4⅜ in. (11.2 cm)

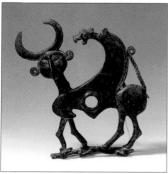

PLATE 74.
Plaque from a Bridle, in the Form of a Man-Headed Winged Bull Trampling an Animal,
8th–7th century B.C.
Luristan (now western Iran)
Bronze, 7½ x 7¼ in. (19 x 18.2 cm)

ORIENTAL ANTIQUITIES AND ISLAMIC ART

74. The metalworkers of Luristan produced weapons, bridles, pins, and other jewelry.

ORIENTAL ANTIQUITIES AND ISLAMIC ART

PLATE 75.

*Capital of a
Column from the
Audience Chamber
(Apadana) in the
Palace of Darius I*
Achaemenid Period,
c. 510 B.C.
Susa (now Iran)
Limestone, height:
126 in. (320 cm)

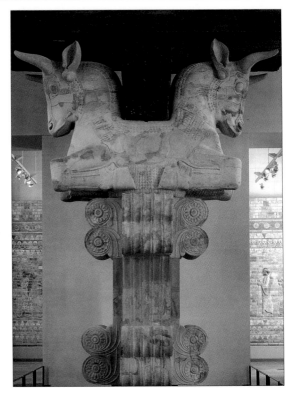

The Persian Empire was founded by Cyrus the Great around
559–530 B.C. and was conquered by Alexander the Great in 330
B.C. Susa became its capital at the beginning of the reign of
Darius the Great, who expanded the empire's boundaries as
far as Egypt and the Indus River but was defeated by the
Greeks at Marathon in 490 B.C. The royal palace built by
Darius and his son Xerxes I (called Ahasuerus in the biblical
Book of Esther) featured a great hall of thirty-six columns that
supported a beamed ceiling; each capital was carved in the
form of two back-to-back bull torsos.

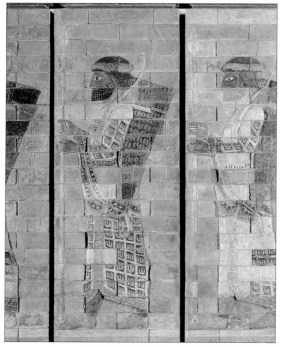

PLATE 76.
Frieze of Archers
Achaemenid Period,
c. 510 B.C. (reign
of Darius I)
Susa (now Iran)
Glazed brick,
height: 78⅝ in.
(200 cm)

ORIENTAL ANTIQUITIES AND ISLAMIC ART

This frieze, reconstituted from fragments, once decorated the
palace walls at Susa. It may represent the "immortals," the
10,000 guards mentioned by the Greek historian Herodotus.

☛ *There is a spiral
staircase just off room
17a that leads down to
room 17, underneath
the north passage
through the Cour
Carrée.*

PLATE 77.
*Vase Handle in
the Form of a
Winged Ibex,*
end of 6th–4th
century B.C.
Partially gilded
silver, 10⅝ x 5⅞ in.
(27 x 15 cm)

PLATE 78.
*Phoenician
Goddess,*
c. 700–600 B.C.
Bronze and silver,
height: 7⅞ in.
(20 cm)

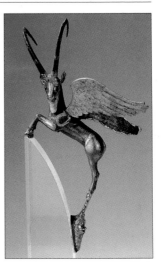

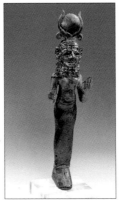

77. The rear hooves of this mythical winged ibex rest on a mask of Silenus, Greek god of drunkenness.

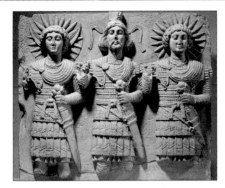

PLATE 79.
Triad of Palmyrian Gods, 1st half of 1st century A.D.
From a sanctuary in Palmyra or environs (now Syria)
Limestone, height: 28 in. (71 cm)

PLATE 80.
Funerary Relief, 1st half of 3d century A.D.
Palmyra (now Syria)
Limestone, height: 16⅞ in. (43 cm)

ORIENTAL ANTIQUITIES AND ISLAMIC ART

☞ From room 21 you can exit into the north Colonnade stair, which leads up to the thematic tour of the Egyptian galleries. To find rooms A–D, go back through the Oriental antiquities galleries to room 10, which opens into room D.

Palmyra, an oasis between the Mediterranean and the Euphrates plain, controlled commerce between the Roman Empire and the Orient. It was conquered in A.D. 272 by the Roman emperor Aurelian.

PLATE 81.

*Stele with the
Storm God Baal,*
15th–13th century B.C.
Ras-Shamra mound
(near the Temple
of Baal), Ugarit
(now Syria)
Sandstone,
height: 55⅞ in.
(142 cm)

ORIENTAL ANTIQUITIES AND ISLAMIC ART

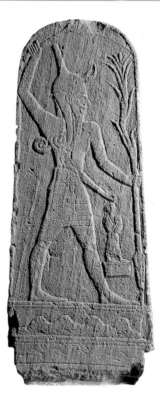

PLATE 82.
Gold Plate with Hunting Scene, 14th–13th century B.C.
Ras-Shamra mound (near the Temple of Baal), Ugarit (now Syria)
Gold, diameter: 7⅛ in. (18 cm); height: 1¼ in. (3 cm)

👁 *Rooms A–D— constructed by Lemercier, renovated by Fontaine, and inaugurated in 1824— were a museum of French sculpture. They still retain their handsome Neoclassical decor.*

PLATE 83.
Cosmetic-Box Cover with Fertility Goddess, 13th century B.C. Minet el-Beida, the port of Ugarit (now Syria) Elephant ivory, height: 5⅜ in. (13.7 cm)

☞ From room A you can take the Henri IV stair in the Pavillon de l'Horloge up to the first floor, where temporary exhibitions are held. Or you can walk down it to the Medieval Louvre.

PLATE 84.
Pyx of Al-Mughira,
A.D. 968
Medina, Spain
Elephant ivory,
6⅞ x 4⅜ in.
(17.6 x 11.3 cm)

PLATE 85.
*Cup with Falconer
on Horseback,*
early 13th century
Iran
Siliceous ceramic
with overglaze deco-
rations and gold and
metallic luster,
diameter: 8⅝ in.
(22 cm)

ORIENTAL ANTIQUITIES AND ISLAMIC ART

84. Made for the son of the caliph of Córdoba, this carved con-
tainer depicts the princely diversions of music and the hunt.

☞ To get to the
galleries of Islamic art,
go back to room 1 and
go down the Colbert
stair to the entresol
level.

PLATE 86.
Basin, called *The Baptistery of Saint Louis*, late 13th–early 14th century
Signed "Ibn Zayn"
Syria or Egypt
Hammered brass, engraved, inlaid with silver and gold, height: 9⅛ in. (23.2 cm); diameter: 19⅞ in. (50.5 cm)

This basin, which was part of the French royal collections, was used for royal baptisms at the Sainte-Chapelle in Vincennes, France.

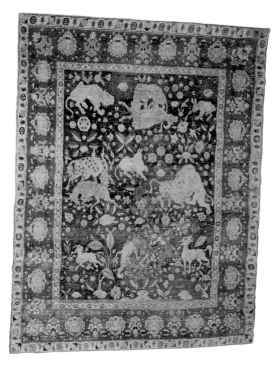

PLATE 87. *Carpet with Animals,* 16th century Kāshān, Iran Asymmetrically knotted silk, 48¾ x 42⅞ in. (124 x 109 cm)

ORIENTAL ANTIQUITIES AND ISLAMIC ART

PLATE 88.
Peacock Plate,
1540–55
Iznik, Turkey
Siliceous ceramic
with painted and
glazed decoration,
height: 3⅛ in.
(8 cm); diameter:
14¾ in. (37.5 cm)

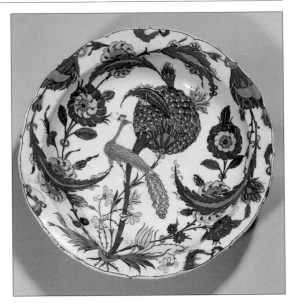

PLATE 89.
*Portrait of
Shah Abbas I*
Signed "Muhammed
Qasim Ispahan,
March 12, 1627"
Ink, color, and gold
on paper, 10¾ x 6⅝
in. (27.5 x 16.8 cm)

PLATE 90.
*Imam Reza
Fighting a Demon*
Page from the
*Fulnama (The
Book of Omens)*,
c. 1550
Tabrīz or Qazvīn,
Iran
23¼ x 21⅜ in.
(59 x 54 cm)

89. The inscription reads "May life provide you with what you desire from the three lips: those of your lover, of the river, and of the cup."

Greek, Etruscan, and Roman Antiquities

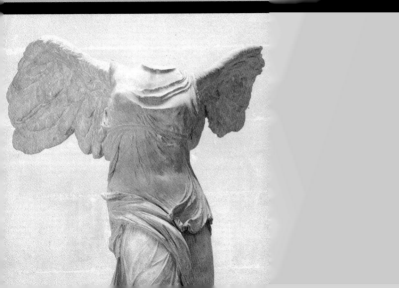

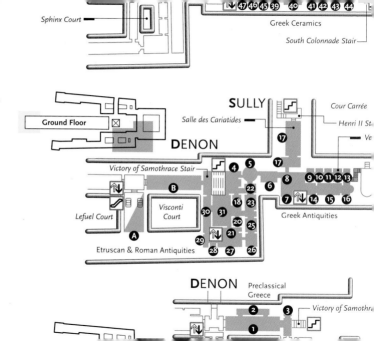

Sphinx Court

Greek Ceramics

South Colonnade Stair

SULLY

Cour Carrée

Salle des Cariatides

Henri II St.

Ve

Ground Floor

DENON

Victory of Samothrace Stair

B

Lefuel Court

Visconti Court

Greek Antiquities

A

Etruscan & Roman Antiquities

DENON Preclassical Greece

Victory of Samothr

Victory of Samothra

Access and Tour

Statuary from the department of Greek, Etruscan, and Roman antiquities is displayed chronologically on the entresol and ground floors; bronzes, pottery, and glassware are on the first floor. Much Greek sculpture, both classical and Hellenistic (i.e., art made after Alexander the Great), survives only in the form of Roman copies. Some of the latter were restored, remounted, or even completed for great collectors of antiquities during the Renaissance, Baroque, and later periods. The installation of great sculptures from venerable collections in the department's initial galleries (rooms 17, A, and B), outside the main chronological display, and the use of other pieces as decoration (in the Denon vestibule), in accordance with earlier practice, are intended to remind visitors of how the collecting of Greco-Roman statuary has evolved.

From the Hall of the Pyramid, take the Denon escalators to the entresol level, turn left, and visit the galleries of preclassical sculpture (rooms 1–3; formerly the imperial stables). From room 3 take the flight of steps that leads up to the ground-floor galleries (rooms 4–13) containing Greek art of the classical and Hellenistic periods, notably two fragments from the Parthenon (room 7; plates 98 and 99) and the *Venus de Milo* (room 12; plate 100), situated at the end of the Pan Corridor (room 8). A parallel gallery facing south, toward the Seine (rooms 14–16), contains Roman copies of Greek works. On the west side of the Cour Carrée is the Salle des Cariatides (room 17), which contains more Roman copies of Greek works.

From there, you can head directly to the first floor via the Henri II stair, located just beyond the far end of the Salle des Cariatides. This will take you to galleries devoted to the other Greek and Roman arts: bronzes (room 32), silver and cameos (room 33), glassware (room 34), terra-cottas (rooms 35–38; in what is called the Musée Charles X), and Greek ceramics (rooms 39–47; in what is called the Galerie Campana, parallel to the Musée Charles X but facing the Seine). Then retrace your steps through room 34 to the grand Victory of Samothrace stair.

Frontispiece:
*The Winged Victory
of Samothrace*
(detail; see plate 138)

At the bottom of the stair, back on the ground floor, are displays of Etruscan art (rooms 18–20) and Roman art (rooms 22–27), as well as in and around the Sphinx Court (rooms 28–31). You might want to bring your tour to a close with a visit to the antiquities formerly in the Borghese, Albani, and Mazarin collections (among others), exhibited in the Galerie Daru (room B, adjacent to room 30) and in the former imperial riding school (room A).

If you prefer, you can take a more thematic tour, first visiting the Greek rooms on the entresol level and the ground-floor galleries of Greek, Etruscan, and Roman statuary (rooms 4–16; 18–31) before climbing the Victory of Samothrace stair for a visit to galleries on the first floor containing glassware (room 34), terra-cottas (rooms 35–38), Greek ceramics (rooms 39–47), silver and cameos (room 33), and bronzes (room 32). Finish by going back to the ground floor via the Henri II stair (next to room 32) to see the large Greco-Roman statuary displayed in the Salle des Cariatides (room 17), the Galerie Daru (room B, from which you can see the Visconti Court, where more Hellenistic sculpture will soon be installed), and the old riding school (room A), which provides ready access back to the Hall of the Pyramid. The order of the images in the plate section (pages 158–95) offers a different sequence; each approach has advantages and drawbacks.

History of the Collection

The core of the department of Greek, Etruscan, and Roman antiquities came from the royal collection, part of which was installed in the Salle des Cariatides from the reign of François I (1515–47) to the end of the eighteenth century. Some pieces acquired by the crown, however, were sent directly to Versailles and reached the Louvre only much later: *Germanicus* (now called *Marcellus;* plate 112), *Cincinnatus,* and works from the collections assembled by the prime ministers Richelieu and Mazarin.

Another collection was assembled by the marquis de Nointel,

Louis XIV's ambassador to the Ottoman Empire, who obtained his marble sculptures directly from Greece (they did not enter the Louvre until the Restoration). As early as 1795, under the aegis of the Muséum Central des Arts, there was a plan to establish a Musée des Antiques in the Petite Galerie, but that was not achieved until 1800. Notable among the property seized from fleeing aristocrats during the Revolution is the Choiseul-Gouffier collection, which entered the Louvre in 1798—its prize was a fragment of the Parthenon frieze (room 7; plate 99).

After the signing of the Treaty of Tolentino in 1797, the Louvre enjoyed a huge influx of antiquities looted by the French military in Italy, including the Vatican's *Laocoön* group and the *Apollo Belvedere*. The Musée Napoléon also bought the renowned Borghese collection in 1807. In 1815, when the fall of Napoleon meant that much of the loot from Italy had to be given back, the Louvre's director, Dominique-Vivant Denon, managed to prevent the return of a few pieces.

In 1821 the arrival of the *Venus de Milo* (room 12; plate 100), a gift from the marquis de Rivière to King Louis XVIII, signaled a rebirth of the department. Its expansion continued with the arrival of the Durand collection (vases, terra-cottas, bronzes) in 1825 and 1836, and with King Louis-Philippe's purchase of the *Apollo* from Piombino (room 32; plate 123) in 1834. Excavations and archaeological expeditions netted further additions from Olympia and from the Temple of Artemis in Magnesia ad Maeandrum (in present-day Turkey).

The Second Empire saw the purchase in 1862 of the marquis Campana's collection of Greek ceramics and Charles de Champoiseau's delivery in 1863 of *The Winged Victory of Samothrace* (plate 138). Later, in 1880, Champoiseau (the French consul to the Ottoman Empire) sent two kouroi from Actium (room 1; plate 94), followed by a kore from Samos (room 1; plate 93). At the end of the century, the Rothschild family donated the Boscoreale treasure—a trove of precious-metal objects discovered buried in a villa near Pompeii (room 32; plate 128).

PLATE 91.
Female Head
Early Cycladic II,
c. 2700–2400 B.C.
Marble, height:
10⅝ in. (27 cm)

The function of these figures, the most remarkable productions of a civilization that flourished in the Cyclades Islands between 3200 and 2000 B.C., remains a mystery.

This piece, in which the face is reduced to a convex surface and the nose to a triangular volume, was acquired by the Louvre in 1896, at a moment when interest in "primitive" art was growing. The austere simplicity of its present state is a bit misleading, for we know from traces of pigment on other examples that additional facial features were painted on.

☛ *In the vestibule of the Roman Egypt display (room A), you'll find the escalator leading to the preclassical Greek galleries (room 1).*

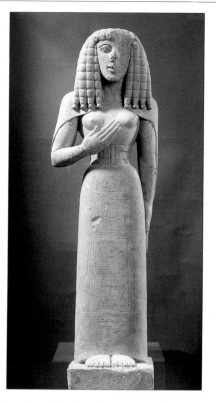

PLATE 92.
Statue of a Woman, known as *La Dame d'Auxerre*
Cretan Daedalic style, c. 640 B.C.
Limestone, height: 29½ in. (75 cm)

Previously in the collection of the museum in Auxerre, France (hence its nickname), this statuette, of unknown origin, has been associated with Cretan art of the seventh century B.C., a period called "Daedalic" after Daedalus, the mythic architect of the Cretan labyrinth at Knossos. The geometric incisions on the robe suggest that the statue originally was painted, probably in bright colors.

👁 Like the mirror-image room of Italian and Spanish sculpture on the other side of the Denon vestibule, the room containing archaic Greek sculpture (room 1) was once part of the imperial stables. It retains its original floor.

PLATE 93.
Kore of Samos
Ionic style, c. 570 B.C.
From the Temple
of Hera, Samos
Marble, height:
75⅝ in. (192 cm)

GREEK, ETRUSCAN, AND ROMAN ANTIQUITIES

Found in the Temple of Hera on Samos, a Greek island in the Aegean Sea, this female figure was probably a votive offering to the goddess. Whereas the *"Dame d'Auxerre"* (plate 92) exemplifies the severe Doric style, this statue is a characteristic example of the more gracious Ionic style that succeeded it.

PLATE 94.
Torso of a Kouros
Naxos style,
c. 560 B.C.
From the Temple
of Apollo, Actium
(Greece)
Marble, height:
39⅜ in. (100 cm)

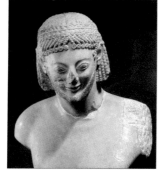

PLATE 95.
Male Head, known
as *The Rampin
Rider*
Attic style, c. 545 B.C.
Marble, height:
10⅝ in. (27 cm)

GREEK, ETRUSCAN, AND ROMAN ANTIQUITIES

94. Just as a kore was a votive offering to a goddess, a kouros, the male equivalent, was a votive offering to a male deity—in this case Apollo, in whose temple at Actium the fragment was found.

95. This head matches the torso of an equestrian figure in the Acropolis Museum in Athens and fragments of a second equestrian figure. Dedicated to a military or sporting victory (as indicated by the stylized crowns on the horses), this group from the Athenian acropolis constitutes the oldest surviving equestrian sculpture in Western art.

PLATE 96.
Male Torso, known
as *The Torso of
Miletus*
Severe style,
c. 480 B.C.
Miletus (Turkey)
Marble, height:
52 in. (132 cm)

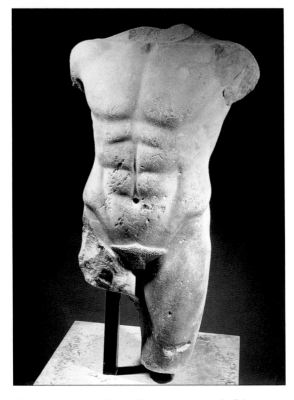

The restrained modeling of this torso is typical of the transitional moment between the archaic and classical periods.

☞ To the right of
room 3 you will find
rooms B and C, with
their displays of Coptic
Egyptian art. To reach
the galleries of classical
Greek art (rooms 4–7),
take the steps adjacent
to room 3.

GREEK, ETRUSCAN, AND ROMAN ANTIQUITIES

PLATE 97.
Funerary Stele,
known as *The*
Exaltation of

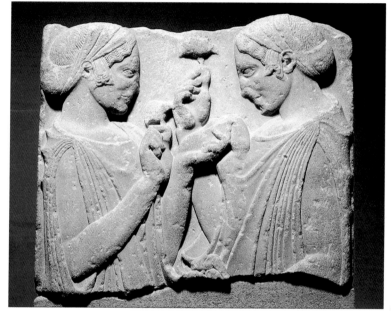

The linear handling and profile poses are typically archaic, but the graceful necks, elegant hands, and serene smiles of the two female figures anticipate the classical style.

the Flower
Severe style,
c. 460 B.C.
Pharsalus (now
Farsála, Greece)
Marble, height:
23⅝ in. (60 cm)

PLATE 98.
Centaur Assailing a Woman,
447–440 B.C.
Metope from the Parthenon, Athens
Marble, 53⅛ x 55½ in. (135 x 141 cm)

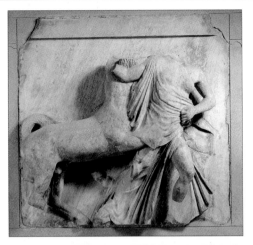

PLATE 99.
Panathenaic Procession,
C. 440 B.C.
Fragment from the Parthenon frieze, Athens
Marble, 37¾ x 81½ in. (96 x 207 cm)

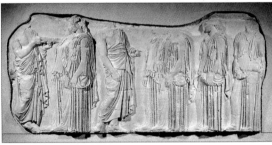

👁 *This room offers a good view of the site of the Garden of the Infanta (the queen's garden that once was located in front of the Petite Galerie), the quai, and the Institut on the other side of the Seine.*

98. The Parthenon—a temple dedicated to Athena, namesake and patron of Athens—was built on the city's acropolis in 447–438 B.C. This is one of several metopes (part of the section on top of the columns) from the exterior colonnade, most of which are now in the British Museum, London.

99. This fragment comes from a large relief representing the Panathenaic procession (the great civic festival of Athens), which ran along the top of the outer wall of the Parthenon's temple, below the colonnade.

GREEK, ETRUSCAN, AND ROMAN ANTIQUITIES

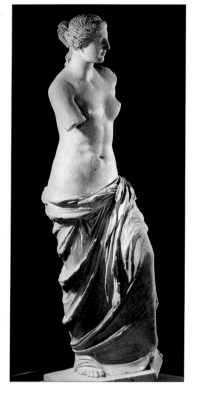

PLATE 100.
Aphrodite, known
as *Venus de Milo*
Classicizing style,
c. 100 B.C.
Melos (Cyclades
Islands, Greece)
Marble, height:
79$\frac{1}{2}$ in. (202 cm)

Found in 1820 (the ceiling of room 34 on the first floor celebrates its discovery), this statue has come to symbolize classical art. Specialists have identified it as a late variant of a nude statue of Aphrodite by the Greek artist Praxiteles, a work often copied and paraphrased during the Hellenistic period.

☞ *From room 13
there are stairs leading
down to the Medieval
Louvre and the
Egyptian antiquities.*

GREEK, ETRUSCAN, AND ROMAN ANTIQUITIES

PLATE 101.
Torso of Aphrodite,
known as *Aphrodite
of Cnidus,*
C. 350 B.C.
Marble, height:
48 in. (122 cm)

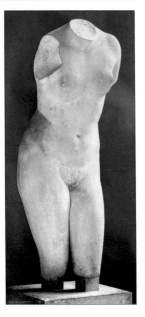

PLATE 102.
Head of Aphrodite,
known as *The
Kauffmann Head*
Classicizing style,
2d century B.C.
Tralles (now
Aydin, Turkey)
Marble, height:
13¾ in. (35 cm)

101. This fragment comes from a Roman copy of an original attributed to Praxiteles.

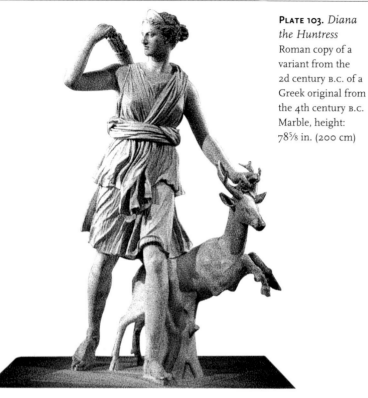

PLATE 103. *Diana the Huntress* Roman copy of a variant from the 2d century B.C. of a Greek original from the 4th century B.C. Marble, height: 78⅝ in. (200 cm)

GREEK, ETRUSCAN, AND ROMAN ANTIQUITIES

The bronze original that inspired this piece was created by a contemporary of the Greek artist Lysippus.

PLATE 104.
Portrait of Socrates,
C. 330 B.C.
Marble, height:
13¼ in. (33.5 cm)

👁 *This room brings together several major Roman copies of Greek statuary, most of them from the Hellenistic period, including* Diana the Huntress *(plate 103),* Centaur Taunted by Eros, *and* Reclining Hermaphrodite *(with a marble mattress added by Gianlorenzo Bernini during his visit to Paris in 1665).*

On the history, architecture, and function of this remarkable room, originally Henri II's ballroom, see page 35.

This Roman copy may reproduce the posthumous bronze portrait of the philosopher by Lysippus.

PLATE 105.
Hanging Marsyas
Roman copy of a
Pergamenian work,
late 3d century or
early 2d century B.C.
Marble, height:
100¾ in. (256 cm)

GREEK, ETRUSCAN, AND ROMAN ANTIQUITIES

The punishment of Marsyas, who foolishly challenged Apollo to a musical competition, was to be flayed alive. Like the famous *Laocoön* group in the Vatican, this powerful work of the Hellenistic "baroque" exerted considerable influence on Western art, beginning in the sixteenth century.

☛ *From the Salle des Cariatides, retrace your steps back to room 4 and turn right.*

PLATE 106.

*Sarcophagus of a
Married Couple,*
late 6th century B.C.
Caere (now
Cerveteri, Italy)
Terra-cotta,
44⅞ x 74¾ in.
(114 x 190 cm)

Etruscan civilization flourished in central Italy roughly
between 675 and 475 B.C. The influence of Greek culture,
which held sway over southern Italy, was strong, but it was the
Etruscans who elevated terra-cotta sculpture to a new level of
sophistication.

This sarcophagus was made to resemble a banquet couch
on which the deceased couple reclines.

☞ To reach the
Etruscan galleries, go
to room 8, at the far
end of the Salle des
Cariatides, turn right,
and continue past the
Mars Rotunda to
room 4.

GREEK, ETRUSCAN, AND ROMAN ANTIQUITIES

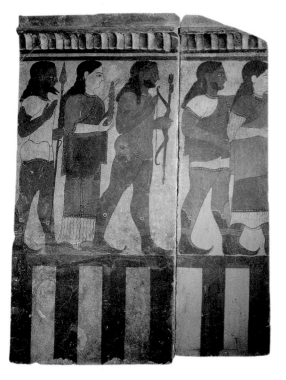

PLATE 107.
Decorative Panels,
late 6th century B.C.
Caere (now
Cerveteri, Italy)
Terra-cotta,
height: 48⅜ in.
(123 cm)

GREEK, ETRUSCAN, AND ROMAN ANTIQUITIES

This fragment of a tomb decoration comes from the Etruscan
town of Caere (now Cerveteri, Italy).

PLATE 108.
Candelabrum,
early 5th century B.C.
From an Etruscan
tomb in Caere (now
Cerveteri, Italy)
Bronze, height:
16⅞ in. (43 cm)

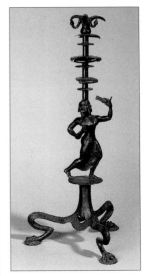

PLATE 109.
*Pendant, Head
of Acheloüs,*
early 5th century B.C.
Gold, height: 1⅝ in.
(4 cm)

☞ *Go back to the
Mars Rotunda in order
to start the sequence
of Roman galleries,
which parallel the
Etruscan rooms.
The Roman galleries
occupy what used to
be Anne of Austria's
apartment, on the
ground level of the
Petite Galerie.*

109. This pendant is executed in repoussé, a metalworking technique in which the pattern was hammered in from the back. The curly hair of the river god is evoked with filigree work and his beard, with gold granulation—two delicate techniques that classical goldsmiths mastered to an impressive degree.

GREEK, ETRUSCAN, AND ROMAN ANTIQUITIES

PLATE 110.
Altar of Domitius Ahenobarbus, end of 2d century B.C.
Fragment of a relief from the Temple of Neptune, Rome
Marble, height: 80⅝ in. (205 cm)

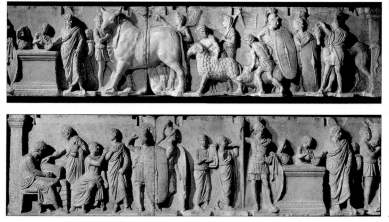

Top: the sacrifice of a steer, a ram, and a pig to Mars. Bottom: a census of Roman citizens. The three other sides (now in the Glyptothek, Munich) represent the wedding of Neptune and Amphitrite.

GREEK, ETRUSCAN, AND ROMAN ANTIQUITIES

👁 *This room was Anne of Austria's salon.*

PLATE 111.
*Portrait Bust of
Livia, Wife of
Augustus,*
C. 30 B.C.
Rome
Basalt, height:
13⅜ in. (34 cm)

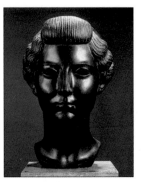

PLATE 112.
*Statue of Marcellus,
Nephew of Augustus,*
20 B.C.
Signed "Kleomenes
the Athenian"
Rome
Marble,
height: 70⅞ in.
(180 cm)

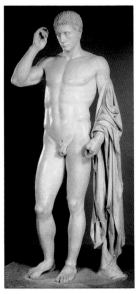

112. This effigy is said by some scholars to be a posthumous
portrait of Augustus (died 23 B.C.) in the guise of Hermes.

PLATE 113.
Fragment from the Ara Pacis: Imperial Procession, dedicated 9 B.C. Rome

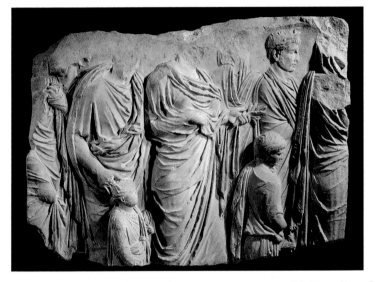

GREEK, ETRUSCAN, AND ROMAN ANTIQUITIES

This fragment comes from the Ara Pacis (altar of peace), which was erected in Rome after the successful completion of Augustus's military campaign in Spain. Its frieze was modeled after the one on the Parthenon in Athens (see plate 99).

Marble, 47¼ x 57⅞ in. (120 x 147 cm)

👁 *This room was originally the Salle des Saisons, the antechamber to Anne of Austria's apartment.*

PLATE 114.
Hadrian,
2d quarter of 2d
century A.D.
Bronze, height:
16⅞ in. (43 cm)

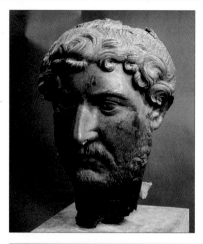

PLATE 115.
*Sarcophagus of
the Muses,*
c. A.D. 150–160
Roman region
Marble, 24 x 81⅛ in.
(61 x 206 cm)

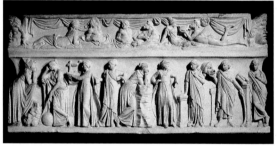

115. The use of sarcophagi to bury the dead became much more pervasive beginning in the second century A.D., first in Rome and then throughout the Empire. Here the nine Muses, each shown with her attribute, are arrayed along the frieze. On the lid, satyrs and maenads recline for a banquet. Drunkenness—linked to the god Dionysus—and the Muses were associated with contemporary mystery cults.

GREEK, ETRUSCAN, AND ROMAN ANTIQUITIES

PLATE 116.
Vase from Emesa
(now Homs, Syria),
6th–7th century A.D.
Silver, height:
17⅜ in. (44 cm)

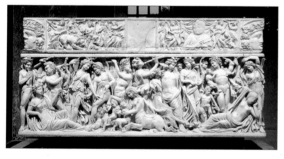

PLATE 117.
*Sarcophagus with
Dionysus and
Ariadne,* C. A.D. 235
Rome
Marble, 38⅝ x 81⅞
in. (98 x 208 cm)

GREEK, ETRUSCAN, AND ROMAN ANTIQUITIES

117. The image of Dionysus coming to awaken the sleeping
Ariadne on Naxos after she had been abandoned by Theseus
became a Christian symbol of the hope for resurrection. The
face of Ariadne, left unfinished on this stone coffin, would
probably have been carved to resemble the deceased.

PLATE 118.
Diptych of the
Muses,
5th century A.D.
Ivory, height: 11⅜ in.
(29 cm)

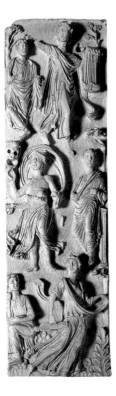

GREEK, ETRUSCAN, AND ROMAN ANTIQUITIES

👁 *For the decor of this*
room, which combines
what was Anne of
Austria's ceremonial
bedchamber and her
small cabinet, see
pages 40 and 43.

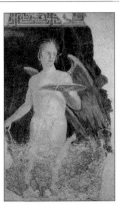

PLATE 119.
Winged Genius,
3d quarter of 1st
century B.C.
From the villa of
Publius Fannius
Sinistor, Pompeii
Wall painting,
49⅝ x 28 in.
(126 x 71 cm)

PLATE 120.
*Melpomene,
Muse of Song,*
A.D. 62–79
From the villa of
Julia Felix, Pompeii
Wall painting,
height: 18⅛ in.
(46 cm)

GREEK, ETRUSCAN, AND ROMAN ANTIQUITIES

These fragments of paintings were detached from the walls of Pompeiian villas. The excavations that began at Pompeii in 1748 and resumed, more systematically, in 1860 have considerably enriched our understanding of Roman civilization.

☞ *If you go to the right, you'll reach room 27, which was the Hall of Antiquities and currently houses works from late antiquity, followed by two rooms devoted to Christian mosaics (rooms 28–29).*

PLATE 121.
*The Judgment
of Paris,*
shortly after A.D. 115
Mosaic from
Antioch (Turkey)
Marble, limestone,
and colored glass,
height: 73 1/4 in.
(186 cm)

Beginning in the second century B.C., Greek mosaics attained
a level of refinement approaching that of painting. In this
example, Paris is seated next to Mercury (the winged messen-
ger of the gods), getting ready to pick the most beautiful of the
three goddesses (from left to right) Minerva, Venus, and Juno.

PLATE 122.
Phoenix,
late 5th century A.D.
Floor mosaic
from Dafne, near
Antioch (Turkey)
Marble and lime-
stone, 19 ft. 8¼ in.
x 13 ft. 11⅜ in.
(6 x 4.25 m)

GREEK, ETRUSCAN, AND ROMAN ANTIQUITIES

The center of the Sphinx Court (room 31) is decorated with
another large mosaic, also from Dafne but earlier.

☛ *As you leave the
Sphinx Court, take the
Victory of Samothrace
stair immediately at
your left to go up to
the first floor.*

PLATE 123.
Apollo,
1st century B.C.
Piombino,
Magna Graecia
Bronze, height:
45⅜ in. (115 cm)

Recovered off the Tuscan coast, near Piombino, this statue resembles an Apollo type, but it is dedicated to Athena.

PLATE 124.
Warrior,
2d half of 2d
century B.C.
Asia Minor
Bronze, height:
9¾ in. (25 cm)

PLATE 125.
Wrestler,
known as *The
Autun Boxer,*
1st century A.D.
Bronze, height:
10⅝ in. (27 cm)

GREEK, ETRUSCAN, AND ROMAN ANTIQUITIES

From Hellenistic Greece to imperial Rome, the demand for bronze figurines continued undiminished. The genre flourished again during the Renaissance (see plates 429 and 439).

PLATE 126.

*Perfume Vase in
the Form of an
African Head,*
2d century A.D.
Bronze, height:
5⅛ in. (13 cm)

PLATE 127.

*Medallion Portrait
of Constantine,*
incorporating a coin
minted at Sirmium
(Yugoslavia), 321 A.D.
Gold, diameter:
3⅝ in. (9.2 cm)

PLATE 128.
Goblet of Boscoreale,
late 1st century B.C.
Silver and gold,
height: 4⅛ in.
(10.4 cm); diameter:
4⅛ in. (10.4 cm)

This goblet, decorated with skeletons, was buried in a Roman villa during the eruption of Vesuvius in A.D. 79.

GREEK, ETRUSCAN, AND ROMAN ANTIQUITIES

PLATE 129.
Bell Idol,
c. 700 B.C.
Workshop of the
Oenochoe group,
Thebes (Egypt)
Terra-cotta, height:
13 in. (33 cm)

Another of these bell-shaped tomb figurines is exhibited in room 1 on the entresol level. Their adjustable legs, which function as clappers, are attached to the torso with string.

👁 *Rooms 35–38, like*
rooms 27–30 (see pages
106–12), belong to
what was originally the
Musée Charles X (see
page 60).

PLATE 130.
*Woman Playing
a Lute,*
300–250 B.C.
Tanagra
Terra-cotta, height:
8⅝ in. (22 cm)

There was a thriving market in the Hellenistic period for such terra-cotta figurines, most of which depict genre subjects: knucklebone players, slaves extracting thorns from their feet, and so on.

PLATE 131.
*Grotesque Heads
and Ethnic Types,*
Hellenistic and
late Hellenistic
Smyrna
Terra-cotta
From left: *Man,*
height: 1⅝ in.
(4 cm); *African,*
height: 2 in. (5 cm);
*Philosopher or
Silenus(?),* height:
2½ in. (6.5 cm);
Silenus(?), height:
1¾ in. (4.5 cm)

GREEK, ETRUSCAN, AND ROMAN ANTIQUITIES

GREEK, ETRUSCAN, AND ROMAN ANTIQUITIES

PLATE 132.
Loutrophoros
Proto-Attic style,
c. 680 B.C.
Terra-cotta, height:
31⅞ in. (81 cm)

PLATE 133.
Oenochoe (jug),
known as the Levey
Oenochoe,
c. 650 B.C.
Eastern Greece
Terra-cotta, height:
15⅝ in. (39.5 cm)

132. The geometric style of the earliest Greek vases was invigorated by influences from Asia Minor, which explains the suppleness of the figures on the various decorative registers.

☞ From the Hall of Columns (next to rooms 40, 38, and 30) you can enter the series of rooms (39–47) known as the Galerie Campana (see page 52).

PLATE 134.
Black-Figure
Amphora
Signed by the
potter Exekias
Attic, c. 540 B.C.
Terra-cotta, height:
19⅝ in. (50 cm)

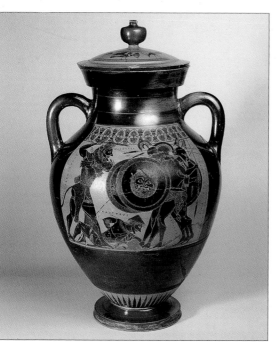

GREEK, ETRUSCAN, AND ROMAN ANTIQUITIES

Exekias (active 550–520 B.C.) abandoned the multiple registers seen in plates 132 and 133 in favor of a single broad band in which the figures, painted in black slip, stand out against a reddish ground.

PLATE 135.
*Red-Figure
Calyx Krater*
Signed by the
painter Euphronios
Attic, c. 510 B.C.
Terra-cotta, height:
18⅛ in. (46 cm)

PLATE 136.
*Red-Figure
Calyx Krater*
Signed by the
potter Brygos
Decoration
attributed to the
Brygos Painter
Attic, c. 490 B.C.
Terra-cotta, diame-
ter: 12¼ in. (31 cm)

135. Around 530 B.C., the color system of Greek vase painting was reversed: the red silhouettes of the figures were left "in reserve" (blank) and the black slip applied around them. On this piece, Euphronios (active 510–500 B.C.) painted Hercules in combat with the giant Antaeus.

Kraters were used to mix water with wine.

136. Depicted here is an episode from Homer's *Iliad:* Briseis, a Trojan woman taken captive by Achilles, serves wine to his elderly tutor.

PLATE 137.
*Red-Figure
Calyx Krater*
Attributed to the
Niobid Painter
Attic, c. 460 B.C.
Terra-cotta, height:
21¼ in. (54 cm)

GREEK, ETRUSCAN, AND ROMAN ANTIQUITIES

GREEK, ETRUSCAN, AND ROMAN ANTIQUITIES

PLATE 138.
The Winged Victory of Samothrace
Rhodian Hellenistic style, c. 190 B.C.
Marble (figure) and limestone (prow base), height: 129⅛ in. (328 cm)

☞ *From the Galerie Campana, go back through the Musée Charles X and the Apollo Rotunda to the top of the Victory of Samothrace stair. After admiring the sculpture on the landing (plate 138), walk down the steps to the Galerie Daru.*

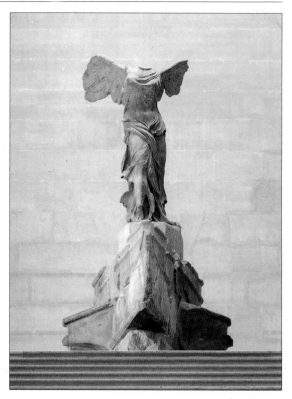

This monumental sculpture was erected in the pool of the Panhellenic sanctuary on the Greek island of Samothrace, probably to commemorate naval victories won by the Rhodians in 190 B.C.

👁 *At the far end of the Galerie Daru, you arrive in the Denon vestibule, the old entrance to the Louvre, which is decorated with a big candelabra made*

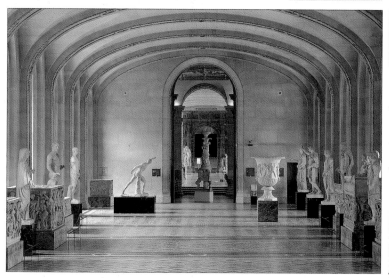

GREEK, ETRUSCAN, AND ROMAN ANTIQUITIES

In the Galerie Daru there are pieces of Roman sculpture on view from the Borghese collection.

by Piranesi from antique and modern elements. Other Roman pieces are presented in the old riding stables (rooms 1–3).

PLATE 139.
The Borghese Gladiator
Hellenistic style, early 1st century B.C.
Antium (now Anzio, Italy)
Either a Roman copy of a 5th-century-B.C. Greek original or an original Roman work in the style of the 5th century B.C.
Marble, length (from head to left heel): 78⅜ in. (199 cm)

Discovered in Rome around 1609, this famous sculpture was in the collection of Cardinal Scipione Borghese by 1613. It was one of three hundred works acquired by the Musée Napoléon (where it arrived in 1809–10) from the collection of Napoleon's brother-in-law, Prince Camillo Borghese.

GREEK, ETRUSCAN, AND ROMAN ANTIQUITIES

PLATE 140.
Krater, known as
The Borghese Vase,
C. 40–30 B.C.
Pentelic marble,
height: 67⅝ in.
(172 cm); diameter:
53⅛ in. (135 cm)

This massive vessel was discovered in 1569 in Rome; by 1645 it was in the Borghese collection. Dionysus and Ariadne, who holds a lyre, are surrounded by a procession of Bacchic dancers—suitable subjects for a krater, which was used for mixing wine and water.

French Painting

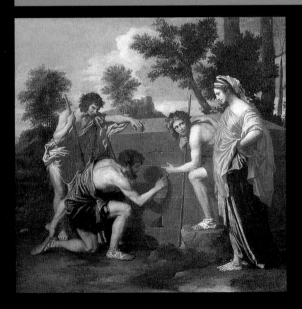

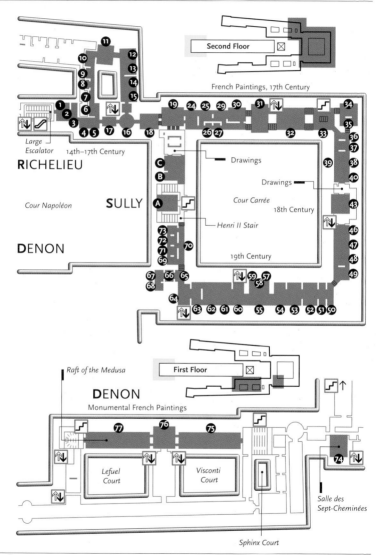

Access and Tour

To reach the galleries containing most of the Louvre's French paintings from the fourteenth to the nineteenth centuries, enter the Richelieu wing from the Hall of the Pyramid and then proceed via one of the elevators or the large escalator to the second floor. For the large nineteenth-century French paintings, use the Denon entry and then take the elevator in the Daru vestibule or the Victory of Samothrace stair to the first floor.

The second-floor galleries devoted to French painting are at the top of the large Richelieu escalator. They consist of a continuous sequence of seventy-three new rooms that form two loops. The first one (rooms 1–16) circles the Khorsabad Court, ending in the "painting of the month" gallery (room 17). The second one (rooms 18–73; A–C) circles the Cour Carrée, ending with the four galleries devoted to the prints and drawings department, containing drawings, cartoons for large decorative compositions, and seventeenth-century pastels (rooms 20–23).

Rooms 1–18, with interiors designed by I. M. Pei (like all those in the Richelieu wing), were the last ones to open, in 1993; the galleries on the north side of the Cour Carrée (rooms 19, 24–35) were decorated by Joseph-André Motte (inaugurated 1992); the final thirty-nine galleries of the tour were designed by the architect Italo Rota. The large nineteenth-century French paintings are installed on the first floor in four galleries, which retain their old decors and red walls: the Salle des Sept-Cheminées (room 74), plus the unit formed by the Salon Denon (room 76) and the two large rooms flanking it, the Daru (room 75) and Mollien (room 77) galleries.

History of the Collection

Almost two-thirds of the paintings in the Louvre are by French artists. King François I was responsible for establishing the royal collection of paintings, which originated as a "Picture Cabinet" located at the Château de Fontainebleau; it was transferred to the Louvre in the seventeenth century. The collection's greatest period was the reign of King Louis XIV, when the sovereign

Frontispiece:
Nicolas Poussin,
*The Arcadian
Shepherds*
(detail; see plate 160)

acquired part of Cardinal Mazarin's collection and that of the banker Everhard Jabach. An inventory of the royal collection drawn up in 1709–10 listed 1,478 paintings, of which 930 were French. When the court had moved to Versailles, more than four hundred paintings remained in the Louvre, where they constituted the core of a quasi-public museum.

King Louis XV's collecting efforts were distinguished, above all, by the purchase of works by living French painters—with the surprising exception of Antoine Watteau. King Louis XVI encouraged history painting on a large scale, and his minister of fine arts acquired many important works by French painters, notably Eustache Le Sueur and the Le Nain brothers. Beginning in 1750, part of the painting collection was exhibited publicly at the Luxembourg palace. After the opening of the Muséum Central des Arts in 1793, the painting collection was exhibited in the Grande Galerie, where works formerly in the royal collection joined pieces from the collection of the Académie Royale de Peinture et de Sculpture (abolished in 1793) as well as those seized from emigrating aristocrats or confiscated from the Church.

Collecting in the nineteenth century was characterized by an increasing acceptance of different styles and periods. In 1869 Dr. Louis La Caze donated a fine collection of seventeenth- and eighteenth-century works. The decades prior to World War I saw the acquisition of the *Pietà of Villeneuve-lès-Avignon* (plate 144), the addition of works by nineteenth-century French masters (initially displayed at a museum of contemporary French painting at the Luxembourg, established in 1818), and the donation of several important private collections. Finally, thanks to the Gustave Caillebotte bequest of 1894 and donations by Etienne Moreau-Nélaton and Comte Isaac de Camondo in 1911, works by the Impressionists entered the Louvre.

Since 1918 the Société des Amis du Louvre has provided much-needed funds for countless acquisitions. After the postwar years, which saw several important donations, there have been some spectacular additions, notably Watteau's *Two Cousins* and *Saint Thomas* by Georges de La Tour.

PLATE 141.

Portrait of Jean II, the Good ("Jehan roy de France"), before 1350
Wood, 23⅝ x 17½ in. (60 x 44.5 cm)

FRENCH PAINTING

This is the oldest independent portrait in Western painting to survive from the postclassical era. It can be securely identified as the portrait of King Jean le Bon (John the Good), which appears in a 1380 inventory of the Hôtel Royal Saint-Pol (residence of the king's son Charles V), along with three other portraits of French rulers.

Jean le Bon (1319–1364) was imprisoned in London after the defeat of the French at Poitiers in 1356. His liberation in 1360 was celebrated by the introduction of a new currency: the franc.

👁 *The window to the right of room 1 offers a sweeping view of the Cour Napoléon and the pyramid; from the window at left, there's a dizzying view down into the Puget Court.*

PLATE 142.

Jean Malouel

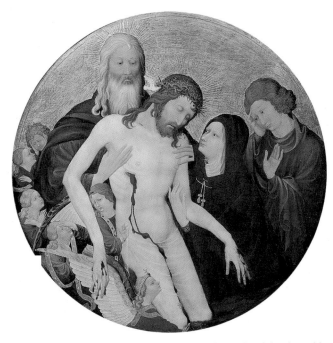

(Nijmegen, before
1370–Dijon, 1415)
*Pietà (Large Pietà
Roundel)*, c. 1400
Wood, diameter:
25⅜ in. (64.5 cm)

This panel was painted for Philippe le Hardi (Philip the Bold;
1342–1404), the powerful duke of Burgundy and second son
of Jean le Bon, whose arms appear on the reverse. It is
attributed to Jean Malouel, painter to the duke from 1397.

With considerable originality, the panel fuses three estab-
lished iconographic themes: the Pietà; the lamentation over
the dead Christ; and the Trinity (Father, Son, and Holy Ghost),
to which the duke was especially devoted.

PLATE 143.
Henri Bellechose

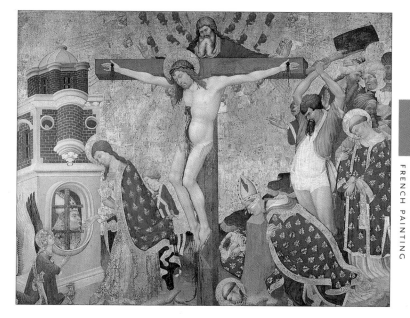

At the left, Saint Denis is shown taking his last communion, symbolically offered by Christ himself. At the right he stands holding his own head, having been decapitated before one and after the other of his two martyred companions—a composition that allowed the artist to depict successive stages of the three executions.

This was painted by Malouel's successor for an altar in the Chartreuse de Champmol (near Dijon) for Jean sans Peur (John the Fearless), son of Philippe le Hardi.

(active at the court of Burgundy, 1415–1440/44)
Saint Denis Altarpiece, 1416
Wood transferred to canvas, 63¾ x 83 in. (162 x 211 cm)

FRENCH PAINTING

PLATE 144.
Enguerrand
Quarton

FRENCH PAINTING

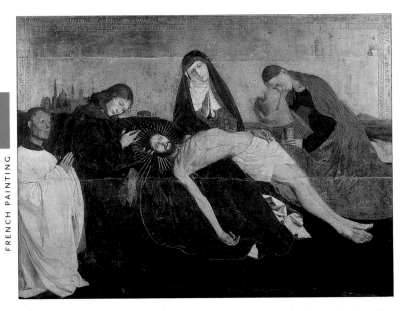

(active Provence, 1444–1466)
Pietà of Villeneuve-lès-Avignon, c. 1455
Wood, 64¼ x 86 in. (163 x 218.5 cm)

Papal residence from 1330 to 1377, and then residence of the antipopes during the Great Schism of 1378–1417, Avignon was a center of Italian art in southern France. Northern painters from France and Flanders active there in the fifteenth century developed an original synthesis of styles.

The donor kneeling at left remains unidentified, and evidence for the attribution to Quarton is insecure.

PLATE 145.
Flemish painter
active in Paris,
mid-15th century
*Retable of the
Parlement of Paris*,
c. 1455
Wood, 89¼ x 106⅜
in. (226.5 x 270 cm)

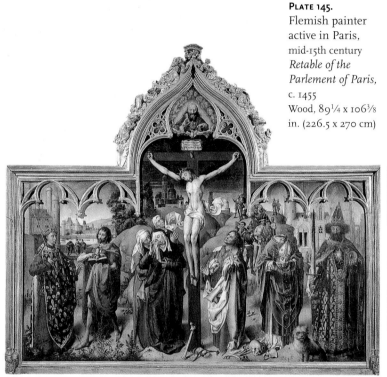

FRENCH PAINTING

The annexation of a large part of Flanders by Burgundy under
Philippe le Hardi and Philippe le Bon as well as the presence
of many Flemish and German painters in France blurred the
boundaries between the northern and French schools during
the 1400s.

 The traditional polyptych format is recalled by the frame of
this retable, but the four saints on the sides (left to right: Saints
Louis, John the Baptist, Denis, and Charlemagne) share with
the central crucifixion scene a single unified space, a landscape
in which the Louvre and the Palais de Justice are recognizable.

PLATE 146.
Jean Fouquet
(Tours, c. 1420–
Tours, 1478/81)
Guillaume Jouvenel
des Ursins,
Chancellor of
France, c. 1465
Wood, 36⅝ x 28¼ in.
(93 x 73.2 cm)

FRENCH PAINTING

Achieving an unprecedented synthesis of the Flemish and Italian traditions, Fouquet, "the prince of early Renaissance painters," emerged as the first "French" painter at the very moment that King Louis XI was laying the foundations of modern France. Fouquet's linear precision, a characteristic Flemish trait, is enlivened by a new amplitude in the suggestion of volume. The gilded paneling in the background incorporates classicizing Renaissance motifs, a feature explained by Fouquet's trip to Rome, where he encountered works by Fra Angelico (see plate 292).

PLATE 147.
Jean Hay, known
as the Master of
Moulins (painter of
Netherlandish origin
active in Moulins,
1480–1500)
*Presumed Portrait
of Madeleine of
Burgundy, Dame
de Laage, Presented
by Saint Mary
Magdalen,*
c. 1490–95
Wood, 22 x 15¾ in.
(56 x 40 cm)

The kneeling donor—probably Madeleine of Burgundy, who
lived at Moulins in the court of the Bourbon dukes—is pre-
sented by her patron saint, Mary Magdalen (holding a vase of
perfume, her attribute). This is a fragment of a larger panel
(probably a triptych), as are the fragments from the retable of
Pierre and Anne de Bourbon exhibited in the case nearby.

PLATE 148.
Attributed to
Jean Clouet
(c. 1480–1540/41)
*François I, King of
France,* c. 1530 (?)
Wood, 37¾ x 29⅛ in.
(96 x 74 cm)

PLATE 149.
François Clouet
(Tours, 1505/10–
Paris, 1572)
*Portrait of Pierre
Quth, Apothecary,*
1562
Wood, 35¾ x 27⅝ in.
(91 x 70 cm)

FRENCH PAINTING

This panel is signed and dated by François Clouet, who succeeded his father, Jean, as painter to the king in 1541. The herbal on the table recalls the sitter's famous garden of medicinal plants.

PLATE 150.
Workshop of
Corneille de Lyon,
also known as
Corneille de La Haye
(The Hague, c. 1500–
Lyons ?, c. 1575)
*Portrait of a
Young Man*
Wood, 6³⁄₈ x 5³⁄₈ in.
(16 x 13.5 cm)

PLATE 151.
Anonymous
*Ball of the Duc de
Joyeuse*, c. 1582
Copper, 16³⁄₈ x 25⁵⁄₈
in. (41.5 x 65 cm)

FRENCH PAINTING

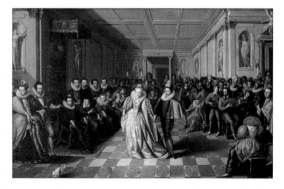

☞ *This small room
also intersects with the
circuit of northern
European paintings; to
continue with the
French section, go
back out the door you
came in.*

PLATE 152.
Jean Cousin, known
as Cousin *"le père"*
(the father)

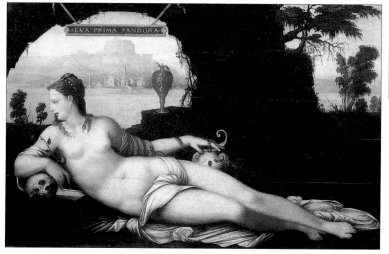

EVA PRIMA PANDORA

According to Greek mythology, Pandora was the first woman. Spurred by curiosity, she opened a jar that had been entrusted to her, releasing into the world all the evils it contained. But she closed the lid just in time to prevent the escape of Hope, mankind's only solace in misfortune. Here the jar and the serpent entwined around its handle suggest a parallel with the story of original sin—an analogy made explicit by the Latin inscription, meaning "Eve, the first Pandora."

(Sens, c. 1490–
Paris, 1560)
*Eva Prima
Pandora*, c. 1556
Wood, 38⅜ x 59 in.
(97.5 x 150 cm)

PLATE 153.
Antoine Caron

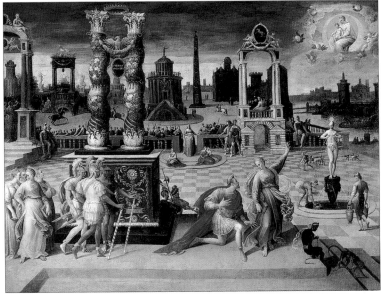

FRENCH PAINTING

(Beauvais, 1521–Paris, 1599)
The Tiburian Sibyl,
c. 1575–80
Canvas, 49¼ x 66⅞
in. (125 x 170 cm)

Sibyls are pagan prophetesses often linked in art with the Judeo-Christian prophets, as in Michelangelo's Sistine ceiling. Here Caron illustrated the Christian interpretation of an ambiguous passage in book six of Virgil's *Aeneid,* in which the Sibyl of Tibur (Tivoli) announces to Emperor Augustus the coming of Christ. The fantastic urban landscape incorporates freely paraphrased monuments from modern and ancient times.

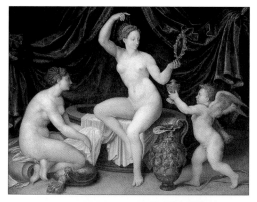

PLATE 154.
*Venus at Her
Toilette,*
mid-16th century
Canvas, 38¼ x 49⅝
in. (97 x 126 cm)

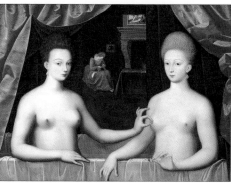

PLATE 155.
*Portrait of Gabrielle
d'Estrées and One
of Her Sisters (?),*
c. 1594
Wood, 37¾ x 49¼ in.
(96 x 125 cm)

FRENCH PAINTING

155. According to Pierre de Bourdeilles (an aristocratic abbot
known as Brantôme), the gallery of the Hôtel Adjacet in Paris
contained "a very beautiful painting in which are represented
very beautiful nude ladies at their bath who touch, feel, han-
dle, and rub one another."

The sister (?) of Gabrielle d'Estrées confirms the preg-
nancy of Henri IV's mistress, who holds a ring, token of the
king's love and perhaps of his promise of marriage—a
promise made moot by Gabrielle's sudden death in 1599.

PLATE 156.
Valentin de
Boulogne

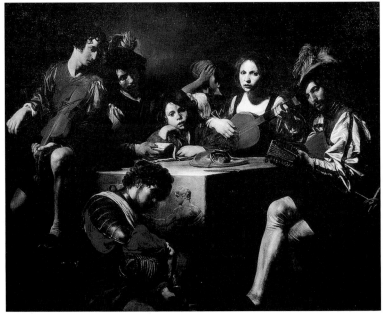

(Coulommiers,
c. 1591–Rome, 1632)
*Concert with
Antique Relief,*
c. 1622–25
Canvas, 68 x 84¼ in.
(173 x 214 cm)

Many French painters of the generation born around 1590 headed for Rome, where many remained for an extended period (Simon Vouet, François Perrier) or settled permanently (Nicolas Poussin, Claude Lorrain). The dark style of Caravaggio (plates 333 and 334), who had died young in 1610, seduced many young Italian, Flemish, and French painters in the 1620s, and the international Caravaggist movement had a long life (see plates 174–75, 253, and 350).

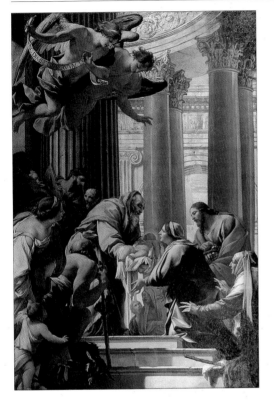

PLATE 157.
Simon Vouet
(Paris, 1590–
Paris, 1649)
*The Presentation
in the Temple,*
c. 1640–41
Canvas, 12 ft. 10⅝ in.
x 8 ft. 2⅜ in.
(3.93 x 2.5 m)

FRENCH PAINTING

The Virgin and Joseph, at left, present the infant Jesus to
the high priest in this painting for the high altar of the
church of Saint-Louis-des-Jésuites (now Saint-Paul–Saint-
Louis), rue Saint-Antoine, Paris. The contrasting diago-
nals of the earthly and airborne figures, the imposing clas-
sical architecture, the eloquent gestures, and the judicious
balance between realism (the infant in the foreground)
and poetry (the angels above) are all characteristic of the
grand style of Vouet, the dominant figure in Parisian
painting under King Louis XIII.

PLATE 158.
Simon Vouet
(Paris, 1590–
Paris, 1649)
Allegory of Wealth,
1640
Canvas, 66⅞ x 48¾
in. (170 x 124 cm)

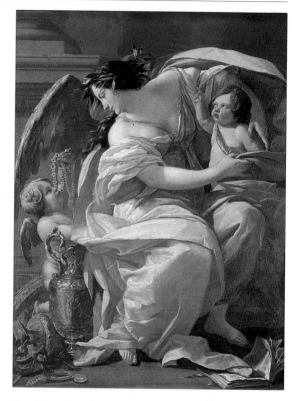

The clear yellow drapery and contrasting blue ribbon over the figure's shoulder make this allegory a seductive exercise in pure painting, and it has always been much admired. Documented in the royal collections from 1706, it was probably painted for Louis XIII, perhaps for a chimney-breast in the château of Saint-Germain-en-Laye.

PLATE 159.
Nicolas Poussin

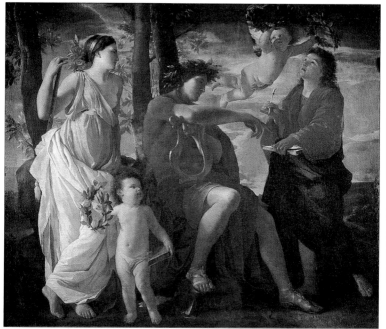

A poet, about to be crowned with laurel by a putto, takes dictation from Apollo, who is accompanied by Calliope, the Muse of epic poetry.

Admiration for Poussin, who settled in Rome in 1624 but often worked for Parisian collectors, continues to increase. In 1639 he was invited to return to Paris to work for Louis XIII. His Parisian sojourn (1640–42; see plate 463 and the paintings in room 19) was a key factor in the emergence of the Attic style, characterized by a purified classicism that influenced Vouet and many others.

(Les Andelys, 1594–Rome, 1665)
The Inspiration of the Poet, c. 1630 (?)
Canvas, 71⅞ x 83⅞ in. (182.5 x 213 cm)

PLATE 160.
Nicolas Poussin

(Les Andelys,
1594–Rome, 1665)
*The Arcadian
Shepherds*, 1638–40
Canvas, 33½ x 47⅝
in. (85 x 121 cm)

Arcadia is a region of Greece that figures in ancient and modern poetry as the epitome of rustic happiness. Here, shepherds decipher on a tomb the Latin inscription *Et in Arcadia ego*, which can be understood either as a statement made by Death himself ("I reign even in Arcadia") or as an epitaph of the deceased ("I, too, lived in Arcadia"). But there is no doubt as to the painting's meaning: "Happiness succumbs to death" (G. B. Bellori, 1672). Often regarded as a paradigm of French classicism, this work, painted in Rome, is closely linked to the classicism of the Carracci.

PLATE 161.
Nicolas Poussin
(Les Andelys,
1594–Rome, 1665)
*The Rape of the
Sabine Women,*
c. 1637–38
Canvas, 41⅝ x 81⅛
in. (105.9 x 206 cm)

PLATE 162.
Nicolas Poussin
(Les Andelys,
1594–Rome, 1665)
Self-Portrait, 1650
Canvas, 38⅝ x 29⅛
in. (98 x 74 cm)

FRENCH PAINTING

161. Poussin depicts a famous (and often portrayed) episode
from the annals of early Rome: on a signal from Romulus, his
men abducted the wives and sisters of the neighboring
Sabines, who had been invited to a celebration. Poussin strove
for accuracy in his view of the early city, incorporating austere
palaces and a temple in the Tuscan order.

162. This symbolic self-portrait was painted for Poussin's
friend and patron Paul Fréart de Chantelou, who fifteen years
later was Bernini's guide in Paris (see plate 498).

PLATE 163.

Claude Gellée, known as Claude Lorrain (Chamagne, c. 1602–Rome, 1682) *Seaport with the Landing of Cleopatra at Tarsus,* 1642–43 Canvas, 46⅞ x 66⅛ in. (119 x 168 cm)

PLATE 164.

Nicolas Poussin (Les Andelys, 1594–Rome, 1665) *Autumn,* c. 1660–64 Canvas, 46½ x 63 in. (118 x 160 cm)

FRENCH PAINTING

☞ *To your right is room 17, devoted to the rotating "painting of the month" exhibitions; it leads back to rooms 1–5, where this tour began. To your left, beyond the steps and Poussin's* Apollo and Daphne *(room 18), the tour continues in galleries devoted to French paintings under Kings Louis XIII and Louis XIV.*

163. Born in Lorraine, Claude was appropriated for the "French school," becoming a highly praised exemplar of French good taste. But his work, all of which was produced in Rome, proclaims his indebtedness to northern and Italian landscape painters.

164. Poussin's series *The Four Seasons* also evokes the four times of day (morning, noon, evening, night) and illustrates four biblical episodes in the history of salvation.

PLATE 165.
Eustache Le Sueur
(Paris, 1616–
Paris, 1655)
*Saint Paul
Preaching in
Ephesus*, 1649
Canvas, 12 ft. 11⅛
in. x 10 ft. 9⅛ in.
(3.94 x 3.28 m)

This painting—one of the "Mays" traditionally presented by the goldsmith's guild to Notre-Dame de Paris each May (this one was the tribute for 1649)—shows Saint Paul converting the Jewish and Greek inhabitants of Ephesus, who burn their now-rejected books of magic (Acts 19: 11–20).

🖙 *To your right are four rooms devoted to the graphic arts of the seventeenth century. In rooms 20–22 are drawings and full-scale cartoons for decorative schemes, including those for the chapel and Pavillon d'Aurore at the Château de Sceaux, executed by Charles Le Brun for the prime minister, Colbert; room 23 holds seventeenth-century pastels.*

FRENCH PAINTING

221

PLATE 166.
François Perrier
(Burgundy, c. 1590–
Paris, 1650)
Acis and Galatea
Canvas, 38¼ x 52⅜
in. (97 x 133 cm)

The cyclops Polyphemus sings from a cliff of his unrequited love for the sea nymph Galatea, who sits on a triumphal aquatic chariot with her lover, Acis.

Perrier represents a more Roman style, with grayed colors and powerful forms, which is quite different from the clarity and elegance of Attic painters such as Jacques Stella and Laurent de La Hyre.

PLATE 167.
Jacques Stella
(Lyons, 1596–
Paris, 1657)
*Cloelia Crossing the
Tiber,* c. 1635–45
Canvas, 53⅞ x 39¾ in.
(137 x 101 cm)

FRENCH PAINTING

According to Livy's *Roman History,* Cloelia and her young companions escaped from the Etruscan camp where they were being held as hostages and returned to Rome by swimming across the Tiber. Plutarch, Stella's authority for showing the young women crossing the river on horseback, later presented the story as an example of female virtue. The restrained elegance of the figures makes this painting one of the most beautiful examples of the Attic style, which triumphed in Paris during the period Cardinal Mazarin was prime minister.

PLATE 168.
Eustache Le Sueur
(Paris, 1616–
Paris, 1655)
*Clio, Euterpe, and
Thalia,* c. 1652–55
Wood, 51¼ x 51¼ in.
(130 x 130 cm)

PLATE 169.
Laurent de La Hyre
(Paris, 1606–
Paris, 1656)
*Laban Searching
for Idols in Jacob's
Baggage,* 1647
Canvas, 37⅜ x 52⅜
in. (95 x 133 cm)

FRENCH PAINTING

168. Three of the nine Muses are depicted here: at left, Clio, Muse of history, leans on a book and holds a trumpet of fame; at right, Euterpe, Muse of music, plays the flute; in the center, rendered in profile, is Thalia, Muse of comedy, who holds a theatrical mask.

169. The Old Testament patriarch Jacob, who had served Laban and married his two daughters Leah and Rachel, fled to Canaan. Laban caught up with the fugitives and searched their baggage for idols they had stolen from him—in vain, for he failed to look inside the chest on which Rachel sits, where they were hidden.

PLATE 170.
Lubin Baugin
(Pithiviers, c. 1612–
Paris, 1663)
*Dessert with
Gaufrettes,*
c. 1630–35
Wood, 16⅛ x 20½
in. (41 x 52 cm)

PLATE 171.
Jacques Linard
(Paris?, c. 1600–
Paris, 1645)
*The Five Senses
and The Four
Elements* (with
objects decorated
with the Richelieu
coat of arms), 1627
Canvas, 41⅜ x 60¼
in. (105 x 153 cm)

FRENCH PAINTING

PLATE 172.
Georges de La Tour

FRENCH PAINTING

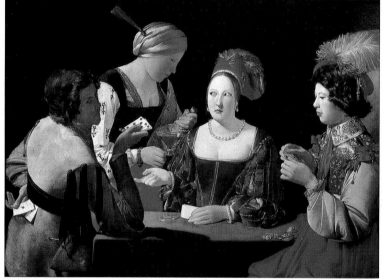

(Vic-sur-Seille, 1593–
Lunéville, 1652)
*Card Sharp with
the Ace of
Diamonds,*
c. 1635–40
Canvas, 41⅝ x 57½
in. (106 x 146 cm)

Exuberantly following Caravaggio's example, artists delighted
in painting scenes of gambling, drinking, smoking, and gal-
lantry. The elegant young man being cheated here was per-
haps meant to evoke the biblical parable of the prodigal son.

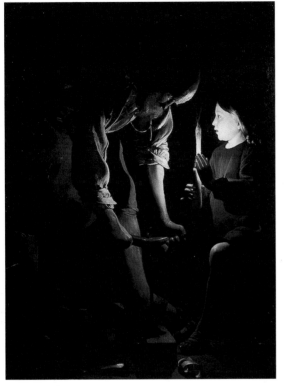

PLATE 173.
Georges de La
Tour (Vic-sur-Seille,
1593–Lunéville, 1652)
*Christ with Saint
Joseph in the
Carpenter's Shop,*
c. 1640–42
Canvas, 53⅞ x 40¼
in. (137 x 102 cm)

This nocturnal painting by La Tour points to the increasing
devotion for Saint Joseph.

PLATE 174.
Le Nain Brothers

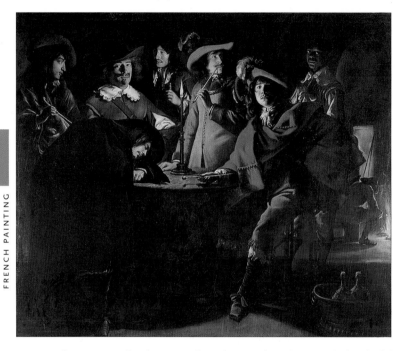

FRENCH PAINTING

(Laon, c. 1600/
1610–Paris, 1648)
Signed and dated
"Le Nain 1643"
The Smoking Den,
1643
Canvas, 46 x 53⅞ in.
(117 x 137 cm)

This depiction of a gathering of smokers avoids the playful
tone of similar Flemish works, becoming almost a group por-
trait or conversation piece.

PLATE 175.
Le Nain Brothers

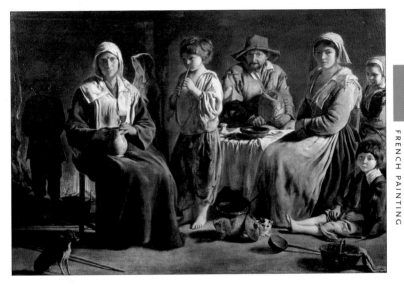

This canvas is neither signed nor dated, but it is very similar to *The Peasant Meal*, exhibited nearby, which is signed and dated 1642. Here, as in that painting, a genre scene is given new vitality by the quality of the faces, which are treated like portraits—another specialty of the Le Nain brothers.

The Forge, a similarly powerful genre painting also exhibited in this room, was acquired for the collection of Louis XVI in 1777, and its presence there helped revive the artists' reputation.

(Laon, c. 1600/ 1610–Paris, 1648)
Peasant Family,
c. 1640–45
Canvas, 44½ x 62⅝ in. (113 x 159 cm)

FRENCH PAINTING

PLATE 176.
Sébastien
Bourdon
(Montpellier, 1616–
Paris, 1671)
Soldiers' Halt
(previously known
as *Bohemians' Halt*)
Wood, 16⅞ x 22¼ in.
(43 x 58 cm)

PLATE 177.
Pierre Patel, known
as Patel *"le père"*
(the father) (Picardy,
c. 1605– Paris, 1676)
*Landscape with
Classical Ruins,*
1646/47
Canvas, 28¾ x 59 in.
(73 x 150 cm)

FRENCH PAINTING

176. Bourdon, who produced fine work in a broad range of genres and styles, here offers a variation on the genre scenes set in the street that had been made fashionable by Pieter Van Laer (known as Il Bamboccio).

☞ Room 30 gives you access to rooms 26 and 27, where you will see a selection of cabinet pictures; from there, continue the tour in rooms 28 and 29.

177. Patel painted landscapes in a crisp yet milky style, producing both independent cabinet pictures (room 26) and compositions intended for insertion within wooden paneling—for example, this painting from a room in the Hôtel Lambert (room 25).

PLATE 178.
Charles Le Brun
(Paris, 1619–
Paris, 1690)
Chancellor Séguier,
c. 1655–57
Canvas, 116⅛ x
138¼ in.
(295 x 351 cm)

PLATE 179.
Philippe de
Champaigne
(Brussels, 1602–
Paris, 1674)
Ex-Voto of 1662,
1662
Canvas, 65 x 90¼
in. (165 x 229 cm)

FRENCH PAINTING

179. The painter's daughter was a nun at the Parisian convent of
Port-Royal whose paralysis was miraculously healed. This votive
painting, which bears a lengthy inscription recounting the story
and the artist's intentions, represents the moment of revelation,
when the young nun (at right) realizes she is about to be healed
while her mother superior prays for her. The psychological acu-
ity of the faces, rendered without flattery, and the miraculous ray
of light against the gray wall of the cell so perfectly reflect the
austere Jansenist ethos of the Port-Royal nuns that this work has
sometimes been seen as a spiritual manifesto.

👁 *On the right side
of the room, some
steps lead up to a
beautiful view of the
Cour Carrée.*

231

PLATE 180.
Charles Le Brun

(Paris, 1619–
Paris, 1690)
*Alexander and
Porus,* 1665, Salon
of 1673
Canvas, 15 ft. 5 in. x
23 ft. 2⅜ in. (4.5 x
7.07 m)

With Prime Minister Colbert's support, Le Brun became the powerful coordinator of the arts during the first part of the personal reign of Louis XIV. But after Colbert's death, in 1683, those in power preferred Pierre Mignard, and Le Brun fell out of favor. Le Brun's four colossal paintings depicting episodes from the history of Alexander the Great are his answer to Raphael's famous *History of Constantine.*

PLATE 181.
Jean Jouvenet
(Rouen, 1644–
Paris, 1717)
*The Miraculous
Draught of Fishes,*
1706
Canvas, 12 ft. 10⅜
in. x 21 ft. 9⅜ in.
(3.92 x 6.64 m)

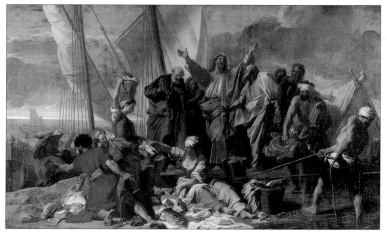

FRENCH PAINTING

Painted for the church of Saint-Martin-des-Champs in Paris, this is a fine example of religious painting in the grand manner.

👁 *To the left is a view of the sculpture and entablature on the north facade of the Louvre, as well as of the (now Protestant) church of the Oratoire.*

PLATE 182.

Hyacinth Rigau
y Ros, known as
Hyacinth Rigaud
(Perpignan, 1659–
Paris, 1743)
*Louis XIV, King of
France,* 1701,
Salon of 1704
Canvas, 109 x 76⅜
in. (277 x 194 cm)

Picturing Louis XIV in his coronation regalia a half-century after the event, this portrait (which long remained at Versailles) was painted for his grandson, who in 1700 became Philip V, king of Spain. Louis XIV is so heavily made up and lavishly costumed that he looks more like a contemporary drag queen than a seventeenth-century monarch.

☛ *Take the stairs to reach rooms 34 and 35.*

PLATE 183.
Joseph Parrocel
(Brignoles, 1646–
Paris, 1704)
*The Army of Louis
XIV Crossing the
Rhine at Tolhuis
(June 12, 1672),*
1699
Canvas, 92⅛ x 64⅝
in. (234 x 164 cm)

This rendering of a very specific battle—as opposed to a generalized military scene—was commissioned for the Château de Marly, where paintings of both types were juxtaposed (see plate 281).

PLATE 184.
Pierre Mignard
(Troyes, 1612–
Paris, 1695)
Self-Portrait, 1690
Canvas, 92½ x 74
in. (235 x 188 cm)

A rival of Le Brun for the patronage of Louis XIV, Mignard conceived this self-portrait as a response to Nicolas de Largillière's impressive portrait of Le Brun (also exhibited nearby).

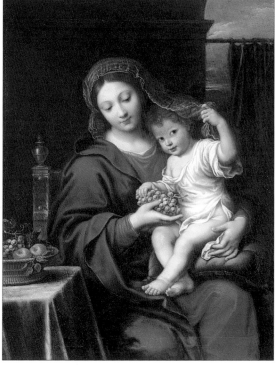

PLATE 185.
Pierre Mignard
(Troyes, 1612–
Paris, 1695)
*Madonna with
Grapes,* c. 1640/50 (?)
Canvas, 47 5⁄8 x 37 in.
(121 x 94 cm)

FRENCH PAINTING

Mignard prided himself on his portraits and on his devotional
paintings—notably his Madonnas, known as *mignardes* (a pun
meaning "delicate things") because of their elegance and grace.

PLATE 186.
Antoine Watteau
(Valenciennes,
1684–Nogent-sur-
Marne, 1721)
*The Pilgrimage to
Cythera*, 1717
Canvas, 50¼ x 76⅜
in. (129 x 194 cm)

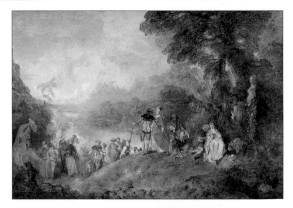

PLATE 187.
Claude Gillot
(Langres, 1673–
Paris, 1722)
*The Scene of the
Carriages*, c. 1707
Canvas, 50 x 63 in.
(127 x 160 cm)

FRENCH PAINTING

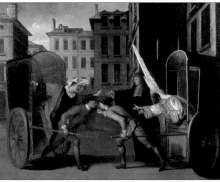

☛ *You can reach
room 36 either by
taking the steps down
from room 35 or by
going directly from
room 33, where four
beautiful landscape
studies from nature by
François Desportes are
on view.*

186. After having sacrificed to Venus, whose statue has been decorated with rose garlands, pairs of lovers leave the Greek island of Cythera. They rise reluctantly to embark in the waiting boat, striking a sequence of poses that suggests their gradual movement from right to left.

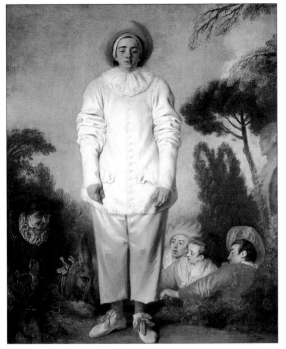

PLATE 188.
Antoine Watteau
(Valenciennes,
1684–Nogent-sur-
Marne, 1721)
Pierrot (previously
known as *Gilles*),
c. 1718–19
Canvas, 72⅜ x 58⅝
in. (184 x 149 cm)

FRENCH PAINTING

The theater in all its forms—from classical tragedy to commedia dell'arte and pantomime—was central to eighteenth-century French culture.

*Room 37 contains
works from the collec-
tion of Dr. Louis La
Caze, who donated
many important
eighteenth-century
French paintings to
the Louvre.*

PLATE 189.
François Boucher

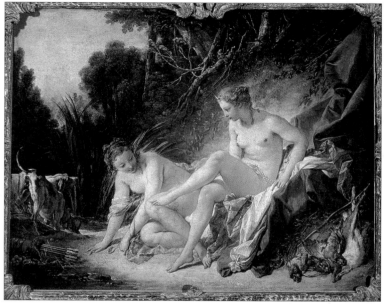

FRENCH PAINTING

(Paris, 1703–
Paris, 1770)
Diana at the Bath,
1742
Canvas, 22 x 28⅝ in.
(56 x 73 cm)

Influenced by the great Venetians as well as by Peter Paul
Rubens and his followers, Boucher, like his contemporary
Giambattista Tiepolo, invented seductive images whose deco-
rative qualities made them well suited to the elegant interiors
of the day.

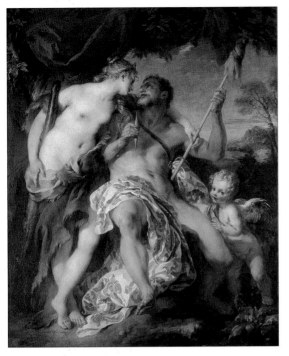

PLATE 190.
François Lemoyne
(Paris, 1688–Paris,
1737)
*Hercules and
Omphale,* 1724
Canvas, 72⅜ x 58⅝
in. (184 x 149 cm)

FRENCH PAINTING

According to Greek mythology, Hercules was sold as a slave to
Omphale, queen of Lydia, and forced to exchange roles with
her, donning women's clothing and spinning wool.

Plate 191.
Jean-Baptiste-
Siméon Chardin
(Paris, 1699–
Paris, 1779)
*The Monkey-
Painter*, c. 1739/40
Canvas, 28⅝ x 23⅜
in. (73 x 59.5 cm)

Plate 192.
Jean-Baptiste-
Siméon Chardin
(Paris, 1699–
Paris, 1779)
The Smoker's Kit,
also known as
Pipes and Tumbler,
c. 1737
Canvas, 12¾ x 16½
in. (32.5 x 42 cm)

FRENCH PAINTING

191. This visual pun was inspired by the notion of the painter as the "ape of nature"—a conceit similarly exploited in earlier works by David Teniers and Antoine Watteau.

192. André Malraux astutely noted in 1951: "Chardin is not an eighteenth-century little master who was more delicate than his rivals; he was, like Corot, a discreetly imperious simplifier. His mute mastery destroyed the baroque Dutch still life, making his contemporaries seem like decorators, and he had no equal in France between the death of Watteau and the Revolution."

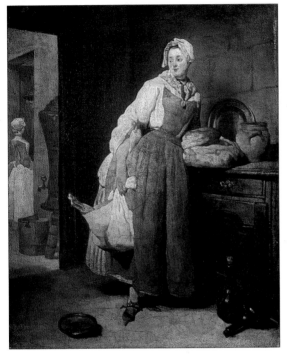

PLATE 193.
Jean-Baptiste-
Siméon Chardin
(Paris, 1699–
Paris, 1779)
*Woman Returning
from the Market,*
1739
Canvas, 18½ x 15 in.
(47 x 38 cm)

👁 *The couloir des
poules (corridor of
hens; room 42)—which
offers beautiful views of
the interior of the
Colonnade—contains
miniatures from the
eighteenth century,
when these tiny formats
were quite popular.
Room 43, which is
devoted to paintings in
the grand manner by
Jean Restout, offers a
fine view of the Cour
Carrée. Rooms 44 and
45 contain pastels.
Room 46, where there
are more paintings by
Boucher, is followed by
room 47, which
contains works that
Denis Diderot wrote
about in his Salons.*

FRENCH PAINTING

Commenting on this work in 1860, Théophile Gautier com-
pared it to that of Pieter de Hooch (see plate 278), while Thoré-
Bürger evoked Jan Vermeer, whose work he himself had just
rediscovered (see plates 276 and 277). Other versions of
Chardin's composition, both dated 1738, are in museums in
Berlin and Ottawa. The taste for paintings of young Dutch
women that had predominated in the eighteenth century
came back into favor during the nineteenth as well.

PLATE 194.
Jean-Baptiste
Greuze

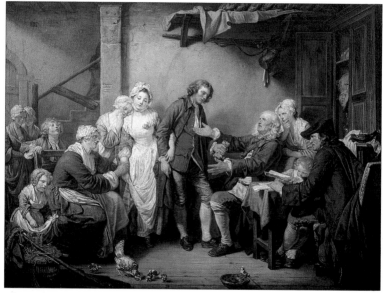

(Tournus, 1725–
Paris, 1805)
The Village Bride,
Salon of 1761
Canvas, 36¼ x 46 in.
(92 x 117 cm)

The Le Nain brothers revitalized genre scenes by treating them like group portraits (see plates 174 and 175); Greuze did so by giving them the grandeur of history painting. After 1770 his genre paintings became more moralizing and austere (see *The Father's Curse* and *The Son Punished,* exhibited nearby). Diderot discussed *The Village Bride* at length in his 1761 *Salon:* "It's a father who has just paid his daughter's dowry. The subject is pathetic and one is overcome with sweet emotion looking at it."

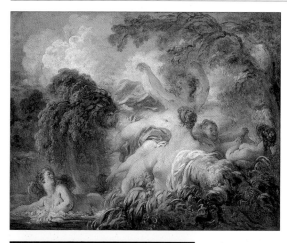

PLATE 195.
Jean-Honoré
Fragonard (Grasse,
1732–Paris, 1806)
Bathers, c. 1763–64
Canvas, 25¼ x 31½
in. (64 x 80 cm)

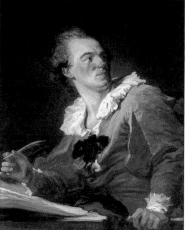

PLATE 196.
Jean-Honoré
Fragonard (Grasse,
1732–Paris, 1806)
*Man Writing
(Inspiration)*,
c. 1769
Canvas, 31½ x 25¼
in. (80 x 64 cm)

FRENCH PAINTING

PLATE 197.
Hubert Robert

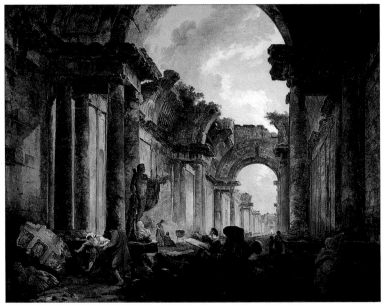

(Paris, 1733–
Paris, 1808)
*Imaginary View of
the Grande Galerie
of the Louvre in
Ruins,* Salon of 1796
Canvas, 45 x 57½ in.
(114.5 x 146 cm)

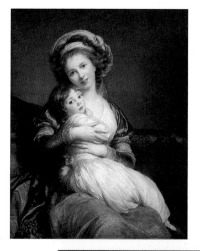

PLATE 198.
Elisabeth-Louise
Vigée-Lebrun
(Paris, 1755–
Paris, 1842)
*Madame Vigée-
Lebrun and Her
Daughter*, 1786,
Salon of 1787
Wood, 41⅜ x 33 in.
(105 x 84 cm).

FRENCH PAINTING

PLATE 199.
Joseph Vernet
(Avignon, 1714–
Paris, 1789)
*Seaport by
Moonlight*, 1771,
Salon of 1773
Canvas, 38⅝ x 64⅝
in. (98 x 164 cm)

198. Official painter to Queen Marie-Antoinette, Vigée-Lebrun (who had to flee France during the Revolution) also produced intimate portraits of many other sitters.

199. One of four overdoors representing the "four times of day," this was painted for the Pavillon de Louveciennes, a retreat on the outskirts of Paris that belonged to the Comtesse du Barry, mistress of Louis XV during his final years.

PLATE 200.
Joseph-Marie Vien
(Montpellier, 1716–
Paris, 1809)
*Young Greek
Women Adorning
a Sleeping Cupid
with Flowers,* 1773
Canvas, 131⅞ x 76⅜
in. (335 x 194 cm)

Executed ten years after Vien's *Seller of Cupids* (Musée National du Château de Fontainebleau), the painting that helped launch the "Greek taste," this work exemplifies the same rather chilly ideal of grace.

PLATE 201.
Baron François
Gérard (Rome,
1770–Paris, 1837)
Cupid and Psyche,
Salon of 1798
Canvas, 73¼ x 52 in.
(186 x 132 cm)

A David student, Gérard here produced a work exemplifying
the Neoclassical "erotic frigidaire" mode that became fashion-
able throughout much of Europe after 1770. Compare the
treatment of the same subject in marble by Canova (plate 415).

PLATE 202.

Marie-Guillaume Benoist (Paris, 1768–Paris, 1826) *Portrait of a Negress,* Salon of 1800 Canvas, 31⅞ x 25⅝ in. (81 x 65 cm)

Trained first by Vigée-Lebrun and then by David, Benoist here produced a work of startling directness.

👁 *In room 55 be sure to take time to look at the lovely studies of clouds and Italian landscapes by Pierre-Henri de Valenciennes.*

PLATE 203.
Pierre Revoil

FRENCH PAINTING

(Lyons, 1776–
Paris, 1842)
*The Convalescence
of Bayard,* Salon
of 1817
Canvas, 53⅛ x 79⅝
in. (135 x 177 cm)

PLATE 204.
Louis-Léopold
Boilly

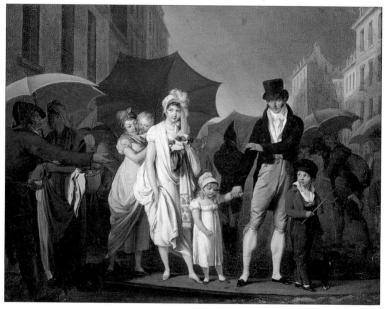

(La Bassée, 1761–
Paris, 1845)
The Downpour,
c. 1805
Canvas, 12¾ x 15⅞ in.
(32.5 x 40.5 cm)

Boilly renewed the northern tradition of genre painting by
becoming a visual chronicler of modern urban life, much as
Honoré de Balzac would soon do, more forcefully, in his fiction.

PLATE 205.
Jean-Auguste-
Dominique Ingres

FRENCH PAINTING

Completed in 1862, when the artist was eighty-two, this painting entered the Louvre in 1911. Installed across from Ingres's equally famous bather, this painting, which he sent from Rome in 1808, marks the peak of the artist's obsession with ideal form, seen here in a scene feverish with fantasy (see also plate 216).

(Montauban,
1780–Paris, 1867)
The Turkish Bath,
1862
Canvas fixed to
wood, diameter:
43⅜ in. (110 cm)

Plate 206.
Théodore
Géricault (Rouen,
1791–Paris, 1824)
*Portrait of a
Compulsive
Gambler,* c. 1822
Canvas, 30⅜ x 25⅜
in. (77 x 64.5 cm)

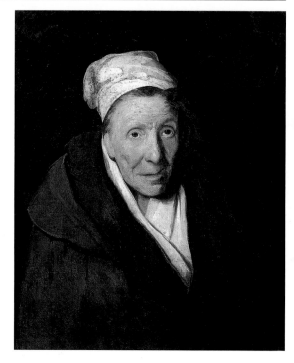

This is one of five portraits of mentally ill subjects painted by
Géricault at the same time that Dr. Philippe Pinel was laying
the foundations of modern psychiatry.

PLATE 207.
Jean-Baptiste-
Camille Corot
(Paris, 1796–
Paris, 1875)
*"Souvenir" of
Mortefontaine,*
Salon of 1864
Canvas, 25⅝ x 35 in.
(65 x 89 cm)

PLATE 208.
Jean-Baptiste-
Camille Corot
(Paris, 1796–
Paris, 1875)
Lady in Blue, 1874
Canvas, 31½ x 19⅞
in. (80 x 50.5 cm)

FRENCH PAINTING

In 1906 Etienne Moreau-Nélaton—painter, ceramist, and art historian—donated a hundred pictures to the Louvre, a group that constitutes a summary of nineteenth-century French painting. The works by Edouard Manet and the Impressionists that he obliged the authorities to accept as part of his gift are now in the Musée d'Orsay. Rooms 69–73 contain works by artists of the Barbizon school and Corot (Moreau-Nélaton published an imposing monograph on this artist), small paintings by Delacroix and Alexandre Decamps, and an oil sketch for *The Raft of the Medusa* (plate 217).

☞ The French painting section ends on the first floor in the two red-walled rooms on either side of the Salon Denon (room 76). Take the Victory of Samothrace stair to the landing with The Winged Victory, which leads to room 75.

PLATE 209.
Jacques-Louis
David

FRENCH PAINTING

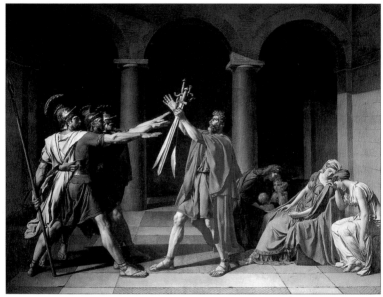

(Paris, 1748–
Brussels, 1825)
*The Oath of the
Horatii,* Salon of
1785
Canvas, 10 ft. 10 in.
x 13 ft. 11½ in.
(3.3 x 4.25 m)

This painting was, in essence, the manifesto of Neoclassicism, painted in Rome. According to Livy's *Roman History,* the three Horatii brothers, selected as Rome's champions in a fight to the death with champions of the enemy, Alba, swore to win or die. Behind the central figure of the father lifting the three swords sit their sisters, distraught because one of them was engaged to one of the opponents. The three simple arches in the background isolate the three groups and, by implication, three successive moments in the story.

PLATE 210.
Jacques-Louis
David

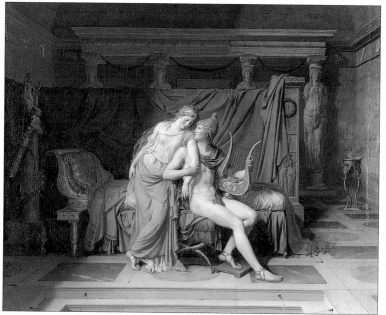

FRENCH PAINTING

Paris, the prince of Troy to whom Venus had promised the world's most beautiful woman, abducted the married Helen, thereby provoking the Trojan War. Rather than depicting the abduction itself (which was painted by Guido Reni; see plate 341), David preferred this scene of intimate ardor, which gave him the opportunity to delineate an ancient interior.

(Paris, 1748–
Brussels, 1825)
*The Loves of Paris
and Helen,* Salon of
1789
Canvas, $57\frac{1}{2}$ x $71\frac{1}{8}$
in. (146 x 181 cm)

PLATE 211.
Jacques-Louis
David

FRENCH PAINTING

(Paris, 1748–
Brussels, 1825)
*The Coronation
of Napoleon
(December 2,
1804)*, 1806–7
Canvas, 20 ft. 4½ in.
x 30 ft. 1 in. (6.21 x
9.79 m)

In this ambitious history painting, which the artist Théodore
Géricault pronounced "as beautiful as a Rubens," David vied
with that great Flemish artist's *Coronation of Marie de Médicis*
(second floor, room 18).

PLATE 212.
Antoine-Jean Gros

French Painting

This illustration of a Napoleonic legend takes considerable liberties with historical fact. It shows the general during his Egyptian campaign of 1799, visiting French soldiers suffering from the plague, as if he were fulfilling the ancient belief that a king's touch could miraculously heal the sick and dying.

(Paris, 1771–
Meudon, 1835)
*Napoleon in the
Pesthouse at Jaffa*,
1804
Canvas, 17 ft. 1⅛ in.
x 23 ft. 5½ in.
(5.23 x 7.15 m)

PLATE 213.
Jacques-Louis
David (Paris,
1748–Brussels, 1825)
Madame Récamier,
1800
Canvas, 68½ x 96 in.
(174 x 244 cm)

PLATE 214.
Pierre-Paul
Prud'hon (Cluny,
1758–Paris, 1823)
*Empress Josephine
in the Park at
Malmaison,* 1805
Canvas, 96⅛ x 70½
in. (244 x 179 cm)

FRENCH PAINTING

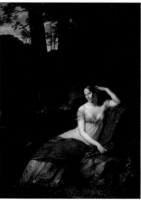

213. "In love with friendship," Madame Récamier presided over a famous salon frequented by such literary luminaries as Benjamin Constant, Madame de Staël, and Chateaubriand.

214. A modern Mona Lisa painted full-length in a park, this painting uses a portrait formula made fashionable by English artists such as Joshua Reynolds and Thomas Gainsborough.

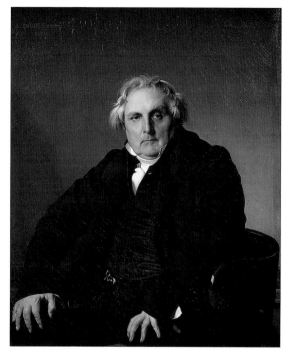

PLATE 215.
Jean-Auguste-
Dominique Ingres
(Montauban, 1780–
Paris, 1867)
*Louis-François
Bertin,* 1832
Canvas, 45⅝ x 37⅜
in. (116 x 95 cm)

FRENCH PAINTING

Completed within a month of Ingres's having finally settled on a satisfactory pose (one he had seen Bertin adopt in the course of conversation), this work exemplifies "true portraiture" as defined by Charles Baudelaire: "the ideal re-creation of an individual." The sitter was coeditor of the *Journal des débats,* one of the most prestigious periodicals of the nineteenth century.

PLATE 216.

Jean-Auguste-
Dominique Ingres
(Montauban,
1780–Paris, 1867)
Grande Odalisque,
Salon of 1819
Canvas, 35¾ x 63¾
in. (91 x 162 cm)

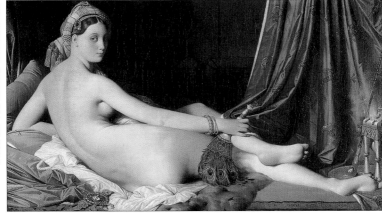

This is an Orientalist variation on the classical theme of the
reclining nude, pervasive in Western art from the ancient
Sleeping Ariadne (Vatican Museum) to Edouard Manet's
Olympia (Musée d'Orsay, Paris) and Tom Wesselmann's Great
American Nude series.

PLATE 217.
Théodore
Géricault

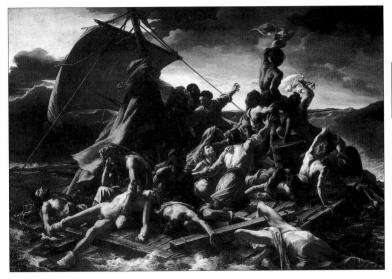

FRENCH PAINTING

Géricault based this work on a shocking tragedy of 1816, the shipwreck off the African coast of the French naval frigate *Medusa,* ineptly commanded by inexperienced émigrés newly commissioned as officers after the fall of Napoleon. Most of the crew died immediately; a passing ship rescued fifteen survivors from a raft on which they had been stranded for fifteen days, kept alive by cannibalism. Géricault's treatment of what Delacroix called that "sublime raft" elevated this news story to the realm of myth.

(Rouen, 1791–
Paris, 1824)
*The Raft of the
Medusa,* Salon
of 1819
Canvas, 16 ft. 1⅜ in.
x 23 ft. 5⅞ in.
(4.91 x 7.16 m)

Plate 218.

Eugène Delacroix
(Charenton-Saint-
Maurice, 1798–
Paris, 1863)
*The Massacre at
Chios*, Salon of 1824
Canvas, 13 ft. 9 in. x
11 ft. 7⅜ in.
(4.19 x 3.54 m)

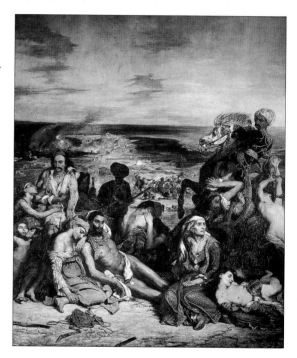

From Lord Byron (who perished at Missolonghi) to
Chateaubriand and Victor Hugo, Europeans embraced the
cause of Greek independence after the 1821 revolt against
Turkish rule. Like *Guernica* (Museo del Prado, Madrid) by Pablo
Picasso, who was aware of such precedents, Delacroix's paint-
ing is a powerful condemnation of needless human suffering.

PLATE 219.
Eugène Delacroix

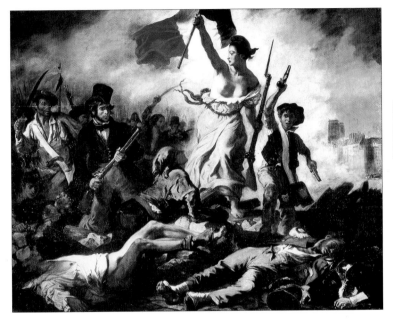

FRENCH PAINTING

This monumental work commemorates the July Revolution of 1830, which overthrew King Charles X and installed Louis-Philippe as constitutional monarch. Mixing pictorial modes (as Rubens did in his Marie de Médicis cycle; see plate 245) Delacroix introduced an allegorical figure of Liberty into a realistic street scene populated by familiar contemporary types: a bourgeois student (wearing a top hat), a worker (wielding a sword), and a street urchin (brandishing two guns).

(Charenton-Saint-Maurice, 1798–Paris, 1863)
Liberty Leading the People (July 28, 1830), 1830
Canvas, 8 ft. 6⅜ in. x 10 ft. 8 in.
(2.6 x 3.25 m)

PLATE 220.
Eugène Delacroix

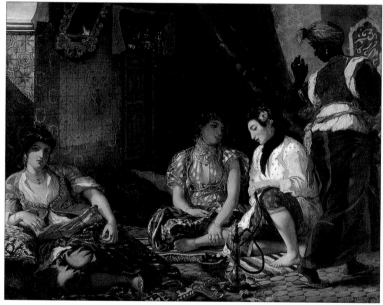

FRENCH PAINTING

(Charenton-Saint-
Maurice, 1798–
Paris, 1863)
*Women of Algiers
in Their
Apartment,*
Salon of 1834
Canvas, 70⅞ x 90¼
in. (180 x 229 cm)

French troops captured Algiers in 1830 and then proceeded to occupy more and more of Algeria. This colonialist reality only intensified the Orientalist dream shared by the entire Romantic generation, from writers Victor Hugo and Gustave Flaubert to artists Alexandre Decamps and Théodore Chassériau.

Delacroix set out for Morocco in 1832. He was to base many of his subsequent works on the voluminous notes and drawings he made during his sojourn there (see plate 476)— records of startling freshness and immediacy.

PLATE 221.
Théodore
Chassériau
(Sainte-Barbe de
Samana, 1819–
Paris, 1856)
Two Sisters, 1843
Canvas, 70⅞ x 53⅛
in. (180 x 135 cm)

Northern European Painting

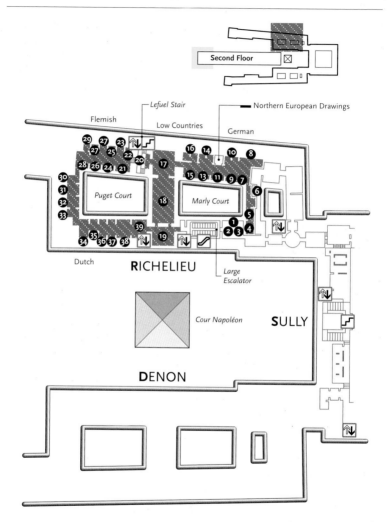

Second Floor

Lefuel Stair

Northern European Drawings

Flemish

Low Countries

German

Puget Court

Marly Court

RICHELIEU

Large Escalator

Dutch

Cour Napoléon

SULLY

DENON

Access and Tour

From the Hall of the Pyramid, take the Richelieu entry then go up either the elevators or the large escalator, both of which provide direct access to the northern European painting galleries on the second floor of the Richelieu wing. Paintings from the old Low Countries and Germany of the fifteenth and sixteenth centuries plus those from the seventeenth-century Low Countries—Belgium (southern Low Countries) and Holland (northern Low Countries)—are exhibited in a series of thirty-nine galleries that circle the Puget and Marly Courts.

The first three galleries (rooms 1–3) contain both French and Flemish works—they are intermingled because Flanders once belonged to the duchy of Burgundy and thus was part of the kingdom of France. Next come the fifteenth-century early Netherlandish paintings (rooms 3–6), German paintings of the fifteenth and sixteenth centuries (rooms 7–8), and paintings from the Low Countries of the sixteenth and early seventeenth centuries (rooms 9–17). From room 17, turn left to visit the Marie de Médicis cycle by Peter Paul Rubens, exhibited in a long gallery between the two courts (room 18), and to see the group of large Flemish paintings in the Richelieu pavilion (room 19). After retracing your steps back to room 17, go straight ahead past the Lefuel stair, with its charming bird and animal paintings by Pieter Bol (room 20), and you will reach the galleries containing the balance of the seventeenth-century paintings. Because of the historical division of the provinces into the northern and southern Low Countries, caused by the seventeenth-century wars of religion, the installation splits into Flemish painting (rooms 21–26) and Dutch painting (rooms 27–39).

New galleries in the Rohan wing (to be reached from room 29) will eventually contain northern European paintings of the eighteenth and early nineteenth centuries, a few of which are now on temporary view in room 70, adjacent to the French painting galleries; for the moment, English paintings can be seen in the Salon Denon (room 76) on the first floor of the Denon wing.

NORTHERN
EUROPEAN
PAINTING

Frontispiece:
Barent Fabritius,
Young Painter
(detail; see
plate 266)

History of the Collection

Painting by the schools of northern Europe is well represented at the Louvre, which boasts more than twelve hundred paintings from the region, making this collection slightly larger than that of Italian paintings. From the fourteenth to the sixteenth century, Flanders was a major economic power with a refined artistic culture that was in constant exchange with that of Italy. Its elites long favored works with a pronounced Italian flavor, although these were often enlivened by northern influence (plate 303). They had little interest in work by native artists of the kind known, misleadingly, since the nineteenth century as "Flemish primitives."

Like other European monarchs, Marie de Médicis commissioned work from Peter Paul Rubens, whose cycle for the Luxembourg gallery entered the museum after the Revolution (room 18; plate 245). French collectors of the period also appreciated Flemish masters both "large" and "small"—for example, Paul Bril (plate 243; nine of the Louvre's twelve paintings by him were in the collection of Louis XIV), Jacob Jordaens, and Anthony van Dyck (plate 252). In 1664–65 the painter Charles Errard was dispatched to the Low Countries "to see and acquire figures, busts, and paintings that he deems worthy of His Majesty's cabinets." In 1683 Louis XIV owned only one painting attributed at the time to Jan van Eyck, who was regarded as the inventor of painting (*Wedding at Cana*, now attributed to Gerard David). The collection of the banker Everhard Jabach, a native of Cologne, entered the royal collection in 1671, netting it five portraits by Hans Holbein (plates 232–33), as well as other works then attributed to him, plus *Cardinal Granvella's Dwarf* by Anthonis Mor (plate 239) and *The Battle of Issus* by Jan Brueghel (plate 244).

By the end of Louis XIV's reign, the rivalry between the Poussinists, partisans of drawing, and the Rubenists, partisans of color, had ended with the victory of the latter, and this shift in taste manifested itself in the royal collection. In an inventory drawn up in 1709–10, 179 of the 1,478 entries are

for northern paintings, including Rubens's *Flemish Kermesse* (plate 249). Under Louis XVI the taste for Dutch painting of the "golden age" increased considerably, a development that affected royal acquisition policy. Charles d'Angiviller enriched the collections with Rembrandt's *Supper at Emmaus* (plate 261) and Jacob van Ruisdael's *Ray of Sunlight* (plate 279), as well as with works by the Italianizing landscape painters, genre painters, and flower painters.

Only after the Revolution, which enriched the Muséum Central des Arts with paintings confiscated from the Church, did the collection acquire older works such as van Eyck's *Madonna of Chancellor Rolin* (plate 222) and the *Pietà* by the Master of Saint-Germain-des-Prés (fig. 4). In the nineteenth century, Romanticism and historicism broadened the horizons of taste, a development strikingly evidenced by such donations to the museum as the Campana collection (1863), with its *Famous Men* from the *studiolo* in the Palazzo Ducale in Urbino (room 6), and the extraordinary donation of Dr. Louis La Caze in 1869. Of the 269 paintings from this group still in the Louvre, 100 are northern, including *The Gypsy Girl* by Frans Hals (plate 258) and *Bathsheba with King David's Letter* by Rembrandt (plate 264).

Increasingly focused on filling in gaps in the northern holdings, the museum has made many impressive acquisitions in this century, notably several "primitive" works by Hans Memling (room 5): two wings from a triptych, *Saint John the Baptist* and *The Magdalen* (acquired 1851; room 5); *Portrait of an Old Woman* (acquired 1908; plate 226); and the superb *Angel with an Olive Branch* (acquired 1993; plate 225). Other additions filling notable gaps: a Dürer *Self-Portrait* (acquired 1922; plate 230); Vermeer's *Lacemaker* (acquired 1870; plate 276), joined in 1983 by the same artist's *Astronomer* (plate 277); *Tree with Crows* by Caspar David Friedrich (acquired 1975; plate 282); and *Young Painter in His Studio* by Barent Fabritius (frontispiece and plate 266), acquired for the opening of the new galleries in 1993.

PLATE 222.
Jan van Eyck
(Maaseyck 1390/
1400–Bruges, 1441)
*The Madonna of
Chancellor Rolin,*
c. 1434
Wood, 26 x 24⅜ in.
(66 x 62 cm)

NORTHERN EUROPEAN PAINTING

Nicolas Rolin was chancellor to Philippe le Bon, duke of
Burgundy, whom van Eyck served for sixteen years. In 1800
the *Madonna* came to the museum from Rolin's family chapel
in the cathedral of Autun, France.

 The donor is shown praying in front of the Virgin and the
infant Jesus, who blesses him. There is a suggestion that the
sacred figures have emerged from a devotional image that the
donor had been contemplating. The background consists of
an urban landscape bathed in morning light; although imagi-
nary, it is rendered with meticulous precision.

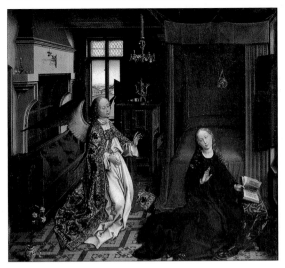

PLATE 223.
Rogier van der
Weyden (Tournai,
1399/1400–
Brussels, 1464)
The Annunciation,
c. 1435
Wood, 33⅞ x 36⅝ in.
(86 x 93 cm)

NORTHERN EUROPEAN PAINTING

Van der Weyden (who around 1450 painted the large *Last Judgment* polyptych for the hospice in Beaune founded by Chancellor Rolin) followed in the footsteps of Jan van Eyck and Robert Campin (the Master of Flémalle). Those artists had originated a new style that broke with the prevailing International Gothic; their innovative work features unified spatial constructions and meticulous detailing rendered in layers of transparent glazes that create the illusion of life.

PLATE 224.
Geertgen tot Sint
Jans (Leiden?-
Haarlem?, active
1460–95)
*The Resurrection of
Lazarus*, c. 1475
Wood, 50 x 38¼ in.
(127 x 97 cm)

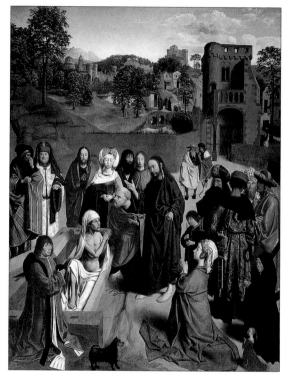

Trained in Haarlem, where he was active, the painter lived in
the convent of the Knights of Saint John.

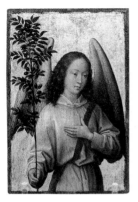

PLATE 225.
Hans Memling
(Seligenstadt am
Main, c. 1435–
Bruges, 1494)
*Angel with an Olive
Branch*, c. 1475–80
Wood, 6⅜ x 4⅜ in.
(16 x 11 cm)

PLATE 226.
Hans Memling
(Seligenstadt am
Main, c. 1435–
Bruges, 1494)
*Portrait of an Old
Woman*, c. 1475
Wood, 13¼ x 11⅜ in.
(35 x 29 cm)

225. This wing fragment comes from a small devotional triptych that belonged to Margaret of Austria. The center panel represented Christ as the Man of Sorrows, flanked on the wings by two angels—this one, bearing an olive branch, and the other a sword.

226. A follower of van Eyck and van der Weyden, Memling continued to use the three-quarter portrait formula favored by them. This fragment was originally part of a portrait of a married couple (the husband is in the Gemäldegalerie, Berlin).

PLATE 227.
Hieronymus
Bosch
(Hertogenbosch, c.
1450–Hertogenbosch,
1516)
The Ship of Fools,
c. 1500 (?)
Wood, 22¾ x 12⅝ in.
(58 x 32 cm)

On a ship that symbolizes life, a monk, a nun, and a group of revelers share a mock banquet, trying to take bites out of a cake hanging by a string. Another figure tries to cut down a chicken from the mast, which has been turned into a greased pole.

The image of a ship of fools, inspired by Flemish carnivals, was also used by several poets contemporary with Bosch: "We wander in search of ports and shores, but we never touch land. Our trips are endless."

PLATE 228.
Master of the Saint
Bartholomew
Altarpiece (active
Cologne, c. 1480–
1510)
*Descent from the
Cross,* c. 1501–5
Wood, 89⅝ (center)
and 60 (sides) x
82⅝ in. (227.5 and
152.5 x 210 cm)

NORTHERN EUROPEAN PAINTING

Also in room 7 is a *Pietà* painted by a Cologne-born artist,
active in Paris around 1500. It is set against a view of Paris
incorporating recognizable depictions of the abbey of Saint-
Germain-des-Prés (foreground), the abbey of Montmartre
(background), and the Louvre (center; see detail, fig. 4).

PLATE 229.
Hans Sebald
Beham
(Nuremberg, 1500–
Frankfurt, 1550)
*Painted Table: The
Story of David*
(detail), 1534
Wood, 11 x 51⅝ in.
(28 x 131 cm)

Although painted marriage chests, or *cassone*, were common
in Italy, few painted tables have survived. One painted by Hans
Holbein, conceived along different lines, is now in the
Kunstmuseum, Zurich. This one was acquired by Louis XIV
from the heirs of Cardinal Mazarin.

PLATE 230.
Albrecht Dürer
(Nuremberg, 1471–
Nuremberg, 1528)
Self-Portrait, 1493
Parchment fixed to
canvas, 22 x 17⅜ in.
(56 x 44 cm)

NORTHERN EUROPEAN PAINTING

The thistle held by the young Dürer could symbolize either his fidelity to his fiancée, whom he married in Nuremberg in 1494, or his religious faith, emphasized in the inscription: "My affairs will go as ordained on high."

PLATE 231.
Lucas Cranach
(Cranach, 1472–
Weimar, 1553)
*Venus Standing in
a Landscape,* 1529
Wood, 15 x 9¾ in.
(38 x 25 cm)

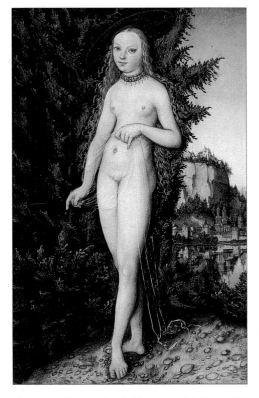

NORTHERN EUROPEAN PAINTING

The tone of this work is half erotic and half moralizing, with
Venus portrayed as a new Eve. The Mannerist style of Cranach,
court painter to Frederick the Wise in Wittenberg, retains a
Gothic flavor.

PLATE 232.
Hans Holbein
the Younger
(Augsburg, 1497/
98–London, 1543)
Erasmus, 1523
Wood, 16½ x 12⅝ in.
(42 x 32 cm)

PLATE 233.
Hans Holbein
the Younger
(Augsburg, 1497/
98–London, 1543)
Nicholas Kratzer,
1528
Wood, 32⅝ x 26⅛ in.
(83 x 67 cm)

NORTHERN EUROPEAN PAINTING

232. A close friend of Erasmus, Holbein painted numerous portraits of the Dutch humanist, who was famous throughout Europe. Here Holbein shows him writing his commentary on the Gospel of Saint Mark.

233. Kratzer, a mathematician and astronomer born in Munich, became a professor at Oxford and was put in charge of Henry VIII's clocks. This portrait, painted during Kratzer's first visit to the English court, shows him surrounded by his scientific instruments and working on a sundial.

PLATE 234.
Joachim Patinir
(Dinant, c. 1480–
Antwerp, 1424)
*Saint Jerome in the
Desert*
Wood, 30⅝ x 53⅞ in.
(78 x 137 cm)

NORTHERN EUROPEAN PAINTING

Common in fifteenth-century Italian art, the subject of Saint
Jerome in the desert was subsequently taken up by northern
painters. Patinir, who was called a "landscape painter" by
Dürer in the earliest known use of that term, here placed the
saint in an imaginary landscape. At one time this work
belonged to the French Symbolist writer Joris-Karl Huysmans.

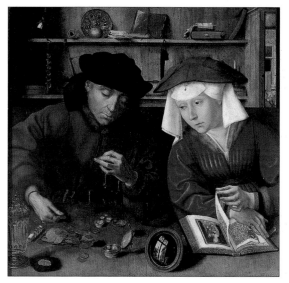

PLATE 235.
Quentin Massys
(Louvain, 1465/66–
Antwerp, 1530)
*The Moneylender
and His Wife,* 1514
Wood, 27⅝ x 26⅜ in.
(70 x 67 cm)

The convex mirror in the foreground reflects another part of
the room, revealing a man looking out a window: this image
within an image offers a view of space outside the frame. By
including such mirror-eyes in their compositions, Flemish
artists added a new twist to the Italian Renaissance conceit of
the painting as a window onto the world; see also *The Arnolfini
Portrait* by van Eyck (1434; National Gallery, London) and *Saint
Eloi, Patron Saint of Goldsmiths* by Petrus Christus (1449;
Metropolitan Museum of Art, New York).

PLATE 236.

Jan Gossaert,
known as Mabuse

NORTHERN EUROPEAN PAINTING

(Maubeuge?, c. 1478–
Middleburg, 1532)
Carondelet Diptych
(left: *Jean Carondelet*;
right: *Virgin and
Child*), 1517
Wood, each panel
16⅝ x 10⅝ in.
(42.5 x 27 cm)

A small devotional diptych consisting of a portrait of Jean
Carondelet (a friend of Erasmus) and a depiction of the Virgin
and Child, this could be considered a portable variant of van
Eyck's *Madonna of Chancellor Rolin* (plate 222). On the backs
of the panels are painted an image of a skull (a vanitas symbol
often included in still lifes), and the coat of arms of the patron,
who was an adviser to Charles V.

PLATE 237.
Pieter Brueghel
the Elder

NORTHERN EUROPEAN PAINTING

There is probably no need to search for political or religious allegory in this work, since cripples, madmen, musicians, and beggars often figure in Flemish paintings and prints. Here the members of one such group don foxtails and self-mocking comic headgear—paper miters, a cardboard tower—in hopes of inspiring pity and alms. Arrayed on a diagonal across the visual field, they make a wonderfully derelict band of outcasts.

(Brueghel? c. 1525–
Brussels, 1569)
The Beggars, 1568
Wood, 7⅛ x 8½ in.
(18 x 21.5 cm)

PLATE 238.

Jan Massys

(Antwerp, c. 1509–
Antwerp, c. 1575)
*David and
Bathsheba,* 1562
Wood, 63¾ x 77⅝
in. (162 x 197 cm)

Jan Massys was the son of Quentin Massys (see plate 235). For
Rembrandt's treatment of a related scene from the story of
David, see plate 264.

NORTHERN EUROPEAN PAINTING

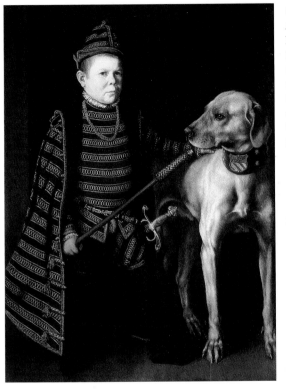

PLATE 239.
Anthonis Mor, also
known as Antonio
Moro (Utrecht,
1519–Antwerp, 1575)
*Cardinal
Granvella's Dwarf,*
c. 1560
Wood, 49⅝ x 36¼
in. (126 x 92 cm)

NORTHERN EUROPEAN PAINTING

After becoming a master painter in Antwerp in 1547, Mor
entered the service of Cardinal Granvella, whose arms are visible
on the dog's collar. Introduced by the cardinal to the court of
Philip II of Spain, Mor soon came to be regarded as one of the
greatest of European portraitists. His fame is now in relative
eclipse, but it still shone brightly in the seventeenth century.

PLATE 240.
Joachim Wtewael
(Utrecht, 1566–
Utrecht, 1638)
*Perseus and
Andromeda*, 1611
Canvas, 70⅞ x 59⅛
in. (180 x 150 cm)

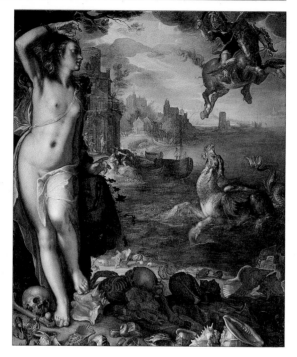



NORTHERN EUROPEAN PAINTING

The subject, inspired by Ovid's *Metamorphoses*, was also
treated by the French painter Pierre Mignard (room 34). Here
Perseus, astride the winged horse Pegasus and brandishing
the head of Medusa, whom he has vanquished, attacks a sea
monster about to devour Andromeda. Wtewael juxtaposed the
large nude figure of Andromeda, still quite Mannerist in pose
and proportions, with a fantastic landscape and, in the fore-
ground, a spectacular still life of seashells.

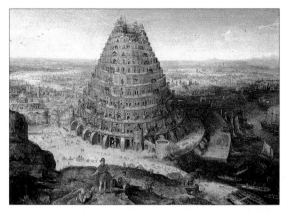

PLATE 241.
Lucas van
Valckenborch
(Louvain? before
1535–Frankfurt-am-
Main, 1597)
The Tower of Babel,
1594
Wood, 16⅛ x 22¼ in.
(41 x 56.5 cm)

PLATE 242.
Louis de Caulery
(Caulery, near
Cambrai?, c. 1580–
Antwerp, 1621/22)
*The Colossus of
Rhodes*
Wood, 14 x 18⅜ in.
(35.5 x 46.5 cm)

NORTHERN EUROPEAN PAINTING

241. This is a variation of a masterpiece by Pieter Brueghel, now
in the Kunsthistorisches Museum, Vienna, dating from 1565.

242. The Colossus, the lighthouse that marked the entrance to
the port of Rhodes, was one of the seven wonders of the world.

PLATE 243.
Paul Bril

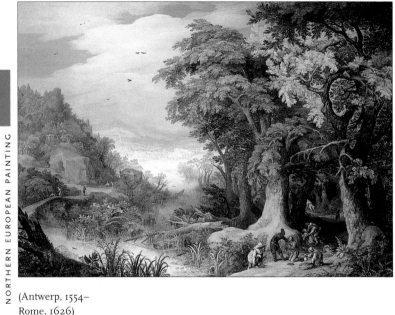

(Antwerp, 1554–
Rome, 1626)
*Armed Attack
in a Forest*
Canvas, 45¼ x 57⅞
in. (115 x 147 cm)

PLATE 244.
Jan Brueghel, also
known as the Velvet
Brueghel (Brussels,
1568–Antwerp, 1625)
The Battle of Issus,
1602
Wood, 33⅞ x 53⅛ in.
(86 x 135 cm)

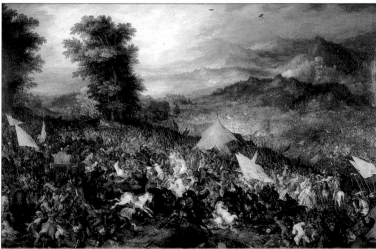

NORTHERN EUROPEAN PAINTING

In 333 B.C. a decisive battle was fought on the Issus plain in
Cilicia, between the Greek army of Alexander the Great and
the Persian army of Darius III.

Jan Brueghel's gifts as a miniaturist are apparent in this
detailed depiction of swarming figures.

👁 *From room 17 there
is a view north to the
Palais-Royal and Sacré-
Coeur; to the south is
the entrance to room
18, the gallery with
Rubens's great Marie
de Médicis cycle.*

PLATE 245.
Peter Paul Rubens
(Siegen, 1577–
Antwerp, 1640)
*The Presentation of
the Portrait of
Marie de Médicis to
Henri IV,* c. 1622–24
Canvas, 12 ft. 9⅛ in.
x 8 ft. (3.94 x 2.45 m)

*☛ At the far end of
this gallery is room 19,
which contains large
paintings by Flemish
students and collab-
orators of Rubens.*

The twenty-four paintings in the cycle to which this canvas belongs were commissioned by Marie de Médicis, mother of Louis XIII, for her Luxembourg palace in Paris. The cycle illustrates "the story of the very famous life and heroic gestures of the said lady," from her birth to her reconciliation with her son (who had conducted an anti-Spain policy, counter to her wishes). A master of visual rhetoric on an epic scale, Rubens here incorporated mythological and allegorical figures into scenes of contemporary history, the last of which depicts events that were scorchingly current when the paintings were made.

PLATE 246.
Jacob Jordaens
(Antwerp, 1593–
Antwerp, 1678)
*The Four Evangelists
(Jesus among the
Doctors?)*, c. 1625
Canvas, 52¾ x 46½
in. (134 x 118 cm)

NORTHERN EUROPEAN PAINTING

This painting was acquired by Louis XVI with the title *The Four Evangelists*. However, judging from the prominence given to the adolescent with a prayer shawl over his shoulders and to the man who seems to be taking notes, this might instead be a depiction of the young Christ explaining scripture to the doctors in the Temple.

👁 *Room 19 offers a
beautiful view of the
Cour Napoléon and
the glass pyramid.*

Plate 247.

Jacob Jordaens

(Antwerp, 1593–
Antwerp, 1678)
*Christ Driving
Traders from the
Temple*, c. 1640
Canvas, 9 ft. 5⅜ in.
x 14 ft. 3⅝ in.
(2.88 x 4.36 m)

The painter Charles-Joseph Natoire acquired this canvas for
Louis XIV.

PLATE 248.
Workshop of
Frans Snyders
(Antwerp, 1579–
Antwerp, 1657)
*Fish Sellers in
Their Stall*
Canvas, 82⅝ x 134⅝
in. (210 x 342 cm)

This is a replica of a painting by Snyders in the Hermitage,
Saint Petersburg.

NORTHERN EUROPEAN PAINTING

☞ Cross the Lefuel
stair, with its monu-
mental still lifes, or exit
by taking the escalator
adjacent to room 19.

PLATE 249.
Peter Paul Rubens
(Siegen, 1577–
Antwerp, 1640)
*The Flemish
Kermesse*, c. 1635–38
Wood, 58⅝ x 102¾
in. (149 x 261 cm)

Louis XIV's acquisition of this painting in 1685 reinforced
Rubens's fame throughout Europe and indicated the continu-
ing taste for Flemish depictions of peasant revels like those by
Pieter Brueghel.

PLATE 250.
Peter Paul Rubens
(Siegen, 1577–
Antwerp, 1640)
*Helena Fourment
Leaving "Her"
House*, c. 1639
Wood, 76¾ x 52 in.
(195 x 132 cm)

NORTHERN EUROPEAN PAINTING

Rubens's second wife and their seven-year-old son stand on
the threshold of the sumptuous residence the painter built for
himself in Antwerp.

PLATE 251.
David III
Ryckhaert
(Antwerp, 1612–
Antwerp, 1661)
*Painters in a
Studio*, 1638
Wood, 23¼ x 37⅜ in.
(59 x 95 cm)

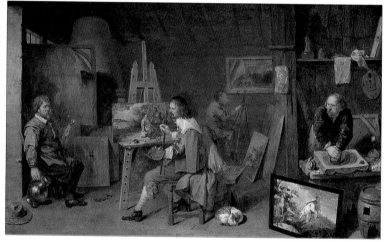

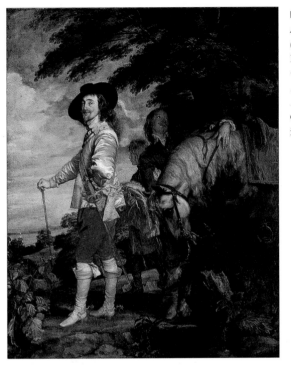

PLATE 252.
Anthony van Dyck
(Antwerp, 1599–
Blackfriars, 1641)
*Charles I, King of
England, at the
Hunt,* c. 1635
Canvas, 104⅝ x 81½
in. (266 x 207 cm)

Although van Dyck painted many history paintings, he owed his European fame primarily to his aristocratic portraits, which reconcile elegance with a subtle intimacy. This painting probably did much to encourage the English fashion for full-length portraits in landscape settings (see plates 284 and 286).

PLATE 253.
David Teniers the
Younger (Antwerp,
1610–Brussels, 1690)
*Tavern Interior:
Game of Cards,*
1645
Canvas, 22⅝ x 30½
in. (57.5 x 77.5 cm)

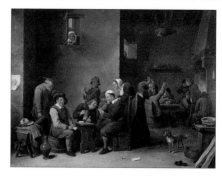

PLATE 254.
Ambrosius
Bosschaert the
Elder (Antwerp,
1573–The Hague,
1621)
*Bouquet of Flowers
in an Arched
Window
Overlooking a
Landscape,* c. 1620
Copper, 9 x 6⅜ in.
(23 x 17 cm)

NORTHERN EUROPEAN PAINTING

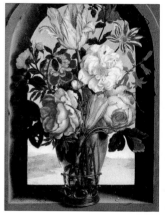

253. It is interesting to compare this genre scene with the analogous one by the Le Nain brothers (plate 174). Teniers emphasized the postures, while the Le Nain brothers were more attentive to the individual facial expressions.

254. Flemish depictions of bouquets mixing flowers from different seasons probably carried religious meaning inspired by Christ's parable of the lilies in the field; they were intended as reminders of the fragility of human life and as spurs to confidence in divine providence.

Plate 255.
Cornelis van
Poelenburch

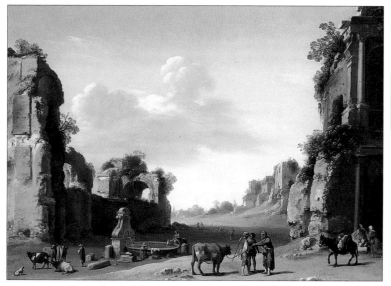

Enraptured by Italy, like Paul Bril before him, Poelenburch was the finest of the Italianizing Flemish landscape painters.

(Utrecht, 1586–
Utrecht, 1667)
*Fantastic View of
the Campo Vaccino
in Rome with an
Ass,* 1620
Copper, 15⅝ x 21½
in. (40 x 54.5 cm)

NORTHERN EUROPEAN PAINTING

PLATE 256.
Hendrick Ter
Brugghen
(Deventer, 1588–
Utrecht, 1629)
The Duet, 1628
Canvas, 41⅜ x 32¼ in.
(106 x 82 cm)

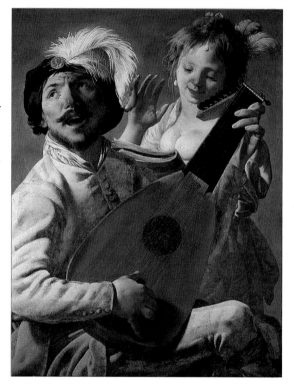

256. Like *The Concert* and *The Guitar Player* by Gerrit Honthorst also in room 28, this *Duet* belongs to the branch of the Caravaggist movement that favored a light palette.

257 and **258.** In these two "genre portraits" by Hals, the pose and features are individualized without being overly specific or emphatic.

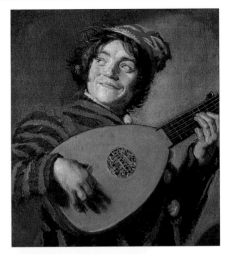

PLATE 257.
Frans Hals
(Antwerp, c. 1581/85–
Haarlem, 1666)
Jester with a Lute,
c. 1626
Wood, 27⅜ x 24⅜ in.
(70 x 62 cm)

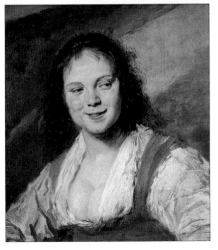

PLATE 258.
Frans Hals
(Antwerp, 1581/85–
Haarlem, 1666)
The Gypsy Girl,
c. 1628–30
Wood, 22¾ x 20½ in.
(58 x 52 cm)

NORTHERN EUROPEAN PAINTING

PLATE 259.
Pieter Jansz
Saenredam
(Assendelft, 1597–
Haarlem, 1665)
*Interior of the
Church of Saint
Bavo in Haarlem,*
1630
Canvas, 16⅛ x 14⅝ in.
(41 x 37 cm)

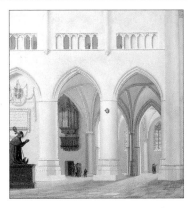

PLATE 260.
Willem Claesz
Heda (Haarlem,
1594–Haarlem, 1680)
Dessert, 1637
Wood, 17⅜ x 21⅝ in.
(44 x 55 cm)

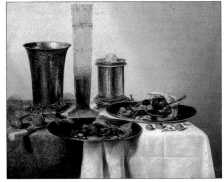

259. This large Gothic church in Haarlem is still standing. Saenredam, known as the "master of white churches," embroidered reality by adding the large tomb at left, for purely artistic reasons.

260. Heda's still life exemplifies the monochromatic vein in Dutch painting.

NORTHERN EUROPEAN PAINTING

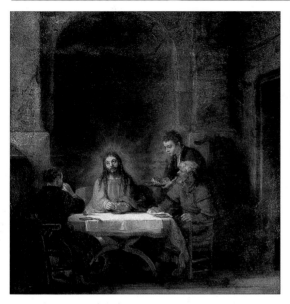

PLATE 261.
Harmensz Rembrandt van Rijn, known as
Rembrandt (Leiden, 1606–Amsterdam, 1669)
The Supper at Emmaus, 1648
Wood, 26 ¾ x 25⅜ in. (68 x 65 cm)

According to the Gospel of Saint Luke, two disciples who left Jerusalem after the Crucifixion did not recognize their unknown traveling companion as the risen Christ until he broke bread with them at an inn in Emmaus.

PLATE 262.
Harmensz Rembrandt
van Rijn, known as
Rembrandt (Leiden,
1606–Amsterdam,
1669)
*Self-Portrait
Wearing a Toque
and a Gold Chain,*
1633
Wood, 27⅝ x 20⅞ in.
(70 x 53 cm)

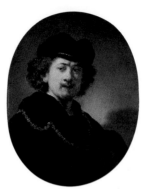

PLATE 263.
Harmensz Rembrandt
van Rijn, known as
Rembrandt (Leiden,
1606–Amsterdam,
1669)
*Self-Portrait with
an Easel,* 1660
Canvas, 43¾ x 35⅜ in.
(111 x 90 cm)

Although Dürer had painted self-portraits at various moments of his life (see plate 230), Rembrandt was the first artist to paint so many portraits of himself.

NORTHERN EUROPEAN PAINTING

PLATE 264.
Harmensz Rembrandt
van Rijn, known as
Rembrandt

David "walked upon the roof of the king's house; and from the roof he saw a woman washing herself; and the woman was very beautiful to look upon" (Samuel II 11:2). Rather than showing David admiring the wife of his captain Uriah, Rembrandt chose instead to depict Bathsheba reflecting on a letter from David inviting her to the palace.

In this illustration of a story from the Old Testament, Rembrandt was, in effect, competing with the mythological nudes by Titian and Veronese.

(Leiden, 1606–
Amsterdam, 1669)
*Bathsheba with
King David's
Letter,* 1654
Canvas, 55⅞ x 55⅞ in.
(142 x 142 cm)

PLATE 265.

Harmensz Rembrandt van Rijn, known as Rembrandt (Leiden, 1606–Amsterdam, 1669)
The Slaughtered Ox, 1655
Wood, 37 x 27 ¼ in. (94 x 69 cm)

The motif of a trussed pig or ox carcass had begun to attract Flemish painters almost a century earlier, and Rembrandt's version inspired, in turn, the twentieth-century British painter Francis Bacon. One such depiction of an "ox," which may or may not be this one, is listed in Rembrandt's estate inventory.

PLATE 266.
Barent Fabritius
(Midden-Beemster,
1624–Amsterdam,
1673)
*Young Painter in
His Studio*, c. 1665
Wood, 28 1/8 x 21 1/8 in.
(71.5 x 53.5 cm)

NORTHERN EUROPEAN PAINTING

In addition to the detailed depiction of an artist's atelier (see also plate 251), note the chalk caricatures on the wall—a widespread practice also observed by visitors to the studios of Michelangelo and Bernini.

PLATE 267.
Adriaen van
Ostade (Haarlem,
1610–Haarlem, 1685)
*Reading the
Gazette,* 1653
Wood, 9¼ x 8 in.
(23.4 x 20.2 cm)

PLATE 268.
Nicolaes Pietersz
Berchem (Haarlem,
1620–Amsterdam,
1683)
The Ferry Crossing,
c. 1670–80
Wood, 19⅝ x 27¾ in.
(50 x 70.5 cm)

NORTHERN EUROPEAN PAINTING

👁 *From the window of
room 33 you have a
sweeping view of the
Tuileries gardens, the
Eiffel Tower, the Arc de
Triomphe, the metallic
dome of the Grand
Palais, and in the
distance the Grand
Arch and towers of the
Défense neighborhood.*

267. A member of the artist's guild in Haarlem, which he scarcely left, van Ostade specialized in peasant scenes. After 1640 he modified his high-contrast, Rembrandtesque style by lightening his palette.

268. The Italianizing landscape painters (Berchem, Cornelis van Poelenburch, Bartholomeus Breenbergh, Herman van Swanevelt, Karel Du Jardin) reconciled northern precision with southern light, depicting Holland as a new Arcadia.

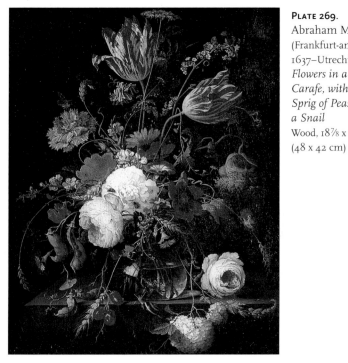

PLATE 269.
Abraham Mignon
(Frankfurt-am-Main,
1637–Utrecht, 1679)
*Flowers in a Crystal
Carafe, with a
Sprig of Peas and
a Snail*
Wood, 18⅞ x 16½ in.
(48 x 42 cm)

NORTHERN EUROPEAN PAINTING

PLATE 270.
Gerrit Dou (Leiden,
1613–Leiden, 1675)
*The Dropsical
Woman*, 1663
Wood, 33⅞ x 26⅞ in.
(86 x 67.8 cm)

PLATE 271.
Gabriel Metsu
(Leiden, 1629–
Amsterdam, 1667)
*The Herb Market
in Amsterdam,*
c. 1660
Canvas, 38¼ x 33¼ in.
(97 x 84.5 cm)

NORTHERN EUROPEAN PAINTING

Merchants' stalls had long been in the repertory of painters
from the Low Countries by the time this was painted, but the
atypical inclusion of the surroundings here makes this a true
open-air scene.

PLATE 272.
Paulus Potter
(Enkhuizen, 1625–
Amsterdam, 1654)
The Meadow, 1652
Canvas, 33⅛ x 47⅝
in. (84 x 121 cm)

PLATE 273.
Karel Du Jardin
(Amsterdam,
1621/22–Venice,
1678)
*The Italian
Charlatans,* 1657
Canvas, 17½ x 20½
in. (44.5 x 52 cm)

PLATE 274.
Ludolf
Backhuyzen

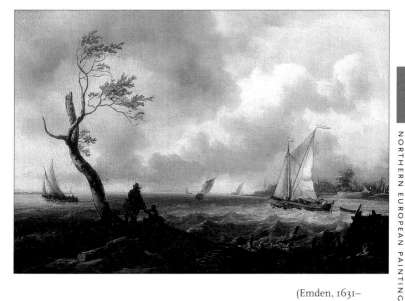

NORTHERN EUROPEAN PAINTING

(Emden, 1631–
Amsterdam, 1708)
*Fishing Boat and
Coasting Vessel in
Bad Weather,*
also called *The
Gust of Wind*
Canvas, 18⅛ x 26 in.
(46 x 66 cm)

PLATE 275.
Gerard Terborch
(Zwolle, 1617–
Deventer, 1681)
The Duet, 1669
Canvas, 32⅜ x 28⅛
in. (82.5 x 72 cm)

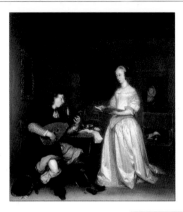

PLATE 276.
Jan Vermeer
(Delft, 1632–
Delft, 1675)
The Lacemaker,
c. 1665
Canvas fixed to
wood, 9⅜ x 8¼ in.
(24 x 21 cm)

NORTHERN EUROPEAN PAINTING

Vincent van Gogh wrote about Vermeer to Emile Bernard in 1877: "The palette of this strange artist includes blue, citron yellow, pearl gray, black, and white. It is true that the entire scale of colors can be found in some of the pictures he painted, but bringing together citron yellow, pale blue, and light gray is as characteristic for him as Velázquez's harmonization of black, white, gray, and pink."

PLATE 277.
Jan Vermeer

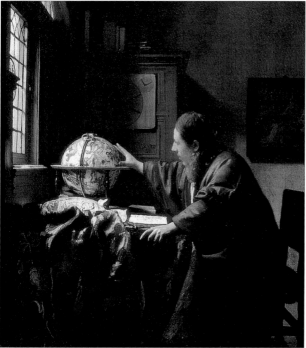

The book is open to the first page of book 3 of Adrien Metuis's publication on the study and observation of stars (second edition, 1621); the celestial globe is by Hondius (1600).

Like Rembrandt's *Philosopher* (room 31), Vermeer's *Astronomer* illustrates the theme of the man of study—a modern and secular version of the popular medieval subject of Saint Jerome writing.

(Delft, 1632–
Delft, 1675)
The Astronomer,
c. 1668
Canvas, 19⅝ x 17⅝
in. (50 x 45 cm)

PLATE 278.
Pieter de Hooch
(Rotterdam, 1629–
Amsterdam, 1684)
The Drinker, 1658
Canvas, 27¼ x 23⅝
in. (69 x 60 cm)

Residing in Delft from 1655 to 1662, de Hooch, like his fellow
resident Vermeer, concentrated on scenes of domestic life.

PLATE 279.
Jacob van Ruisdael

On exhibit at the Louvre from 1793, this work pictures the graceful return after a storm of the sun, whose light pierces the mobile bank of clouds. Like Rubens's landscapes with rainbows, this image evokes fleeting earthly beauty, the vicissitudes of chance, and confidence in divine providence.

(Haarlem, 1628/29–
Amsterdam, 1682)
*The Ray of
Sunlight*,
c. 1660–65
Canvas, 32⅝ x 39 in.
(83 x 99 cm)

PLATE 280.
Meindert
Hobbema
(Amsterdam, 1613–
Amsterdam, 1709)
Water Mill,
c. 1660–70 (?)
Canvas, 31½ x 26 in.
(80 x 66 cm)

NORTHERN EUROPEAN PAINTING

In contrast to the luminous lyricism of Ruisdael (plate 279), the focus here is the picturesque precision of nature.

PLATE 281.
Philips
Wouwerman

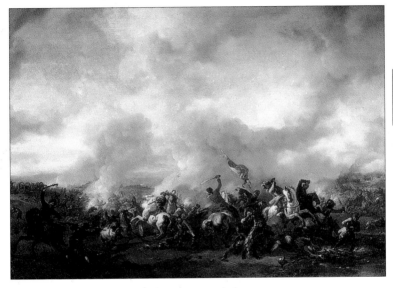

NORTHERN EUROPEAN PAINTING

By contrast with depictions of heroic battles and historical ones (plate 183), battle is here reduced to the modest scale of genre painting, resulting in a vein of imagery that flourished in Europe and was taken up not only by Flemish but also by Italian and French painters—for example, Jacques Courtois.

(Haarlem, 1619–
Haarlem, 1668)
Cavalry Encounter
Canvas, 39 x 53⅛ in.
(99 x 135 cm)

323

PLATE 282.
Caspar David
Friedrich

(Greifswald, 1774–
Dresden, 1840)
Tree with Crows,
c. 1822
Canvas, 23¼ x 29⅛
in. (59 x 74 cm)

The tree to which the crows are flying appears to be dead, but the branches are illuminated by the sun, making this a succinct symbol not only of death's inevitability but also of the resurrection promised to humanity.

PLATE 283.
Carl Spitzweg
(Munich, 1808–
Munich, 1885)
*Reading the
Breviary,* c. 1845
Wood, 11⅝ x 9 in.
(29.5 x 23 cm)

☞ *Northern European paintings of the eighteenth and early nineteenth centuries will soon be installed in the Rohan wing, which will be reached from room 29. For the moment, a small selection of German and northern works can be seen in room 70 on the second floor of the Richelieu wing, adjacent to the Henri II stair.*

NORTHERN EUROPEAN PAINTING

PLATE 284.
Thomas
Gainsborough
(Sudbury, 1727–
London, 1788)
Lady Alston, c. 1765
Canvas, 89 x 66⅛ in.
(226 x 168 cm)

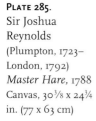

NORTHERN EUROPEAN PAINTING

PLATE 285.
Sir Joshua
Reynolds
(Plumpton, 1723–
London, 1792)
Master Hare, 1788
Canvas, 30⅜ x 24¾
in. (77 x 63 cm)

284. Gainsborough became a fashionable portraitist of British high society, whose members he painted in contemporary dress, striking poses that are sometimes startlingly casual.

🖛 *For the moment, English paintings are on view in the Salon Denon, pending completion of the Rohan wing.*

285. This portrait was commissioned by Lady Jones, wife of the Orientalist Sir William Jones and aunt of the two-year-old sitter. According to the customs of the day, he still wears a muslin dress like those worn by little girls his age.

PLATE 286.

Thomas Lawrence
(Bristol, 1769–
London, 1830)
*Mr. and Mrs.
Angerstein,* 1792
Canvas, 99¼ x 63
in. (252 x 160 cm)

Upon the death of Reynolds, Lawrence succeeded him in the official role of painter to the king.

PLATE 287.
Johan Heinrich
Füssli, known as
Henry Fuseli
(Zurich, 1741–
London, 1825)
Lady Macbeth, 1784
Canvas, 87 x 63 in.
(221 x 160 cm)

Between 1786 and 1800 Fuseli painted two cycles of paintings after Shakespeare, picturing episodes from *King Lear*, *The Tempest*, and *Macbeth*.

PLATE 288.
Joseph Mallord
William Turner

NORTHERN EUROPEAN PAINTING

Like other late paintings by Turner, who tended to work on several canvases at once, this painting was left unfinished.

(London, 1775–
London, 1851)
*Landscape with
Distant River and
Bay*, c. 1845
Canvas, 37 x 48⅜ in.
(94 x 123 cm)

Italian and Spanish Painting

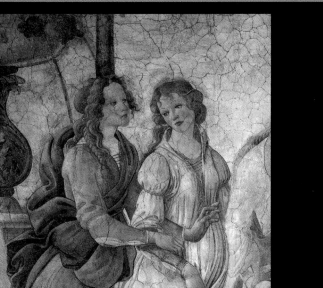

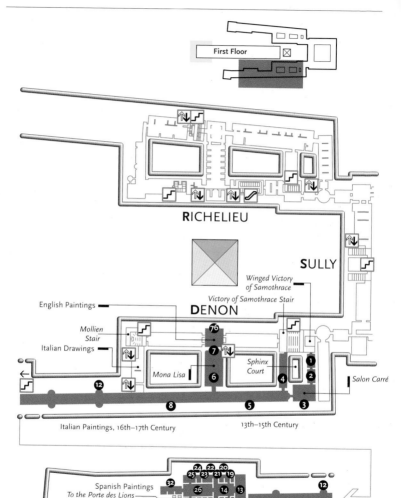

First Floor

RICHELIEU

SULLY

Winged Victory of Samothrace

Victory of Samothrace Stair

English Paintings

DENON

Mollien Stair

Italian Drawings

76

7

Mona Lisa

6

Sphinx Court

1

2

4

Salon Carré

12

8

5

3

Italian Paintings, 16th–17th Century

13th–15th Century

Spanish Paintings
To the Porte des Lions

24 **22** **20**
25 **23** **21** **19**

32

26 **14** **13**

12

31 **27** **18** **15**

Italian Paintings, 17th–18th Century

Access and Tour

There are three ways to reach the galleries of Italian painting and the small collection of Spanish paintings in rooms 1–32 on the first floor of the Denon wing. You can enter the Denon wing, go up to ground level, proceed through the Galerie Daru (room B, where *The Borghese Gladiator* [plate 139] and *The Borghese Vase* [plate 140] are exhibited), ascend the main flight of the Daru stair, and turn right when you reach *The Winged Victory of Samothrace* (plate 138), on the first floor. This will take you to the Percier and Fontaine rooms (rooms 1 and 2), where this tour starts.

Or you can use the Sully entry, walk up the Henri II stair to the first floor, and go through Greco-Roman rooms 32–34 to the Apollo Rotunda and the top of the Victory of Samothrace stair, beyond which you will see the Percier and Fontaine rooms.

Or you can enter from the Tuileries via the Porte des Lions, on the first floor, and proceed from the Spanish painting galleries (rooms 26–32) to the Italian paintings, taking this tour in reverse chronological order, from the eighteenth to the thirteenth century.

Most of the paintings on this tour hang in the two most famous rooms of the Louvre: the Salon Carré (room 3) and the Grande Galerie (rooms 5, 8, and 12; see page 64 for a discussion of their architecture). Overall, the works are organized chronologically, with complementary displays in the intersecting galleries: remounted frescoes from the fifteenth and sixteenth centuries (rooms 1 and 2); small paintings of the International Gothic and various Italian schools (room 4); Italian masterpieces of the sixteenth century, arrayed around the *Mona Lisa* (room 6); and Italian drawings (rooms 9–11).

History of the Collection

Assembled around major works from the royal collections of François I and Louis XIV, the Louvre's ensemble of Italian paintings constitutes most of what remains of the museum's original core. In the inventory of paintings in the royal collection drawn up

Frontispiece:
Sandro Botticelli, *Venus and the Graces Presenting Gifts to a Young Woman* (detail; see plate 289)

in 1710, near the end of Louis XIV's reign, a quarter of those listed were Italian (369 out of 1,478). This emphasis was not a matter of chance. Although the artistic Renaissance was born from a dialogue between Flemish painters and Italian artists, notably from Florence and Venice, the Florentine painter and writer Giorgio Vasari established what would prove to be a durable pro-Italian spin on the history of the Renaissance in his *Lives of the Best Painters, Sculptors, and Architects* (1550; revised 1568).

The collection assembled by François I, which decorated his bathing suite at the Château de Fontainebleau, included a dozen paintings by Leonardo and Raphael as well as such other major works as Andrea del Sarto's *Charity* (plate 323). Under Louis XIV, royal acquisitions took a retrospective turn, encompassing great sixteenth-century masters as well as the early-seventeenth-century reformers of painting, which meant not only the Carracci and their Bolognese followers but Caravaggio as well. The king purchased the collection of Everhard Jabach (which included several works formerly owned by the English king Charles I) and acquired major works from the heirs of Cardinal Mazarin, including *Portrait of Baldassare Castiglione* by Raphael (plate 325), and *Jupiter and Antiope* by Correggio (plate 326). Purchases and gifts also resulted in the acquisition of contemporary works, such as Salvator Rosa's *Heroic Battle*.

Since Italian paintings were considered essential to any first-rate collection, Revolutionary authorities seized from aristocrats many important Italian works for the museum, including pictures formerly owned by Isabella d'Este, from the Château de Richelieu (plate 306), and the *Pietà* by Rosso Fiorentino (plate 327) from the Château d'Ecouen. Such appropriations expanded when the Revolutionary armies invading Italy looted works such as Veronese's *Marriage at Cana* (plate 321) and Federico Barocci's *Circumcision* (plate 330), which entered the museum in 1797 and 1798, respectively.

Intending to make the Musée Napoléon a school for all of Europe's artists, its director, Dominique-Vivant Denon, requi-

sitioned altarpieces illustrating artistic developments from the fourteenth to the sixteenth century. Anticipating later developments in taste with remarkable acuity, he selected works by Italian precursors of the Renaissance, from Cimabue (plate 290) and Giotto (plate 291) to Fra Angelico (plate 292). In 1815 all of the looted works were supposed to be returned, but many early Italian paintings were "forgotten" during implementation of this decree, and even so prized a work as Mantegna's *San Zeno Altarpiece* ended up leaving behind one of its predella panels (plate 299) in the course of this move back and forth.

In 1863 the Campana collection further enriched the museum with works such as Uccello's *Battle of San Romano* (plate 293) and Cosimo Tura's *Pietà* (plate 301). Since then, through donations, acquisitions, and the state's acceptance of works of art from private collections in lieu of estate taxes, this panorama has been enriched by additional major works, from *Ginevra d'Este* by Pisanello in 1893 (plate 297) to *Christ and the Adulterous Woman* by Lorenzo Lotto (plate 318) in 1982.

When it first opened to the public, the museum owned only one important Spanish painting, Bartholomé Estebán Murillo's *Young Beggar* (plate 352), acquired for Louis XVI. But with nineteenth-century Romanticism, France discovered Spanish painting. For King Louis-Philippe, a writer on art named Baron Isidore Justin Taylor assembled a collection of Spanish paintings, called the Galerie Espagnole, that was exhibited at the Louvre from 1838 to 1848, but it was the king's personal property and was dispersed after his overthrow by the revolution of 1848. This loss meant that the Spanish collection has remained modest, despite patient efforts to acquire representative pieces by the principal artists and styles of this tradition.

PLATE 289.
Sandro Botticelli
(Florence, c. 1445–
Florence, 1510)
*Venus and the
Graces Presenting
Gifts to a Young
Woman*, c. 1483
Fresco, 83⅛ x
111⅜ in.
(211 x 283 cm)

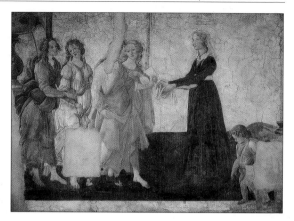

This fresco, like its companion depicting a young man with personifications of the liberal arts (room 1b), was detached from a wall of the loggia of Villa Lemmi near Florence. The pair may have been commissioned to celebrate a marriage.

👁 *On the history and decor of the Percier and Fontaine rooms, see pages 58–59.*

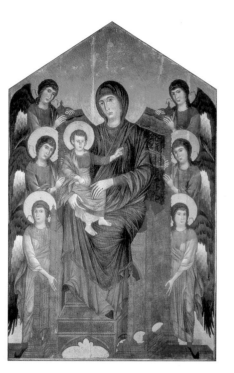

PLATE 290.
Cenni di Pepi,
known as Cimabue
(Florence, c. 1240–
Florence, after 1302)
Maestà (Virgin and
Child in Majesty
Flanked by Six
Angels), c. 1270 (?)
Wood, 14 ft. ⅛ in.
x 9 ft. 1¼ in.
(4.27 x 2.8 m)

ITALIAN PAINTING

This altarpiece was taken from the church of San Francesco in
Pisa for the Musée Napoléon in 1813 and never returned. The
traditional Byzantine iconography was reinvigorated here by
Cimabue's modeling, in which Vasari saw anticipations of
"the rebirth of painting."

👁 For the history and
decor of the Salon
Carré, see page 64.

PLATE 291.

Giotto di Bondone, known as Giotto (Colle di Vespignano, c. 1267– Florence, 1337)
Saint Francis of Assisi Receiving the Stigmata,
c. 1290–95 (?)
Wood, 123¼ x 64¼ in. (313 x 163 cm)

Like Cimabue's *Maestà* (plate 290), this altarpiece was taken from the church of San Francesco for the Musée Napoléon. The predella panels below the main composition illustrate three episodes from the life of the saint (1182–1226) that also figure in the fresco cycle at Assisi, which some scholars also attribute to Giotto: Innocent III dreaming of Francis preventing the Church from collapsing; Innocent III approving the statutes of the Franciscan mendicant order; and Francis preaching to the birds.

Florentine artists acknowledged Giotto as the precursor of the Renaissance in painting.

PLATE 292.
Fra Angelico
(Vicchio di Mugello?,
c. 1400–Rome, 1455)
*The Coronation of
the Virgin,* before
1435
Wood, 82⅜ x 81⅛ in.
(209 x 206 cm)

ITALIAN PAINTING

This panel was painted for the Dominican convent in Fiesole,
from which it was transferred to the Louvre in 1812, after the
suppression of religious houses during the French occupa-
tion. Both the main composition and the predella scenes
underneath show a mastery of perspective that made it poss-
ible to unify the pictorial space.

PLATE 293.
Paolo Uccello

ITALIAN PAINTING

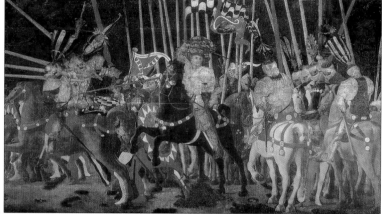

(Florence, 1397–
Florence, 1475)
*The Battle of San
Romano,* c. 1455
Wood, 71⅝ x 124¾
in. (182 x 317 cm)

This is one of three panels (the others are in Florence and
London) painted for the palace of Cosimo di Medici in
Florence to celebrate the Florentine victory over the Sienese in
1432. Smitten with the newly discovered device of perspective,
Uccello here delighted in juxtaposing a prancing horse in
three-quarters view at center, another shown in profile at left,
and another rendered in foreshortening at right, all set against
the visual counterpoint of an impressive frieze of lances.

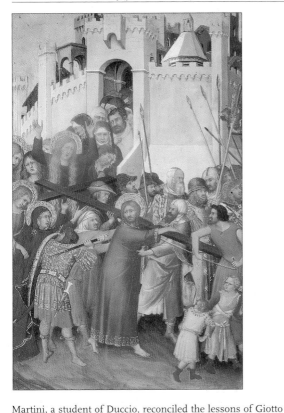

PLATE 294.
Simone Martini
(Siena, c. 1284–
Avignon, 1344)
*Christ Carrying the
Cross,* c. 1325–35
Wood, 11 x 6⅜ in.
(28 x 16 cm)

Martini, a student of Duccio, reconciled the lessons of Giotto
with the elegance of the International Gothic style, which he
encountered at the court in Naples.

PLATE 295.
Gentile da
Fabriano (Fabriano,
c. 1370–Rome, 1427)
*The Presentation in
the Temple*, 1423
Wood, 10⅜ x 26 in.
(26.5 x 66 cm)

PLATE 296.
Stefano di Giovanni,
known as Sassetta
(Siena, 1392?–
Siena, 1450)
*Virgin and Child
Surrounded by Six
Angels, with Saint
Anthony of Padua
and Saint John the
Evangelist,*
c. 1437–44
Wood; central panel:
81½ x 46½ in. (207
x 118 cm); side pan-
els: 76¾ x 22⅛ in.
(195 x 57 cm)

295. An important exponent of the Italian International Gothic style, Gentile da Fabriano influenced Pisanello, and his work was still admired in the sixteenth century. Michelangelo noted (according to Vasari) that "in painting, he had a touch like his name" (i.e., "gentle").

296. A master of the Sienese school, Sassetta responded to recent developments in Florentine painting while also remaining faithful to local traditions.

ITALIAN PAINTING

PLATE 297.
Antonio Puccio,
known as Pisanello
(Verona?, before
1395–Verona, 1455)
Ginevra d'Este,
c. 1436–38 (?)
Wood, 16⅞ x 11¼ in.
(43 x 30 cm)

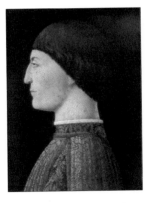

PLATE 298.
Piero della
Francesca (Borgo
San Sepolcro,
c. 1422–Borgo San
Sepolcro, 1492)
*Sigismondo
Malatesta,* c. 1450
Wood, 17⅜ x 13⅜ in.
(44 x 34 cm)

ITALIAN PAINTING

297. This princess of Ferrara is shown in profile against a decorative, almost abstract background of flowers and butterflies.

298. A noted soldier and patron of the arts, Malatesta was the lord of Rimini, where he had the church of San Francesco remodeled after plans by Leon Battista Alberti.

PLATE 299.
Andrea Mantegna

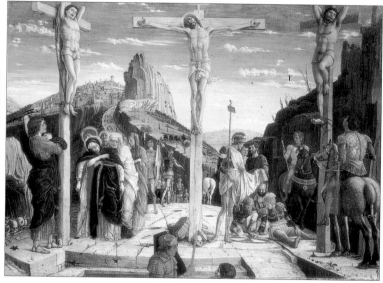

(Isola di Carturo, 1431–Mantua, 1506)
Calvary, c. 1456–59
Wood, 29⅞ x 37¾ in. (76 x 96 cm)

This was originally the central predella panel of the *San Zeno Altarpiece* in Verona, which was taken by French forces in 1798; the altarpiece was returned in 1815, but minus its three predella panels—the two lateral ones, *Christ on the Mount of Olives* and *The Resurrection*, are now in the Musée des Beaux-Arts, Tours, France.

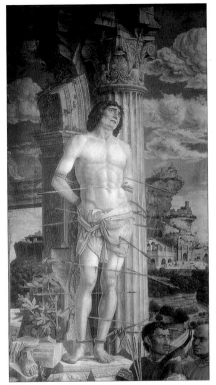

PLATE 300.
Andrea Mantegna
(Isola di Carturo,
1431–Mantua, 1506)
Saint Sebastian,
c. 1480
Canvas, 100⅜ x 55⅛
in. (255 x 140 cm)

👁 *For discussion of
the history and
architecture of the
Grande Galerie, see
pages 39, 51, and 52.*

ITALIAN PAINTING

PLATE 301.

Cosimo Tura

(Ferrara, c. 1430–
Ferrara, 1495)
Pietà, c. 1480
Wood, 52 x 105½ in.
(132 x 268 cm)

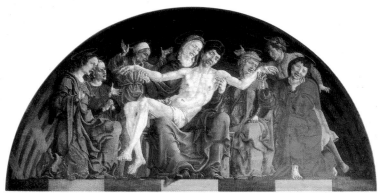

This *Pietà* (the upper lunette of a polyptych painted for a
church in Ferrara) makes clear how extensively Mantegna
influenced Tura.

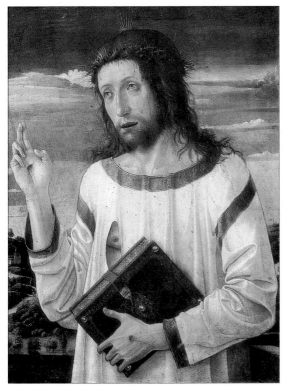

PLATE 302.
Giovanni Bellini
(Venice, c. 1430–
Venice, 1516)
Christ Blessing,
c. 1460
Wood, 22¾ x 18⅛ in.
(58 x 46 cm)

ITALIAN PAINTING

"Comparing Bellini's earliest works with the ones he painted
in his old age, we are sometimes tempted to think they come
from different centuries. . . . He indeed fits the description of
him as 'the oldest of the moderns, the most modern of our
forefathers'" (Pietro Selvatico, 1856).

PLATE 303.
Antonello da
Messina (docu-
mented in Messina,
1456–Messina, 1479)
Portrait of a Man,
known as *The
Condottiere*, 1475
Wood, 14¼ x 11¾ in.
(36 x 30 cm)

Antonello's reconciliation of the luminosity and meticulous
detailing typical of Flemish painting with a well-rounded
Italian monumentality is characteristic of much contemporary
work produced in Venice (where he lived in 1475–76), notably
by Giovanni Bellini and Giorgione.

The sitter has not been identified, and no evidence supports
the possibility that this energetic face belonged to a condottiere.

PLATE 304.
Domenico
Ghirlandaio
(Florence, 1449–
Florence, 1494)
*Old Man with His
Grandson,* c. 1490
Wood, 24⅝ x 18¼ in.
(62.7 x 46.3 cm)

PLATE 305.
Attributed to
Lorenzo Costa
(Ferrara, c. 1460–
Mantua, 1535)
Saint Veronica
Wood, 25½ x 21¼ in.
(64.7 x 54 cm)

ITALIAN PAINTING

304. The face of the old man was based on a drawing made
by Ghirlandaio while the man was on his deathbed.

PLATE 306.
Andrea Mantegna

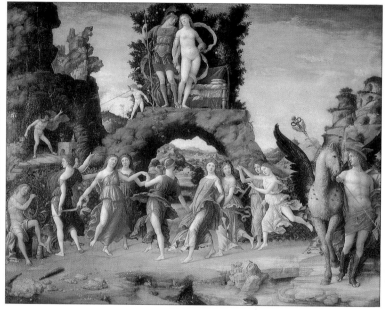

ITALIAN PAINTING

(Isola di Carturo, 1431–Mantua, 1506) *Parnassus*, also known as *Mars and Venus*, 1496–97 Canvas, 62⅝ x 75⅝ in. (159 x 192 cm)

Isabella d'Este, daughter of the duke of Ferrara and the young wife of Francesco Gonzaga, duke of Mantua, was described by a contemporary as "completely dedicated to the Muses." This picture, painted for her *studiolo* (little studio), illustrates the illicit love of Mars and Venus, amorously intertwined at top; beside them, their son Cupid aims his blowpipe at the genitals of Vulcan, Venus's deceived husband. Below, the Muses dance to the sound of Apollo's lyre at left, while at right Mercury leans against the winged horse Pegasus.

PLATE 307.
Vittore Carpaccio

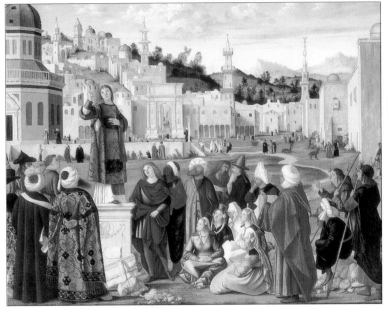

ITALIAN PAINTING

Carpaccio specialized in narrative cycles. This composition comes from one that was painted for the Scuola di San Stefano, a Venetian religious confraternity; its elements have been dispersed among museums in several cities, including Milan, Stuttgart, and Berlin.

(Venice, c. 1450/54–
Venice, 1525/26)
*Saint Stephen
Preaching in
Jerusalem*, 1511–20
Canvas, 58½ x 76⅜
in. (148 x 194 cm)

Plate 308.
Pietro Vannuci,
known as Perugino
(Città della Pieve,
c. 1448–Fontignano,
1523)
Saint Sebastian,
c. 1490/1500
Wood, 69⅜ x 45⅝ in.
(176 x 116 cm)

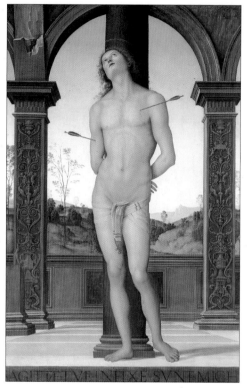

Comparison of Perugino's *Saint Sebastian* with Mantegna's treatment of the subject (plate 300) reveals the tension between two antithetical styles: the harsh linearity favored by Mantegna versus the softer modeling typical of Perugino.

PLATE 309.
Leonardo da Vinci
(Vinci, 1452–
Cloux, 1519)
*Portrait of a
Woman,* known
as *La Belle
Ferronnière,* c. 1490
Wood, 19⅝ x 13¾ in.
(50 x 35 cm)

ITALIAN PAINTING

This portrait, which seems to have been in the French royal collections since Louis XII or François I, was listed in a seventeenth-century inventory as a portrait of "La Belle Ferronnière" (mistress of François I), but it more likely represents a lady from Milan.

PLATE 310.
Leonardo da Vinci
(Vinci, 1452–
Cloux, 1519)
*The Virgin of the
Rocks,* 1483–86
Canvas, transferred
from wood, 78⅜ x
48 in. (199 x 122 cm)

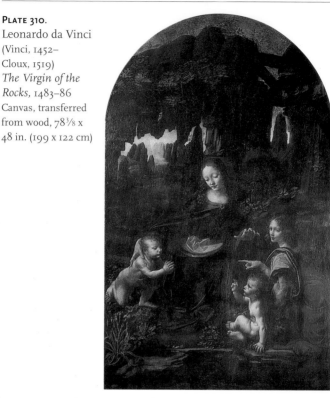

Painted for a church in Milan, this work was given or sold to
King François I and replaced in the church by a second version
(which ultimately ended up in London's National Gallery).

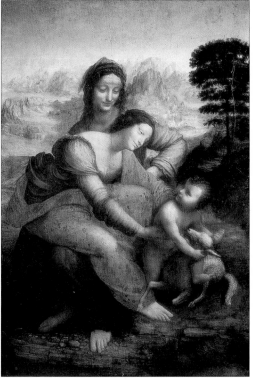

PLATE 311.
Leonardo da Vinci
(Vinci, 1452–
Cloux, 1519)
*Virgin and Child
with Saint Anne,*
c. 1510
Wood, 66⅛ x 51¼ in.
(168 x 130 cm)

Painted in Florence, where it was much admired, this work was subsequently taken to France by Leonardo. After the artist's death in France it returned to Italy; Richelieu acquired it there and gave it to King Louis XIII.

PLATE 312.
Raffaello Sanzio,
known as Raphael
(Urbino, 1483–
Rome, 1520)
*Virgin and Child
with Saint John the
Baptist,* known as
La Belle Jardinière,
1507
Wood, 48 x 31½ in.
(122 x 80 cm)

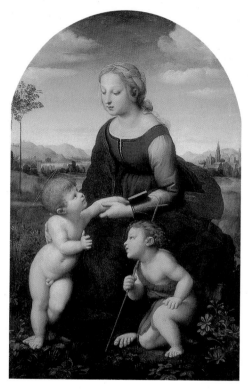

Raphael painted this work during his stay in Florence
(1504–8), where he was influenced by Leonardo and
Michelangelo. It may have been acquired by King François I; it
is documented as being in the collection of King Louis XIV.

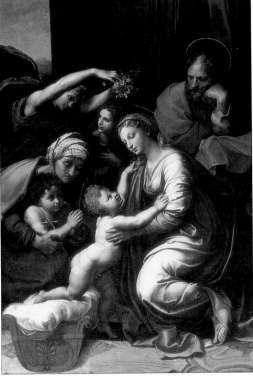

PLATE 313.
Raffaello Sanzio,
known as Raphael
(Urbino, 1483–
Rome, 1520)
The Holy Family,
known as *The Large
Holy Family of
François I,* 1518
Canvas, 74⅜ x 55⅛
in. (190 x 140 cm)

ITALIAN PAINTING

The complex composition, refined color scheme, luxurious
fabrics, and elegant marble floor evidence the evolution of
Raphael's art toward the style known as Mannerism.

☞ *At right is the
entrance to the Salle
des Etats (room 6),
which contains
masterpieces of the
cinquecento, or
sixteenth century,
notably Leonardo's
Mona Lisa.*

314.
Leonardo da Vinci
(Vinci, 1452–
Cloux, 1519)
Mona Lisa, 1503–6
Wood, 23⅝ x 18½ in.
(60 x 47 cm)

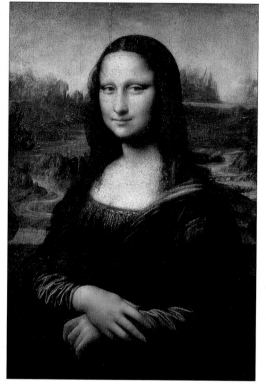

There is some doubt as to the identities of the sitter and the patron of this internationally renowned painting. Vasari reported that Leonardo had been commissioned by Francesco del Giocondo to paint a portrait of his wife, Mona Lisa, and that the artist spent four years working on it but left it unfinished; Vasari added that the work had since come into the possession of King François I and was at Fontainebleau. Another contemporary witness reports having seen the portrait of a certain Florentine lady, represented nude at the request of Giuliano di Medici. Was that work the portrait of Mona Lisa? We do not know.

PLATE 315.
Tiziano Vecelli,
known as Titian
(Pieve di Cadore,
1488/89–Venice,
1576)

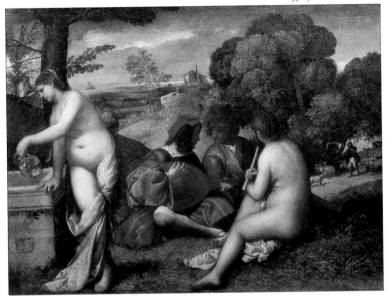

ITALIAN PAINTING

This "realist" allegory of music and inspiration has been attributed to Giorgione or to Titian; alternatively, it may have been begun by the former and completed by the latter.

Le Concert Champêtre,
c. 1510–11
Canvas, 43⅜ x 54⅜
in. (110 x 138 cm)

👁 *For a discussion of the architecture of the Salle des Etats, see p. 64.*

PLATE 316.
Tiziano Vecelli,
known as Titian
(Pieve di Cadore,
1488/89–Venice,
1576)
Portrait of a Man,
known as *Man with
a Glove*, c. 1520–25
Canvas, 39⅜ x 35 in.
(100 x 89 cm)

This portrait of an unidentified man was originally in the
Gonzaga family's collection in Mantua, Italy, before passing
through the collection of King Charles I of England to the
banker Everhard Jabach, who sold it to Louis XIV.

PLATE 317.
Tiziano Vecelli,
known as Titian

ITALIAN PAINTING

This is one of the finest works by Titian, who was leader of
the Venetian school, just as Raphael was of the Roman school.

(Pieve di Cadore,
1488/89–Venice,
1576)
*The Supper at
Emmaus*, c. 1535
Canvas, 66½ x 96⅛
in. (169 x 244 cm)

PLATE 318.
Lorenzo Lotto

ITALIAN PAINTING

(Venice, 1480–
Loreto, 1556)
*Christ and the
Adulterous
Woman,* c. 1530–35
Canvas, 48¾ x 61⅜
in. (124 x 156 cm)

PLATE 319.
Paolo Caliari,
known as Veronese
(Verona, 1528–
Venice, 1588)
*The Pilgrims at
Emmaus*, c. 1559–60
Canvas, 9 ft. 6¼ in.
x 14 ft. 8⅜ in.
(2.9 x 4.48 m)

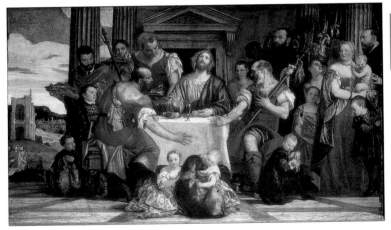

ITALIAN PAINTING

In the background, Jesus is shown walking with his new-found companions; in the foreground, they recognize him as the risen Christ. Veronese enriched the gospel story by adding many secondary figures, some of which represent the donor and his family. For a sparer treatment of the subject, see the painting by Rembrandt (plate 261).

PLATE 320.
Paolo Caliari,
known as Veronese
(Verona, 1528–
Venice, 1588)
Portrait of a Lady,
known as *La Belle
Nani*, c. 1560 (?)
Canvas, 46⅞ x 39¾
in. (119 x 101 cm)

ITALIAN PAINTING

Neither the identification of the model nor the date is certain,
but the conception brings to mind Veronese's fresco portrait
of Signora Barbaro (1561) in the Salone d'Olimpio in the Villa
Barbaro in Maser, Italy.

PLATE 321.
Paolo Caliari,
known as Veronese

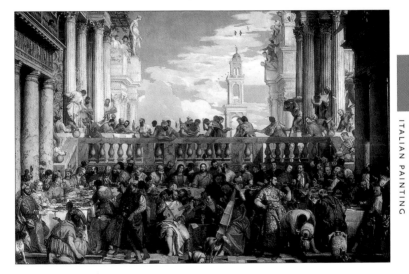

ITALIAN PAINTING

Despite being placed in the center, Jesus is a bit lost in this teeming mass of sumptuously dressed figures of all kinds, some of which were recognizable to contemporaries as portraits of Venetian musicians and artists, notably Titian, Bassano, and Tintoretto (in white). The work was painted for the refectory of the convent of San Giorgio Maggiore in Venice and entered the Louvre in 1798.

(Verona, 1528–
Venice, 1588)
*The Marriage at
Cana,* 1562–63
Canvas, 21 ft. 10¾
in. x 32 ft. 5¾ in.
(6.66 x 9.9 m)

PLATE 322.
Jacopo Robusti,
known as Tintoretto

ITALIAN PAINTING

(Venice, 1518–
Venice, 1594)
Paradise, c. 1578–79
Canvas, 56⅜ x
142½ in.
(143 x 362 cm)

This is an oil sketch for the painting commissioned for the
Council Room in the Doge's Palace in Venice after the fire
of 1577.

☞ To continue the
tour, return to the
Grande Galerie.

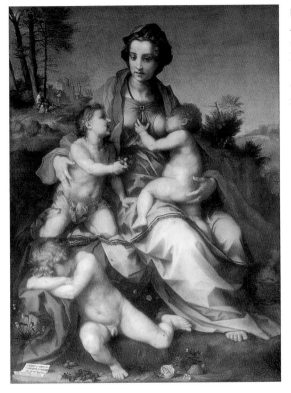

PLATE 323.
Andrea del Sarto
(Florence, 1486–
Florence, 1530)
Charity, 1518
Canvas, 72⅜ x 53⅞
in. (185 x 137 cm)

ITALIAN PAINTING

Though a bit schematic, this pyramidal composition was much imitated. It was painted during the artist's sojourn at the court of François I.

PLATE 324.
Giulio Romano
(Rome, 1492/99–
Mantua, 1546)
The Circumcision
Canvas, 45⅜ x 48 in.
(115 x 122 cm)

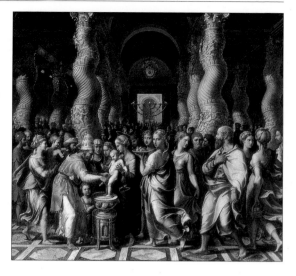

A collaborator and heir of Raphael's, Giulio reshaped that master's classicizing style in startlingly excessive ways.

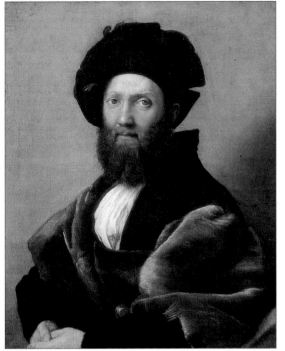

PLATE 325.
Raffaello Sanzio,
known as Raphael
(Urbino, 1483–
Rome, 1520)
*Baldassare
Castiglione,*
c. 1514–15
Canvas, 32⅜ x 26⅜
in. (82 x 67 cm)

ITALIAN PAINTING

One of the most beautiful male portraits ever made, this portrays the author of *The Book of the Courtier* (1528), who was a man of letters and a friend to artists. Castiglione kept this canvas until his death.

PLATE 326.
Antonio Allegri,
known as Correggio
(Correggio, 1489?–
Correggio, 1534)
*Venus, Satyr, and
Cupid,* also known
as *Jupiter and
Antiope,* c. 1525
Canvas, 74⅜ x 48⅜
in. (190 x 124 cm)

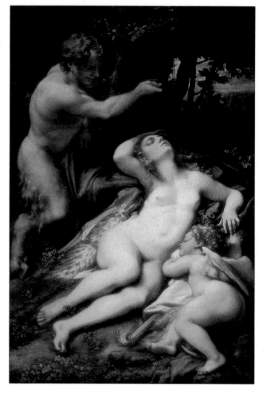

This depiction of the sleeping Venus observed by a satyr is
probably a pendant to the same artist's *Education of Cupid*
(National Gallery, London), the two works having been con-
ceived to represent the two aspects of love, sensual and intel-
lectual. It has also been interpreted as showing the sleeping
Antiope surprised by Jupiter in the guise of a satyr, thus
reflecting the taste for the seductive mythological paintings at
which Titian excelled.

PLATE 327.
Giovanni Battista
di Jacopo, known as
Rosso Fiorentino

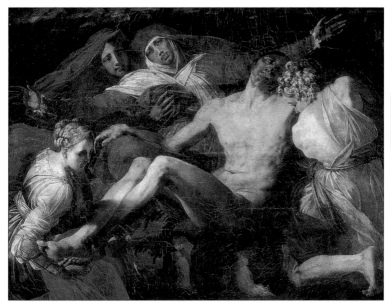

ITALIAN PAINTING

Recommended to François I by the Italian writer Pietro Aretino, Rosso took up residence at Fontainebleau, where he painted the gallery in the king's apartment. This *Pietà* was commissioned by Constable Anne de Montmorency, an intimate of the king, for the chapel of his château at Ecouen (now the Musée National de la Renaissance).

(Florence, 1496–
Fontainebleau, 1540)
Pietà, c. 1530–35
Canvas, transferred
from wood, 50 x 64¼
in. (127 x 163 cm)

PLATE 328.
Niccolò dell' Abbate

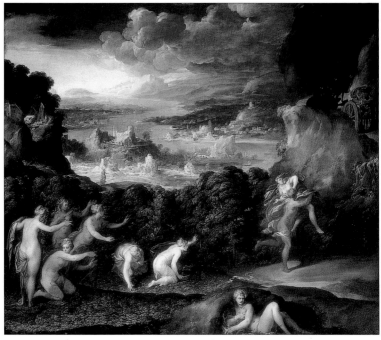

(Modena, c. 1509/12–
Fontainebleau or
Paris, 1571?)
*The Abduction of
Proserpina*, c. 1560
Canvas, 77¼ x 85¾
in. (196 x 218 cm)

After a brilliant career in Modena, Niccolò arrived in
Fontainebleau in 1552, where he worked closely with another
Italian visitor, Primaticcio, painting after his designs and
becoming a major figure of the "school of Fontainebleau."

PLATE 329.
Giuseppe
Arcimboldo
(Milan, 1527–
Milan, 1593)
Winter
Canvas, 29⅞ x 25 in.
(76 x 63.5 cm)

ITALIAN PAINTING

Arcimboldo's pictorial caprices, which use all sorts of visual conceits, seduced the court in Prague, where he resided beginning in 1562.

☞ At right, after the
Arcimboldo paintings,
are three rooms of
Italian drawings and
tapestry cartoons
(rooms 9–11). Beyond
them is the large
Mollien stair, at the
top of which is a café.
If you wish to take a
break there now, come
back here when you're
ready to continue
the tour.

PLATE 330.
Federico Barocci
(Urbino, c. 1535–
Urbino, 1612)
The Circumcision,
1590
Canvas, 130¼ x 98¾
in. (356 x 251 cm)

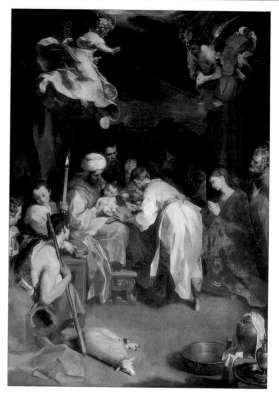

With its naturalistic details and clarity of image, this major painting by Barocci goes beyond its Mannerist roots, despite its contrived color scheme and its abstract linear qualities. Barocci's art was essential to the Catholic Counter-Reformation movement.

PLATE 331.
Annibale Carracci
(Bologna, 1560–
Rome, 1609)
Fishing, 1585–88
Canvas, 53⅛ x 99⅝
in. (135 x 253 cm)

ITALIAN PAINTING

This is an early realist landscape by Annibale, who later pro-
duced idealized landscapes that greatly influenced classicizing
landscape painters such as Nicolas Poussin and Claude Lorrain.

PLATE 332.
Annibale Carracci
(Bologna, 1560–
Rome, 1609)
*Pietà with Saint
Francis and Mary
Magdalen*, c. 1602
Canvas, 109⅛ x 73⅝
in. (277 x 187 cm)

ITALIAN PAINTING

Caravaggio and the Carracci (Annibale and Agostino, who were brothers, and their cousin Ludovico) were the great anti-Mannerist reformers of Italian painting, advocating a return to nature mediated by the great Renaissance masters, notably Titian and Correggio.

PLATE 333.
Michelangelo
Merisi, known as
Caravaggio

ITALIAN PAINTING

According to Giovanni Pietro Bellori's life of Caravaggio (1672), the artist took as his model a gypsy woman he encountered in the street: "Holding in contempt the most famous marbles of antiquity and Raphael's most celebrated paintings, he took nature as the object of his brush." Like the Carracci, Caravaggio broke with Mannerism by returning to the direct observation of nature, without resort to classical models or the works of Raphael. Even so, his art was carefully pondered—and here, tempered by grace.

(Caravaggio,
c. 1571–Port'Ercole,
1610)
The Fortune Teller,
c. 1594–95
Canvas, 39 x 51⅝ in.
(99 x 131 cm)

PLATE 334.
Michelangelo
Merisi, known as
Caravaggio
(Caravaggio, c. 1571–
Port'Ercole, 1610)
*The Death of the
Virgin*, 1605–6
Canvas, 12 ft. 1⅜ in.
x 8 ft. (3.69 x 2.45 m)

ITALIAN PAINTING

This painting was refused by the clergy who had commissioned it for a Roman church because they were so shocked by its powerful, uncompromising realism. Acquired by the duke of Mantua on the recommendation of Rubens, it then passed through the hands of King Charles I of England and the banker Everhard Jabach before being acquired by Louis XIV.

The large swag of red drapery suggestive of mourning, the graceful figure of the suffering Magdalen in the foreground, and the pained expressions of the apostles make this one of the most beautiful visual meditations on death.

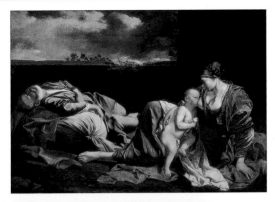

PLATE 335.
Orazio Gentileschi
(Pisa, 1563–
London, 1639)
*The Rest on the
Flight into Egypt*,
c. 1628
Canvas, 62¼ x 88⅝
in. (158 x 225 cm)

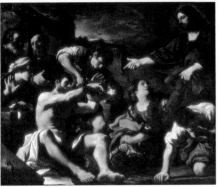

PLATE 336.
Giovanni Francesco
Barbieri, known as
Guercino (Cento
di Ferrara,
1591–Bologna, 1666)
*The Resurrection of
Lazarus*, c. 1619
Canvas, 78⅜ x 91⅝
in. (199 x 233 cm)

ITALIAN PAINTING

335. An elegant essay in Caravaggism, this image owes more to the master's early works than to his later, more tragic paintings.

336. Struck by the work of Ludovico Carracci, Guercino was also influenced by the compositions and dramatic lighting effects of Caravaggio. This painting was acquired on the advice of Vivant Denon for the collection of Louis XVI: "We don't have any works by this significant master of large paintings and I think it matters to have such great models before one's eyes" (quoted by Charles d'Angiviller, 1785).

PLATE 337.
Domenico Zampieri,
known as
Domenichino
(Bologna, 1581–
Naples, 1641)
Saint Cecilia, c. 1618
Canvas, 63 x 47¼ in.
(160 x 120 cm)

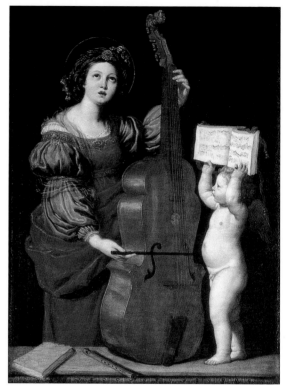

A student and assistant of Annibale Carracci, Domenichino was a Bolognese classicist greatly influenced by Raphael—as evidenced by this work, which was clearly inspired by a version of the subject by Raphael that Domenichino would have seen in Bologna (now in that city's art museum).

The instrument (a bass viol) and the book of music (a *psallenda* celebrating the saint) are meticulously rendered, but it is the expression of devotion that contemporaries found most striking: "One seems to hear her voice singing the praises of her divine spouse" (André Félibien, 1679).

PLATE 338.
Domenico Zampieri,
known as
Domenichino

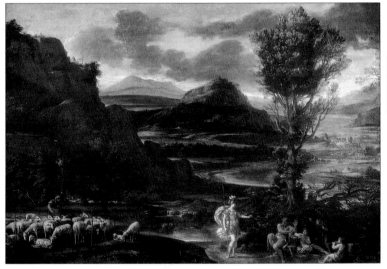

ITALIAN PAINTING

Like the landscapes by Annibale Carracci in the Palazzo Aldobrandini in Rome, this landscape was a source of inspiration for the great historiated landscapes by Nicolas Poussin and Claude Lorrain (see plate 163).

The painting represents an episode from book 7 of Torquato Tasso's *Gerusalemme Liberata* (1581).

PLATE 338.
Domenico Zampieri,
known as
Domenichino

(Bologna, 1581–
Naples, 1641)
*Landscape with
Erminia and
the Shepherds,*
c. 1622–25
Canvas, 48⅛ x 71⅛
in. (123 x 181 cm)

PLATE 339.
Francesco Albani
(Bologna, 1578–
Bologna, 1660)

The Toilet of Venus,
or *Air,* 1621–33
Canvas, 79½ x 99¼
in. (202 x 252 cm)

Having descended from the heavens, Venus is adorned by the
Graces to please her lover Adonis, while cupids water the
swans unyoked from her chariot and repair its axles.

This painting is one of a set of four depicting stories about
Venus and Diana, commissioned in 1621 by Ferdinando
Gonzaga for the Villa Favorita in Mantua. An assistant of
Annibale Carracci (as was Domenichino), Albani was another
important representative of Emilian classicism, but his style is
sweeter and more refined than his colleague's.

PLATE 340.
Guido Reni
(Bologna, 1575–
Bologna, 1642)
*David with the
Head of Goliath,*
c. 1604–6
Canvas, 93³⁄₈ x 53⁷⁄₈
in. (237 x 137 cm)

PLATE 341.
Guido Reni
(Bologna, 1575–
Bologna, 1642)
*The Abduction of
Helen,* 1631
Canvas, 102 x 104³⁄₈
in. (259 x 265 cm)

ITALIAN PAINTING

Reni divided his artistic allegiances between power and grace,
allowing first one then the other to prevail in his works. In
plate 340, "Guido wanted to dwell on the moment of repose
after the victory: the victor seems to applaud his triumph dis-
creetly and reflect on the power of the God of Israel" (Nicolas-
Bernard Lépicié, 1754). His abduction of Helen (plate 341) is
here rendered as a decorous courtly procession: "The love,
grace, and sweetness emanating from [Helen's] face prompt
sighs from those who consider this beauty a bit too attentively"
(Henri Sauval, c. 1655).

PLATE 342.
Pietro Berrettini,
known as Pietro
da Cortona

(Cortona, 1596–
Rome, 1669)
*Romulus and
Remus Taken in by
Faustulus,* c. 1643
Canvas, 98¾ x 104⅜
in. (251 x 265 cm)

Like *The Abduction of Helen* (plate 341), this painting once decorated the gallery in the Hôtel La Vrillière, which was "undoubtedly the most complete in Paris" (according to Henri Sauval, a local historian of the period) and virtually a museum of contemporary painting.

Pietro synthesized the lessons of Titian and Rubens plus the new idiom of Giovanni Lanfranco to achieve a new Roman "grand style."

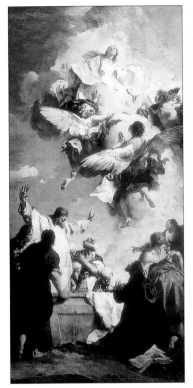

PLATE 343.
Giambattista
Piazzetta (Venice,
1683–Venice, 1754)
*The Assumption of
the Virgin,* 1735
Canvas, 16 ft. 10¾ in.
x 8 ft. ½ in. (5.15 x
2.45 m)

ITALIAN PAINTING

👁 *Rooms 14/26 once
housed Rubens's Marie
de Médicis cycle (now
in room 18 of the Riche-
lieu wing's second floor).
All of the rooms in this
section (rooms 13–32)
were remodeled by the
architect Yves Lion to
accommodate the new
installation of late
Italian and Spanish
paintings.*

PLATE 344.
Giovanni Paolo
Pannini (Piacenza,
1691–Rome, 1765)
*Gallery of Views of
Ancient Rome,* 1758
Canvas, 90⅞ x 119⅜
in. (231 x 303 cm)

PLATE 345.
Giovanni Paolo
Pannini (Piacenza,
1691–Rome, 1765)
*Gallery of Views of
Modern Rome,* 1758
Canvas, 90⅞ x 119⅜
in. (231 x 303 cm)

ITALIAN PAINTING

Many collections of prints illustrating the magnificence of
Rome were published, starting in the sixteenth century. In this
pair, Pannini created a spectacular "imaginary museum" of
Roman *vedute* (views), a genre in which he specialized.

PLATE 346.
Francesco Guardi

This is one of a dozen canvases by Guardi (eight in the Louvre, two in Nantes, one in Grenoble, one in Brussels) illustrating the *solanità dogali*—celebrations organized in 1763 on the occasion of the election of the doge.

(Venice, 1712– Venice, 1792)
The Doge on the Bucentauro at San Niccolo du Lido,
c. 1766–70
Canvas, 26⅜ x 39⅜ in. (67 x 100 cm)

PLATE 347.

Jaime Hughet

(Valls, c. 1415–
Barcelona, 1492)
*The Flagellation of
Christ*, c. 1450
Wood, 36¼ x 61⅜
in. (92 x 156 cm)

In this altarpiece, painted for the confraternity of shoemakers
in Barcelona, Hughet (rather like Fra Angelico) remained
faithful to Gothic tradition in his use of a gold background
while showing a "modern" concern for the construction of a
convincing illusion of space through the use of perspective
and light.

PLATE 348.
Domenikos
Theotokópoulos,
known as El Greco
(Candie, 1541–
Toledo, 1614)
*Christ on the Cross
Adored by Two
Donors*, c. 1585–90
Canvas, 102⅜ x 67⅜
in. (260 x 171 cm)

This canvas, painted for a convent of Hieronymite nuns in
Toledo, Spain, and acquired by the Louvre in 1908, had been
part of King Louis-Philippe's Galerie Espagnole—a private col-
lection of more than four hundred paintings he assembled
beginning in 1835, when Romanticism was making Spain
fashionable.

PLATE 349.
Francisco de
Zurbarán (Fuente
de Cantos, 1598–
Madrid, 1664)
*The Lying-in-State
of the Body of Saint
Bonaventure,* 1629
Canvas, 96½ x 86⅝
in. (245 x 220 cm)

This is one of four episodes from the life of the saint painted
for the Colegio de San Buenaventura in Seville, to comple-
ment four others painted previously by Francisco de Herrera.

PLATE 350.
Juan Carreño de
Miranda (Avilés,
1614–Madrid, 1683)
*The Founding of
the Trinitarian
Order,* 1666
Canvas, 16 ft. 4⅞ in.
x 10 ft. 10⅜ in.
(5 x 3.31 m)

Painted for the high altar of the Trinitarian church in Pamplona, Spain, this work was given to the Louvre in 1969.

PLATE 351.
Jusepe de Ribera
(Játiva, 1591–
Naples, 1652)
*The Club-Footed
Boy*, 1642
Canvas, 64⅝ x 35⅝
in. (164 x 93 cm)

This is a famous example of the Caravaggesque naturalism of
Ribera, known as "Il Spagnoletto" (the Spaniard), who settled
in Naples in 1616.

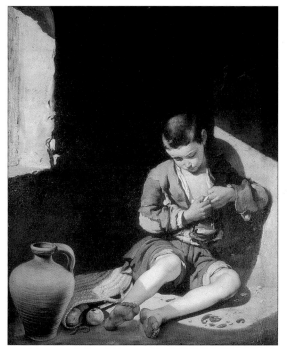

PLATE 352.
Bartolomé
Estebán Murillo
(Seville, 1618–
Seville, 1682)
The Young Beggar,
c. 1650
Canvas, 52¾ x 39⅜
in. (134 x 100 cm)

Abandoning the affected sentimentality typical of his sacred subjects, Murillo here worked with considerable verve, using a Caravaggesque naturalism absorbed from the work of Ribera (note the dirty soles of the boy's feet in the foreground).

PLATE 353.
Francisco Goya
y Lucientes
(Fuendetodos, 1746–
Bordeaux, 1828)
*The Marquesa de la
Solana*, c. 1793
Canvas, 71⅛ x 48 in.
(181 x 122 cm)

Some paintings are so handsome, and so seemingly simple, that
they must be admired in silence. Goya's paintings are like that.

PLATE 354.
Francisco Goya
y Lucientes
(Fuendetodos, 1746–
Bordeaux, 1828)
*Ferdinand
Guillemardet,* 1798
Canvas, 73¼ x 48¾
in. (186 x 124 cm)

SPANISH PAINTING

☞ *From room 32 you
can take the stairs to
exit via the Porte des
Lions.*

Sculpture

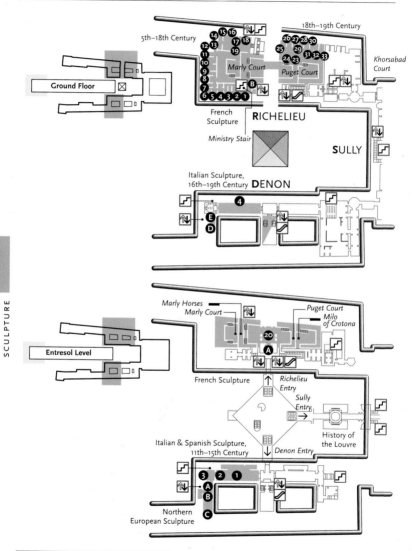

SCULPTURE

Ground Floor

5th–18th Century

18th–19th Century

Marly Court

Puget Court

Khorsabad Court

French Sculpture

RICHELIEU

Ministry Stair

SULLY

Italian Sculpture, 16th–19th Century

DENON

Entresol Level

Marly Horses
Marly Court
Puget Court
Milo of Crotona

French Sculpture

Richelieu Entry

Sully Entry

History of the Louvre

Italian & Spanish Sculpture, 11th–15th Century

Denon Entry

Northern European Sculpture

Access and Tour

The sculpture galleries consist of two independent circuits on either side of the Hall of the Pyramid: French sculpture in the Richelieu wing, sculpture from other countries in the Denon wing. From the Hall of the Pyramid, take the Richelieu entry to reach the galleries of French sculpture, which are exhibited on the ground floor in and around two roofed courtyards: the Marly Court at left and the Puget Court at right, between which is the Girardon Crypt. The Richelieu passage between the two courtyards offers an excellent general view of them (and especially of Pierre Puget's *Milo of Crotona*, plate 382, which is not seen to advantage in the court itself); elevated views that are even more dramatic can be enjoyed from a "bridge" linking the two courts and their adjacent sets of galleries.

Once you reach the Marly Court, proceed left, toward the Ministry stair, to start the sequence of galleries containing the earliest works on the tour, extending from the Middle Ages to the seventeenth century: Romanesque (rooms 1–3), Gothic (rooms 4–10), Renaissance (rooms 11–15), and the "century of Louis XIII" (rooms 16–19). In the center, on the entresol level between the two roofed courts with their monumental sculpture intended for display in gardens and public squares, is the Girardon Crypt (room 20; named after François Girardon's equestrian portrait of Louis XIV, which is in the middle of the room), containing sculpture from the reign of Louis XIV. Off the Puget Court, at right, is a second cluster of galleries (rooms 21–33) containing eighteenth-century sculpture, organized around three thematic galleries: tombs (room 21), academic reception pieces (room 25), and statues of great men (room 29).

Sculpture from countries other than France is installed in the Denon wing on the opposite side of the Hall of the Pyramid. Italian and Spanish sculpture from the eleventh to the fifteenth century is displayed on the entresol level, at right, in the Donatello Gallery (formerly part of the imperial stables). To one side is a study gallery designed for the blind and vision impaired. Proceeding to the left around the Lefuel Court, you

Frontispiece:
Antonio Canova,
Cupid and Psyche
(detail; see plate 415)

SCULPTURE

will encounter three more galleries on the entresol level (A–C), which contain northern European sculpture from the twelfth to the sixteenth century; directly above them, on the ground floor, are two additional galleries (D–E) containing northern European sculpture of the seventeenth to the nineteenth century. If you walk from room E through the Mollien stairwell and turn right, you will find the large Michelangelo Gallery (room 4; formerly known as the Galerie Mollien), which contains Italian sculpture from the sixteenth to nineteenth centuries. At its far end is the Denon vestibule, from which you can exit into the Hall of the Pyramid—unless you prefer to take a break in the cafe in the Mollien stairwell, which boasts fine views of the architectural sculpture in the Cour Napoléon.

History of the Collection

When the Muséum Central des Arts first opened its doors in 1793, only ancient sculpture was on display, for that was the only kind then deemed worthy of study by artists. There was one notable exception: Michelangelo's *Slaves* (plate 412) seized from Cardinal Richelieu's Château Le Poitou and installed in the Apollo Gallery in 1794.

Otherwise, postclassical sculpture was initially left to other institutions. Reception pieces by those who were official "sculptors to the king," which had been kept in the rooms of the Louvre occupied by the Académie Royale, were sent to Versailles. Sculpture seized from religious institutions and émigrés was gathered by Alexandre Lenoir in the storage depot at the former convent of the Petits-Augustins (now part of the Ecole des Beaux-Arts complex), which he transformed into the Musée des Monuments Français. After 1815, when France had to return most of the antiquities it had seized in Italy, some fifty celebrated pieces from the Musée des Monuments Français were moved to the Galerie d'Angoulême in the Louvre, which opened in 1824; these included *Diana the Huntress* from the Château d'Anet (plate 103), as well as several

large pieces from the gardens at Versailles, notably Puget's *Milo of Crotona*.

Léon de Laborde—named curator of medieval, Renaissance, and modern sculpture in 1849—developed the collection of medieval sculpture, which occasionally triggered polemical outbursts indicating that this area of culture remained controversial. The Louvre made its first purchase of a medieval statue in 1850 (*King Childebert*, plate 359), and its first purchase of a medieval Italian sculpture in 1876 *(Stanga Door)*. In 1871, after having developed the collection of medieval and Renaissance objects, Henri Barbet de Jouy was named curator of a new department of medieval, Renaissance, and modern sculpture and art objects, which was split into two departments in 1893. Louis Courajod, curator of the new sculpture department, set about transforming the collection into a "living course in French sculpture." Thanks to donations (Marquise Arconati-Visconti, 1914; Mège bequest, 1958) and acquisitions (Donatello's *Virgin and Child*, 1880, plate 404; reliefs from the Hôtel de Besenval by Clodion, 1986, room 30), this effort has been continued. After being installed first in the Pavillon des Etats in 1932, then in the Pavillon de Flore (which became part of the museum in 1969), the sculpture collections are now shown to fine effect in a new installation conceived for the Grand Louvre.

PLATE 355.
*Daniel among
the Lions,*
6th century and
late 11th century
Paris
Marble, 19⅝ x 20⅞
x 18⅞ in. (50 x 53 x
48 cm)

SCULPTURE

The sculptures in these first rooms are fragments from buildings no longer extant—in some cases, destroyed centuries ago. This capital is from a basilica founded in Paris by the Frankish king Clovis, and it was re-used in the new Sainte-Geneviève basilica in the eleventh century.

☞ To reach the
galleries of French
sculpture located
around the Marly
Court, you have to
cross the lower landing
of the Ministry stair.

PLATE 356.
The Dead Christ,
known as *The*
Courajod Christ,
2d quarter of
12th century
Burgundy
Wood with traces
of gilt and poly-
chrome, 61 x 66⅛ x
11¾ in. (155 x 168 x
30 cm)

PLATE 357.
Saint Michael
Slaying the Dragon,
2d quarter of
12th century
Stone, 33½ x 30⅜ x
9¾ in. (85 x 77 x 25
cm)

SCULPTURE

356. This fragment comes from a group depicting the removal
of Christ's body from the cross.

357. Originally this fragment was part of a tympanum on the
abbey of Notre-Dame in Nevers, France.

PLATE 358.
King Solomon and
The Queen of Sheba,
last quarter of
12th century
Ile-de-France
Stone, *King Solomon:*
96⅛ x 17⅝ in. (244
x 45 cm); *The Queen
of Sheba:* 92½ x 17⅜
in. (235 x 44 cm)

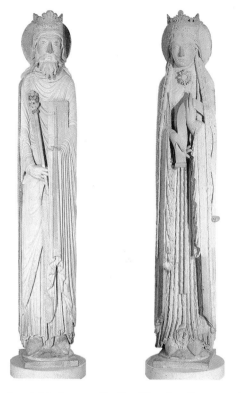

Close in spirit to those on the Royal Portal at Chartres cathedral, these column-figures come from the west facade of the collegiate church of Notre-Dame in Corbeil, France.

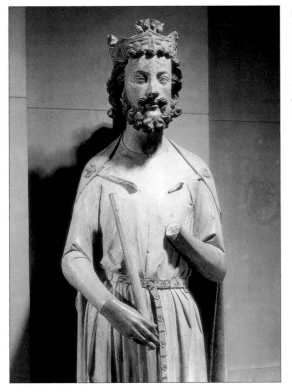

PLATE 359.
King Childebert
(detail), c. 1239–44
Ile-de-France
Limestone with
traces of polychrome,
75¼ x 20⅞ x 21⅝ in.
(191 x 53 x 55 cm)

This statue once decorated the refectory of the abbey of Saint-Germain-des-Prés, Paris.

PLATE 360.
*Head of a Woman
with Hat in the
Shape of a Tower,*
1st third of 13th
century
Champagne
Stone, 8⅜ x 6½ x 7⅞
in. (21 x 16 x 20 cm)

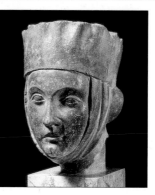

PLATE 361.
*Saint Matthew
Taking Dictation
from an Angel,*
2d quarter of
13th century
Chartres
Limestone,
26 x 19⅝ in.
(66 x 50 cm)

SCULPTURE

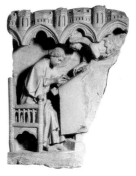

360. Probably from Reims cathedral, this high-relief sculpture was influenced by the art of the Ile-de-France.

361. This fragment probably was originally part of the choir screen at Notre-Dame de Chartres.

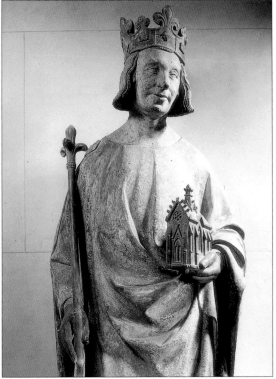

PLATE 362.
*Charles V, King
of France* (detail),
1365–80
Ile-de-France
Stone, 76¾ x 28 x
16⅛ in. (195 x 71 x
41 cm)

SCULPTURE

Charles V, who transformed the Louvre fortress into a luxurious
residence, was quite fond of precious objects (see his scepter,
plate 425), as were his brothers Philippe de Bourgogne, Jean de
Berry, and Louis d'Anjou.

PLATE 363.
Jean de Liège
(active from 1361–
died 1381)
*Tomb for the
Entrails of Charles
IV le Bel (died 1328)
and Jeanne
d'Evreux (died 1371),*
1372
Marble, height:
43⅜ in. (110 cm)

PLATE 364.
*Tomb of
Philippe Pot,*
last quarter of
15th century
Burgundy
Painted stone,
70⅞ x 104⅜ in.
(180 x 265 cm)

SCULPTURE

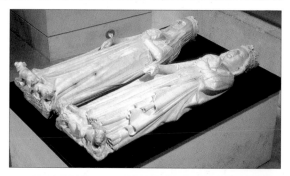

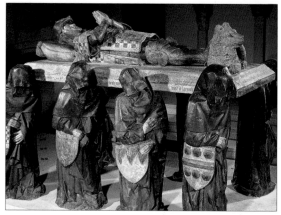

363. Beginning in the fourteenth century, the bodies, hearts, and entrails of princes and kings were often distributed among different tombs (see also plate 374).

364. Philippe Pot (died 1493), grand *sénéchal* of the duchy of Burgundy, oversaw the preparation of his tomb (originally in a chapel in the abbey of Cîteaux) before his death; this spooky re-creation of a funeral procession was an innovation.

PLATE 365.
Saint John on Calvary,
3d quarter of
15th century
Loire Valley
Wood with traces of
polychrome, 55 1/8 x
18 1/8 x 15 3/8 in.
(140 x 46 x 39 cm)

PLATE 366.
The Education of the Holy Child,
late 15th century
Bourbonnais
Stone with traces of
polychrome, 31 1/8 x
17 5/8 in. (79 x 45 cm)

SCULPTURE

365. This fragment from a Crucifixion scene comes from the abbey of Beaugerais in Touraine, France.

PLATE 367.
Michel Colombe

SCULPTURE

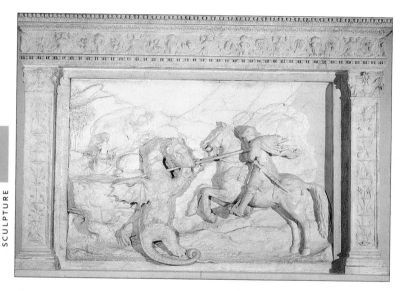

(Berry or
Bourbonnais,
c. 1430–Tours,
after 1511?)
*Saint George and
the Dragon,* 1508–9
Marble, 68⅞ x 107⅛
in. (175 x 272 cm)

The framing elements of this piece from the upper chapel of
the Château de Gaillon (summer residence of the archbishops
of Rouen) indicate the degree to which the new Italian decora-
tive vocabulary penetrated France during the first decade of
the sixteenth century.

PLATE 368.
Louise de Savoie,
early 16th century
Loire Valley
Terra-cotta,
18½ x 21¼ x 9⅛ in.
(47 x 54 x 23 cm)

PLATE 369.
Workshop of
Guillaume
Regnault
(c. 1460–1532)
Virgin and Child,
1st third of 16th
century
Loire Valley
Marble, 72 x 23⅝ in.
(183 x 60 cm)

SCULPTURE

368. The tempered realism of this portrait of the mother of King François I brings to mind certain Florentine busts of the fifteenth century (see those in the Donatello Gallery, on the entresol level of the Denon wing).

369. Like the alabaster *Virgin and Child* by Olivet (displayed next to it in the gallery), this statue diverges somewhat from the new Italian style, despite the infant's resemblance to Italian putti.

PLATE 370.
Jean Goujon
(Normandy?, c. 1510–
Bologna, c. 1566)
Nymph and Triton,
c. 1547–49. Paris
Stone, 28⅝ x
76¾ x 5⅛ in.
(73 x 195 x 13 cm)

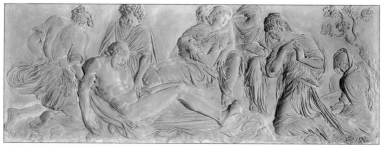

SCULPTURE

PLATE 371.
Jean Goujon
(Normandy?, c. 1510–
Bologne, c. 1566)
*Lamentation over
the Dead Christ,*
1544
Stone, 26⅜ x 71⅝ in.
(67 x 182 cm)

370. *Nymph and Triton* is one of Goujon's reliefs that were removed from the Fontaine des Innocents (originally in the Saints-Innocents cemetery, Paris) and replaced by copies when the fountain was rebuilt in the center of a public square in Paris.

371. This comes from the choir screen (destroyed in 1745) of Saint-Germain-l'Auxerrois, where it had originally been flanked by Goujon's reliefs of the four evangelists (also in room 14).

PLATE 372.
Attributed to
Germain Pilon

(Paris, c. 1528–
Paris, 1590)
*Lamentation over
the Dead Christ*
Bronze, 18⅝ x 32⅜
in. (47.6 x 82.2 cm)

PLATE 373.
Germain Pilon
(Paris, c. 1528–
Paris, 1590)
Virgin of Sorrows,
c. 1585
Polychrome terra-
cotta and gypsum,
66⅛ x 46⅞ x 30⅝ in.
(168 x 119 x 78 cm)

SCULPTURE

This is a model for a marble statue that was commissioned
for the funerary rotunda for the Valois dynasty, to be located next
to the basilica of Saint-Denis. The rotunda was never completed;
the statue is now in the church of Saint-Paul–Saint-Louis, Paris.

PLATE 374.
Barthélémy Prieur
(Berzieux, 1536–
Paris, 1611)
*Monument for the
Heart of Constable
Anne de
Montmorency*
Serpentine columns
with statues of
Abundance, Peace,
and Justice
Marble and bronze,
120½ x 19⅜ in. (at
base) (306 x 49 cm)

SCULPTURE

The architectural parts of this monument, previously in the Celestine church in Paris, were designed by Jean Bullant, architect of the châteaus of Montmorency, Ecouen, and Chantilly.

PLATE 375.
Sibyls (?),
mid-16th century
Champagne
Painted stone, left to
right: 25 x 9⅝ x 5¼ in.
(63.5 x 24.7 x 13.2 cm);
25⅜ x 10¼ x 6⅜ in.
(64.6 x 25.8 x 16.1 cm);
24½ x 9⅝ x 5¼ in.
(62.3 x 24.4 x 13.1 cm)

SCULPTURE

PLATE 376.
Pierre I Biard
(Paris, 1559–
Paris, 1609)
Fame, 1597
Bronze, 79½ x 47¼
in. (202 x 120 cm)

This statue once graced the tomb of the duke and duchess of Epernon in Cadillac, France.

PLATE 377.
Jacques Sarazin
(Noyon, 1592–
Paris, 1660)
Temperance
Marble, 40¼ x
29½ x 3½ in.
(102 x 75 x 9 cm)

PLATE 378.
Attributed to
Jacques Sarazin
(Noyon, 1592–
Paris, 1660)
*Louis XIV as a
Child,* 1643–47
Bronze, 18½ x
17⅜ x 9⅜ in.
(47 x 44 x 24 cm)

SCULPTURE

377. This is one of four reliefs from the monument for the heart of Louis XIII, which was originally in the large Jesuit church in Paris (now Saint-Paul–Saint-Louis).

378. At one end of the Pont au Change, a monument was erected (dedicated 1647) commemorating the transfer of the monarchy from the ailing Louis XIII to the dauphin Louis (later Louis XIV, whose bust from the monument is seen here) and his mother, Anne of Austria, who served as regent.

PLATE 379.
Guillaume I
Coustou (Lyons,
1677–Paris, 1746)
*Horse Restrained
by a Groom,*
known as *Marly
Horse,* 1739–45
Marble, 11 ft. 7¾ in.
x 9 ft. 2¾ in. x 3 ft.
9⅜ in. (3.55 x 2.84 x
1.15 m)

SCULPTURE

This sculpture was part of two groups created to decorate the royal horse pond at the Château de Marly, outside Paris. During the Revolution they were moved, at Jacques-Louis David's suggestion, to the Champs-Elysées; in 1985 the originals were moved to the Louvre and copies were installed on the Champs-Elysées.

☛ *Leave room 19b and take the steps down to the entresol level of the Marly Court, then head toward the Girardon Crypt, which is between the Marly and Puget Courts.*

PLATE 380.
Antoine Coysevox
(Lyons, 1640–
Paris, 1720)
*The Prince of
Condé,* 1688
Bronze, 29½ x 27⅝
x 12⅝ in. (75 x 70 x
32 cm)

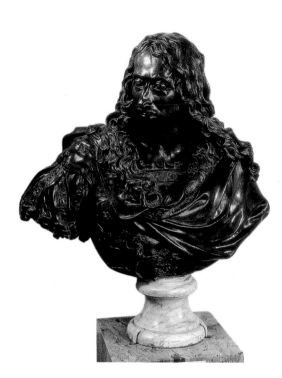

SCULPTURE

PLATE 381.
Pierre Puget
(Marseilles, 1620–
Marseilles, 1694)
*Alexander and
Diogenes*, 1689
Carrara marble,
130⅝ x 116½ x 17⅜ in.
(332 x 296 x 44 cm)

PLATE 382.
Pierre Puget
(Marseilles, 1620–
Marseilles, 1694)
Milo of Crotona,
1671–82
Marble, 106⅜ x
55⅛ x 38⅝ in.
(270 x 140 x 98 cm)

SCULPTURE

A Greek athlete and philosopher, Milo of Crotona fatally over-
estimated his strength, resulting first in his hand being
crushed by a falling tree trunk and then in his being devoured
by wild beasts. His story illustrated the same stoic tolerance of
pain endured by other ancient Greeks; see, for example,
Marsyas (plate 105).

PLATE 383.
Martin Van den
Bogaert, known as
Martin Desjardins

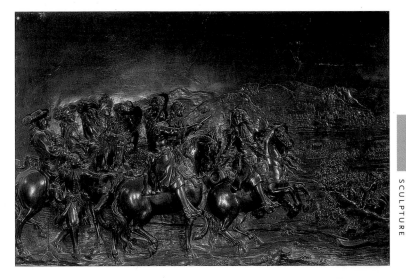

(Breda, 1637–
Paris, 1694)
*The Crossing of
the Rhine*
Bronze relief from
the Place des
Victoires, Paris,
43⅜ x 66⅛ x 4⅝ in.
(110 x 168 x 12 cm)

PLATE 384.
Etienne-Maurice
Falconet (Paris,
1716–Paris, 1791)
Menacing Cupid,
Salon of 1757
Marble, 35¾ x 19⅝
in. (91 x 50 cm)

PLATE 385.
Edme Bouchardon
(Chaumont, 1698–
Paris, 1762)
*Cupid Fashioning a
Bow from Hercules'
Club,* 1747–50
Marble, 68⅛ x 29½
x 29½ in. (173 x 75 x
75 cm)

SCULPTURE

☞ *Enter the first gallery devoted to funerary sculpture (room 21), then go left to enter the following sequence of small rooms (22–24), installed chronologically.*

PLATE 386.
Jean-Baptiste
Pigalle (Paris, 1714–
Paris, 1785)
Voltaire, 1776
Marble, 59 x 35 x
30⅜ in. (150 x 89
x 77 cm)

SCULPTURE

SCULPTURE

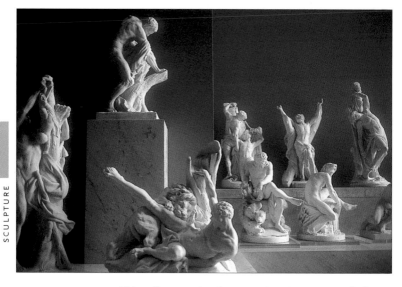

This gallery contains the "reception pieces" required of every sculptor prior to being admitted to the Académie Royale.

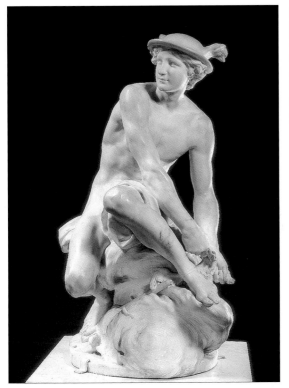

PLATE 387.
Jean-Baptiste
Pigalle (Paris,
1714–Paris, 1785)
Mercury, 1744
Marble, 23¼ x 13¾
x 11¾ in. (59 x 35 x
30 cm)

SCULPTURE

PLATE 388.
Jean-Jacques
Caffieri (Paris,
1725–Paris, 1792)
*Canon Alexandre-
Gui Pingré,* 1788
Terra-cotta,
26⅜ x 21⅝ x 13⅜ in.
(67 x 55 x 34 cm)

PLATE 389.
Augustin Pajou
(Paris, 1730–
Paris, 1809)
*The Comtesse du
Barry,* 1773
Marble, 28⅜ x 18⅞
x 10¼ in.
(72 x 48 x 26 cm)

389. The subject of this "official" portrait bust, analogous to
a ceremonial or state portrait, was King Louis XVI's last offi-
cial mistress.

SCULPTURE

PLATE 390.
Jean-Antoine
Houdon (Versailles,
1741–Paris, 1828)
*Sabine Houdon
at the Age of Six
Months,* 1788
Plaster, 15 x 9½ x
6⅜ in. (38 x 24 x
16 cm)

PLATE 391.
Jean-Antoine
Houdon (Versailles,
1741–Paris, 1828)
Voltaire, 1778
Marble, 24¾ x 17⅜
x 13¾ in. (63 x 44.3 x
35 cm)

SCULPTURE

Communicating with stark directness the full range of human feelings and facial expressions, Houdon's portrait busts were among the greatest achievements of eighteenth-century sculpture.

PLATE 392.
Pierre Julien
(Saint-Paulien, near
Le Puy, 1731–Paris,
1804)
Poussin, 1804
Marble, 64⅝ x 40 x
48⅝ in. (164 x 101.5
x 123.5 cm)

SCULPTURE

PLATE 393.
Jean-Antoine
Houdon (Versailles,
1741–Paris, 1828)
*Mausoleum for the
Heart of Victor
Charpentier, Comte
d'Ennery,* 1781
Marble, 91⅜ x 88⅝
in. (232 x 225 cm)

PLATE 394.
Claude Michel,
known as Clodion
(Nancy, 1738–
Paris, 1814)
Pan and Syrinx,
1782
Tonnerre stone,
40⅞ x 127¼ x 12⅝ in.
(104 x 323 x 32 cm)

PLATE 395.
Claude Michel,
known as Clodion
(Nancy, 1738–
Paris, 1814)
*Egyptian Woman
with a Naos,* c. 1780
Terra-cotta,
18⅞ x 7⅝ x 5⅛ in.
(48 x 19.5 x 13 cm)

394. Pan pursues the nymph Syrinx, who escapes by being transformed into a reed, which Pan used to create the first flute—a myth about the sublimation of desire into poetry and music.

395. This early expression of French Egyptomania predates Napoleon's Egyptian expedition. A *naos* is a portable altar for carrying a statue of a god.

SCULPTURE

PLATE 396.
Denis-Antoine
Chaudet (Paris,
1763–Paris, 1810)
Peace
Silver, silver gilt,
bronze, gilt bronze,
65⅝ x 42½ x 33 in.
(167 x 108 x 84 cm)

Chaudet attempted to re-create accurately the appearance of
Greek sculpture, inspired by the archaeological explorations of
Johann Joachim Winckelmann and his French followers.

PLATE 397.
Joseph Chinard
(Lyons, 1756–
Lyons, 1813)
Young Harpist
Unfired terra-cotta,
11 x 4⅝ x 9¼ in.
(28 x 12 x 25 cm)

This little sculpture is in the style of antique terra-cottas; see plates 130 and 131.

PLATE 398.
James Pradier
(Geneva, 1790–
Rueil, 1852)
Wounded Niobid,
1822
Marble (after a plaster model of 1817),
57½ x 48¾ x 21⅝ in.
(146 x 124 x 55 cm)

Scholarship students at the French Academy in Rome could study plaster copies in the gardens of the Villa Medici of the famous antique *Niobids* group (marble originals in the Uffizi, Florence). Here, Pradier "corrected" one of these figures to reconcile it with contemporary Neoclassical taste.

399.
François Rude
(Dijon, 1784–
Dijon, 1855)
*Young Neapolitan
Fisherman Playing
with a Turtle,*
1831–33
Marble, 32⅜ x 34⅝ x
18⅞ in. (82 x 88 x
48 cm)

SCULPTURE

PLATE 400.
Auguste Préault
(Paris, 1809–
Paris, 1879)
Silence, 1842
Plaster, diameter:
16⅛ in. (41 cm);
height: 7½ in
(19 cm)

400. This plaster cast of a relief from the tomb of Jacob Roblès in the Père Lachaise cemetery in Paris inspired Théophile Gautier to write in 1849 that it was "seemingly fashioned with the large chisel of Death." Jules Michelet had commented in 1846, "Horror of the fatal enigma, the seal that closes the mouth at the moment one knows the word, all that was grasped for once in a sublime work that I came across in an enclosed part of Père Lachaise, in the Jewish cemetery."

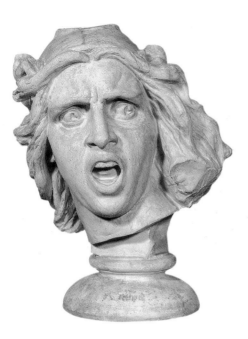

PLATE 401.
François Rude
(Dijon, 1784–
Dijon, 1855)
The Marseillaise
Plaster, 26¾ x 25⅝
x 7⅛ in. (68 x 65 x
18 cm)

Rude's atelier produced this plaster model for the head of *The
Marseillaise* on the Arc de Triomphe.

PLATE 402.
Antoine-Louis
Barye (Paris,
1795–Paris, 1875)
Stag from Java
Bronze, height: 4 in.
(10 cm)

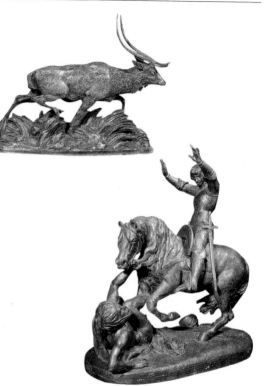

PLATE 403.
Antoine-Louis
Barye (Paris, 1795–
Paris, 1875)
*Charles VI
Frightened in the
Forest of Le Mans,*
1833
Plaster coated with
wax resembling
bronze, 19½ x 18⅛ x
9½ in. (49.5 x 46
x 24 cm)

SCULPTURE

403. The horse recalls Barye's achievements as an animal
sculptor who produced small bronzes in the course of devel-
oping his large works (see also *Lion and Serpent* in the Puget
Court), but the group as a whole takes a different subject and
approach. It evokes the fear that seized King Charles VI while
he was passing through the forest of Le Mans, an early indica-
tion of the madness that would become a factor in the Hundred
Years War.

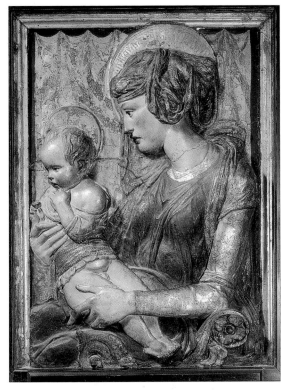

PLATE 404.
Donatello
(Florence, 1386–
Florence, 1466)
Virgin and Child,
Padua, after 1443
Painted and gilded
terra-cotta, $40^{1}/_{4}$ x
$29^{1}/_{2}$ x $4^{5}/_{8}$ in.
(102 x 75 x 12 cm)

SCULPTURE

This small devotional relief, possibly painted by Donatello himself, may have been sent to Florence from Padua, where the sculptor was living at the time. The seriousness of the Virgin, who seems to foresee the Passion, was imitated by Andrea Mantegna.

☞ *The Donatello Gallery is located in rooms that used to house the imperial stables. To reach it, leave the Richelieu wing, cross the Hall of the Pyramid to the Denon entry, entresol level, and turn left.*

PLATE 405.
Agostino Antonio
di Duccio
(Florence, 1418–
Perugia, 1481)
*Virgin and Child
Surrounded by
Angels,* 3d quarter
of 15th century
Florence
Marble, 31⅞ x 30⅜ in.
(81 x 77 cm)

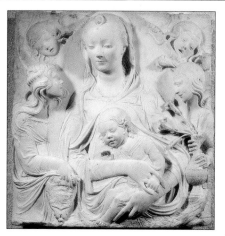

PLATE 406.
Desiderio da
Settignano
(Settignano, 1428–
Florence, 1464)
*Christ and Saint
John the Baptist
as Children*
Marble, diameter:
20⅛ in. (51 cm)

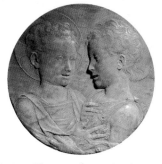

405. This piece was commissioned by Piero de' Medici from the sculptor of the Tempio Malatestiano in Rimini. The sinuous, quasi-abstract handling of the drapery is no longer indebted to the International Gothic style; instead it embodies the new ideal of sophisticated elegance being fostered at the time by intellectual circles in central Italy.

406. Following Donatello's example, Desiderio became a master of *stiacciato* (literally "squashed"), extremely low-relief technique.

PLATE 407.
Della Robbia
Workshop

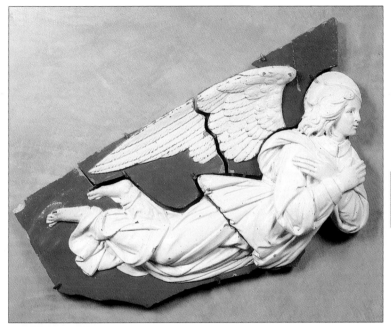

SCULPTURE

In Florence during the 1440s, Jacopo della Robbia perfected the technique of polychromed and enameled terra-cotta. The family workshop, headed by his nephew Andrea after his death, continued to put the technique to good use.

Flying Angel, early 16th century Varnished terra-cotta, $16\frac{1}{2}$ x $33\frac{3}{4}$ in. (42 x 86 cm)

PLATE 408.
Tilman
Riemenschneider
(Heiligenstadt?,
c. 1460–Würzburg,
1531)
*Virgin of the
Annunciation,*
late 15th century
Marble with poly-
chrome highlights,
20⅞ x 15⅝ x 7½ in.
(53 x 40 x 19 cm)

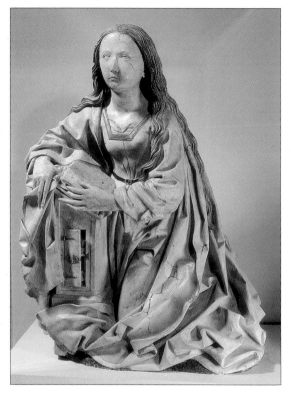

408 and **409.** Comparison of these two German depictions of
the Virgin from the late Gothic period reveals distinct differ-
ences, but they differ even more markedly from Virgins by
French sculptors of the same period (see plate 366).

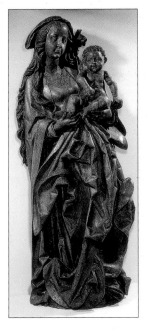

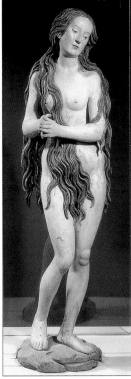

PLATE 409.
Virgin and Child,
late 15th century
Upper Rhine
Limewood, 67⅝ x
29⅞ x 19½ in.
(172 x 76 x 49.5 cm)

PLATE 410.
Gregor Erhart
(c. 1515–1540)
*Saint Mary
Magdalen,*
early 16th century
Polychrome lime-
wood, 69⅝ x 17⅜
x 16⅞ in.
(177 x 44 x 43 cm)

410. Whether praying in a bedroom or in the desert before being transported to heaven, the repentant Magdalen was one of the most popular penitential subjects of European devotional imagery from the fifteenth to the seventeenth century. When shown nude, covered only by her hair, she evokes Eve.

PLATE 411.
Adrien de Vries
(The Hague, 1546–
Prague, 1626)
*Mercury and
Psyche*, 1593
Bronze, 84⅝ x 36¼
x 28⅜ in.
(215 x 92 x 72 cm)

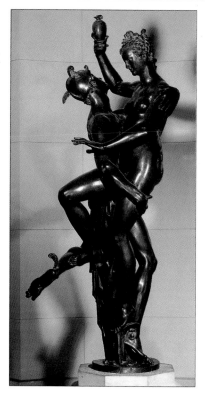

Residing in Prague from 1583 until his death in 1612, Emperor Rudolf II made it the European capital of modern science and of artistic curiosities, attracting painters like Arcimboldo (plate 329) and sculptors like Adrien de Vries, who favored the elongated figures and serpentine lines typical of his teacher Giambologna.

☞ *To reach the
Michelangelo Gallery
(previously called the
Galerie Mollien), take
the Mollien stairs
(adjacent to room 3)
up to the ground floor.*

SCULPTURE

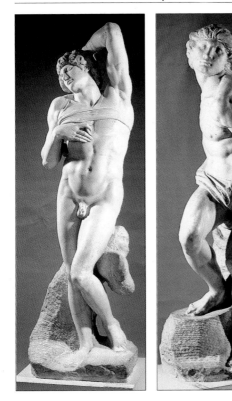

PLATE 412.
Michelangelo
Buonarroti, known
as Michelangelo
(Caprese, near
Arezzo, 1475–Rome,
1564)
Dying Slave (left)
and *Rebel Slave*
(right), 1513–15
Marble, height:
82⅜ in. (209 cm),
each

SCULPTURE

Both of these unfinished figures were intended for the monumental tomb of Pope Julius II (died 1513), but they were not used in the final composition.

In 1544 Michelangelo gave both *Slaves* to the Florentine Roberto Strozzi, who presented them to King François I a few years later. He in turn gave them to Constable Anne de Montmorency, who placed them in niches on one of the courtyard facades of his château at Ecouen. Presented to Richelieu in 1632, they subsequently decorated the portal of the cardinal's Château Le Poitou, from which they were seized during the Revolution.

PLATE 413.
Alessandro
Vittoria (Trent,
1525–Venice, 1608)
*Portrait of a
Venetian Patrician*
Terra-cotta, 33½ x
22⅝ x 14⅝ in.
(85 x 65 x 37 cm)

PLATE 414.
Gianlorenzo
Bernini (Naples,
1598–Rome, 1680)
*Cardinal Amand
de Richelieu,*
1640–41
Marble, 33⅛ x 27⅝
x 12⅝ in.
(84 x 70 x 32 cm)

SCULPTURE

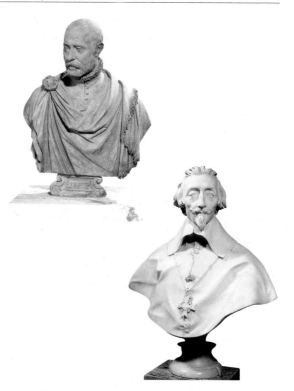

413. Vittoria was a contemporary of the architect Andrea Palladio and of the painters Bassano, Tintoretto, and Veronese.

Terra-cotta remained the preferred sculptural medium for portraits, its suppleness making it ideally suited to evoking a sitter's individuality.

414. Based on portraits sent from Paris to Rome, this bust of Louis XIII's great minister is less vivacious than those that Bernini made from life of Cardinal Scipione Borghese (Rome, Borghese Gallery) and Louis XIV (Versailles).

PLATE 415.
Antonio Canova

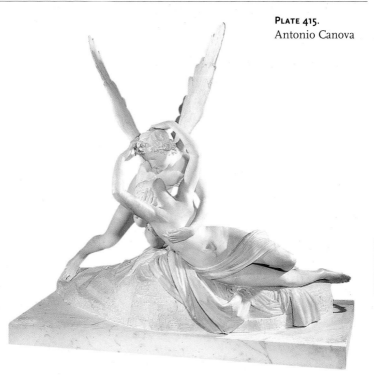

SCULPTURE

The leading Neoclassical sculptor, analogous to Jacques-Louis David in painting, Canova worked for Napoleon starting in 1802.

(Possagno, near Venice, 1757– Venice, 1822)
Cupid and Psyche, 1787–93
Marble, 21⅝ x 26¾ x 39¾ in.
(55 x 68 x 101 cm)

Objets d'Art

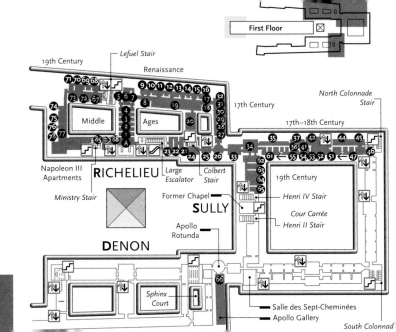

First Floor

19th Century

Lefuel Stair

Renaissance

71 70 69 68

73 72 67

74

75
76
78 77

9 10 11 12 13 14 15 16

5 6 7

8

17

18

32
31
30
29
28
27

Middle

Ages

4
3
2
1
A

19

20

North Colonnade
Stair

17th Century

17th–18th Century

35 37 42 44 45

38 41 46

36 28 → 28

Napoleon III
Apartments

RICHELIEU

23 22 21

25 26

24

33

34

62 61 ← 55 54 53 52 51 ← 47

63
64
65

19th Century

Ministry Stair

Large
Escalator

Colbert
Stair

Former Chapel

Henri IV Stair

SULLY

Cour Carrée

Henri II Stair

DENON

Apollo Rotunda

Sphinx
Court

66

Salle des Sept-Cheminées
Apollo Gallery

South Colonnade

Access and Tour

From the Hall of the Pyramid, enter the Richelieu wing and then take either the elevators or the large escalator up to the first floor, where you'll find the entry to this department (room A) next to the Café Richelieu.

Objects dating from the High Middle Ages to the end of the eighteenth century are displayed in a chronological sequence of galleries located on this floor in the Richelieu wing and in the north wing of the Cour Carrée. Treasures from the Middle Ages are between the roofed Marly and Puget Courts (rooms 1–4); those from the fifteenth century and the Renaissance are in galleries paralleling the rue de Rivoli (rooms 5–16). To the right of room 16 are two small galleries containing niello work and glassware (rooms 17–18), followed by large galleries containing tapestries and tableware (rooms 19–20). These are followed by galleries of sumptuous objects produced for European courts under the Valois and the first Bourbons (rooms 21–33).

To the east of the Boulle Salon (room 34, in the northwest corner of the Cour Carrée) are two parallel sequences of galleries with objects from the seventeenth and eighteenth centuries, which extend the length of the north wing of the Cour Carrée (rooms 35–61). Proceeding south from the Boulle Salon, in the west wing of the Cour Carrée, are the four Conseil d'Etat rooms, which contain nineteenth-century objects (rooms 62–65). The final galleries in the nineteenth-century sequence are adjacent to the Napoleon III apartments along three sides of the Marly Court (rooms 67–88). The crown jewels are exhibited separately, in the Apollo Gallery (room 66); to reach it, cross the Hall of the Pyramid to the Denon entry and go up the Victory of Samothrace stair to the first floor.

History of the Collection

The emphasis on painting in private and public collections is a modern phenomenon. Objets d'art (art objects—i.e., decorative arts) long dominated royal and princely collections, being superior in quality and considered more valuable than paint-

Frontispiece:
Pierre Delabarre,
Ewer (detail;
see plate 458)

ings. The decree issued at the founding of the Muséum Central des Arts in 1793 specified that its exhibits would include paintings, antique sculpture, and objets d'art.

Initially the collection comprised works from royal collections, those seized during the Revolution, and new acquisitions—for example, the armor of King Charles IX (plate 440), purchased in the museum's inaugural year. It also inherited the holdings of the Garde-Meuble de la Couronne, the storehouse of royal furnishings. Housed from 1774 in one of the buildings designed by Jacques-Ange Gabriel for the Place Louis XV (now Place de la Concorde), the Garde-Meuble had functioned as a public museum even before the Revolution. Most of its holdings were transferred to the Louvre in 1796. By then, almost all of Charles V's sumptuous collection had disappeared (according to the inventory of 1380, it boasted almost four thousand items), but the collection of Louis XIV was largely intact and henceforth constituted one of the museum's treasures.

Pietra dura vases and small "antique" bronzes, both originals and imitations, were among the collection's most cherished pieces. For this reason, between 1802 and 1847 the entire collection of art objects was part of the department of antique sculpture. Soon, however, Romanticism fostered a taste for medieval and Renaissance objects. The collection was considerably altered by acquisition in 1825 of the Durand collection (ceramics, enamels, stained-glass windows), followed in 1828 by the more than eight hundred objects assembled by the painter Pierre Revoil and in 1830 by the treasury from the Order of the Holy Spirit, which had been founded by King Henri III.

In 1849 sculpture and art objects from the medieval, Renaissance, and modern periods were separated from the antiquities and given their own department, headed by Léon de Laborde. Under the Second Empire, the collection of art objects was enriched, most notably, by the Sauvageot donation in 1856 (almost fifteen hundred items, medieval objects, and faience by Bernard Palissy) and the purchase of the Campana collection in 1862, which included fine majolica.

In 1893 the department was finally split in two, with post-classical sculpture and art objects given separate departments. Since then, acquisitions, transfers from the Garde-Meuble, gifts, and works donated in lieu of taxes have further strengthened the department, whose holdings are shown more fully in the Grand Louvre installation than ever before. Linkage of the Louvre's objets d'art collection to that of the Musée des Arts Décoratifs, which occupies the far end of the Richelieu wing and the Pavillon de Marsan, is currently under discussion.

OBJETS D'ART

PLATE 416.
Barberini Diptych,
1st half of 6th
century
Constantinople
Ivory, 13½ x 10⅝ in.
(34.2 x 26.8 cm)

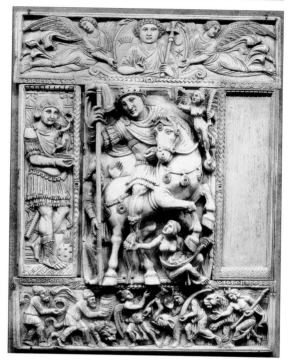

OBJETS D'ART

After the destruction of the Western Roman Empire by the
Barbarians in A.D. 476, Constantinople, capital of the Eastern
Empire, continued to cultivate forms that had flourished in
the early Empire. Ivory sculpture, in particular, took on
renewed vigor as a vehicle for Christian iconography.

This composite plaque, originally half of an imperial dip-
tych, shows an emperor—perhaps Justinian—on horseback
savoring his victory while the vanquished population brings
him tribute (bottom); a figure of Christ gives his blessing (top).

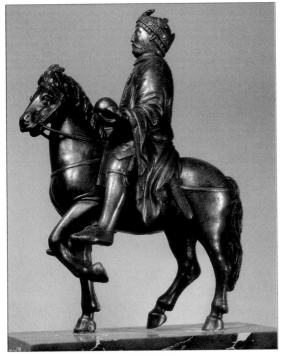

PLATE 417.
*Equestrian
Statuette of
Charlemagne*
Carolingian,
9th century
Bronze with traces
of gilt, height:
9¼ in. (23.5 cm)

This small bronze, which comes from the cathedral in Metz, represents a Carolingian emperor, either Charlemagne or his grandson Charles the Bald. The horse was made during the Late Empire and restored in the eighteenth century; the figure comes from the Carolingian period.

OBJETS D'ART

PLATE 418.

Paten

Alexandria (?), 1st century, and abbey of Saint-Denis, 9th century

Serpentine, gold, garnets, and precious stones, diameter: 6⅝ in. (17 cm)

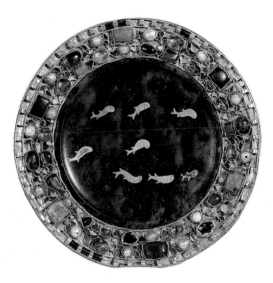

Presented to the abbey of Saint-Denis by Charles the Bald, this paten (a small dish used to present the Communion host) consists of an antique saucer made of serpentine set into a Carolingian mount. The incorporation of antique elements in this way would long be a constant of luxury goldsmith work.

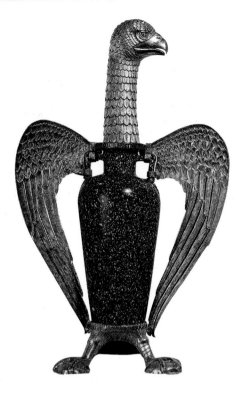

PLATE 419.
Eagle Vase of Suger
Vase from Egypt or
Imperial Rome;
eagle mount from
Saint-Denis,
before 1147
Antique porphyry
vase in setting of
gilded and nielloed
silver, 17 x 10⅝ in.
(43.1 x 27 cm)

OBJETS D'ART

During his abbacy at Saint-Denis, where he rebuilt the abbey
church, Suger commissioned goldsmiths based in the Ile-de-
France to fashion liturgical objects incorporating ancient arti-
facts. Like the light through the church's stained-glass win-
dows, the splendor of these liturgical vessels was meant to
make God's magnificence visible.

PLATE 420.
Harbaville Triptych,

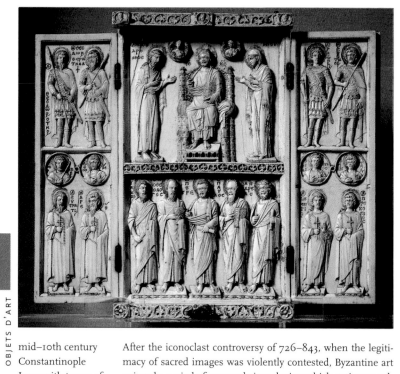

mid–10th century
Constantinople
Ivory with traces of
gilt and polychrome,
9⅜ x 11 in.
(24 x 28 cm)

After the iconoclast controversy of 726–843, when the legitimacy of sacred images was violently contested, Byzantine art enjoyed a period of renewed vigor during which antique models retained their authority.

PLATE 421.
Bracelet: The Resurrection, c. 1170
Meuse
Champlevé enamel on gilded copper, 4⅜ x 5¾ in. (11.3 x 14.7 cm)

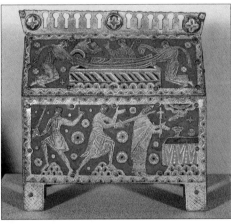

PLATE 422.
Thomas Becket Châsse, late 12th–early 13th century
Limoges
Champlevé enamel on gilded copper, gems, and separately cast applied elements, 8⅛ x 7¾ x 3½ in. (20.6 x 19.8 x 8.8 cm)

421. Though fabricated in the Meuse Valley, this ceremonial bracelet was apparently found in Russia, in the tomb of a grand duke, who may have received it as a gift from Frederick I Barbarossa.

422. At the end of the twelfth century, workshops in Limoges became renowned throughout Europe for ecclesiastical objects of all kinds made of copper decorated with champlevé enamel: *châsses* (large reliquaries), ciboria (vessels to hold the Communion host), chalices, crosses, and so on.

👁 *On each side of rooms 1–3, there are lovely views straight down into the Marly (to the left) and Puget (to the right) Courts.*

OBJETS D'ART

459

PLATE 423.
Alpais Ciborium,
c. 1200
Limoges
Signed "Maître G.
Alpais" inside the lid
Chased, engraved,
and gilded copper,
with champlevé
enamel, gems, and
separately cast
applied elements,
11¾ x 6⅝ in.
(30 x 16.8 cm)

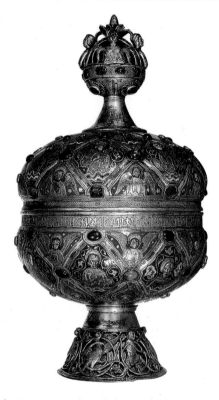

This ciborium, acquired in 1828, was apparently found near Arles in the abbey of Montmajour.

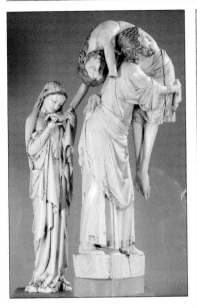

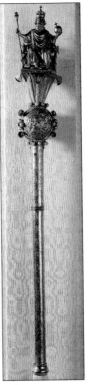

PLATE 424.
Descent from the Cross, c. 1260–80
Paris
Elephant ivory with traces of gilt and polychrome,
11⅜ x 9⅝ in.
(29 x 24.5 cm)

PLATE 425.
Scepter of Charles V, 1364(?)–80
Paris
Gold (formerly enameled with fleurs-de-lys), pearls, and gems, height:
23⅝ in. (60 cm)

OBJETS D'ART

424. Ivory carving—with secular as well as sacred subjects— enjoyed a period of renewed vitality in Paris during the middle of the thirteenth century.

425. This elegant piece bears witness to the French monarchy's taste for sumptuous artifacts at a time when Paris was, after Constantinople, the richest and most populous city in Europe. Very few of the other four thousand some objects inventoried in 1380 (after the death of King Charles V) survive.

PLATE 426.

*Reliquary Polyptych
of the True Cross,*

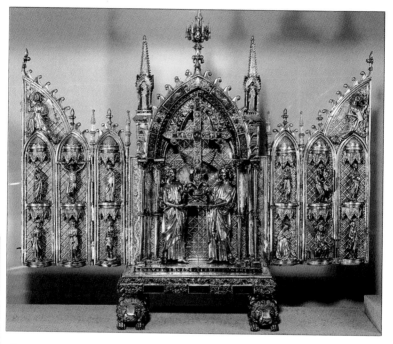

OBJETS D'ART

after 1254
Meuse or northern
France
Embossed, chased,
and engraved silver
gilt; niello inlay; and
gems, 31⅛ x 36¼ in.
(79 x 92 cm)

Made to house a relic associated with a miracle of 1254, this reliquary demonstrates the diffusion of the Parisian style to northern workshops.

PLATE 427.
Plate,
c. 1450

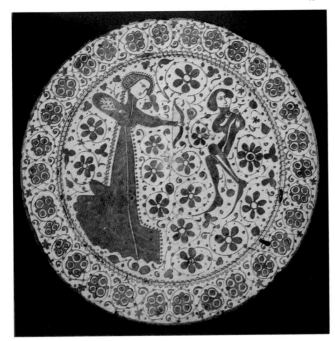

In the fifteenth century, workshops in Valencia and nearby Manisses (room 5) produced remarkable ceramics that were exported to Italy via Majorca (hence the name "majolica"). Italy soon began to produce fine ceramics as well, and craftsmen in Faenza perfected a tin-glazed earthenware technique that was later adopted by workshops in Castel Durante, Deruta, Gubbio, and Urbino—all of which produced pieces incorporating Renaissance themes and motifs for princely collections (see rooms 7 and 19).

Manisses, Spain
Tin-glazed earthenware, diameter: 15⅜ in. (39 cm)

OBJETS D'ART

463

PLATE 428.
Jean Fouquet
(Tours, c. 1420–
Tours, 1477/78)
Self-Portrait, c. 1450
Painted enamel on
copper, diameter:
2⅝ in. (6.8 cm)

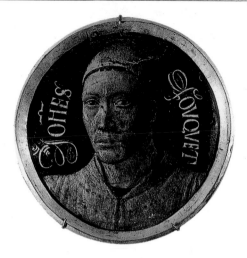

OBJETS D'ART

Originally set into a diptych frame presented to Notre-Dame
de Melun by Etienne Chevalier, adviser to Charles VII, this lit-
tle medallion served as the artist's signature. It recalls Lorenzo
Ghiberti's self-portrait on the frame of his Gates of Paradise
doors for the Baptistry in Florence, which Fouquet doubtless
saw during his Italian sojourn.

👁 *This room offers a
good view of the Palais-
Royal.*

PLATE 429.
Attributed to
Bartolomeo
Bellano (Padua,
c. 1440–Padua,
1496/97)
*Saint Jerome and
the Lion,* late 15th
century
Bronze, 9¾ x 8⅛ in.
(25 x 20.5 cm)

☞ At left, beyond the
Lefuel stair and the
galleries of nineteenth-
century art objects
(rooms 67–71), are the
Napoleon III Apart-
ments (rooms 74–81),
which you might want
to visit at this point. If
you prefer to continue
the chronological tour,
proceed to the galleries
at right (rooms 9–16),
which contain late
Gothic and Renais-
sance artifacts from
Flanders and France,
including tapestries
and goldsmith work
(rooms 8–10) plus
painted enamels and
glass (room 11).

OBJETS D'ART

465

PLATE 430.
Andrea Riccio

OBJETS D'ART

(Padua, 1470–
Padua, 1532)
Paradise, c. 1516–20
Bronze, 14⅝ x 19⅜
in. (37 x 49 cm)

Paduans by birth, both Bellano (a student of Donatello) and
Riccio specialized in small bronzes, a genre that developed
rapidly in the Renaissance. Such pieces, which were cast using
the lost-wax technique, often represent the same themes as
small antique bronzes (see plates 124 and 125). Small plaques
and cast medals underwent a parallel development during this
period (see room 14).

PLATE 431.

August, 1531–33
Sixth piece in *The Hunts of Maximilian* tapestry suite, woven in Brussels after designs by Bernaert van Orley

Wool, silk, and gold and silver thread, 14 ft. 8⅜ in. x 18 ft. 3⅝ in. (4.48 x 5.58 m)

The suite was woven in emulation of *The Acts of the Apostles* tapestry series, which was based on cartoons by Raphael (first weaving completed 1521; Vatican); some of van Orley's preparatory drawings are now in the Louvre. This series became known as *The Hunts of Maximilian* only in 1644; it would more aptly be called *The Months of Maria* or *The Months of Charles V,* for the latter monarch appears in several of the compositions along with members of his family.

☞ *After visiting room 16 (furniture and tapestry), 17 (majolica), and 18 (glassware), you will arrive in a parallel gallery (room 19, at the right) overlooking the Puget Court. In the center of the tapestry galleries (rooms 16, 19, and 20) are displays of luxury artifacts: metalwork, ceramics, enamel ware, painted glassware, and elaborate furniture of the kind found in princely households.*

OBJETS D'ART

PLATE 432.
Fontana Factory
Dish and Plate,
c. 1560–70
Urbino
Tin-glazed earthen-
ware, diameter of
basin: 8½ in.
(21.5 cm); diameter
of plate: 7⅞ in.
(20 cm)

PLATE 433.
Pierre Courteys
(died 1581)
*Oval Dish with
Apollo and the
Muses,* 3d quarter
of 16th century
Limoges
Tin-glazed earthen-
ware, diameter:
19½ in. (49.5 cm);
height: 14¾ in.
(37.5 cm)

👁 *The walls of this
gallery are hung with
The History of Scipio
tapestry suite, which
was woven at the
Gobelins manufactory
after another suite
woven for the maréchal
de Saint-André,
companion to King
Henri II. The designs
were originally
commissioned by King
François I.*

☛ *At the end of this
gallery you will find
the Colbert stair.
Looking right, you'll
see the entrance to
rooms 21–23; past the
stairs is room 24.*

Enamel vessels such as those displayed in the vitrine at the center of this room became quite fashionable in the mid–sixteenth century.

OBJETS D'ART

469

PLATE 434.
Léonard Limosin
(Limoges, c. 1505–
Limoges, c. 1575)
*Constable Anne de
Montmorency*, 1556
Painted enamel on
copper plaques set
in gilt-wood mount,
28³⁄₈ x 22 in.
(72 x 56 cm)

OBJETS D'ART

👁 *Don't miss the
collection of thirteen
pieces of so-called
Saint-Porchaire pottery,
also in this room. Little
is known about their
production, but they all
come from prestigious
collections.*

Anne de Montmorency, constable of France, built the Château
d'Ecouen (now the Musée National de la Renaissance). See also
plate 374, the monument built to contain the constable's heart.

PLATE 435.
Léonard Limosin
(Limoges, c. 1505–
Limoges, c. 1575)
*Resurrection
Altarpiece,* 1552–53
Painted enamel on
copper plaques set
in gilt-wood mount,
42⅛ x 29½ in.
(107 x 75 cm)

Tapestries, stained-glass windows, enamel altarpieces, and faience plaques gave princely chapels the allure of paradise. This *Resurrection Altarpiece,* executed after a design by the Italian Niccolò dell' Abbate (who worked closely with Primaticcio, notably at Fontainebleau), was made for the Sainte-Chapelle in Paris.

☛ *If you want to continue your tour of this department, do not descend the Richelieu escalator after room 23; instead, retrace your steps a bit and go past the Colbert stair to rooms 24–26, which overlook the Cour Napoléon.*

OBJETS D'ART

PLATE 436.
*Jezebel Promising
Naboth's Vineyard
to King Ahab,* after
a design by Lucas
van Leiden,
c. 1525–30
Stained glass,
11 x 7½ in.
(27.9 x 19.1 cm)

PLATE 437.
*Beer Stein with
Adam and Eve,*
1570–80
Siegeburg
White stoneware,
11¼ x 4⅛ in.
(28.6 x 10.5 cm)

OBJETS D'ART

PLATE 438.
"Siege of Tunis"
Ewer and Platter,

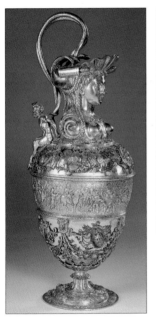

The platter is decorated with scenes from Charles V's siege of Tunis in 1535.

1558–59
Antwerp
Silver gilt and enamel, height of ewer: 17⅛ in. (43.5 cm); diameter of platter: 25¼ in. (64 cm).

OBJETS D'ART

PLATE 439.
Giovanni da
Bologna,
also known as
Giambologna and
Jean Boulogne
(Douai, 1529–
Florence, 1608)
*Nessus and
Deianira,*
c. 1575–80
Bronze, 16⅝ x 12 in.
(42.1 x 30.5 cm)

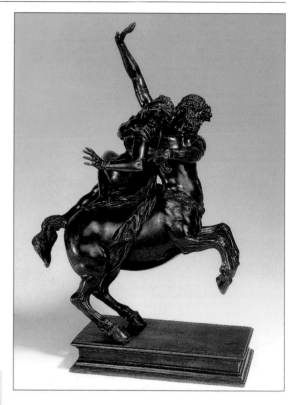

OBJETS D'ART

☛ *At left are rooms
27–32, devoted to
French tapestries and
other decorative arts of
the late sixteenth and
early seventeenth
centuries. After visiting
them, you will have to
return to the rotunda
and turn left to reach
the Boulle Salon
(room 34).*

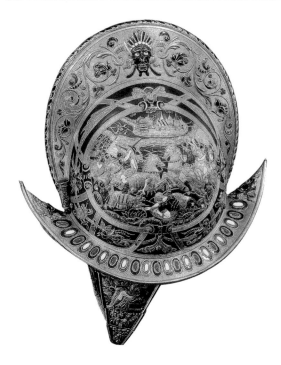

PLATE 440.
Pierre Redon
(died c. 1572)
Helmet of Charles IX, c. 1570
Embossed and gold-plated iron with enamel inlay,
13¾ x 14⅝ in. (35 x 37 cm)

The matching shield is also on view nearby.

OBJETS D'ART

PLATE 441.
Bernard Palissy
(Agen, 1510–
Paris, 1590)
"Rustic Ware"
Platter, c. 1565
Lead-glazed
earthenware,
3 x 20⅝ x 15⅞ in.
(7.4 x 52.5 x 40.3 cm)

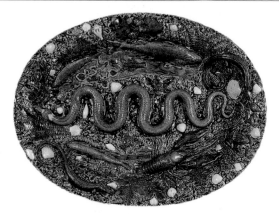

PLATE 442.
Bernard Palissy
(Agen, 1510–
Paris, 1590)
"Rustic Ware"
Water Pitcher,
c. 1565
Ceramic, 10⅝ x 4⅝
in. (27 x 12 cm)

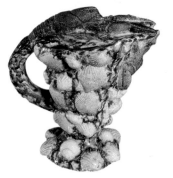

OBJETS D'ART

Authentic pieces of "rustic ware" by Palissy, with their charac-
teristic high-relief figures of snakes, fruit, and other natural
elements, are extremely rare. Most of those attributed to him
are in fact nineteenth-century productions.

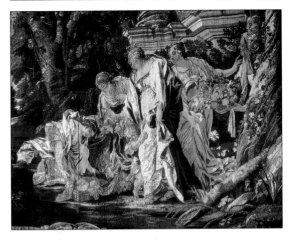

PLATE 443.
The Finding of Moses (detail),
c. 1630
Third piece in *Old Testament* tapestry suite, woven in the Louvre workshop, Paris, after designs by Simon Vouet
Wool and silk,
16 ft. 2⅞ in. x 19 ft. 3½ in. (4.95 x 5.88 m)

OBJETS D'ART

☛ To reach the galleries in the north wing of the Cour Carrée, return to the Giambologna Rotunda (room 26) and turn left.

PLATE 444.
André-Charles
Boulle (Paris,
1642–Paris, 1732)
*Armoire with
Figures of Socrates
and Aspasia*, c. 1710
Oak and pine carcase,
ebony, copper, tor-
toiseshell, and brass
marquetry, gilt-
bronze mounts,
104⅜ x 53⅛ x 21¼ in.
(265 x 135 x 54 cm)

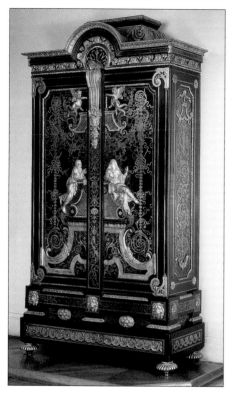

☛ *The Boulle Salon
(room 34) is a cross-
roads. If the galleries
in the north wing of
the Cour Carrée are
closed (as sometimes
happens), or if you
are tired and want to
shorten the tour, you
can proceed directly to
your right to the Con-
seil d'Etat rooms with
their Louis-Philippe
interiors (rooms 62–
65), then retrace your
steps, turn left, and
continue beyond the
large escalators to the
Napoleon III Apart-
ments (rooms 74–81).*

Boulle is the most famous of all French cabinetmakers. As
with Bernard Palissy (see plates 441 and 442), it is not always
easy to distinguish authentic Boulle pieces from imitations
produced outside his workshop.

This armoire incorporates what is called Boulle marquetry,
fabricated by gluing together sheets of brass and tortoiseshell
and then cutting decorative patterns into them. Two kinds of
panels can be assembled from the resulting pieces: *première-
partie*, consisting of a dark shell ground with brass inlay; and
contre-partie, consisting of a light brass ground with shell inlay.

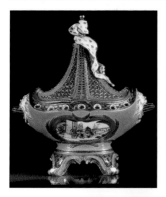

PLATE 445.
Sèvres
Manufactory
*"Ship" Potpourri
of Madame de
Pompadour*, 1760
Soft-paste porcelain,
14⅝ x 13¾ in.
(37 x 35 cm)

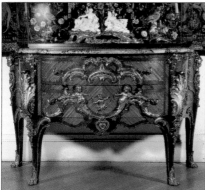

PLATE 446.
Charles Cressent
(Amiens, 1685–
Paris, 1768)
*"Monkey"
Commode*, c. 1745
Pine and oak carcase,
satinwood and pur-
plewood veneer, gilt-
bronze mounts,
Sarrancolin marble
top, 35⅜ x 57⅞ x
24¼ in. (90 x 147
x 63 cm)

446. Cressent's training as a sculptor enabled him to create
elegant figured mounts for his rococo furniture. Here, the
playful depiction of a monkey being swung by two putti
derives from similar motifs in arabesque designs.

OBJETS D'ART

PLATE 447.
François-Thomas
Germain (Paris,
1726–Paris, 1791)
Firedog, 1757
Gilt bronze,
23¼ x 23⅝ x 17⅝ in.
(59 x 60 x 45 cm)

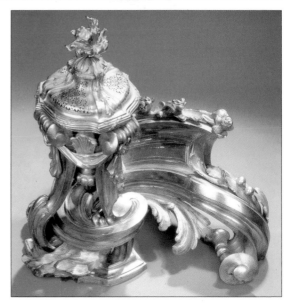

OBJETS D'ART

Goldsmith to the king (as his father, Thomas Germain, had
been), François-Thomas was granted lodgings in the Louvre,
on the ground floor of the Grande Galerie.

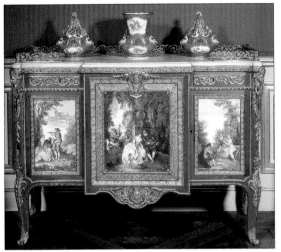

PLATE 448.
Martin Carlin
(Fribourg, c. 1730–
Paris, 1785)
*Three-Door
Commode for the
Comtesse du Barry,*
1772
Oak carcase; veneer
of pear, rosewood,
and amaranth; with
Sèvres porcelain
panels (1765)
painted after
compositions by
Jean-Baptiste Pater,
Nicolas Lancret,
and Carle Van Loo,
$34^{3}/_{8}$ x $47^{1}/_{4}$ x $18^{7}/_{8}$ in.
(87 x 120 x 48 cm)

OBJETS D'ART

PLATE 449.
Jean-Henri
Riesener (Paris,
1734–Paris, 1806)
*Roll-Top Desk of
Queen Marie-
Antoinette,* 1784
Marquetry with
sycamore lozenge
veneer, gilt-bronze
mounts, 41³⁄₈ x 44¹⁄₂
x 25¹⁄₄ in. (105 x 113
x 64 cm)

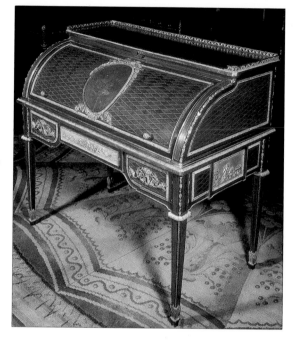

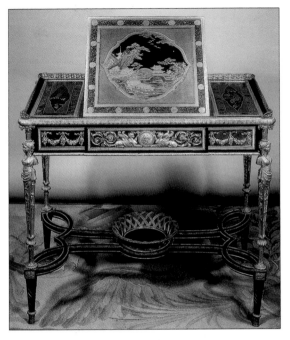

PLATE 450.
Adam Weisweiler
(Neuwied, 1744–
Paris, 1820)
*Writing Table of
Queen Marie-
Antoinette*, 1784
Oak carcase,
Japanese lacquer
panels, ebony,
mother-of-pearl,
steel plates, gilt-
bronze mounts,
32⅜ x 18½ x 17⅜ in.
(82 x 47 x 44 cm)

This elegant Neoclassical design incorporates an eminently modern material—steel.

☛ *The numbering of
the galleries goes in
the opposite direction
of the order of the
Conseil d'Etat rooms
(62–65). You may
want to go through
the galleries once to
look at the decorative
arts, and then go back
through again to admire
the decor, particularly
the painted ceilings.
These rooms also offer
good views of the
pyramid and of the
Arc du Carrousel.*

OBJETS D'ART

PLATE 451.

*Bedroom Suite of
Madame Récamier,*

c. 1799
Paris

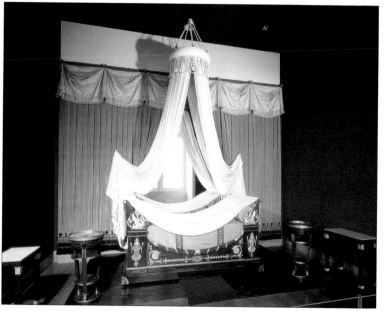

Bed, daybed, two *bergères,* two *fauteuils,* two chairs, tabouret
Attributed to the Jacob brothers after designs by Louis-Martin Berthault (Paris, 1770–Paris, 1823)

Mahogany with gilt-bronze fittings
Bergères (easy chairs): 33¹⁄₈ x 24¹⁄₂ x 24³⁄₈ in. (84 x 62.2 x 62 cm)
Fauteuils (arm chairs): 35¹⁄₄ x 18⁵⁄₈ x 23¹⁄₄ in. (89.5 x 57.5 x 59 cm)

Chairs: 33¹⁄₂ x 18⁵⁄₈ x 13³⁄₄ in. (85 x 47.5 x 35 cm)
Tabouret: 17¹⁄₂ x 19⁵⁄₈ x 16¹⁄₈ in. (44.5 x 50 x 41 cm)

OBJETS D'ART

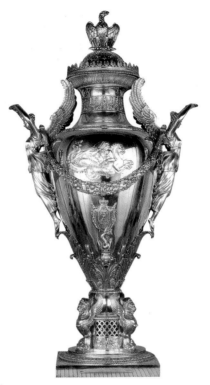

PLATE 452.
Martin-Guillaume
Biennais
(Lacochère, 1764–
Lacochère, 1843)
*Tea Fountain from
the Tea Service of
Napoleon I,*
1809–10
Silver gilt, 31½ x
17⅝ in. (80 x 45 cm)

Designed by the architect Charles Percier, the service con-
sisted of twenty-eight pieces (half of which are now in the
Louvre) incorporating Etruscan and Roman motifs.

PLATE 453.
Dagoty Factory
*Set of Three Cornet
Vases*, c. 1810
Paris
Hard-paste porcelain
imitating red
lacquer,

OBJETS D'ART

height (large): 81½
in. (207 cm); height
(small): 54⅝ in.
(139 cm); diameter
(large): 58⅝ in.
(149 cm); diameter
(small): 45⅜ in.
(115 cm)

The taste for chinoiserie became widespread in the eighteenth
century.

PLATE 454.
Sèvres
Manufactory
Egyptian Cabaret
Service of
Napoleon I, 1810

Western curiosity about Egypt dates from the Renaissance, but Napoleon's Egyptian campaign intensified the demand for scenes of the Nile Valley, which soon became one element among many in a craze for things Oriental.

Decorative panels by Lebel and Béranger after prints from *Voyage en Haute et Basse Egypte* by Dominique-Vivant Denon, gilding by Micaud the son Hard-paste porcelain

OBJETS D'ART

487

PLATE 455.
François-Honoré
Jacob-Desmalter
(Paris, 1770–
Paris, 1841)
*Jewel Cabinet of
Empress Josephine,*
1809
Oak carcase, yew
and purplewood
veneer, mother-of-
pearl, gilt-bronze
mounts, 108 x 79 x
24 in. (275 x 200 x
60 cm)

Designed by the architect Charles Percier and incorporating
bronze mounts after the sculptor Chaudet (see sculpture gal-
leries, room 31), this piece features the kind of neo-Pompeian
motifs that were then reinvigorating the Neoclassical decora-
tive vocabulary.

PLATE 456.
Marie-Jeanne
Rosalie
Désarnaud-
Charpentier, after
designs by Nicolas-
Henri Jacob (Paris,
1782–Paris, 1842)
*Toilette Table and
Chair,* c. 1819
Crystal and gilt
bronze, table:
66½ x 48 x 25¼ in.
(169 x 122 x 64 cm)

OBJETS D'ART

👁 *From the four
Conseil d'Etat rooms
(62–65), you will have
views of the Cour
Napoléon and the Arc
du Carrousel.*

PLATE 457.
François-Désiré
Froment-Meurice
(Paris, 1802–
Paris, 1855)
*Grape-Harvest
Cup*, c. 1844
Gilded and enam-
eled silver, pearls,
agate, mahogany,
and gilt bronze,
height: 13¾ in.
(35 cm)

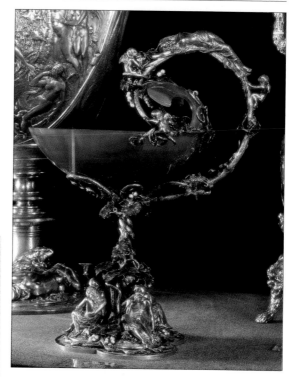

☞ *If you have already
seen the crown jewels
exhibited in the Apollo
Gallery (room 66), or
if you would prefer to
see them later, you can
retrace your steps to
the large escalators next
to room 23 and con-
tinue on to the Napo-
leon III Apartments
and the galleries con-
taining the balance of
the nineteenth-century
collection (rooms 88–
67)—perhaps stopping
en route at the Café
Richelieu, which is
conveniently situated
between the escalators
and these galleries.*

OBJETS D'ART

PLATE 458.
Pierre Delabarre
(active 1625–died
after 1654)
Ewer
Vessel: 1st century
B.C. or A.D.; mount:
Paris, c. 1630
Sardonyx and enam-
eled gold, height: 11
in. (28 cm)

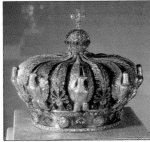

PLATE 459.
Alexandre-Gabriel
Lemonnier (Rouen,
c. 1808–Paris, 1884)
*Crown of Empress
Eugénie,* 1855
Gold, with 2,490
diamonds and 56
emeralds, height:
5⅛ in. (13 cm);
diameter: 5⅞ in.
(15 cm)

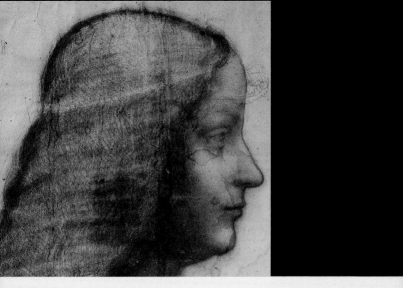

Prints and Drawings

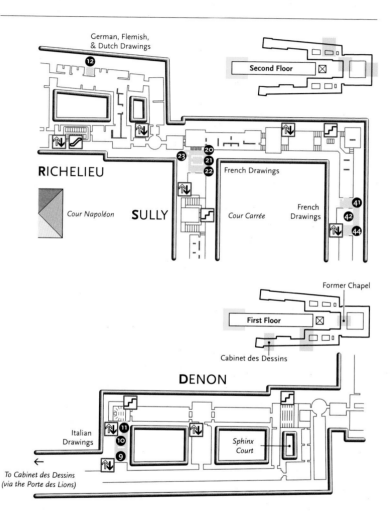

German, Flemish,
& Dutch Drawings

12

Second Floor ⊠

RICHELIEU

Cour Napoléon

SULLY

20
23 **21**
22

French Drawings

Cour Carrée

French
Drawings

41
42
44

Former Chapel

First Floor ⊠

Cabinet des Dessins

DENON

Italian
Drawings

11
10
9

Sphinx
Court

To Cabinet des Dessins
(via the Porte des Lions)

Access and Tour

The prints and drawings department is located at the end of the Denon wing, next to the Pavillon de Flore (which now houses the museum's conservation laboratory). It operates a study room where scholars and others can work closely with the graphic art collection (by appointment only); access is through the Porte des Lions, across from the entry to the Italian and Spanish paintings.

In 1861–67 Hector Lefuel rebuilt the Pavillon de Flore (for which Jean-Baptiste Carpeaux carved a *Flora;* see his terracotta maquette in the History of the Louvre galleries, entresol level). Between 1869 and 1872 Lefuel also oversaw the decoration of the Escalier des Souverains (Stair of Sovereigns) at the extreme west end of the Denon wing. When the Pavillon de Flore, which had been home to several administrative agencies, was allocated to the museum in 1967, this stair was demolished, but its decorated floor was preserved and the study room was installed in the newly available space (now occupied by the conservation and documentation offices). In the center of the room's ceiling is a *Triumph of Flora* (1871–73) by Alexandre Cabanel; the wall arches are decorated with four reliefs by Eugène Guillaume recounting the *History of Flora*.

For reasons of conservation, the Louvre's prints and drawings are never placed on permanent display but are shown only on rotation in temporary exhibitions. The first such exhibition was mounted as early as 1797 in the Apollo Gallery; recently, graphic works have been installed in the former chapel on the first floor of the Pavillon de l'Horloge and in special exhibition galleries on the entresol level near the Sully entry. Occasionally a few works are shown alongside related ones in other media—notably, in the French paintings galleries, the fourteenth-century altar frontal known as the *Parement de Narbonne* (room 2), Charles Le Brun's full-scale cartoons for the Château de Sceaux (rooms 20–23), and a selection of eighteenth-century pastels (rooms 41–44); and, in

Frontispiece:
Leonardo
da Vinci,
Isabella d'Este
(detail; see plate 493)

the Italian paintings galleries, a selection of cartoons by Italian masters (rooms 9–11).

History of the Collection

The core of the Louvre's graphic arts collection came from the royal drawings collection, established largely thanks to the concerted efforts of the prime minister Jean-Baptiste Colbert, who saw such acquisitions as reinforcing his policy of strategic royal magnificence. By 1730 the crown owned 8,600 pieces, enriched by the purchase of Everhard Jabach's collection in 1671; and by the acquisition of drawing collections owned by three first painters to the king: Charles Le Brun in 1690, Pierre Mignard in 1695, Charles Coypel in 1722. The collection was further enlarged by the purchase of more than a thousand additional sheets at the 1775 Mariette sale; by 1790 the royal drawings collection had grown to more than ten thousand items. The department's holdings now number more than one hundred thousand items, having been expanded through revolutionary seizures (the Saint-Morys collection), purchases (the Filippo Baldinucci albums in 1806; the Codex Villardi of drawings by Pisanello in 1856), and many donations (Moreau-Nélaton, 1907 and 1927; heirs of Edmond de Rothschild, 1936; David-Weill, 1947).

In the pages that follow, we reproduce a small selection of drawings, without commentaries, which otherwise cannot be seen at the museum without special authorization.

PLATE 460.
Jean Fouquet
(Tours, c. 1420–
Tours, 1477/81)
*The Crossing of the
Rubicon*
Watercolor and
gouache with gold
heightening on vel-
lum, 17⅛ x 12¾ in.
(44 x 32.5 cm)

PLATE 461.
Jacques Callot
(Nancy, 1592–
Nancy, 1635)
*Louis XIII and
Richelieu at the
Siege of Ré*
Black chalk and
brown wash on
paper, 13⅜ x 20¼ in.
(34 x 52.8 cm)

PLATE 462.
Nicolas Poussin
(Les Andelys, 1594–
Rome, 1665)
Extreme Unction
Pen and brown ink
and brown wash on
paper, 9 x 13⅜ in.
(23 x 34 cm)

PRINTS AND DRAWINGS

PLATE 463.
Nicolas Poussin
(Les Andelys,
1594–Rome, 1665)
*Study for the
Grande Galerie of
the Louvre,* c. 1640
Pen and brown wash
on paper, 8⅝ x 28⅝
in. (22 x 73 cm)

PLATE 464.
Claude Gellée,
known as Claude
Lorrain (Chamagne,
c. 1602–Rome, 1682)
*Aeneas and the
Cumaean Sibyl*
Pen and brown ink,
brown and gray
wash, and white
heightening on
beige paper, 10 x 14
in. (25.3 x 35.5 cm)

PLATE 465.

Charles Le Brun

(Paris, 1619–
Paris, 1690)
*The Apotheosis
of Hercules*
Black chalk, pen and
brown ink, red wash,
and white heighten-
ing on beige paper,
12¾ x 18⅛ in.
(32.6 x 46 cm)

PRINTS AND DRAWINGS

PLATE 466.
Antoine Watteau
(Valenciennes,
1684–Nogent-sur-
Marne, 1721)
*Face of Pierrot,
Five Little Girls
"en buste," a
Draped Man, and
a Woman's Head*
Red and white chalk
on buff paper,
10⅝ x 15¾ in.
(27.1 x 40 cm)

PLATE 467.
François Boucher
(Paris, 1703–
Paris, 1770)
Naiads and Triton,
c. 1753
Red, black, and
white chalk on buff
paper, 11½ x 18½ in.
(29.1 x 46.9 cm)

Plate 468.
Maurice Quentin
de la Tour
(Saint-Quentin,
1704–Paris, 1788)
*The Marquise de
Pompadour,*
1752–55
Pastel on blue gray
paper, 69⅞ x 51½
in. (177.5 x 131 cm)

PLATE 469.
Jean-Baptiste-
Siméon Chardin
(Paris, 1699–
Paris, 1779)
*Self-Portrait with
Easel*, 1771
Pastel on blue paper
fixed to canvas,
16 x 12¾ in.
(40.7 x 32.5 cm)

PLATE 470.
Jean-Honoré
Fragonard (Grasse,
1732–Paris, 1806)
The Pasha
Brush and brown
wash on paper, with
traces of black chalk
at top, 9¾ x 13⅛ in.
(24.8 x 33.2 cm)

PLATE 471.
Hubert Robert
(Paris, 1733–
Paris, 1808)
The Draftswomen,
1786
Pen and brown ink
and watercolor on
paper, 27⅝ x 38⅝ in.
(70 x 98 cm)

PLATE 472.
Jacques-Louis
David (Paris, 1748–
Brussels, 1825)
*Marie-Antoinette
Led to Her
Execution*
Pen and brown ink
on paper, 5¾ x 4 in.
(14.8 x 10.1 cm)

PRINTS AND DRAWINGS

PLATE 473.
Pierre-Paul
Prud'hon (Cluny,
1758–Paris, 1823)
Love Seduces
Innocence, Pleasure
Entraps, and
Remorse Follows
Black and white
chalk on blue paper,
21¼ x 18 in.
(54.7 x 45.7 cm)

PLATE 474.
Jean-Auguste-
Dominique Ingres
(Montauban, 1780–
Paris, 1867)
*The Stamaty
Family,* 1818
Graphite on paper,
18¼ x 14⅝ in.
(46.3 x 37.1 cm)

PLATE 475.
Théodore
Géricault (Rouen,
1791–Paris, 1824)
Leda and the Swan
Black crayon, brown
wash, blue water-
color, and white
gouache on brown
paper, 8½ x 11⅛ in.
(21.7 x 28.4 cm)

PRINTS AND DRAWINGS

PLATE 476.
Eugène Delacroix
(Charenton-Saint-
Maurice, 1798–
Paris, 1863)
*The Jewish Bride
of Tangier,* 1832
Watercolor over
graphite on beige
paper, 11⅜ x 9⅜ in.
(28.8 x 23.7 cm)

PLATE 477.
Rogier van der
Weyden (Tournai,
1399/1400–
Brussels, 1464)
Head of the Virgin
Metalpoint on light
gray tinted paper,
5⅛ x 4⅜ in.
(12.9 x 11 cm)

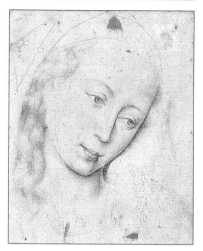

PLATE 478.
Albrecht Dürer
(Nuremberg, 1471–
Nuremberg, 1528)
Erasmus
Black chalk on
paper, 14⅝ x 10½ in.
(37.1 x 26.7 cm)

PLATE 479.
Hans Baldung
Grien (Gmünd,
1484/85–
Strasbourg, 1545)
*Phyllis and
Aristotle*
Pen and black ink on
paper, 11⅛ x 8 in.
(28.1 x 20.2 cm).

PLATE 480.
Hans Holbein
the Elder
(Augsburg, c. 1460–
Isenheim, 1524)
*Head of a
Young Woman*
Metalpoint reworked
in pen and black ink,
with heightening in
red and white chalk
on pink tinted paper,
7⅝ x 6⅛ in.
(19.6 x 15.4 cm)

PRINTS AND DRAWINGS

PLATE 481.
Pieter Brueghel
the Elder
(Brueghel?, c. 1525–
Brussels, 1569)
Alps Landscape
Pen and brown ink
on paper, 9⅜ x 13½
in. (23.6 x 34.3 cm)

PLATE 482.
Peter Paul Rubens
(Siegen, 1577–
Antwerp, 1640)
*Saint George
Slaying the Dragon*
Pen and brown ink
and brown wash on
paper, 13¼ x 10½ in.
(33.7 x 26.7 cm)

PRINTS AND DRAWINGS

PLATE 483.
Jacob Jordaens
(Antwerp, 1593–
Antwerp, 1678)
*The Coronation of
the Virgin by the
Holy Trinity*
Watercolor and
gouache over black
chalk with oil height-
ening on paper,
squared for transfer
in black chalk,
9¼ x 8¼ in.
(46.5 x 38.5 cm)

PRINTS AND DRAWINGS

PLATE 484.
Anthony van Dyck
(Antwerp, 1599–
Blackfriars, 1641)
The Arrest of Christ
Pen and brown ink
and brown wash on
paper, squared for
transfer in black
chalk, 9½ x 8¼ in.
(24.1 x 20.9 cm)

PLATE 485.
Rembrandt Harmensz
van Rijn, known as
Rembrandt (Leiden,
1606–Amsterdam,
1669)
*View of the
Singel Canal in
Amersfoort*
Pen and brown ink
and brown wash on
paper, 6 x 10⅞ in.
(15.3 x 27.7 cm)

PLATE 486.
Jean-Etienne
Liotard (Geneva,
1702–Geneva, 1789)
Madame Tronchin,
1758
Pastel on wove
paper, 24¾ x 19⅝ in.
(63 x 50 cm)

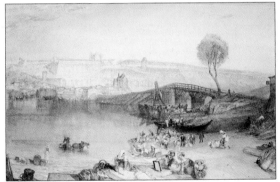

PLATE 487.
Joseph Mallord
William Turner
(London, 1775–
London, 1851)
*View of the
Château of Saint-
Germain-en-Laye
and Environs*
Watercolor on paper,
11¾ x 18 in.
(29.9 x 45.7 cm)

PRINTS AND DRAWINGS

PLATE 488.
Antonio Puccio,
known as Pisanello
(Verona?, before
1395–Verona, 1455)
Two Horses
Pen and brown ink
with traces of black
chalk on paper, 7⅞ x
6½ in. (20 x 16.6 cm)

PLATE 489.
Jacopo Bellini
(died Venice,
1470/71)
*The Flagellation
of Christ*
Pen and brown
ink on vellum,
16 5/8 x 11 1/8 in.
(42.2 x 28.3 cm)

PRINTS AND DRAWINGS

PLATE 490.
Antonio
Pollaiuolo
(Florence, 1431?–
Rome, 1498)
Three Male Nudes
Pen and brown ink
and brown wash on
beige paper, 10⅜ x
13¾ in. (26.5 x 35 cm)

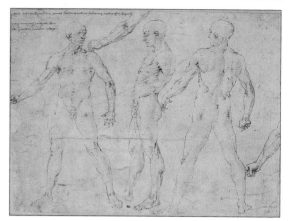

PLATE 491.
Michelangelo
Buonarroti, known
as Michelangelo
(Caprese, near
Arezzo, 1475–
Rome, 1564)
*Studies for Bronze
David and Right
Arm of Marble
David*, c. 1502
Pen and ink on
paper, 10⅜ x 7⅞ in.
(26.4 x 18.5 cm)
Inscribed in Italian:
"David with his
sling/and I with my
drill/Michelangelo"

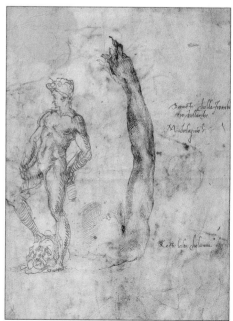

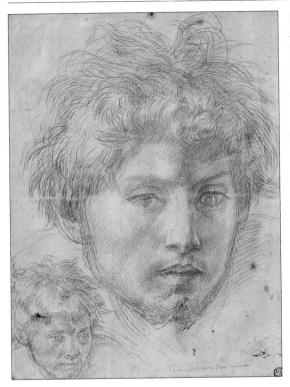

PLATE 492.
Andrea del Sarto
(Florence, 1486–
Florence, 1530)
*Two Studies of a
Man's Head
(Frontal View)*
Red chalk on beige
paper, 13⅛ x 10 in.
(33.5 x 25.5 cm)

PRINTS AND DRAWINGS

PLATE 493.
Leonardo da Vinci
(Vinci, 1452–
Cloux, 1519)
Isabella d'Este
Black and red chalk
with pastel heightening on paper,
24¾ x 18⅛ in.
(63 x 46 cm)

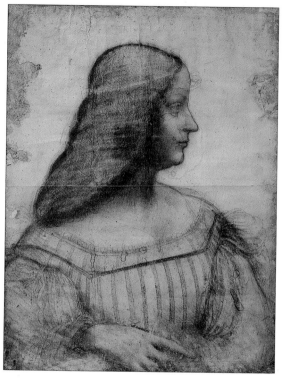

PLATE 494.
Raffaello Sanzio,
known as Raphael
(Urbino, 1483–
Rome, 1520)
*Psyche Offering
Venus Water from
the Styx,* study for
the Psyche Loggia in
the Villa Farnesina,
Rome, c. 1518
Red chalk on paper,
10⅜ x 7⅝ in.
(26.3 x 19.3 cm)

PLATE 495.
Francesco Mazzola,
known as
Parmigianino
(Parma, 1503–
Casalmaggiore, 1540)
Two Canephorae,
study for the eastern
barrel vault of Santa
Maria della Steccata,
Parma, 1531–39
Red chalk, pen and
brown ink, and
brown wash with
white heightening
on beige paper,
$7^5/8$ x $5^1/2$ in.
(19.6 x 14.1 cm)

PLATE 496.
Tiziano Vecelli,
known as Titian
(Pieve di Cadore,
1488/89–
Venice, 1576)
*The Battle of
Spoleto* (previously
known as *The Battle
of Cadore*), composi-
tional study for a
canvas painted for
the Sala del Maggior
Consiglio in the
Doge's Palace,
Venice, c. 1513–14
Black chalk and gray
brown and brown
wash with white
heightening on blue
paper, squared for
transfer in black
chalk, 15⅛ x 17⅝ in.
(38.3 x 44.6 cm)

PLATE 497.
Annibale Carracci
(Bologna, 1560–
Rome, 1641)
*Study for the Vault
of the Farnese
Gallery*
Red chalk and pen
and brown ink on
paper, 15⅛ x 10⅜ in.
(38.6 x 26.4 cm)

PRINTS AND DRAWINGS

PLATE 498.
Gianlorenzo
Bernini (Naples,
1598–Rome, 1680)
*First Project for the
East Facade of the
Louvre*
Pen and brown ink
and brown wash on
paper, 16¼ x 26⅜
in. (41.1 x 67 cm)

PLATE 499.
Giovanni Battista
Piranesi (Venice,
1720–Rome, 1778)
Palace Interior
Pen and brown ink
and brown wash
over red chalk on
paper, 20⅛ x 30⅛
in. (51.2 x 76.5 cm)

PRINTS AND DRAWINGS

PLATE 500.
Francisco Goya
y Lucientes
(Fuendetodos, 1746–
Bordeaux, 1828)
*"Mala Mujer"
(Wicked Woman)*,
c. 1801–3
Brown wash on
paper, 8 x 5⅝ in.
(20.3 x 14.3 cm)

PRINTS AND DRAWINGS

Chronology

1190 King Philippe-Auguste orders the construction of a protective wall around Paris.

AFTER 1190 A fortress is constructed to the west, beside the Seine and against the outside of the new wall.

1204 The fortress is first called "the Louvre" in official records; the origins and meaning of this name are unclear.

1360–64 King Charles V modernizes the Louvre by having his architect (Raymond du Temple) add new blocks to the east and north, plus a large spiral staircase.

1528 The castle's keep is demolished by order of King François I.

1546 François I commissions the architect Pierre Lescot to construct a new block in the west wing.

1547 After the death of François I, the new king, Henri II, confirms his father's choice of Lescot as overseer of the Louvre project.

1547–58 The west wing is completed, and the large ballroom is inaugurated for the wedding of the dauphin François to Mary Stuart.

1559–89 The three sons of Henri II (François II, Charles IX, and Henri III) continue construction of the south wing of the Louvre; his widow, Catherine de Médicis, begins construction of the Tuileries palace and builds a gallery with a roof terrace facing the Seine (later known as the Petite Galerie).

1594 King Henri IV makes his triumphal entry into Paris and announces his intention to reside there.

1594–1610 The Grande Galerie is constructed along the Seine; in 1608 Henri IV sets aside much of its ground floor as lodgings for artists and craftsmen holding royal warrants.

1595–1609 An upper floor is added to the Petite Galerie.

1624 King Louis XIII lays the foundation stone for a pavilion (later known as the Pavillon de l'Horloge) destined to become the western focus of a new courtyard.

1639 Work on the Louvre, which had almost ground to a halt, resumes at the urging of the newly appointed superintendent of the king's buildings, François Sublet de Noyers; Jacques Lemercier is architect.

1643 Louis XIII dies; Anne of Austria, queen regent for her young son Louis XIV (born 1638), affirms Cardinal Mazarin in the post of prime minister.

1649–53 France is wracked by successive civil wars known as the Fronde Parlementaire and the Fronde Princière.

1654 The architect Louis Le Vau takes charge of work at the Louvre.

1655–58 Le Vau remodels the ground-floor apartment of the Petite Galerie for Anne of Austria.

1661 Fire on the first floor of the Petite Galerie destroys the Galerie des Rois (Gallery of Kings). Mazarin dies; the personal reign of King Louis XIV begins.

1664 An international design competition for completion of the Louvre is held. Charles Le Brun creates the Apollo Gallery on the first floor of the Petite Galerie. Le Vau redesigns the end of the

Grande Galerie, adding a large rectangular salon (later known as the Salon Carré).

1665 Gianlorenzo Bernini visits Paris to elaborate on his design for the Louvre.

1667 Jean-Baptiste Colbert, the finance minister, establishes a committee, including the architect Claude Perrault, to create a new design for the east facade; construction of the resulting Colonnade begins the next year.

1682 Louis XIV (who distrusts Paris because of his experiences during the Fronde) announces transfer of the seat of government from Paris to Versailles. As a result, the Louvre becomes less a royal residence and more an art venue, as the royal academies take up residence there and it becomes home to periodic art exhibitions.

1737 September—first exhibition in the Salon Carré, later known as the Salon.

1749 Lafont de Saint-Yenne publishes *L'Ombre du grand Colbert* (The Shadow of the great Colbert), a pamphlet criticizing the minister's failure to complete the Louvre.

1755 Construction resumes under the direction of two architects: Jacques-Ange Gabriel and Jacques-Germain Soufflot.

1789 The Revolution begins; Louis XVI is forcibly taken from Versailles to the Tuileries palace. (Napoleon, Louis XVIII, and Louis-Philippe will later reside there as well.)

1793 August 10—the Muséum Central des Arts opens in the Salon Carré and the Grande Galerie.

1800–1801 Artistic booty seized by Napoleon's victorious armies is displayed in the Salles des Antiques and the western half of the Grande Galerie.

1802 Dominique-Vivant Denon becomes director of the museum, which is renamed the Musée Napoléon the following year.

1806–8 The Arc du Carrousel is constructed to designs by Charles Percier and Pierre-François Fontaine. During the First Empire, the Louvre-Tuileries palace complex is renovated and expanded under their direction, with the completion of sculpture in the Cour Carrée, the addition of galleries of antiquities and of statues of famous Frenchmen, the construction of new stairways, and so on. Analogous work continues, overseen by Fontaine alone, under the Restoration (1815–30) and the July Monarchy (1830–48).

1809 The Mars Rotunda becomes the main entrance to the museum.

1815 Napoleon is defeated at Waterloo. France is obliged to return its artistic booty; Denon resigns. The monarchy is restored, under King Louis XVIII (1815–24), King Charles X (1824–30), and King Louis-Philippe (1830–48).

1824 The Galerie d'Angoulême is inaugurated.

1827 The Musée Charles X, for which Jean-Auguste-Dominique Ingres paints *The Apotheosis of Homer* ceiling, is inaugurated.

1833 The Galerie Campana is completed.

1848 A month after the Revolution of 1848, the Second Republic legislates that the Louvre, now renamed "The Palace of the People," will be dedicated to exhibitions; construction of the "New

Louvre" is entrusted to Louis Visconti and renovation of the "Old Louvre" to Félix Duban.

1851 Duban's renovated Apollo Gallery (with Eugène Delacroix's *Apollo Vanquishing the Serpent Python* installed on the ceiling), Salon Carré, and Salle des Sept-Cheminées are inaugurated; Duban also oversees work on the decor of the Grande Galerie.

1852 July 25—Napoleon III lays the cornerstone of the New Louvre, designed by Visconti. On the latter's death in 1853, Hector Lefuel replaces him; the style of his ornament will be harshly criticized.

1855 The museum is opened to the general public six days a week. (It had previously been open only on Sundays; henceforth it is closed only on Mondays.) The Pavillon Denon becomes the main entrance to the museum.

1857 The Cour Napoléon is inaugurated, and the "grand project" of the Valois and the Bourbons is completed.

1861 The minister of state's apartment is inaugurated; from 1871 to 1989 it will be occupied by the Finance Ministry.

1870 The Second Empire falls; the Third Republic begins.

1871 Communards burn the Tuileries palace.

1882 The ruins of the Tuileries palace are razed; from this point on, the president of the Republic resides at the Elysée palace.

1886 The Salle des Etats (current site of the *Mona Lisa*) is converted from a legislative meeting hall to a skylit gallery.

1911 August 21—the *Mona Lisa* is stolen by an Italian painter named Vincenzo Peruggia; the painting is recovered in Italy nearly two years later.

1953 Georges Braque's painted ceilings are installed in the Salle du Roi.

1967 André Malraux (Charles de Gaulle's minister of culture) reclaims the Pavillon de Flore, turning its offices into galleries.

1981 President François Mitterrand begins the Grand Louvre project, which removes all unrelated governmental offices in order to dedicate the entire Louvre to its role as a museum.

1984–86 Extensive archaeological excavations are carried out; the medieval foundations of the Louvre are made a public display.

1986 The collections from 1848 to the early twentieth century are transferred to the new Musée d'Orsay.

1989 I. M. Pei's controversial glass pyramid to mark the new main entrance opens to the public.

2000 The Grand Louvre project is completed.

Suggestions for Further Reading

The Louvre

Archimbaud, Nicholas D'. *Louvre: Portrait of a Museum*. New York: Stewart, Tabori and Chang, 1998.

Aruz, Joan, ed. *The Royal City of Susa: Ancient Near Eastern Treasures in the Louvre*. New York: Metropolitan Museum of Art, 1993.

Berger, Robert. *The Palace of the Sun: The Louvre of Louis XIV*. University Park, Penn.: Pennsylvania State University Press, 1993.

Berman, Lawrence M., et al. *Pharaohs: Treasures of Egyptian Art from the Louvre*. Cleveland, Ohio: Cleveland Museum of Art, 1996.

Bresc Bautier, Geneviève. *The Louvre: An Architectural History*. New York: Vendome Press, 1995.

Durand, Jannic, and Daniel Alcouffe. *Decorative Arts at the Louvre*. London: Scala Books, 1995.

Gaborit, Jean-René. *The Louvre: European Sculpture*. London: Scala Books, 1994.

Gowing, Lawrence. *Paintings in the Louvre*. Introduction by Michel Laclotte. New York: Stewart, Tabori and Chang, 1987.

Laclotte, Michel. *Treasures of the Louvre*. New York: Abbeville Press, 1993.

General Surveys

Chastel, André. *French Art*. 3 volumes. Paris: Flammarion, 1995–96.

Freedberg, Sydney. *Painting in Italy, 1500–1600*. New Haven, Conn.: Yale University Press, 1993.

Haskell, Francis, and Nicholas Penny. *Taste and the Antique: The Lure of Classical Sculpture, 1500–1900*. New Haven, Conn.: Yale University Press, 1981.

Honour, Hugh, and John Fleming. *The Penguin Dictionary of Decorative Arts*. London: Viking, 1989.

———. *The Visual Arts: A History*, 4th ed. New York: Harry N. Abrams, 1995.

Pope-Hennessy, John. *Introduction to Italian Sculpture*. London: Phaidon Press, 1996.

Robertson, Martin. *A History of Greek Art*. 2 volumes. London: Cambridge University Press, 1975.

Smith, W. Stevenson. *The Art and Architecture of Ancient Egypt*. Revised by William Kelly Simpson. New Haven, Conn.: Yale University Press, 1998.

Silver, Larry. *Art in History*. New York: Abbeville Press, 1993.

Turner, Jane, ed. *The Dictionary of Art*. 34 volumes. New York: Grove, 1996.

Index

Page numbers in *italic* refer to plates.

Abbate, Niccolò dell', *372*
Abduction of Helen, The, 383
Abduction of Proserpina, The, 372
Acis and Galatea, 222
Aeneas and the Cumaean Sibyl, 499
Agostino Antonio di Duccio, *440*
Air, 382
Albani, Francesco, *382*
Alexander and Diogenes, 421
Alexander and Porus, 232
Allegory of Wealth, 68, 216
Alpais Ciborium, 460
Alps Landscape, 512
Altar of Domitius Ahenobarbus, 173
Amulet in the Form of a Falcon with a Ram's Head, 108
Andrea del Sarto, *334, 367, 519*
Angelico, Fra, *335, 339*
Angel with an Olive Branch, 273, 277
Annunciation, The, 69, 275
Antonello da Messina, *348*
Aphrodite, 157, 165
Aphrodite of Cnidus, 166
Apollo, 157, 182
Apotheosis of Hercules, The, 500
Arcadian Shepherds, The, 197, 218
Architect with a Plan, 129
Arcimboldo, Giuseppe, *373*
Armed Attack in a Forest, 292
Armoire with Figures of Socrates and Aspasia, 478

Army of Louis XIV Crossing the Rhine at Tolhuis (June 12, 1672), The, 235
Arrest of Christ, The, 514
Assumption of the Virgin, The, 385
Astronomer, The, 273, 319
August, 467
Autumn, 220
Autun Boxer, The, 183

Backhuyzen, Ludolf, *317*
Baldassare Castiglione, 68, 334, 369
Ball of the Duc de Joyeuse, 210
Baptistery of Saint Louis, The, 148
Barocci, Federico, *334, 374*
Barye, Antoine-Louis, *438*
Basin, 148
Bathers, 245
Bathsheba with King David's Letter, 273, 309
Battle of Issus, The, 272, 293
Battle of San Romano, The, 335, 340
Battle of Spoleto, 523
Bauguin, Lubin, *225*
Bedroom Suite of Madame Récamier, 484
Beer Stein with Adam and Eve, 472
Beggars, The, 287
Beham, Hans Sebald, *280*
Bellano, Bartolomeo, *465*
Bellechose, Henri, *203*
Belle Ferronnière, La, 353
Belle Jardinière, La, 356
Belle Nani, La, 364
Bell Idol, 186
Bellini, Giovanni, *347*
Bellini, Jacopo, *517*

Benoist, Marie-Guillaume, *250*
Berchem, Nicolaes Pietersz, *312*
Bernini, Gianlorenzo, *446, 524*
Biard, Pierre I, *417*
Biennais, Martin-Guillaume, *485*
Black-Figure Amphora, 189
Body of a Woman, Probably Nefertiti, 101
Bohemians' Halt, 230
Boilly, Louis-Léopold, *252*
Book of Omens, The, 151
Borghese Gladiator, The, 194
Borghese Vase, The, 195
Bosch, Hieronymus, *278*
Bosschaert, Ambrosius, the Elder, *302*
Botticelli, Sandro, *331, 336*
Bouchardon, Edme, *424*
Boucher, François, *240, 243, 501*
Boulle, André-Charles, *478*
Bouquet of Flowers in an Arched Window Overlooking a Landscape, 302
Bourdon, Sébastien, *230*
Bracelet: The Resurrection, 459
Bril, Paul, *272, 292*
Brueghel, Jan, *272, 293*
Brueghel, Pieter, the Elder, *287, 512*
Brygos Painter, *190*

Caffieri, Jean-Jacques, *428*
Callot, Jacques, *498*
Calvary, 69, 335, 344
Candelabrum, 172
Canon Alexandre-Gui Pingré, 428
Canova, Antonio, *397, 447*
Capital (Bawit), 115

Capital of a Column from the Audience Chamber (Apadana) in the Palace of Darius I, 140
Caravaggio, 68, 334, 377, 378
Cardinal Amand de Richelieu, 446
Cardinal Granvella's Dwarf, 272, 289
Card Sharp with the Ace of Diamonds, 226
Carlin, Martin, 481
Caron, Antoine, 212
Carondelet Diptych, 286
Carpaccio, Vittore, 351
Carpet with Animals, 149
Carracci, Annibale, 334, 375, 376, 523
Carreño de Miranda, Juan, 391
Cat Goddess Bastet, The, 110
Caulery, Louis de, 291
Cavalry Encounter, 323
Centaur Assailing a Woman, 164
Champaigne, Philippe de, 231
Chancellor Nakhti, 96
Chancellor Séguier, 231
Chardin, Jean-Baptiste-Siméon, 242, 243, 503
Charity, 334, 367
Charles I, King of England, at the Hunt, 301
Charles V, King of France, 407
Charles VI Frightened in the Forest of Le Mans, 438
Chassériau, Théodore, 267
Chaudet, Denis-Antoine, 433
Chinard, Joseph, 434
Christ and Abbot Mena, 115
Christ and Saint John the Baptist as Children, 440
Christ and the Adulterous Woman, 335, 362
Christ Blessing, 347
Christ Carrying the Cross, 341

Christ Driving Traders from the Temple, 296
Christ on the Cross Adored by Two Donors, 71, 389
Christ with Saint Joseph in the Carpenter's Shop, 227
Cimabue, 335, 337
Circumcision, The (Barocci), 334, 374
Circumcision, The (Giulio), 368
Claude Lorrain, 220, 499
Clio, Euterpe, and Thalia, 68, 224
Clodion, 401, 432
Cloelia Crossing the Tiber, 223
Clouet, François, 209
Clouet, Jean, 208
Club-Footed Boy, The, 392
Coffin of Imeneminet, 87
Colombe, Michel, 410
Colossus of Rhodes, The, 291
Comtesse du Barry, The, 428
Concert Champêtre, Le, 359
Concert with Antique Relief, 214
Condottiere, The, 348
Constable Anne de Montmorency, 470
Convalescence of Bayard, The, 251
Corneille de Lyon, 210
Coronation of Napoleon (December 2, 1804), The, 258
Coronation of the Virgin, The (Angelico), 339
Coronation of the Virgin by the Holy Trinity, The (Jordaens), 513
Corot, Jean-Baptiste-Camille, 255
Correggio, 334, 370
Cosmetic-Box Cover with Fertility Goddess, 146
Cosmetics Spoon: Young Woman Swimming, 102

Costa, Lorenzo, 349
Couple, 93
Courajod Christ, The, 403
Courteys, Pierre, 469
Cousin "le père," 211
Coustou, Guillaume I, 419
Coysevox, Antoine, 420
Cranach, Lucas, 282
Cressent, Charles, 479
Crossing of the Rhine, The, 423
Crossing of the Rubicon, The, 497
Crown of Empress Eugénie, 491
Cupid and Psyche (Canova), 397, 447
Cupid and Psyche (Gérard), 249
Cupid Fashioning a Bow from Hercules' Club, 424
Cup with Falconer on Horseback, 147
Cylinder Seal of Sharkalisharri, King of Akkad, 130

Dagoty Factory, 486
Dame d'Auxerre, La, 159
Daniel among the Lions, 402
David, Jacques-Louis, 68, 256–58, 260, 505
David and Bathsheba, 288
David with the Head of Goliath, 383
Dead Christ, The, 403
Death of the Virgin, The, 68, 378
Decorative Panels, 171
Delabarre, Pierre, 449, 491
Delacroix, Eugène, 69, 264–66, 509
Della Robbia Workshop, 441
Désarnaud-Charpentier, Marie-Jeanne Rosalie, 489
Descent from the Cross (ivory carving), 461
Descent from the Cross (Master

of the Saint Bartholomew Altarpiece), *279*

Desiderio da Settignano, *440*

Desjardins, Martin, *423*

Desportes, François, *238*

Dessert, *306*

Dessert with Gaufrettes, *225*

Diana at the Bath, *240*

Diana the Huntress, *167*, *400*

Diptych of the Muses, *178*

Dish and Plate, *468*

"*Divine Consort,*" *Karomama, The*, *109*

Doge on the Bucentauro at San Niccolo du Lido, The, *387*

Domenichino, *380*, *381*

Donatello, *401*, *439*

Dou, Gerrit, *314*

Downpour, The, *252*

Draftswomen, The, *504*

Drinker, The, *320*

Dropsical Woman, The, *314*

Duet, The (Terborch), *318*

Duet, The (Ter Brugghen), *304*

Du Jardin, Karel, *316*

Dürer, Albrecht, *273*, *281*, *510*

Dyck, Anthony van, *514*

Dying Slave, *69*, *400*, *445*

Eagle Vase of Suger, *457*

Ebih-Il, the Superintendent of Mari, *125*

Education of the Holy Child, The, *409*

Egyptian Cabaret Service of Napoleon I, *487*

Egyptian Woman with a Naos, *432*

Empress Josephine in the Park at Malmaison, *260*

Equestrian Statuette of Charlemagne, *455*

Erasmus (Dürer), *510*

Erasmus (Holbein), *283*

Erhart, Gregor, *443*

Euphronios, *190*

Eva Prima Pandora, *211*

Ewer, *449*, *491*

Exaltation of the Flower, The, *163*

Exekias, *189*

Extreme Unction, *498*

Ex-Voto of 1662, *231*

Eyck, Jan van, *69*, *272*, *273*, *274*

Fabritius, Barent, *269*, *273*, *311*

Face of Pierrot, Five Little Girls "en buste," a Draped Man, and a Woman's Head, *501*

Falconet, Etienne-Maurice, *424*

Fame, *417*

Fantastic View of the Campo Vaccino in Rome with an Ass, *303*

Female Head, *158*

Ferdinand Guillemardet, *395*

Ferry Crossing, The, *312*

Finding of Moses, The, *477*

Firedog, *480*

First Project for the East Facade of the Louvre, *524*

Fishing, *375*

Fishing Boat and Coasting Vessel in Bad Weather, *317*

Fish Sellers in Their Stall, *297*

Five Senses and The Four Elements, The, *225*

Flagellation of Christ, The (Bellini), *517*

Flagellation of Christ, The (Hughet), *388*

Flemish Kermesse, The, *273*, *298*

Flowers in a Crystal Carafe, with a Sprig of Peas and a Snail, *313*

Flying Angel, *441*

Fontana Factory, *468*

Fortune Teller, The, *377*

Founding of the Trinitarian Order, The, *391*

Fouquet, Jean, *206*, *464*, *497*

Four Evangelists, The (Jesus among the Doctors?), *295*

Fragment from the Ara Pacis: Imperial Procession, *175*

Fragment of a Female Statuette, *130*

Fragment of a Statue of an Old Man, *111*

Fragonard, Jean-Honoré, *245*, *504*

François I, King of France, *208*

Friedrich, Caspar David, *273*, *324*

Frieze from a Mosaic Panel, *126*

Frieze of Archers, *141*

Frog and Frog Seal, *80*

Froment-Meurice, François-Désiré, *490*

Fulnama, *151*

Funerary Portrait from Faiyum, *113*

Funerary Relief, *143*

Funerary Stele, *163*

Fuseli, Henry, *328*

Gainsborough, Thomas, *326*

Gallery of Views of Ancient Rome, *386*

Gallery of Views of Modern Rome, *386*

Geertgen tot Sint Jans, *276*

Gentile da Fabriano, *342*

Gentileschi, Orazio, *379*

Gérard, Baron François, *249*

Géricault, Théodore, *69*, *254*, *263*, *508*

Germain, François-Thomas, *480*

Ghirlandaio, Domenico, *349*

Gilles, *239*

Gillot, Claude, *238*

Ginevra d'Este, 335, 343
Giotto, 335, 338
Giovanni da Bologna, 474
Giulio Romano, 368
Goblet of Boscoreale, 157, 185
Goblet with Animal
 Decoration: Ibex,
 Greyhounds, Wader Birds,
 137
God Amun Protecting
 Tutankhamen, The, 105
Goddess Hathor Welcoming
 Seti I, The, 106
God Osiris with His Family,
 The, 108
Gold Plate with Hunting
 Scene, 145
Goujon, Jean, 412
Goya y Lucientes, Francisco,
 394, 395, 525
Grande Odalisque, 262
Grape-Harvest Cup, 490
Greco, El, 71, 389
Greuze, Jean-Baptiste, 244
Grien, Hans Baldung, 511
Gros, Antoine-Jean, 259
Grotesque Heads and Ethnic
 Types, 187
Guardi, Francesco, 387
Gudea, Prince of Lagash, 119,
 129
Guebel el-Arak Dagger, 89
Guercino, 379
Guillaume Jouvenel des Ursins,
 Chancellor of France, 206
Gust of Wind, The, 317
Gypsy Girl, The, 273, 305

Hadrian, 176
Hals, Frans, 273, 305
Hanging Marsyas, 169
Harbaville Triptych, 458
Head of Aphrodite, 166
Head of a Woman with Hat in
 the Shape of a Tower, 406
Head of a Young Woman, 511

Head of Gudea, Prince of
 Lagash, 119, 129
Head of King Djedefre as a
 Sphinx, 91
Head of the Virgin, 510
Heda, Willem Claesz, 306
Helena Fourment Leaving
 "Her" House, 299
Helmet of Charles IX, 452, 475
Herb Market in Amsterdam,
 The, 315
Hercules and Omphale, 241
Hippopotamus, 95
History of Scipio, The, 469
Hobbema, Meindert, 322
Holbein, Hans, the Elder, 511
Holbein, Hans, the Younger,
 272, 283
Holy Family, The, 357
Hooch, Pieter de, 320
Horse Restrained by a Groom,
 419
Houdon, Jean-Antoine, 429,
 431
Household Objects, 82
Hughet, Jaime, 388
Hunts of Maximilian, The,
 467

Idol of the Eyes, 121
Imaginary View of the Grande
 Galerie of the Louvre in
 Ruins, 246
Imam Reza Fighting a Demon,
 151
Imenmes and Depet, Parents of
 General Imeneminet, 103
Ingres, Jean-Auguste-
 Dominique, 253, 261, 262,
 507
Inspiration of the Poet, The,
 217
Interior of the Church of Saint
 Bavo in Haarlem, 306
Isabella d'Este, 493, 520
Italian Charlatans, The, 316

Jacob-Desmalter, François-
 Honoré, 488
Jean Carondelet, 286
Jester with a Lute, 305
Jewel Cabinet of Empress
 Josephine, 488
Jewish Bride of Tangier, The,
 509
Jezebel Promising Naboth's
 Vineyard to King Ahab,
 472
Jordaens, Jacob, 272, 295,
 296, 513
Jouvenet, Jean, 233
Judgment of Paris, The, 180
Julien, Pierre, 430
Jupiter and Antiope
 (Correggio), 334, 370

Kauffmann Head, The, 166
King Akhenaton/Amenhotep
 IV, 100
King Childebert, 70, 401, 405
King Ramses II, 85
King Sargon II and a
 Dignitary, 117, 134
King Solomon, 404
Kore of Samos, 157, 160
Krater, 195

Laban Searching for Idols in
 Jacob's Baggage, 224
Lacemaker, The, 71, 273, 318
Lady Alston, 326
Lady in Blue, 255
Lady Macbeth, 328
Lady Naÿ, The, 76, 99
La Hyre, Laurent de, 224
Lamentation during a Burial,
 104
Lamentation over the Dead
 Christ (Goujon), 412
Lamentation over the Dead
 Christ (Pilon), 413
Landscape with Classical
 Ruins, 230

Landscape with Distant River
and Bay, 329
Landscape with Erminia and
the Shepherds, 381
Large Holy Family of François
I, The, 357
Large Sphinx, The, 73, 76, 78
La Tour, Georges de, 200,
226, 227
la Tour, Maurice Quentin de,
502
Law Codex of Hammurabi,
King of Babylon, 132
Lawrence, Thomas, 327
Le Brun, Charles, 231, 232,
500
Leda and the Swan, 508
Lemonnier, Alexandre-
Gabriel, 491
Lemoyne, François, 241
Le Nain Brothers, 71, 228, 229
Leonardo da Vinci, 68, 334,
353–55, 358, 493, 520
Le Sueur, Eustache, 68, 221,
224
Levey Oenochoe, 188
Liberty Leading the People
(July 28, 1830), 69, 265
Liège, Jean de, 408
Limosin, Léonard, 470, 471
Linard, Jacques, 225
Lintel from a Door: King
Sesostris III Making an
Offering of Bread to the God
Montu, 97
Liotard, Jean-Etienne, 515
Lotto, Lorenzo, 335, 362
Louis XIII and Richelieu at the
Siege of Ré, 498
Louis XIV, King of France,
234
Louis XIV as a Child, 418
Louise de Savoie, 411
Louis-François Bertin, 261
Loutrophoros, 188
Love Seduces Innocence,

Pleasure Entraps, and
Remorse Follows, 506
Loves of Paris and Helen, The,
257
Lute, 83
Lying-in-State of the Body of
Saint Bonaventure, The,
390

Mabuse, 286
Madame Récamier, 260
Madame Tronchin, 515
Madame Vigée-Lebrun and
Her Daughter, 247
Madonna of Chancellor Rolin,
The, 69, 273, 274
Madonna with Grapes, 237
Maestà (Virgin and Child in
Majesty Flanked by Six
Angels), 337
"Mala Mujer" (Wicked
Woman), 525
Male Head, 161
Male Torso, 162
Malouel, Jean, 202
Mantegna, Andrea, 69, 335,
344, 345, 350
Man with a Glove, 360
Man with Shaved Head, 112
Man Writing (Inspiration),
245
Marie-Antoinette Led to Her
Execution, 505
Marly Horse, 419
Marquesa de la Solana, The,
394
Marquise de Pompadour, The,
502
Marriage at Cana, The, 69,
334, 365
Mars and Venus, 350
Marseillaise, The, 437
Martini, Simone, 341
Massacre at Chios, The, 264
Massys, Jan, 288
Massys, Quentin, 285

Master Hare, 326
Mausoleum for the Heart of
Victor Charpentier, Comte
d'Ennery, 431
Meadow, The, 316
Medallion Portrait of
Constantine, 184
Melpomene, Muse of Song, 179
Memling, Hans, 273, 277
Menacing Cupid, 424
Mercury, 427
Mercury and Psyche, 444
Metsu, Gabriel, 315
Michelangelo, 69, 400, 445,
518
Mignard, Pierre, 236, 237
Mignon, Abraham, 313
Milo of Crotona, 399, 401, 422
Miraculous Draught of Fishes,
The, 233
Mr. and Mrs. Angerstein, 327
Model of a Boat, 80
Models of a Scene of Labor and
a Granary, 81
Mona Lisa, 68, 358
Moneylender and His Wife,
The, 285
"Monkey" Commode, 479
Monkey-Painter, The, 242
Monument for the Heart of
Constable Anne de
Montmorency, 415
Mor, Anthonius, 272, 289
Moulins, Master of, 207
Murillo, Bartolomé Esteban,
335, 393

Naiads and Triton, 501
Nakhthhoreb in Prayer, 79
Napoleon in the Pesthouse at
Jaffa, 259
Nebqued Papyrus, 76, 87
Nessus and Deianira, 474
Nicholas Kratzer, 283
Niobid Painter, 191
Nymph and Triton, 412

Oath of the Horatii, The, 68, 256

Oenochoe, 188

Old Man with His Grandon, 349

Ostade, Adriaen van, *312*

Oval Dish with Apollo and the Muses, 469

Overseer of Royal Sacrifices, The, 131

Painted Table: The Story of David, 280

Painters in a Studio, 300

Pajou, Augustin, *428*

Palace Interior, 524

Palette Celebrating a Victory, 89

Palissy, Bernard, *452, 476*

Pan and Syrinx, 432

Panathenaic Procession, 157, 164

Pannini, Giovanni Paolo, *386*

Paradise (Riccio), 466

Paradise (Tintoretto), 366

Parmigianino, *522*

Parnassus, 350

Parrocel, Joseph, *235*

Pasha, The, 504

Patel *"le père,"* 230

Paten, 456

Patera of General Djehuty, 77, 98

Patinir, Joachim, *284*

Peace, 433

Peacock Plate, 150

Peasant Family, 71, 229

Pendant, Head of Acheloüs, 172

Perfume Vase in the Form of an African Head, 184

Perrier, François, *222*

Perseus and Andromeda, 290

Perugino, *352*

Phoenician Goddess, 142

Phoenix, 181

Phyllis and Aristotle, 511

Piazzetta, Giambattista, *385*

Piero della Francesca, *343*

Pierrot, 239

Pietà (Large Pietà Roundel) (Malouel), 202

Pietà (Rosso), 334, 371

Pietà (Tura), 335, 346

Pietà of Villeneuve-lès-Avignon, 200, 204

Pietà with Saint Francis and Mary Magdalen, 376

Pietro da Cortona, *384*

Pigalle, Jean-Baptiste, *425, 427*

Pilgrimage to Cythera, The, 238

Pilgrims at Emmaus, The, 363

Pilon, Germain, *413, 414*

Pipes and Tumbler, 242

Piranesi, Giovanni Battista, *524*

Pisanello, Antonio, *335, 343, 496, 516*

Plaque from a Bridle, in the Form of a Man-Headed Winged Bull Trampling an Animal, 139

Plate, 463

Poelenburch, Cornelis van, *303*

Pollaiuolo, Antonio, *518*

Portrait Bust of Livia, Wife of Augustus, 174

Portrait of a Compulsive Gambler, 254

Portrait of a Lady, 364

Portrait of a Man (Antonello), 348

Portrait of a Man (Titian), 360

Portrait of a Negress, 250

Portrait of an Old Woman, 273, 277

Portrait of a Venetian Patrician, 446

Portrait of a Woman, 353

Portrait of a Young Man, 210

Portrait of Gabrielle d'Estrées and One of Her Sisters(?), 213

Portrait of Jean II, the Good ("Jehan roy de France"), 201

Portrait of Pierre Quth, Apothecary, 209

Portrait of Shah Abbas I, 151

Portrait of Socrates, 168

Potter, Paulus, *316*

Poussin, *430*

Poussin, Nicolas, *197, 217–20, 498, 499*

Pradier, James, *435*

Praying Figure, Dedicated by Prince Ginak, 122

Préault, Auguste, *436*

Preparation of Lily Perfume, The, 112

Presentation in the Temple, The (Gentile), 342

Presentation in the Temple, The (Vouet), 215

Presentation of the Portrait of Marie de Médicis to Henri IV, The, 68, 294

Presumed Portrait of Madeleine of Burgundy, Dame de Laage, Presented by Saint Mary Magdalen, 207

Prieur, Barthélémy, *415*

Prince of Condé, The, 420

Princess from the Family of Akhenaton/Amenhotep IV, A, 102

Princess Nefertiabet with a Meal, 91

Prud'hon, Pierre-Paul, *260, 506*

Psyche Offering Venus Water from the Styx, 521

Puget, Pierre, *399, 401, 421, 422*

Pyx of Al-Mughira, 147

Quarton, Enguerrand, *204*

Queen Napirasu, Wife of
 Untash-Napirisha, 138
Queen of Sheba, The, 404

Raft of the Medusa, The, 69,
 263
Raherka, Inspector of Scribes,
 and His Wife Merseankh, 94
Rampin Rider, The, 161
Ramses II Depicted as a Child,
 107
Rape of the Sabine Women,
 The, 219
Raphael, 68, 334, 356, 357,
 369, 521
Ray of Sunlight, The, 68, 273,
 321
Reading the Breviary, 325
Reading the Gazette, 312
Rebel Slave, 69, 400, 445
Red-Figure Calyx Krater
 (Brygos Painter), 190
Red-Figure Calyx Krater
 (Euphronios), 190
Red-Figure Calyx Krater
 (Niobid Painter), 191
Redon, Pierre, 475
Regnault, Guillaume, 411
Reliquary Polyptych of the True
 Cross, 462
Rembrandt, 68, 273, 307–10,
 514
Reni, Guido, 383
Rest on the Flight into Egypt,
 The, 379
Resurrection Altarpiece, 471
Resurrection of Lazarus, The
 (Geertgen), 276
Resurrection of Lazarus, The
 (Guercino), 379
Retable of the Parlement of
 Paris, 31–32, 205
Revoil, Pierre, 251
Reynolds, Sir Joshua, 326
Ribera, Jusepe de, 392
Riccio, Andrea, 466

Riemenschneider, Tilman,
 442
Riesener, Jean-Henri, 482
Rigaud, Hyacinth, 234
Robert, Hubert, 246, 504
Roll-Top Desk of Queen Marie-
 Antoinette, 482
Romulus and Remus Taken in
 by Faustulus, 384
Rosso Fiorentino, 371
Rubens, Peter Paul, 68, 272,
 273, 294, 298, 299, 512
Rude, François, 436, 437
Ruisdael, Jacob van, 68, 273,
 321
"Rustic Ware" Platter, 476
"Rustic Ware" Water Pitcher,
 476
Ryckhaert, David III, 300

Sabine Houdon at the Age of
 Six Months, 429
Saenredam, Pieter Jansz, 306
Saint Bartholomew
 Altarpiece, Master of, 279
Saint Cecilia, 380
Saint Denis Altarpiece, 70, 203
Saint Francis of Assisi
 Receiving the Stigmata, 338
Saint George and the Dragon,
 410
Saint George Slaying the
 Dragon, 512
Saint Jerome and the Lion, 465
Saint Jerome in the Desert, 284
Saint John on Calvary, 409
Saint Mary Magdalen, 443
Saint Matthew Taking
 Dictation from an Angel,
 406
Saint Michael Slaying the
 Dragon, 403
Saint Paul Preaching in
 Ephesus, 221
Saint Sebastian (Mantegna),
 345

Saint Sebastian (Perugino),
 352
Saint Stephen Preaching in
 Jerusalem, 351
Saint Veronica, 349
Sarazin, Jacques, 418
Sarcophagus of a Married
 Couple, 170
Sarcophagus of King Ramses
 III, 86
Sarcophagus of the Muses, 176
Sarcophagus with Dionysus
 and Ariadne, 177
Sassetta, 342
Scene of the Carriages, The, 238
Scepter of Charles V, 461
Seaport by Moonlight, 247
Seaport with the Landing of
 Cleopatra at Tarsus, 220
Seated Scribe, 92
Self-Portrait (Dürer), 273, 281
Self-Portrait (Fouquet), 464
Self-Portrait (Mignard), 236
Self-Portrait (Poussin), 219
Self-Portrait Wearing a Toque
 and a Gold Chain
 (Rembrandt), 308
Self-Portrait with an Easel
 (Rembrandt), 308
Self-Portrait with Easel
 (Chardin), 503
Senynefer, Head of the King's
 Office, and His Wife
 Hatchepsut, 99
Sesostris III as a Young Man,
 97
Set of Three Cornet Vases, 486
Sèvres Manufactory, 479, 487
Ship of Fools, The, 278
"Ship" Potpourri of Madame de
 Pompadour, 479
Sibyls (?), 416
"Siege of Tunis" Ewer and
 Platter, 473
Sigismondo Malatesta, 343
Silence, 436

Slaughtered Ox, The, 310
Slaves, 69, 400, 445
Smoker's Kit, The, 242
Smoking Den, The, 228
Snyders, Frans, 297
Soldiers' Halt, 230
"Souvenir" of Mortefontaine, 255
Spitzweg, Carl, 325
Stag from Java, 438
Stamaty Family, The, 507
Standard of Mari, The, 126
Statue of a Woman, 159
Statue of Marcellus, Nephew of Augustus, 156, 174
Statuette of a Man, 88
Statuette of a Praying Figure, 133
Stele of Djet, the Serpent King, 90
Stele of the Vultures, 124
Stele with the Storm God Baal, 144
Stella, Jacques, 223
Studies for Bronze David and Right Arm of Marble David, 518
Study for the Grande Galerie of the Louvre, 499
Study for the Vault of the Farnese Gallery, 523
Supper at Emmaus, The (Rembrandt), 68, 273, 307
Supper at Emmaus, The (Titian), 361

Tapestry with Putti Harvesting Grapes, 114
Tavern Interior: Game of Cards, 302
Tea Fountain from the Tea Service of Napoleon I, 485
Temperance, 418
Temple Guardian Lion, 131
Teniers, David, the Younger, 302

Terborch, Gerard, 318
Ter Brugghen, Hendrick, 304
Thomas Becket Châsse, 459
Three-Door Commode for the Comtesse du Barry, 481
Three Male Nudes, 518
Tiburian Sibyl, The, 212
Tintoretto, 366
Titian, 359–61, 523
Toilet of Venus, The, 382
Toilette Table and Chair, 489
Tomb for the Entrails of Charles IV le Bel (died 1328) and Jeanne d'Evreux (died 1371), 408
Tomb of Philippe Pot, 70, 408
Torso of a Kouros, 157, 161
Torso of Aphrodite, 166
Torso of Miletus, The, 162
Tower of Babel, The, 291
Tree with Crows, 273, 324
Triad of Palmyrian Gods, 143
Triangular Harp, 83
Tura, Cosimo, 335, 346
Turkish Bath, The, 253
Turner, Joseph Mallord William, 329, 515
Two Canephorae, 522
Two Horses, 516
Two Kittens Nursing, 82
Two Sisters, 267
Two Studies of a Man's Head (Frontal View), 519

Uccello, Paolo, 335, 340

Valckenborch, Lucas van, 291
Valentin de Boulogne, 214
van Dyck, Anthony, 272, 301
Vase Dedicated by Entema, King of Lagash, to the God Ningirsu, 127
Vase from Emesa, 177
Vase Handle in the Form of a Winged Ibex, 142
Vase with Two-Headed Winged

Monsters Carrying Gazelles, 139
Venus, Satyr, and Cupid, 334, 370
Venus and the Graces Presenting Gifts to a Young Woman, 331, 336
Venus at Her Toilette, 213
Venus de Milo, 157, 165
Venus Standing in a Landscape, 282
Vermeer, Jan, 71, 273, 318, 319
Vernet, Joseph, 247
Veronese, 69, 334, 363–65
Victory Stele of Naram-Sin, King of Akkad, 128
Vien, Joseph-Marie, 248
View of the Château of Saint-Germain-en-Laye and Environs, 515
View of the Singel Canal in Amersfoort, 514
Vigée-Lebrun, Elisabeth-Louise, 247
Village Bride, The, 244
Virgin and Child (Donatello), 401, 439
Virgin and Child (limewood sculpture), 443
Virgin and Child (Mabuse), 286
Virgin and Child (Regnault), 411
Virgin and Child Surrounded by Angels, 440
Virgin and Child Surrounded by Six Angels, with Saint Anthony of Padua and Saint John the Evangelist, 342
Virgin and Child with Saint Anne, 355
Virgin and Child with Saint John the Baptist, 356
Virgin of Sorrows, 414
Virgin of the Annunciation, 442

Virgin of the Rocks, The, 354
Vittoria, Alessandro, 446
Voltaire (Houdon), 429
Voltaire (Pigalle), 425
Votive Relief of Urnanshe, King
 of Lagash, 123
Vouet, Simon, 68, 215, 216
Vries, Adrien de, 444

Walking Lion, 133
Wall Fragment from the
 Akhthetep Mastaba, 81
Warrior, 183
War Scene: Cavalrymen of
 Ashurbanipal, 136
Water Mill, 322
Watteau, Antoine, 238, 239,
 501
Weisweiler, Adam, 483
Weyden, Rogier van der, 69,
 275, 510
Winged Bull, 135
Winged Genius, 179
Winged Victory of Samothrace,
 The, 153, 157, 192

Winter, 373
Woman Playing a Lute, 187
Woman Returning from the
 Market, 243
Woman with a Stole, 130
Women of Algiers in Their
 Apartment, 266
Wounded Niobid, 435
Wouwerman, Philips, 323
Wrestler, 183
Writing Table of Queen Marie-
 Antoinette, 483
Wtewael, Joachim, 290

Young Beggar, The, 335, 393
Young Greek Women Adorning
 a Sleeping Cupid with
 Flowers, 248
Young Harpist, 434
Young Neapolitan Fisherman
 Playing with a Turtle, 436
Young Painter in His Studio,
 269, 273, 311

Zurbarán, Francisco de, 390

Photography Credits